THE APPRECIATION OF THE ARTS 4

General Editor: Harold Osborne

The Art of Appreciation

London
Oxford University Press
New York · Toronto
1970

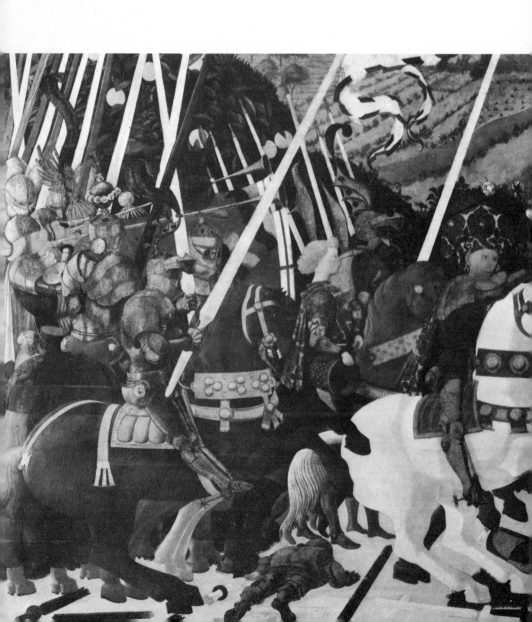

THE APPRECIATION OF THE ARTS 4

THE ART OF APPRECIATION

Harold Osborne

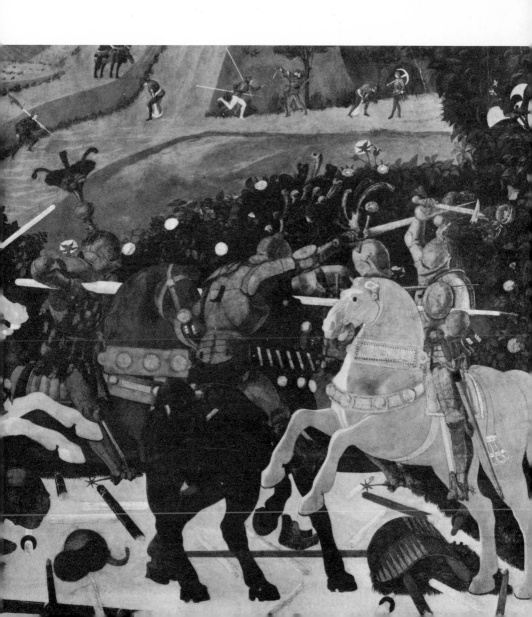

Oxford University Press, Ely House, London W. 1

GLASGOW NEW YORK TORONTO MELBOURNE WELLINGTON
CAPE TOWN SALISBURY IBADAN NAIROBI LUSAKA ADDIS ABABA DAR ES SALAAM
BOMBAY CALCUTTA MADRAS KARACHI LAHORE DACCA
KUALA LUMPUR SINGAPORE HONG KONG TOKYO

© Oxford University Press 1970

Printed by Fletcher & Son Ltd
Norwich and bound by
Richard Clay (The Chaucer Press) Ltd
Bungay Suffolk

Contents

Illustrations

(The small numbers in the right-hand margin of the text refer to pages on which relevant illustrations or discussion may be found.)

Acknowledgements

Acknowledgement is due to: Phaidon Press Ltd. for permission to quote from E. H. Gombrich, *Art and Illusion*; Yale University Press for permission to quote from M. Hamilton Swindler, *Ancient Painting*; Cambridge University Press for permission to quote from Roger Fry, *Last Lectures* and Kenneth Clark, *Leonardo da Vinci*; John Murray Ltd. and Princeton University Press for permission to quote from Kenneth Clark, *The Nude*; Oxford University Press for permission to quote from Anthony Blunt, *Picasso's Guernica* and L. R. Rogers, *Sculpture*; Allen and Unwin Ltd. for permission to quote from Pepita Haezrahi, *The Contemplative Activity*; Faber and Faber Ltd. and the University of California Press for permission to quote from Rudolf Arnheim, *Art and Visual Perception*; Thames and Hudson Ltd. and Viking Press Inc. for permission to quote from René Berger, *The Language of Art*; Roman Ingarden for permission to quote from his articles in the *British Journal of Aesthetics*; the Indian Institute of Advanced Study, Simla, for permission to quote from *Indian Aesthetics and Art Activity*; Penguin Books Ltd. for permission to quote from Vasari, *Lives of the Artists* (trans. Bull); Harvard University Press and Heinemann Educational Books Ltd. for permission to quote from the *Imagines* by Philostratus, trans. Fairbanks, in the Loeb Classical Library.

Appreciation as a skill

It is impossible not to be aware of a certain deeply rooted ambivalence in prevailing attitudes towards matters of aesthetic judgement. On the one hand it is taken for granted that appreciation of art and natural beauty is in some sense a matter for everyone and not the prerogative of a restricted class of experts. In the appraisal of the fine arts, as in questions of politics and gastronomy, the man-in-the-street will boldly hazard and affirm his opinion, although in other fields of expertise, such as medicine or engineering or law, he would automatically defer to the professional. On the other hand society does recognize and support specialists of the arts. They are curators of public galleries and museums, art historians, critics, teachers, collectors, dealers and connoisseurs. Considerable sums of public and private money are spent on the culti- vation of the arts and the massive approval which is accorded to this expenditure in most advanced communities can only be justified on the assumption that expertise is involved, that cultivation is feasible. Yet behind the prevailing attitude of ordinary people there is a tacit and true assumption that a great deal of knowledge about the arts and even day- by-day exposure to masterpieces of fine art do not necessarily or in all cases qualify the expert to impose his aesthetic appraisals on the lay- man, and when confronted with a work of art many men will confi- dently voice their own opinion with the preamble: 'I am not an expert, but . . .'

Our attitude to natural beauty is different again. In this field expertise is not assumed and there exist no professional critics or connoisseurs. Travel brochures and illustrated calendars aim at the widest general appeal and do not address themselves to an educated level of taste. In

the case of industrial products ambiguous attitudes continue to reign. By and large designers are expected to cater for majority taste as evinced by the sale of their goods; yet much is solemnly written about good and bad design. It is commonly believed that the general standard of taste can be raised by suitable techniques; yet popular taste is mainly controlled by advertisements whose primary motive is economic.

Everywhere where aesthetic judgement comes into play people take it for granted that there is good taste and bad taste. Yet there are no standards of taste, no admitted experts in good taste. Indeed many men would regard it as presumptuous to hold themselves out as persons of superior taste; yet few would willingly admit to bad taste.

Aided by new techniques of book-making and reproduction, an unprecedented expansion of interest in the arts has spread through all levels of society over the last thirty or fifty years. But the obscure puzzlement engendered by the ambiguities of outlook we have mentioned has not been eased by a certain disillusionment which has attended the rapid popularity enjoyed by picture-books of the arts with informatory text supplied by acknowledged experts for readers without specialized knowledge in artistic matters. It has become a very general experience with those who use these books as their introduction to the arts to discover that after reading them and enjoying the lavishly produced illustrations a man may still find himself as uncertain and confused as before when he comes into direct contact with art works themselves. The consumption of popularized expertise does not of itself enhance or refine a man's capacities for discriminative appreciation and indeed often seems to have little result beyond equipping him somewhat better to sustain his part intelligently in conversation about the history or technology of the arts. Expertise is still differentiated from taste and a smattering of it does not automatically confer increased powers of appreciation. In this chapter we shall argue that appreciation of the arts is not a branch of theoretical knowledge, nor yet an emotional indulgence, but an acquired skill. As a skill it can be cultivated and refined. Factual knowledge may be helpful in a variety of ways but cannot by any possibility become a substitute for the training of skilled capacity. At bottom, therefore, the purpose of this book—and of the series to which it belongs—is practical: to show how the power of appreciation can be trained. In this book the object is specifically to examine in general what it means for an interested and intelligent person

without special expertise to cultivate the skill to appreciate the fine arts and how he would set about doing this. Other volumes in the series are devoted to appreciation in the particular arts.

A skill is a trained or cultivated ability to perform in a certain way and the term frequently carries an implication that a person can so perform with more than average dexterity. Thus skill is a potentiality concept. A skill is a dispositional quality or constellation of qualities. It is an ability which a person has continuously whether or not he is manifesting it in present performance at any particular time. Skills are inclined to atrophy unless they are exercised, although some skills—such as the ability to swim or to ride a bicycle or speak a language—may remain latent or unused over considerable lengths of time without totally disappearing. Generally speaking, once a skill has been acquired it can be recovered after a period of disuse more rapidly and more easily than it can be acquired from scratch by someone who has never before cultivated it. The acquisition of a skill often results from a predisposing propensity, which in some cases may amount to a compulsive urge, and pre-eminence in any branch of skill is difficult to achieve without specific natural endowment. We speak of talent when a person has both the settled inclination and the corresponding natural endowment in a relatively high degree. The exercise of a well-developed skill is usually attended by a particular satisfaction analogous in some ways to the satisfaction derivable from the successful expression of personality traits, and this may be effective to warrant massive expenditure of energy in its attainment and to outweigh discomfort and inconvenience. Conversely a skill which is not exploited or a talent which is denied outlet may become the source of considerable personal discomfort. When a skill brings into play faculties and propensities for which a man's ordinary life affords inadequate outlet its exercise often becomes a 'self-rewarding' activity and acquires a value intrinsic to itself. This, or something like this (see pp. 210 ff), appears to be a source of the special value which is often ascribed to appreciation of the arts in our own time as distinct from historical periods and cultures when the arts had a more integral function in the social structure and their cultivation was less self-conscious than it is today.

It will be our thesis that the appreciation of beautiful things, and the fine arts in particular, calls for a skill resulting from the cultivation of

capacities which are common to the majority of people, though both the capacities themselves and the impulse to develop them vary greatly from person to person. In some people a capacity is lacking: a blind man cannot cultivate a skill to appreciate visual beauty and a tone-deaf person will hardly become a connoisseur of music. By and large, however, appreciation calls for no exceptional kinds of endowment. But the relevant propensities are very irregularly distributed and even where they exist their exercise may be impeded by conflict with rival propensities or imposed habits of life. Aesthetic capacities or their full cultivation are in some measure divergent from the main stream of practical life in organized society and the inclination to develop them into skills may be blunted by early educational influences, family environment, or a way of life which is rigidly circumscribed by regard for utility. A skill is particularly difficult to cultivate if it calls for the revival late in life of submerged faculties or aptitudes and it has frequently been remarked of recent years that the analytical habits of mind and the practical outlook fostered by our technological culture run counter to modes of awareness and attitudes of attention which are essential to successful appreciative commerce with the arts. This appears to be one reason why some of the most intelligent and highly educated persons today find themselves in adult life obtuse to the arts and without the aptitude to appreciate them. The word they use is 'understand'.

Even persons of exceptional artistic aptitude are rather seldom equally endowed for appreciation in all the arts. Those gifted for all-round appreciation are rare and more typical is the case of the late Clive Bell, who was outstanding in his generation for his cultivated skill in the appreciation of visual art but confessed that he had little talent for music. 'For my part,' he says in his book *Enjoying Pictures*,[1] 'I am not so much better off at a concert than the colonel is in a picture-gallery. The adventitious beauties, or some of them, I enjoy, a melody here, a harmony there; but as for grasping an intricate and unfamiliar piece of music as a whole, disentangling the parts, and realizing each in itself and in relation to the rest, that I cannot do.' In the same book he calls attention to the interesting fact that while people who care genuinely for painting are apt to care genuinely for pure poetry also, the reverse is not the case. The poetry reader may well be all at sea in a picture-gallery. The habits of attention and awareness which go with literary appreciation and the calls which it makes on the imagination are not

those which are most prominently called into play in the appreciation of visual art. The conceptual and anecdotal element which necessarily bulks so large in literature can easily be given too great importance in the appreciation of painting, whereas those visual features which are crucial to painting and sculpture cannot by any means be circumscribed within the generalizing straitjacket of discursive language. Hence it has been noticed that people who seek their introduction to the visual arts from the writings of critics with a preponderantly literary or scientific bent are particularly liable to misdirection if, as is often the case, they have not independently cultivated a robust skill in connection with visual appreciation.

These considerations underlie what will be a guiding theme throughout the present study: namely, that no tight formula for appreciation can usefully be given. General statements can certainly be made about it, and need to be made. But within these generalizations the ways of appreciation differ from one art form to another and even within any one art form different modes of attention are often demanded by different styles of work. In addition to this, there is good reason to believe that persons of different temperament and disposition have different but equally effective ways of making appreciative contact with those arts to which they are addicted and only damage can be done by trying to regiment everyone into one standard procedure. The implications of this will become more apparent in the sequel.

Skills differ from habits, although the attainment of many skills involves habit-formation, while some habits and even addictions are tied to certain skills. Everyone who has been taught to play a game by a professional coach knows that the acquisition of this sort of skill requires not only new habits of muscular co-ordination and automatic response but usually the eradication of certain pre-formed habits. And as has been already suggested, the cultivation of skill in appreciation may demand, as well as the formation of new habits of attention and interest, the conquest of habits acquired in the course of a theoretically biased education. In principle habits spell modes of automatic and unreflective performance which can be relied upon to come into operation without conscious effort and attention. Skills on the other hand, whether it be billiards or the appreciation of poetry, demand in their exercise a tautening of attention, concentration of control, and a heightening and enhancement of consciousness.

Skills, including the skill to appreciate things of beauty, are differentiated also from knowledge by the fact that they cannot be acquired solely through learning, understanding, and applying prescriptions formulated in words and written down in books. They are acquired by guided practice and by a process of trial and error. They can be imparted by demonstration and example within the framework of broad general precepts but they cannot be taught in the way that scientific knowledge is taught. For the possessor of a skill is unable at will to become fully conscious of the rules by which his performance is controlled or to formulate all of these rules in a set of fully articulate precepts which others could understand and follow. It was the mistake of seventeenth-century academicism to believe that this is possible. But a skill, so long as it remains a skill and not a science, always involves latent knowledge, that is knowledge which cannot be completely specified. And such latent knowledge includes both knowledge of fact and know-how in the sphere of performance ('knowledge that' and 'knowledge how'). Therefore, following a penetrating analysis of the concept of skill by Michael Polanyi,[2] we may further describe a skill as a cultivated capacity for performance of a sort which involves following a set of rules not all of which are consciously known or can be completely specified by the performer. Contrasting the traditional crafts with science, for example, Polanyi wrote that 'while *the articulate contents of science* are successfully taught all over the world in hundreds of new universities, *the unspecifiable art of scientific research* has not yet penetrated to any of these'. His point was that the body of scientific knowledge can be made verbally articulate and thus mastered by any person of adequate understanding, perseverance, and determination, but the art of scientific research cannot be reduced to a set of articulate prescriptions or mastered in any such straightforward way. A similar difference pertains between scientific art history or iconography on the one hand and the skill to appreciate the aesthetic qualities of art works on the other.

The ability to play chess has sometimes been adduced as a typical example of a skill and may usefully illustrate the difference there is between knowledge and skill. For here a distinction must be drawn. A person becomes able to play chess by learning the rules which govern the legal moves of the pieces and these moves are completely specifiable. Once he knows the game he is able to plan his play in accordance with

the rules without having constantly to recite them to himself or holding them in the forefront of his mind while he is playing. He confines his performance within the framework of the rules he has learnt and he is able at any moment to bring to mind any of the rules, should need arise. Of such a person we say that he knows how to play chess, that he *can play*; but it does not follow that he is a skilful player. A skilful chess player is one who within the framework of the rules is able to perform more effectively than the average. He has available other rules of procedure which are not completely specifiable by him. In addition to knowing the rules of the game, and in addition to technique (a second-order set of learned rules of procedure), he has what is called a good sense of position, ingenuity, invention, and intuition of partially envisaged possibilities. In these abilities, which constitute his skill, he cannot instruct others by precise precepts but at the most through general maxims, demonstration, and example so long as the pupil himself has a natural flair. A person who wishes to cultivate appreciation of the arts will make little headway by mastering the rules of the game, searching for precepts, and memorizing massive accumulations of factual knowledge about the works to which he is exposed. What he needs is to cultivate the latent knowledge and unspecifiable know-how which are the essence of any skill at all.

Skills may be divided very broadly into capacities for practical performance—examples of which may be found in the sphere of sport and in traditional handicrafts—and capacities for mental performance, as for example the cultivation of mystical experience or mathematical ability. Appreciation obviously belongs to the second type. There is, certainly, often a strong mental factor in bodily skills (as the footballer and the boxer well know) and bodily habit is closely linked to the attainment of some mental skills. But the broad division is valid. A concert performer requires both muscular and mental skills, and the two, although inextricably linked in a successful performance, can be distinguished. It makes sense, for instance, to say that such and such a performer lacked the muscular skill (that is, the technique) to do justice to his appreciative insight into the music; and it makes sense to say that his performance was an exhibition of virtuosity devoid of perceptiveness.

Among mental skills there is a special class which are cognitive in character rather than performatory in the narrower sense of that word.

Examples of cognitive skills are those of the wine-taster, the perfume-blender, the piano tuner, and the diagnostician. There is no word in use which exactly covers the class of cognitive skills and I propose—again following Polanyi—to adopt 'connoisseurship', though this is to give that word a special sense different in important respects from the implications which it customarily carries in the literature of the arts.[3] In this sense of the word the cultivated ability to appreciate fine art and the beauties of nature will be a branch of connoisseurship. We shall later have occasion to differentiate appreciation from other cognitive mental skills on the ground that it lays emphasis not only or even primarily on discriminatory acuity but perhaps even more on an ability to apprehend complex organizations of visual and auditory wholes and the recondite overall qualities of such wholes. At this point it should be said that in classifying appreciation as a cognitive skill nothing is implied with regard to the place of theoretical knowledge or analytical reasoning in our dealings with works of art. Nor in calling appreciation 'cognitive' is there any implied antithesis to feeling or emotion, which may themselves be cognitive. These points will be taken up in later chapters.

Most of the fine arts now practised have emerged fairly recently from the practical crafts. Indeed until the conception of the 'fine arts'—or *les beaux arts*, as they were known in France—of poetry, music, painting, sculpture, architecture, and dance was established in the course of the eighteenth century, artist and craftsman were not held distinct. Plato could speak quite naturally in the *Hippias Major* of Phidias as an artisan skilled in the know-how of making statues, and during the Middle Ages books such as those of Theophilus and Cennino Cennini[4] were primarily handbooks of craftsmanship and techniques, not manuals of aesthetics. From classical antiquity the word 'art' meant what we now mean by traditional crafts or cultivated practical skills, much as we still speak of 'the art of medicine', 'the art of fencing', etc. The traditional crafts are good examples of socially fostered practical skills. Because their rules of performance were not completely specifiable they were transmitted by personal contact and not by precept alone. The apprentice learned by watching and copying the master, by a process of guided trial and error, by submitting to the maxims and criticisms of authority until he had matured his own ability both to judge and to produce. When a tradition was interrupted for a generation or more the know-how might disappear and the craft would be lost beyond recovery. No

increment of scientific knowledge has sufficed to produce violins as fine as those made by the old craftsmen of Cremona or the 'inlaid' Sanggam celadon of Korea or the polychrome woven textiles of Paracas. But in principle it is not impossible that the rules of any skilled craft should come to be completely understood and should then be exhaustively specified; when this happens we no longer call it a craft but industrial science. Indeed one of the conditions of progress in an industrialized community demands the exhaustive or near-exhaustive specification of rules of craftsmanship, turning skills into manufacturing know-how and know-how into science. But the task of changing into overt and specificable knowledge what was already in a certain sense known has turned out to be unexpectedly laborious and intricate. A fundamental part of modern industrial development has consisted in elucidating and reducing to specifiable rules techniques of manipulation taken over from ancient crafts and the process has almost always had to be abandoned before completion, sacrificing quality to speed and workmanship to uniformity for the advantage of all but the craftsman and the connoisseur.

Part of the difficulty of converting craft to industrial science lies in the important element of connoisseurship inherent in the great crafts of antiquity. For connoisseurship and craftsmanship, two branches of skill, commonly go together, mutually reinforcing one another. A craft is an art of making and manipulating; connoisseurship is an art of apprehending, testing, selecting, appraising. And the fine craftsman is not only the possessor of manual and muscular skills for the manipulation of his materials but he is also a connoisseur of his materials and of the things made from them by the exercise of his craft. Therefore as the pressures of industrialization encourage the conversion of crafts into applied sciences, they must also require that the element of connoisseurship which enters as an essential ingredient into traditional craftsmanship shall be rendered into science by converting its latent know-how into specified rules. Industry therefore tries to import systems of objective measuring and grading in place of the subjective appraisals of the craftsman. In principle this can be done to an extent, though invariably at some sacrifice; it is more difficult than to render explicit the unspecified rules of manipulation. For connoisseurship in this field consists primarily of skill to recognize and appraise complex qualities of which neither the constituent elements nor the clues are

consciously known. The connoisseur–craftsman will take a piece of material in his hands—wood, leather, stone, fibre, clay—he will palpate it, smell it, taste it, delicately explore it with all his senses, and will finally pronounce a verdict without being able to explain fully what the basis of his assessment was. Industrial science substitutes other properties—elasticity, toughness, rigidity, malleability—and devises objective ways of measuring these. This brings an advantage where precise uniformity of mass-produced products is desired and it also enables the industrialist to dispense with the rare combination of trained experience and natural aptitude which goes to make the expert connoisseur in craftsmanship. It is the source of the characteristic difference between finely made machine products and the products of the craftsman. The former have the advantage of precision and predictability; the latter have the individuality which attends a loving exercise of skill. It is significant too that some styles of contemporary art have sought an aesthetic which has affinities with the machine product.

Some of the fine arts today continue to incorporate an important element of skilled craftsmanship and to the extent that an artist is still a craftsman he must also be a connoisseur of his materials and his tools. This holds good from the monumental sculptor appraising his stone to the painter choosing a brush. Indeed in China a whole literature of connoisseurship grew up around the brush, ink, paper, and grinding-stone, called 'The Four Precious Things of the Writing Desk'. Both connoisseurship and craftsmanship have become less prominent in the fine arts since many of the old studio processes, such as the grinding of pigments and the priming of canvases, have been industrialized. But something survives and is handed down in an enfeebled and lackadaisical way through the art schools and technical institutes. We may also notice the emergence of a rudimentary connoisseurship of the new synthetic materials which sculptors, architects, and painters now use and there is also the beginning of a connoisseurship for the appearance of machine-made precision which some art styles deliberately cultivate. Some tincture of the artist's connoisseurship of whatever sort can be an invaluable aid to those who appreciate the products of art. For a work of art is not always—perhaps seldom is—most successfully apprehended as a completely self-sufficient thing, entirely divorced from the processes by which it came into being and the materials from which it was fashioned. In architecture, particularly, some awareness of the ways in

which the possibilities and limitations of materials influenced techniques and the ways in which the techniques of working the materials influenced the aesthetic aspects of building brings a new dimension to appreciation. We do not speak of a purely intellectual understanding separate and apart from apprehension, but the knowledge of materials and techniques, of what they will do or not do, without being on each occasion consciously argued and dwelt on, will enter into and expand our awareness of the buildings themselves. Similarly in the appreciation of sculpture it is not enough to know theoretically and in the abstract that granite is hard, that alabaster bruises, that porphyry flakes, that sycamore is springy and inclined to split while cherry is structurally compact, straight-grained, and carves well. Such items of information can merge into a feeling for materials and contribute to a connoisseurship which goes beyond articulate and specifiable knowledge. It is this which is an adjunct to appreciation and in some cases (not the majority nowadays) persons may approach the more complex levels of appreciation by way of an understanding and love of materials. It is significant that historically most sculptors and architects worked in materials which were not only easily accessible but wholly familiar to their public.

Our subject is the appreciation not the creation of art. But it is worth mentioning that according to contemporary ideas the capacity to create fine works of art cannot be taught or imparted. Craftsmanship stands in close relation to art, but it is not a relation from which it would follow that the better the quality of the craftsmanship the better the work of art. To the extent to which fine art relies on craftsmen's techniques it is a user of skills. But artistic creation is not itself a skill. It is not a kind of performance subjected to rules which could, even theoretically and ideally, be exhaustively specified. It is an intimation of this fact—or apparent fact—which has lent plausibility to the prominence ascribed to the concepts of genius, creativity, and originality in connection with the arts during the two hundred years since the beginning of the Romantic era. These Romantic assumptions about art were formulated by Immanuel Kant, who in the *Critique of Judgement* defined the fine arts as those arts which 'must necessarily be regarded as arts of *genius*' and described genius as the natural endowment which 'gives the rule to art' but cannot itself be replaced by applications to rules. He wrote of genius as follows:

From this it may be seen that genius (i) is a *talent* for producing that for which no definite rule can be given: and not an aptitude in the way of cleverness for what can be learned according to some rule; and that consequently *originality* must be its primary property. (ii) Since there may also be original nonsense, its products must at the same time be models, i.e. be *exemplary*; and, consequently, though not themselves derived from imitation, they must serve that purpose for others, i.e. as a standard or rule of estimating. (iii) It cannot indicate scientifically how it brings about its product, but rather gives the rule as *nature*. Hence, where an author owes a product to his genius, he does not himself know how the *ideas* for it have entered his head, nor has he it in his power to invent the like at pleasure, or methodically, and communicate the same to others in such precepts as would put them in a position to produce similar products.[5]

But although the creation of art is not, according to modern ways of thinking, capable of being learnt and taught to rule, the appreciation of art *is* a skill. Yet unlike the manual crafts, appreciation has no inherited techniques or know-how. The professional 'connoisseurs' (in our sense of the word) of appreciation are the critics, and there are no traditional techniques of criticism. When we speak of schools of criticism we mean something rather like what is meant by schools of philosophy or theology—groups of persons who share common opinions, common outlooks, and perhaps to some extent common methods. There have been no guilds, no studio traditions, no transmission of know-how from generation to generation. And there exist today no techniques of appreciation which have come down to us from the past and could be taught by maxim and demonstration in training centres or eventually converted from craftsman's skill to practical science. Indeed criticism in

the past has been largely confined to discussions of craftsmanship, degrees of realism, and the interest of the subject-matter. Aesthetic criticism, or the verbal expression of appreciation, is a very recent arrival. Yet in principle there is no reason why the latent rules of appreciative skill might not to some extent be made progressively explicit and articulate. In fact, however, aesthetic criticism when it occurs today is the result only of individual flair and not an outcome of a systematically cultivated skill. It therefore presupposes appreciative skill ready formed in the reader and is rarely of great practical value as a guide to the formation of this skill. Courses for students in art appreciation have no tradition to call upon, no established techniques to recommend, no agreed terminology. There is in the field of practical aesthetics

no recognized system of communication and no organized body of knowledge to communicate.

A different kind of connoisseurship from that of the craftsman already mentioned is exemplified by the tea-taster, the wine-taster, and the blender of perfumes. One of its most brilliant manifestations may be seen in the cultivated sensitivity possessed by some Chinese for the tactile qualities and the appearance of jade. Whereas the craftsman uses the sensuous qualities of things as a clue to their material structure, the skill of the wine-taster consists in his ability delicately to discriminate among the flavours and bouquets of wines and to describe them with more than ordinary precision within the limits of a specialized vocabulary. The industrialist then studies what objective conditions are best calculated to produce the selected qualities. Such connoisseurship still plays an important role in industry. Even manufacturers of bakery machinery employ qualified bakers who among other things are skilled to discriminate the flavour and consistencies of breads and then try to design their machines so that they will reproduce the characteristic taste and crusty consistency of home-baked bread. This kind of connoisseurship has relevance for the arts in so far as sensuous qualities are regarded as important. For example it comes into play when we judge what is called good tone in music, the patina of sculpture, muddy or brilliant pigment colour in painting. Connoisseurship of good tone and approved timbre in music is an essential feature both in the making of musical instruments and in the training of musicians who use them. It is one element, though not a most important one, in the acquired skill to appreciate musical performance.

But aesthetic appreciation of the arts differs in important ways from both these forms of connoisseurship. The connoisseur of beautiful things has skill to savour and appraise the beauty of a picture, a tune or a vase and up to a point he can characterize the particular beauty of each in terms of aesthetic categories such as grace, delicacy, grandeur, and so on. If he is able in the use of words he can probably suggest by metaphor and implication the presence of many aesthetic features which have no names in the language. But the beauty which he apprehends in each case seems to belong uniquely to the aesthetic construct in question and can be adumbrated but not described by means of aesthetic categories which are applicable to other objects also. In other words the aesthetic categories in terms of which alone a connoisseur could attempt to

characterize the specific beauty of a particular work of art, while recognizably apt, take on a vastly different meaning in each artistic construct to which they are applicable, so that whereas one could—ideally and with considerable extension of vocabulary—describe the flavour and bouquet of a new wine accurately enough to enable an experienced gourmet to know what to expect, it may well be that the most exhaustive categorization of an artistic masterpiece in terms of aesthetic categories would convey little or nothing about it to an art expert who had not the picture before him or who was unable to visualize other pictures of a closely similar kind (e.g. pictures by the same artist in a similar style) to which it was compared. For this reason a broad experience of the arts at first hand is particularly important both in reading the critics and in apprehending the true aesthetic qualities of art works. It seems to be the case furthermore that there exists no regular or reliable connection between the aesthetic qualities which it is the province of the art connoisseur to recognize and appraise and the physical properties of the art works which display them, so that even given an accurate and exhaustive aesthetic description it would not be sensible to seek experimentally a physical structure which could be relied on to exhibit these qualities in a wide variety of cases. Indeed there is something ludicrous in the very idea of describing the specific beauty of a piece of music or a picture so fully and precisely as to enable a manufacturer to turn out many more pieces of music or pictures with the same or indistinguishable beauty, as can be done nearly enough with timbre or pigment colour.

If this should turn out to be the case, it would seem likely that the unconscious rules of skill by which the performance of aesthetic connoisseurs is governed will be of a different sort from those of most other kinds of connoisseurship. On the other hand they may well bear an analogy with our everyday appraisal of other persons, which depend upon sympathetic rapport as much as on analysis and calculation. Our impressions of other persons, our direct unreasoned knowledge of them, go beyond what we consciously deduce and are usually too individualized to be completely confined within the straitjacket of descriptive categories. The characterologist classifies people into types and dockets each with well-defined descriptive terms, but in so doing he loses the individuality which is the essence of our living contact with our fellow men.

When the capacity for appreciating works of art is brought under the heading of connoisseurship in the sense in which we here use the term as a category of skill, this is tantamount to denying that it is merely an expression of personal preference, a matter of individual likes and dislikes. Although personal taste may be associated with it and may sometimes serve as a touchstone in the exercise of the skill, the judgements of appreciation cannot be simply judgements of personal taste, of individual likes and dislikes, if it is true that appreciation is a form of connoisseurship. For that is a cognitive skill, purporting to apprehend and discriminate qualities residing in the object of attention, qualities which can be recognized and tested by others who have the skill. A connoisseur in the sense in which we have used the word here is not a man who just happens to like good things—although it may help if in fact he does like them. He is a man of discerning perception who can discriminate, compare, and describe those qualities of which he is a connoisseur and reject things in which they are not present. He is not as a rule a man whose likings coincide with those of the majority; his own tastes may often be esoteric. The expert wine-taster is not paid because he likes what the average wine-drinker likes but for an exceptional ability to discriminate the savours and bouquets of many different wines and to describe them. He is a man of sensitive and discriminating taste.

Therefore the cultivation of appreciative skill is not a matter of training ourselves to enjoy things we did not enjoy before—although this may result as an additional bonus. It is not as if we learned to acquire a new taste for quinces, persimmons, and Giotto. It is more like acquiring new powers of perception, like the awakening of a sense that was dulled. By acquiring skill in appreciation we acquire power to perceive features of the world around us which had hitherto passed unnoticed and unremarked and to hold clearly and deliberately in attention aspects which without this skill had impinged only casually and incidentally upon our awareness. This is not a matter of reasoning or inference or the theoretical analysis and manipulation of information presented all along by the senses. It is the opening up of a new dimension of awareness. For this reason the acquisition of the skill demands methods of cultivation different from those which are taught with the object of improving a man's reasoning powers or for the extension of practical knowledge.

Appreciation as percipience

It is only in the course of the present century that the word 'appreciation' has gradually been adopted as a key term into aesthetic discourse. As it is now current, 'appreciation' is one of those utility locutions, so common in every language, which has made its way in response to a felt need until it now seems so essential that no synonym or substitute comes easily to mind. Indeed when some years ago a paper of mine was to be translated into Polish it came as a surprise to me to realize that that language has no equivalent term, and the difficulties which we experienced in rendering it satisfactorily brought to light ambiguities inherent in the English word. In a practical way we all know what 'appreciation' means—or everyone seems to know until the question is put. Yet the concept is difficult to pin down and there is no authoritative definition of it. When educational courses in art appreciation are announced it is not unusual for some people to query whether appreciation can be taught; yet few ever pause to ask what appreciation is.

It is clear that in the context of artistic discourse 'appreciation' is not —or is not primarily—an evaluative term in accordance with its dictionary definition: 'to estimate a thing at its true worth'. We may make a valuation of a work of art as a result of appreciation, and indeed it has often been said that the only genuine aesthetic valuation is that which arises from an act of appreciation. But appreciation is understood rather as a basis for achieving possible valuation than as itself an act of evaluation. The current aesthetic usage of 'appreciation' is closer to an older meaning which the *Oxford English Dictionary* gives as: 'perception, especially of delicate impressions or distinctions'. In the 1920s

Clive Bell used it to mean sensitive and emotionally tinged percipience, as for example in the paragraph from his essay 'The Aesthetic Hypothesis' in which he amplifies his often quoted sentence: 'To appreciate a work of art we need bring with us nothing but a sense of form and colour and a knowledge of three-dimensional space.'[1] In the 1930s John Dewey in the United States brought the word in as an occasional synonym of 'aesthetic perception'.[2] Since then the word has established for itself a far more central position and Dr. Munro is fully in line with contemporary practice when, in his book *Evolution in the Arts*, he equates it with 'to understand and enjoy', and writes: 'We are now beginning to teach children how to see pictures, hear music, and read poetry so as to grasp the form, style, and subtle nuances of individual expression. Experts differ on the best ways of doing so.'[3]

In a rather similar fashion during the nineteenth century the word 'aesthetic' established itself without formal definition in philosophical and general artistic discourse after it had been introduced as a neologism by the German philosopher Alexander Baumgarten (1714–62). Both words are now so ubiquitous that it is difficult to realize how the English writers on 'aesthetics' from the third Earl of Shaftesbury to Archibald Alison and Dugald Stewart managed without either of them. The very vagueness of the word 'aesthetic' contributed to its usefulness as a signpost marking out in the most general way our characteristic manner of commerce with natural beauty and the fine arts, while the psychology and phenomenology of so-called 'aesthetic' experience have remained a primary preoccupation of the branch of philosophy which has also been named 'aesthetics'. The newer concept of appreciation is linked closely with that of aesthetic experience and is therefore central to any inquiry into appropriate ways of cultivating a skill for the enjoyment of the arts. In its application it is narrower than 'aesthetic', which covers both the production and the enjoyment of whatever is beautiful. In current usage 'appreciation' is complementary to 'creation': the former term covers the appropriate activities of the consumer and the latter the activities of the producer. The artist creates, his public appreciates what he has created. But built into the notion of appreciation, as the term is used, there is an implication of a sort of consumption which is appropriate and peculiar to things of beauty and particularly characteristic of works of art. The term 'appreciation' is linked to a kind of consumption to which the term 'aesthetic' can properly be applied. It does not make

nonsense to say that such and such a business magnate paid vast sums of money for an artistic masterpiece which he was unable to appreciate. Nor do we commit a logical solecism if we say of some art historians that they have a very extensive knowledge *about* certain works of art— knowledge of their iconography, techniques, the social conditions in which they were produced, etc.—but that they are without a capacity to appreciate these works. Appreciation is wedded to the concept of 'aesthetic' apprehension. Through a successful act of appreciation we make aesthetic contact with an object, achieve a more adequate aware- ness of its aesthetic properties, enjoy the aesthetic impact which it makes upon us. It is through the qualifications implicit in the word 'aesthetic' that we distinguish appreciation of the arts from economic or other forms of non-appreciative contact.

Therefore in order to study appreciation, and to reach a clearer under- standing of its varieties and methods, it is necessary first to know in a general way what is meant by calling any experience 'aesthetic' and the characteristics in virtue of which we call any contact with the world around us an 'aesthetic' contact.

In quite general terms, when we take up an aesthetic attitude towards something, one may say that we are engaged in appreciation of it in so far as without abandoning or disrupting that attitude we achieve an experience which is full and satisfying, free from frustration. Frustra- tion may occur either because the object is not suitable to sustain aesthetic interest or because we are not adequately equipped to appre- hend that particular object aesthetically. It may well be misleading to speak, as is often done, of *the* aesthetic attitude. We are obviously doing very different things, very differently occupied, when we are engaged in aesthetic appreciation of say Durham Cathedral, an oratorio by Handel, a miniature by Hilliard, *Anna Karenina*, *King Lear*, the sculptures of the Parthenon, and so on. Our aesthetic commerce with the environment is as multifarious as our practical, intellectual or emotional commerce. Yet despite arguments to the contrary, as we can differentiate practical from theoretical attitudes, scientific analysis from attitudes of will or emotional response, so we can sensibly differentiate aesthetic attitudes as a class from the other modes of behaviour in which we indulge.[4]

Appreciation is a complicated and many-sided activity; nevertheless we are saying something to the point when we say that it is to be des- cribed in terms of taking up an aesthetic attitude to something rather

than thinking analytically about it or responding to it emotionally or assessing its utility value or failing to notice it at all. Perhaps most basically of all to be aesthetically preoccupied with a thing is to apprehend it, to enter into growing awareness of it, in a special kind of way which will here be described as 'percipience'. It involves the cultivation of awareness for its own sake and without practical motivation. It is from this point of view that aesthetic activity is discussed in the present chapter.

We no longer look to the arts, as was normal a century ago, for a moral or a didactic message. Instead it is nowadays commonly claimed that appreciation of the arts affords a counterpoise to the rationalistic bias of contemporary technological culture and offers many people a field in which to exercise faculties which might otherwise remain stunted and impoverished. A typical example of such claims may be quoted from Sir Herbert Read, who in *The Form of Things Unknown* said:

> So long as civilisation was based on handcrafts, there always existed, in the actual mode of living, some counterpoise to abstract conceptual thought. But during the course of the last two centuries millions of people have become divorced from all perceptual effort. Of course, people still have to use their eyes (automatically, with the same kind of reactions we might expect from a calculating machine, but with less reliability); but there is little need for any positive co-ordination of hand and eye, for any visual exploration of the world, for any constructive use of perceptual experience. [He goes on to allege that through cultivation of the arts men] will correct the bias of an exclusively linguistic mode of thought, and, what is equally important, correct the bias of a mechanised mode of life.[5]

Underlying such generalizations we might point to the empirical facts that many people whose habits are preponderantly intellectual and verbal—those for example who teach and write in the universities, work for banks or insurance companies—and some people who move primarily in the fields of technology and applied science, frequently experience difficulty in throwing off analytical and practical habits of mind which impede appreciative commerce with the arts. And, if we may cap generalization with generalization, it is perhaps not too far-fetched to suggest that the recent massive expansion of interest among people who are neither patrons nor professionals of the arts may stem in part from an unrecognized impulse to find some compensation for an imbalance in contemporary life and education whose tendency is to

cramp and confine the faculties of perception. Be that as it may, there is certainly prevalent a belief that through the visual even more than the literary arts can be found occasion and inducement to exercise faculties of perceptiveness which otherwise are in danger of becoming blunted through neglect.

Nevertheless, the heritage of Romanticism continues so strongly to colour the presuppositions of our thinking that a proposal to discuss appreciation from the point of view of a perceptual skill to be cultivated and trained does at first blush seem to many people too cool and unemotional an approach to what is still primarily conceived to be a matter of feeling and emotional rapport. The ever more voluminous ephemeral literature of the arts—concert programmes, exhibition catalogues, reviews, popular criticism, and history—is permeated with a tacit if unargued alternative: that in coming to terms with a work of art we must seek either to understand it theoretically or to achieve a correct emotional response to it. The same assumption is reflected in popular discourse. When the subject of the arts crops up in any tea-table conversation you may hear one man remark: 'I don't understand modern art', while another will say: 'I have read it up but it still leaves me cold.' Both statements conceal the same fundamental error, namely the assumption that to perceive a work of art, to grasp it fully in awareness, is an automatic thing and easy of accomplishment, something equally within the competence of any man, while the difficulties of appreciation begin later with the 'understanding' of what has been perceived or with the emotional response to it. Almost the complete opposite is the case. The difficulty and the skill are not of the understanding but of apprehending in perception, and we may confidently assume that neither of the participants in our tea-table conversation has successfully perceived the art works about which he speaks. The manner of perceiving works of art will therefore be our first topic.

We pass our lives, strenuously or languorously, in a never-ending give and take with a partly malleable, partly resistant environment, material and human, adapting it to our ends when we can and accommodating ourselves to it when we must. Occasionally the busy flow of life's intricate involvements is interrupted as there occur sudden pauses in our practical and theoretical preoccupations, moments of calm amidst the turmoil like clear patches of blue behind the clouds scurrying in a wind-blown sky, as our attention is caught by the rainbow sheen

ruffing a pigeon's neck, the rhythmic rise and fall of susurration on a summer's day, the smoky calligraphies of wheeling birds painted on a transparent grey sky in winter, the grotesque contorted menace of an olive tree's branches, the lissom slenderness of a birch, or the sad sloppiness of a rain-crushed dandelion. Sometimes, if more rarely, we catch a glimpse of familiar things in an unfamiliar light. Commonplace objects suddenly shed their murk and enter the focus of attention. Perhaps for the first time in our memory we *see* a familiar sight. The trite fenestration of the house across the way reveals itself in a flash of insight as a limping, rather pathetic four-square pattern against the tangential folds of the curtains behind. A pillar-box is seen not merely as a receptacle but as a shape. Our eyes are opened to the squat lugubrious block of the desk telephone whose primly rounded lines can't make up their minds whether to be rectilinear or curved or to fake a streamlined sophistication. The clumsily pretentious cornice appears as irritating as a crookedly hanging picture and a disproportionately small door-knob looks so ludicrous that discomfort battles with the impulse to laugh.

In ordinary life we are accustomed to use our perceptions as clues to practical situations, signposts to action, and the raw material of conceptualizing thought. We do not notice the perceptual qualities of the things we see beyond what is necessary to enable us to recognize, classify, and place them. We are aware of generalized and indeterminate perceptual qualities. Exceptions occur most frequently when we look at things which have (in the context in which we see them) no practical significance—such as flowers, scenery, sunsets, shells, objects of art— or objects of personal adornment when our interest is precisely in their decorative qualities. On such occasions, and whenever our practical concerns are in abeyance and we look at things for their own sake, there is a tendency—which may indeed be fleeting and slight but which can always be detected—for attention to be deflected from other things and focused upon the object which moves towards the centre of our awareness. There is also a tendency for perceptual activity to be enhanced and to predominate over analytical and classificatory thinking as we become engrossed, however momentarily, in the perceptual object which holds our attention. Our interest 'terminates' in the object and our concern with it goes no further than perceiving, bringing it more fully and more completely into perceptual awareness. When attention is set into this posture and we look at things for their own sake, the vague

and indeterminate qualities which we habitually see become more precise and determinate: the perceptual object—the object of which we are aware—changes as its qualities are transformed, although the physical thing at which we are looking is not changed. As the intensity and the manner of attention changes so the object of each man's perception is transformed and it may be that, except when looking at the world conventionally and practically, no two men's perceptual experience of the same physical thing is the same. In the words of Merleau-Ponty, 'attention is . . . the active constitution of a new object which makes explicit and articulate what was until then presented as no more than an indeterminate horizon'.[6] This is why when we do sometimes see a familiar object in this way, for itself and shorn of its practical implications, the impact is as a revelation of something new and strange. The principle is fundamental also when we compare and discuss the 'aesthetic objects' which we have actualized in perception on the basis of physical works of art (see ch. 7).

To some people these moments of heightened perception are exciting and important, even to the extent of experimenting with hallucinatory drugs in order to induce them artificially.[7] For others they are frivolities which besmirch the solemnities of work and entertainment. In yet others the capacity for them has been submerged, and these are the people who in sober truth have lost the power of vision. Some artists—not all—have been exceptionally alert to such ways of perceiving and one of the things which they have done is to crystallize and make concrete such perceptions, helping others in their turn to render the commonplace once more visible and, because visible, unfamiliar. When this happens in a painting we experience a feeling of illumination—so *that* is what it really looks like! To bring back visibility to the ordinary and present familiar things in an unfamiliar significance which nevertheless strikes us as a revelation of their true nature is one of the things which the artist can do, and Schopenhauer is not the only philosopher who has drawn attention to this.

The sort of perceptual experiences which I have been trying to describe are the raw material of aesthetic experience and their cultivation is useful for the training of appreciation. They do not take us all the way, perhaps not even very far. But they, and still more the attitude of mind and attention which favours their arousal, are the prototype from which can be developed the habit of aesthetic contact with works of art and

other objects capable of supporting more sustained acts of appreciation. By accustoming himself to them a man does predispose himself to the sort of perceptual attitude which is most favourable to successful contact with the arts.

The engrossment with the object which lies at the heart of aesthetic appreciation has been traditionally known by the term 'disinterested enjoyment'—a turn of phrase at first sight singularly inappropriate to describe a posture of attention where interest falls wholly upon the object. The term may be explained historically. The notion of 'disinterestedness' came to prominence in opposition to the 'intelligent egoism' of Thomas Hobbes, who had argued that all the precepts of morality and religion can in the last resort by reduced to enlightened self-interest. Against this view Lord Shaftesbury, and with him Cudworth and other of the Cambridge Platonists, maintained that virtue and goodness must of necessity be 'disinterested': that is, they must be free from self-interest, pursued for their own sake and not from motives of self-interest, however enlightened. Also in the religious sphere the concept of 'disinterested' love of God—that is the love of God for His own sake and not from hope of heaven or fear of hell—arose out of a controversy between the Jansenists and the Jesuits about the same time. This idea of disinterested interest—interest in something for its own sake alone—was applied in the field of aesthetics when Shaftesbury contrasted the disinterested attention which is essential to what is now called an aesthetic attitude with any desire to possess, use, or otherwise manipulate an object. Shaftesbury gave as a paradigm of this attitude of disinterested attention our enjoyment of mathematics, where our perception does not relate to any 'private interest of the creature, nor has for its object any self-good or advantage', but, as he said, 'the admiration, joy or love turns wholly upon what is exterior and foreign to ourselves'. This line of thought was summed up by Archibald Alison, who excluded from the sphere of the aesthetic 'the useful, the agreeable, the fitting, or the convenient'.[8] The word 'contemplation' has been used to express this kind of disinterested engrossment which is central to aesthetic commerce with the environment. Edmund Burke, for example, defined beauty as 'that quality . . . in bodies by which they cause love' and defined the love which is 'symptomatic' of beauty as the satisfaction which 'arises to the mind on the contemplation of anything beautiful'. Two centuries later Professor C. W. Valentine, wanting to describe the

concept of 'aesthetic attitude' assumed by him for the purposes of experimental aesthetics, said in *The Experimental Psychology of Beauty* (1962): 'We may say roughly that an aesthetic attitude, in the wider sense of the term, is being adopted whenever an object is apprehended or judged without reference to its utility or value or moral rightness; or when it is merely being contemplated.' This is the attitude of perception, the activity of the spectator pure and simple, the mental stance and the posture of attention which are habitual in those who have developed a trained skill to appreciate.

The concept of disinterested contemplation was renewed in the present century under the name of 'psychical distance' by Edward Bullough, who gives one of the most vivid descriptions on record of what is meant by seeing the ordinary and commonplace in an aesthetic light. He takes as his example a fog at sea:

Imagine a fog at sea: for most people it is an experience of acute unpleasantness. Apart from the physical annoyance and remoter forms of discomfort such as delays, it is apt to produce feelings of peculiar anxiety, fears of invisible dangers, strains of watching and listening for distant and unlocalised signals. The listless movement of the ship and her warning calls soon tell upon the nerves of the passengers; and that special, expectant, tacit anxiety and nervousness, always associated with this experience, make a fog the dreaded terror of the sea (all the more terrifying because of its very silence and gentleness) for the expert seafarer no less than for the ignorant landsman.

Nevertheless, a fog at sea can be a source of intense relish and enjoyment. Abstract from the experience of the sea fog, for the moment, its danger and practical unpleasantness, just as everyone in the enjoyment of a mountain-climb disregards its physical labour and its danger (though, it is not denied, that these may incidentally enter into the enjoyment and enhance it); direct the attention to the features 'objectively' constituting the phenomenon—the veil surrounding you with an opaqueness as of transparent milk, blurring the outline of things and distorting their shapes into weird grotesqueness; observe the carrying-power of the air, producing the impression as if you could touch some far-off siren by merely putting out your hand and letting it lose itself behind that white wall; note that curious creamy smoothness of the water, hypocritically denying as it were any suggestion of danger; and, above all, the strange solitude and remoteness from the world, as it can be found only on the highest mountain tops: and the experience may acquire, in its uncanny mingling of repose and terror, a flavour of such concentrated poignancy and delight as to contrast sharply with the blind and distempered

anxiety of its other aspects. This contrast, often emerging with startling suddenness, is like a momentary switching on of some new current, or the passing ray of a brighter light, illuminating the outlook upon perhaps the most ordinary and familiar objects—an impression which we experience sometimes in instants of direst extremity, when our practical interest snaps like a wire from sheer over-tension, and we watch the consummation of some impending catastrophe with the marvelling unconcern of a mere spectator.[9]

The change of attitude—which Bullough calls 'distance'—is produced, he explains, in the first instance

by putting the phenomenon, so to speak, out of gear with our practical, actual self; by allowing it to stand outside the context of our personal needs and ends—in short, by looking at it 'objectively', as it has often been called, by permitting only such reactions on our part as emphasize the 'objective' features of the experience, and by interpreting even our 'subjective' affections not as modes of *our* being but rather as characteristics of the phenomenon.

The attitude of disinterested attention, which we may henceforward call the attitude of *contemplation*, has been admirably described also by Pepita Haezrahi, taking as her example the sight of a falling leaf in the autumn.

Our leaf falls. It detaches itself with a little plopping sound from its place high up in the tree. It is red and golden. It plunges straight down through the tree and then hesitates and hovers for a while just below the lowest branches. The sun catches it and it glitters with mist and dew. It now descends in a leisurely arc and lingers for another moment before it finally settles on the ground.

You witness the whole occurrence. Something about it makes you catch your breath. The town, the village, the garden around you sink into oblivion. There is a pause in time. The chain of your thoughts is severed. The red and golden tints of the leaf, the graceful form of the arc described by its descent fill the whole of your consciousness, fill your soul to the brim. It is as though you existed in order to gaze at this leaf falling, and if you had other preoccupations and other purposes you have forgotten them. You do not know how long this lasts, it may be only an instant, but there is a quality of timelessness, a quality of eternity about it. You have had an aesthetic experience.

The attitude of mind and attention which is involved in this experience and which makes it possible she then characterizes as follows:

A farmer on seeing the leaf fall might mark the arc it describes in its descent, deduce from this the direction of the wind, the imminence of rain, and hurry

off to do whatever farmers do when the rain is imminent. A botanist may observe the leaf, think that it is falling rather earlier in the year than usual, pick it up and examine its capillaries, look for signs of disease or other causes for the weakening of the tissues and so on. A sensitive soul, on seeing the leaf fall may be induced to reflect on the transience of worldly glory, the uncertainty of human existence, the fickleness of human nature and generally indulge in sad musings. A poet on seeing the leaf fall, may or may not experience this experience aesthetically, but may be led to think of a metre or a rhythm he could use in his next poem, or of a striking metaphor. We, here, would think of how to analyse the aesthetic experience of seeing a leaf fall, if someone could be induced to undergo one.

Only the spectator who had that experience, and was content to stop at the experience, without trying to draw any conclusions from it, or make any further use of it, without trying to go behind the given appearance of the falling leaf to what it may purport (like the weakening of vegetable tissues) or symbolise (like the shortness of human life), has remained within the aesthetic domain.

You will have observed that, apart from the spectator's, all those various ways of looking at the falling leaf had two features in common. They all amounted to attempts, first, to relate this occurrence to things outside itself, to find a place for it in some system or other of well-defined causal connections. And secondly, to relate this occurrence to various preoccupations in life, to make use of it for some ulterior purpose . . .

The spectator alone made no attempt to relate the falling leaf to anything beyond itself, made no attempt to use it for any purpose whatever. He treated it as a thing complete, absolute and valuable in itself, which need be neither explained, nor utilised in order justify the amount of attention paid to it. We have therefore described the attitude of the spectator as a non-utilitarian, non-volitional, non-emotional, non-analytical attitude. We have described it as an attitude of pure attention, an act of unselfish almost impersonal concentration, an incorporeal 'gazing'. In fact we have described an act of contemplation, the expression of a contemplative attitude.[10]

The foregoing descriptions by Bullough and Haezrahi will pinpoint a mode of experience which, although naturally sporadic, can be cultivated and will be familiar to many people. It is this which I take to be paradigmatic for aesthetic experience generally and it is basic to an understanding of appreciation in its more advanced forms.

From the time when men awoke to aesthetic self-consciousness and began deliberately to think and philosophize about the appreciation and enjoyment of beauty aesthetic experience has been presented in terms of

an attitude of mind, sometimes called the contemplative attitude, which involves a particular posture of attention, a special way of being interested in things, differing in certain respects from the usual habits of interest and attention we display in the conduct of practical affairs and in our scientific and theoretical preoccupations.[11] I now propose to examine more systematically some of the features which have been regarded as characteristic of this attitude and I will list eight features in virtue of which in the main experiences have been classed as aesthetic. Some of these features are closely linked, others less so. I do not wish to claim that all of them are necessarily present in any experience properly called aesthetic—that, after all, is a matter of linguistic usage and dictionary definition. Our actual aesthetic commerce with the environment is as many-sided and diverse as the sort of experiences which are called practical or scientific or sentimental or moral, and it will not be regimented or stereotyped. Just as moments of aesthetic experience interpenetrate in the practical affairs of life (as, for instance, when we recognize a person by gracefulness of posture, clumsiness of gait, serenity of demeanour, etc.), so our mature appreciation of complex aesthetic objects such as works of art is usually interwoven with theoretical and analytical procedures as we bring ourselves to greater familiarity with them. I do wish to claim that the eight features listed are important, individually and collectively, in determining us to regard any experience as aesthetic rather than practical or theoretical, and I would be prepared to insist that trained facility in all these ways of apprehending the environment is an important step in the cultivation of skill in the art of appreciation. Understanding of these characteristic slants of attention and interest will help to bridge the gap from the archetypal manifestations of aesthetic apprehension already described to the mature and more exacting appreciation of accomplished works of art.

1. When we perceive anything aesthetically there is a tendency for attention to be deflected from other things and centred upon it. It is therefore abstracted in attention from the environmental system of which it forms a part. As is sometimes said, it is 'framed apart' for attention. Attention is 'arrested' upon it and we do not apprehend it as a unit in a system of things held in awareness.

It is notorious that some of the arts employ deliberate devices to favour this concentration of attention and to facilitate the isolation of

the object from its environment. Pictures are enclosed in frames, which isolate them from the surrounding wall, contract the field of vision, and help us to fix attention within the area marked out by the frame. So important is this that many amateurs are unable to 'see' an unframed picture. It takes considerable practice to do this and many people who can do it succeed only by setting an imaginary frame round the picture. Conversely an unsuitable frame can 'kill' a picture by taking attention from it, by suggesting deep recession when the point of the picture is flat pattern in the picture plane, or for other such reasons. When we see a play or a film we look out from a darkened auditorium on to a lighted scene or screen, and our awareness of our immediate surroundings falls temporarily into abeyance. Music is a structure built up of artificial sounds which do not occur in nature and concentration within the world of structure which they create is ordinarily so intense that the listener is no longer fully aware of his surroundings and the intrusion of an alien sound impinging willy-nilly on the attention—such as the blare of a motor horn—causes disproportionate shock. Even our more elementary moments of aesthetic vision involve some isolation of the object and it is this which causes, in part at any rate, the sense of a pause and an interruption to the tenor of our practical concerns.

2. Implicit to the isolation of the object for attention is the fact that we do not conceptualize or think discursively about it. We do not classify it as an instance of a kind with such and such common class-features and such and such distinguishing characteristics. We do not ponder its causes or deliberate about its uses or effects. Our interest and attention are arrested by it and do not go outside it. We are not concerned to signpost it or 'place' it in a wider environment. It is this, chiefly, which distinguishes the attitude of appreciation from that of the art historian. The historian's concern is with fixing the individual work as a unit in a systematic context, establishing its origins, its sociological implications, drawing stylistic and other comparisons and contrasts, tracing all the various vicissitudes it has undergone. The information he provides, or some of it, may well be of use to the connoisseur, helping him to apprehend the work more completely, to perceive aspects and features of it which might otherwise have passed him by or only imperfectly come to his awareness. But it will be as background information only, predisposing him to notice things germane to appreciation. The intellectual interest in knowing all that can be known *about* a work

of art may be ancillary to, but is not identical with, the aesthetic interest. The two interests are related but distinct. A historian can get by passably with small powers of appreciation and a connoisseur need have little historical knowledge, though he would be rash to belittle the help that can accrue from historical orientation in some cases.

3. When something is apprehended aesthetically we do not analyse it into an assemblage of constituent parts standing in such and such relations to each other. We do indeed *perceive* it as a complex structure of interrelated parts, but this is a different thing from theoretical analysis. The difference will be dealt with more fully later (pp. 188–200). Here it is sufficient to say that when a thing is analysed in discursive thought it is broken up into a set of constituent parts each of which can be fully articulated and described in isolation, the whole being composed of these determinate parts standing to each other in the relations in which they do stand; but when a thing is perceived as a complex structure, the perceived parts do not as it were pre-date or stand independently of the structure in which they are perceived but are articulate to perception only as parts of that structure. An art critic may analyse the component parts of a picture—the images contained in Picasso's *Guernica*, for 264–5 example. He may point out: 'This is a lamp; this is the head of a horse in agony; this is a screaming woman.' In each case he mentions a class of things to which the particular image belongs and describes it conceptually. He may go on to analyse and explain the symbolism of these images and trace their significance in the personal history and the *oeuvre* of the artist.[12] All this may be of the utmost importance in helping the viewer to achieve full aesthetic awareness of the picture and to direct his attention upon its significant features. But it is not itself an aesthetic mode of attention; it does not take the place of seeing the picture as a picture.

4. 'An aesthetic experience', said Paul Weiss, 'is all surface, and here and now.'[13] The 'here and now' character of the experience has been analysed particularly by the Polish aesthetician Stanislaw Ossowski.[14] The greater part of our waking life, he says, is lived in such a way that present experience is coloured by expectations for the future and associations from the past. This happens not only when we envisage some far-reaching aims, when we are planning ahead or exercising forethought. The future and the past are implicit in our most ordinary and everyday perceptions; we attend to them primarily for their practical

significance and in the very act of perceiving we interpret them for the implications of what is to come. Whenever we are expectant, whenever we are anxious or apprehensive, hopeful, confident, or exultant, whenever we become aware of something as suspect, dangerous, or innocuous—in all such situations as these we are moulding the present experience in the light of its implications for the future. So too, when we are surprised, disappointed, moved by regret or self-congratulation, soothed by a comfortable feeling of familiarity, or disturbed by a sense of the unfamiliar, we are experiencing the present in the context and colouring of a selected past. All such attitudes and emotions are foreign to aesthetic contemplation—although they may, of course, enter into the content of the art work which is the object of our contemplation.

It is because, or partly because, when we attend to anything aesthetically, these practical attitudes are arrested and put into abeyance that the [temporarily disuse] aesthetic experience has its own characteristic emotional colour. Too many writers from too many points of view have testified to the serenity and detachment of aesthetic contemplation for this to be an accidental feature: it is noticed even when the object of contemplation has dynamic or dramatically emotional characteristics, and it seems to be a distinguishing feature of the aesthetic mood. A very similar emotional state has been claimed by Henri Michaux to result from the taking of psilocybine. [(magic mushrooms!)]

It eliminates [he says] in a surprising and practically total fashion the preparation for the next act, the state of mobilisation in which the adult finds himself with a view to the day to be filled, the acts to be accomplished, the things to be done, to be avoided. Every minute is pregnant with a programme for the future. To be alive is to be *ready*. Ready for what may happen, in the jungle of the city and of the day. One must possess an incessantly and subconsciously adjusted foresight. The normal state, far from being one of repose, is a *placing under tension*, with a view to efforts to be exerted (should occasion arise, or presently). A placing under tension which is so habitual that one does not know how to reduce it. The normal state is a state of preparation, of disposal towards. Of pre-organization.

By psilocybine (and, we may say, during aesthetic contemplation) 'you are put into a state of calm, of arrest'.[15]

These things will be discussed at greater length in their appropriate place. Here two consequences may be noted for future elaboration. (i) Our emotional dispositions, our unconscious expectations, our manner of putting out tentacles for the appropriate associations from the reser-

voir of our past experience: these are the things which determine what features and what aspects of anything we are predisposed to notice, attend to, and bring more fully to awareness. When we are engaged in the appreciation of fine art it is necessary not only that the ordinary practical predispositions are put in abeyance but also that a proper and appropriate alternative set of predispositions takes over in each case. (ii) Aesthetic interest leads to outward-turning forms of activity and inclines us typically to absorption in an object presented for perception, not to an inward dwelling upon our own moods and emotions. During aesthetic contemplation we are less rather than more conscious of our own feelings than usual.

5. If, as our analysis has indicated, aesthetic contemplation is a fixing of the attention upon a presented object and a process of bringing ourselves to increasing awareness of that object in perception, then it follows that those meditative musings and plays of the imagination in which poetic sensibility delights to indulge are also foreign to an aesthetic engrossment. And this, startling as it may seem, is in fact the case; for such imaginative play necessarily deflects attention for the object and weakens our absorption in it. He who sees a falling leaf and muses on it as a symbol of transience, meditating on the impermanence of all earthly things, the brevity of human existence, etc., is not contemplating the falling leaf aesthetically. Such musings and meditations are not alien to an artistic temperament; they may themselves become the raw material of poetry. But they are not germane to an aesthetic experience of the leaf. As a symbol the leaf loses its individuality and particularity; *any* falling leaf is a symbol of transience, not just this one. In so far, then, as we muse upon presented things as symbols of ideas or allow them to spark off trains of imaginative imagery or thought, to that extent our preoccupation with them has ceased to be aesthetic percipience.

In saying this we are going counter to one of the most popular trends of art criticism from the earliest times until the present day. In antiquity, from Homer to Philostratus, it was usual and expected for a critic to describe the narrative features of a picture and to extrapolate imaginatively from them, suggesting incidents and events which were not, and often could not be, depicted in the picture itself. Even a century ago it was a general practice of critics to offer similar imaginative extrapolations concerning the moral message or philosophical implications of

pictorial art (see Appendix III). At the end of the eighteenth century Archibald Alison maintained at length that such play of imagination is central to aesthetic appreciation, consisting in the indulgence of a stream of ideas and images activated by and emotionally related to the object of appreciation.[16]

Thus [he says] when we feel either the beauty or the sublimity of natural scenery—the gay lustre of a morning in spring, or the mild radiance of a summer evening—the savage majesty of a wintry storm, or the wild magnificence of a tempestuous ocean—we are conscious of a variety of images in our minds, very different from those which the objects themselves can present to the eye. Trains of pleasing or solemn thought arise spontaneously within our minds; our hearts swell with emotions, of which the objects before us seem to afford no adequate cause; and we are never so much satiated with delight, as when, in recalling our attention, we are unable to trace either the progress or the connection of those thoughts which have passed with so much rapidity through our imagination.

He instances the tendency of scenery in spring to 'infuse into our minds somewhat of that fearful tenderness with which infancy is usually beheld'. And he says:

With such a sentiment, how innumerable are the ideas which present themselves to our imagination! Ideas, it is apparent, by no means confined to the scene before our eyes, or to the possible desolation which may yet await its infant beauty, but which almost involuntarily extend themselves to analogies with the life of man, and bring before us all those images of hope and fear, which according to our peculiar situations have the dominion of our heart!

He asserts a similar principle for the appreciation of the arts.

The landscapes of Claude Lorraine, the music of Handel, the poetry of Milton, excite feeble emotions in our minds when attention is confined to the qualities they present to our senses, or when it is to such qualities of their composition that we turn our regard. It is then, only, we feel the sublimity or beauty of their productions, when our imaginations are kindled by their power, when we lose ourselves amid the number of images that pass before our minds, and when we waken at last from this play of fancy as from the charm of a romantic dream.

Alison's account was not idiosyncratic. In believing that he had shown it to be 'consonant with experience' that the indulgence of these trains of thought and imagery, the musings and emotionally coloured

meditations, are an essential feature of aesthetic commerce with the world around us Alison was in keeping with the outlook of his day. Kant seems to say much the same sort of thing in his doctrine of aesthetical ideas. It is a view which runs directly counter to the more rigorous aesthetic understanding of today. Nowadays every competent instructor would recommend his students to concentrate attention firmly on the object and avoid like the plague those temptations to day-dreaming and the emotionally coloured divagations of fancy which for earlier critics and theorists were the essence of appreciation. Not that they are to be condemned in themselves. But appreciation, we now think, is something else again.

6. In illustration of what he meant by the 'disinterested' interest which is characteristic of aesthetic commerce with anything Kant said: 'One must not be in the least prepossessed in favour of the real existence of the thing, but must preserve complete indifference in this respect, in order to play the part of judge in matters of taste.'[17] This repudiation of interest in the *existence* of aesthetic objects, which Kant took over from English eighteenth-century writers, has often been misunderstood. As practical men and lovers of beauty we are interested in the continued existence of beautiful things. If the palace which we now contemplate with enjoyment were a mirage with no real existence, we should not be able to see it and enjoy its beauty next time we passed that way. As Leibniz said earlier, the man who suffers pain from the destruction of a beautiful picture even though it belongs to another man, loves it with a disinterested love. We certainly have a practical interest in the real existence of beautiful things since the possibility of continuing in the future to enter into aesthetic commerce with them and enjoy their beauty depends upon their existence. But within the process of appreciation itself, while we are aesthetically intent on the object, considerations of its real existence are irrelevant. Aesthetic contemplation is concerned with the object as presented, with the appearance.

Another problem arises in connection with aesthetic attitudes to properties of appearance which turn out to be deceptive. Let us say I have given aesthetic admiration to the appearance of strength and hardness displayed by a tall tree trunk. When I approach it I find that the appearance was deceptive: the tree was in fact rotten and crumbles at a touch. In these circumstances, it has been argued, I can no longer enjoy aesthetically the appearance of sturdiness and soundness in the tree. 'If

I know that the tree is rotten. I shall not be able again to savour its seeming-strength. I could, no doubt, savour its "deceptively strong appearance"; but that would be quite a different experience from the first.'[18] There is, I think, some inadequacy of analysis here. When I first see the tree and attend aesthetically to what I see, I accord aesthetic admiration to an appearance which I describe as an appearance of strength and hardness. I describe the appearance in these terms because trees which look like this usually do prove to be strong and hard. But I do not in fact make inferences from the appearance to a belief that the tree really has many years of life before it and that if cut down, it would yield good hard timber—or if I do make such inferences, they are irrelevant and an interruption to the mood of aesthetic attention, an intrusion of practical assessments. If later I acquire knowledge that the tree is rotten and therefore these inferences, if I drew them, would be false, this is a contingent fact which may in the particular instance of this tree act as a psychological impediment, making it difficult or impossible for me again to attend aesthetically to the appearance of this tree. I may never again be able to bring myself into the mood of contemplating aesthetically an appearance whose description, and the factual implications implicit in the description, conflict with what I now know to be the case. In just such a way for many centuries European people were unable aesthetically to appreciate the wild grandeur of mountain scenery because they were inhibited by a latent sense of insecurity, a knowledge of likely danger, from according unmixed aesthetic attention to them. But the impediment which now makes aesthetic contemplation of the tree impossible does not alter the nature of the earlier experience I had before this impediment existed.

Considerations of this sort seem niggling. Nevertheless they do attain some importance in principle when we come to consider the aesthetic bearing of truth, genuineness and verisimilitude in connection with works of art.

7. Aesthetic contemplation has been described as a form of absorption. It is not the only form. We may be absorbed in a puzzle, a piece of research, or a football match; children are absorbed in a fairy story. Whenever anything interests us we tend to become absorbed in it while the interest lasts and the degree of our absorption depends on the strength of the interest in relation to whatever else is occupying us at the time. In aesthetic contemplation, however, the field of attention is

narrowed, our usual practical concerns are put into abeyance, and our mode of awareness is confined to direct percipience. For these reasons, it would appear, as has been frequently noticed, that aesthetic contemplation is one of the activities which especially tends to invite absorption. For the time being at any rate we tend to become engrossed with the aesthetic object which has attracted attention to itself. As a correlate of this an aesthetic object upon which attention has been turned is apt to stand out and strike us with the impact of a heightened and enhanced reality. There is a peculiar vividness about aesthetic experience which favours mental alertness and stimulates the faculties.

Certainly absorption is not always successful and may be frustrated. When there come to us moments of aesthetic vision amidst the turmoil of practical concerns we do not always accord them more than a modicum of attention: other, more urgent demands may hold us back from answering the call. Even when we set ourselves to the express purpose of enjoying aesthetic experience, when we attend a concert or visit a gallery, we may not be in the mood, the encroachment of other interests or the dominance of practical anxieties may make too great claims on the attention and frustrate our intention. Or we may just be unable at that moment to call up the necessary alertness and acuity of percipience. But when aesthetic contemplation is successful and absorption is achieved there is a loss of subjective time-sense, a loss of the sense of place and a loss of bodily consciousness. We are no longer fully conscious of ourselves as persons sitting in a concert hall or standing before a canvas in a picture gallery. We are no longer conscious of the passing of time (interesting problems arise concerning the relations between the artificial time-intervals set up within a musical structure, the subjective time-sense of the absorbed listener and objective time-lapse). In a sense to be examined later, we become identified with the aesthetic object by which our attention is gripped and held.

Nevertheless absorption is never complete to the point where egoconsciousness disappears. That this is so may be proved from our behaviour with the representational arts. We retain always a residual awareness of ourselves as spectators at a play or a cinema; we never quite lose sight of the fact that we are looking at a picture or reading a novel. And this seems to be not merely a contingent fact but a logical requirement of the aesthetic mode of awareness. For if we were to become absorbed to the point of undergoing illusion and behaved as if

we were in the presence of the realities represented, our condition would no longer be called 'aesthetic'.[19]

8. Moments of aesthetic vision may be courted deliberately or they may flash upon us unsolicited and unexpectedly. Anything at all may be made the object of aesthetic attention. But not all things are capable of sustaining attention in the aesthetic mode. Attention can be prolonged only so long as awareness is being expanded or diversified thereby. The artificial fixing and prolongation of attention under any other conditions leads inevitably to reverie, somnolence, or self-hypnosis. If we try to force ourselves to hold an aesthetic object actively in attention beyond what it can support, our mode of attention changes from aesthetic to discursive or analytical. This is why moments of aesthetic vision in daily life are for the most part sporadic and fleeting. The objects which engage them are not in general sufficiently complex for percipience; after a relatively short period we cannot bring them more fully into perceptual awareness and attention must either pass from them or must be changed to some other mode. We smell a flower repeatedly in order to enjoy the pleasure which this gives. But putting aside the subjective pleasantness of the experience, we cannot for long periods, or even repeatedly, concentrate upon perceiving the specific *quale*, the olfactory character in perception, of that particular odour. And it is the latter not the former which we call 'aesthetic'.

Works of art are aesthetic objects specifically designed or particularly adapted to favour prolonged and repeated activity of aesthetic percipience. If successful, they are above all other things capable of sustaining aesthetic attention and they afford to percipience more ample scope. Indeed it has sometimes been alleged that great works of art have no exhaustion point for appreciation.[20] Works of art can, at their best, extend the perceptive faculties to the full without satiation and as it were demand ever increased mental vivacity and grasp to contain them. This, it may be thought, is at any rate a major part of what has been meant when philosophers and critics have spoken of the 'life-enhancing' quality of art appreciation. Years of study and experience, half a lifetime of growing familiarity, may contribute to the full appreciation of a great work of art: the experience itself is always accompanied by a feeling of heightened vitality; we are more awake, more alert than usual, the faculties are working at greater pressure, more effectively, and with greater freedom than at other times, and the discovery of new

36

insights is their constant guerdon. *reward* When a work no longer holds anything new for us aesthetic boredom inevitably sets in and for the time being at any rate we have 'outgrown' that particular work or artist.

I have written at some length about aesthetic percipience because it is paradigmatic for the appreciation of fine art and a basic element in the cultivation of that skill. There is probably a minority of people totally immune to the experience, although in many the capacity for it has been suppressed and submerged. It may occur as a sudden gleam of beauty seen momentarily amidst the more pressing predicaments of practical affairs or in moments of leisure it may stamp more precise and prolonged hiatuses in the stream of practical concerns. An aesthetic attitude, with its characteristic marks of heightened percipience and a temporary alienation or sloughing of practical and theoretical interests, can be taken up towards anything at all. But only works of art, or perhaps their equivalents in nature, can extend to full capacity the faculties of perception exercised within this mode of attention. Some people find it easy to assume this attitude towards works of art and can assume it more or less at will. Others find it difficult or are completely at sea, occupying themselves with art works, if at all, in irrelevant and unprofitable ways. But to engage successfully in prolonged and intense 'disinterested' attention—or in repeated acts of 'disinterested' contemplation over an extended period—as is necessary in order to bring any masterpiece of art fully into awareness, needs cultivation and directed practice. It is the first and necessary step towards mature appreciation.

Appreciation as enjoyment:
Aesthetic hedonism

Contrasted with the view of appreciation as percipience is one which has taken sensory pleasure as the paradigm of aesthetic experience. In opposition to Indian and most Oriental aesthetics the hedonistic conception of aesthetic enjoyment has always been most ubiquitous and persistent in the West. The ancient Greeks spoke of what we now call the fine arts as the 'pleasure-giving crafts' and the nearest they came to finding a word for the quality in virtue of which an art work makes its aesthetic impact was 'sweetness' or 'charm'. In the *Hippias Major* Plato makes Socrates suggest to the sophist Hippias a popular view that 'beauty is the pleasant which comes through the senses of hearing and sight'[1] (referred to by Aristotle in *Topica*, 146a21) and the philosopher Epicurus is quoted by Maximus of Tyre as saying: 'If you mention the beautiful, you are speaking of pleasure; for hardly would the beautiful be beautiful if it were not pleasant.' Through the centuries, and today hardly less than in the past, writers of all philosophical persuasions have given support in their casual and most unpremeditated remarks to the ingrained assumption that the criterion of any aesthetic object lies in its capacity to please. English eighteenth-century writers on the as yet unnamed subject of aesthetics had a common purpose to elicit general principles of good taste from a study of what, in the words of Hume, 'has been universally found to please in all countries and in all ages'.[2] Exemplary of this way of thinking is the statement of Lord Kames in the preface to his influential book *Elements of Criticism*, that his object was 'to form a standard of taste' by inquiring into 'such attributes, relations, and circumstances, as in the fine arts are chiefly employ'd to

raise agreeable emotions'. In the following century Sir William Hamilton remarked that it would have been more appropriate if the study of beauty had been named not 'aesthetics' but 'apolaustics'—the science of what pleases. More recently simple sensuous pleasure has been held out to be the paradigm of aesthetic enjoyment. William James, for example, identified aesthetic emotion with 'the pleasure given us by certain lines and masses, and combinations of colours and sounds'. It is, he said, 'a simple, primary and immediate pleasure in certain pure sensations and harmonious combinations of them'.[3] Among the analytical philosophers the logical basis of this view has been worked out by J. O. Urmson in a paper entitled 'What Makes a Situation Aesthetic?' Urmson took sensuous pleasure as the paradigm and prototype of aesthetic appreciation and argued that our justification for calling any judgement aesthetic is that it should be based upon nothing else but the immediate pleasure we take in the experience.

If [he says] we examine some very simple cases of aesthetic evaluation it seems to me that the grounds given are frequently the way the object appraised looks (shape and colour), the way it sounds, smells, tastes or feels. I may value a rose bush because it is hardy, prolific, disease-resistant and the like, but if I value the rose aesthetically the most obviously relevant grounds will be the way it smells; the same grounds may be a basis for aesthetic dislike. . . . Things, then, may have sensible qualities which affect us favourably or unfavourably with no ulterior grounds. Surely there is no need to illustrate further these most simple cases of aesthetic evaluation.

Immanuel Kant, on the other hand, whose *Critique of Judgement* was the culmination of the thinking about the arts which had taken place in the previous century and itself laid the foundations for modern aesthetics, took the opposite view, not only sharply distinguishing sensuous pleasure from the pleasure of aesthetic appreciation but excluding it altogether from genuine aesthetic enjoyment. 'That taste is still barbaric', he said, 'which needs an added inducement of *charm* or *emotion* in order that there may be satisfaction, and still more so if it adopts these as the measure of its approval.' In Kant's view aesthetic pleasure is a pleasure arising from the heightened exercise of our cognitive faculties on an object adequate to give them scope. He argued that the very possibility we have of reducing nature to knowledge, coming to terms with our environment, is sufficient reason for regarding nature as if it were teleologically adapted to our cognitive powers. But things may be

adapted to cognition either in the way of theoretical understanding and scientific system-building or in the way of immediate apprehension whether by sense-perception or by intellectual intuition. When we direct our attention on something which is particularly well adapted to our powers of immediate apprehension and capable of sustaining and exercising them to the full, giving them free and ample play apart from any reasoning *about* it or theoretical analysis of it, then we enjoy an aesthetic experience and we call that thing beautiful. Such things 'through their manifoldness and unity serve at once to strengthen and sustain the mental powers that come into play'. An aesthetic judgement —or, as Kant calls it, a judgement of taste—'consists precisely in a thing being called beautiful solely in respect of that quality in which it adapts itself to our mode of taking it in'. The pleasure which we experience in aesthetic appreciation is, then, a pleasure taken in the free and unimpeded exercise of our powers of awareness upon an object adapted to give them full play, stretching them to capacity and sustaining them in enhanced activity. The pleasure we experience in the free and successful exercise of a skilled faculty excited to a condition of exceptional alertness is a different thing from the sensuous pleasure of, say, smelling a rose. It is consequent upon, not constitutive of, appreciation. If you think of appreciation as an acquired skill which can be cultivated and perfected, the distinction is analogous to that which an expert billiards player experiences when he puts his skill into practice to pull off a complicated shot and the pleasure he experiences in drinking a pint of beer while his opponent plays.

The difference between Kant and the hedonistic philosophers is not of purely theoretical and academic interest but has far-reaching consequences for the cultivation of appreciation. If sensuous pleasure is the paradigm of appreciation in the arts, then broadening and expanding our skill in appreciation will be something analogous to conditioning ourselves to a liking for exotic foods or other out-of-the-ordinary sensations, at the risk of finding the more accessible ones pall upon us. If we accept Kant's lead, it will be analogous to training any other inherent faculty into a skill. I have given reasons for regarding appreciation as percipience, a form of cognition, whose paradigm is to be sought in moments of heightened awareness. If this is the case, pleasure, though not to be denied, becomes an incidental thing and of ancillary importance only. When I take pleasure in smelling a rose I am in a state of

divided attention: half my attention is on the smell, half is on the pleasure I am experiencing. But if I switch to the state of percipience which I have called 'aesthetic', I become aware as never before of the precise quality of the odour, and I dwell on its olfactory *quale*; if my attention is wholly engaged in percipience of the smell, however momentarily, for just so long the awareness of its pleasantness and of the pleasure I get from it recedes. To the extent to which I am absorbed in the objective sensation I cease to be aware of pleasure—although I may afterwards remember it as pleasant. A similar thing may occur with unpleasant sensations, even with pains. If I succeed in fixing my attention upon the feeling of tooth-ache, concentrating on the precise felt quality of the throbs and twinges, I can for a time lessen the unpleasantness of the pain. An aesthetic atti-tude is one which carries attention and awareness out upon the object (the mental or 'intentional' object) of experience away from inner feeling and subjective affect.

There is indeed a trivial sense in which the hedonists are patently right, since it may be taken as axiomatic that in regions of conduct where no strong social obligations impinge a man does what he does because he likes doing it, whether it be sun-bathing, appreciation of the arts, or self-mortification. A man does what he likes doing, or he would not do it. But in any sense in which this is not false it is hardly more than tautology; and it is necessary—though sometimes difficult—when philosophizing to keep one's eye on the ball. Anyone who keeps con-cretely before his mind experiences of the enjoyment of great master-pieces of art will not be in doubt that sensuous pleasure, however uncontaminated or 'disinterested' it may be, is both inadequate and inapposite as a model. Listen to one of the late Beethoven quartets; look with absorption at El Greco's *Burial of Count Orgaz*; attend a good performance of *King Lear* or see *Hiroshima Mon Amour*: without wishing to deny that there is a sense in which you 'liked' it, you will nevertheless regard the word 'pleasure' as so inadequate to the experience, so jejune of its import, as to be impertinent for describing it. To apply the word 'pleasant' to Goya's *Disasters of War* or Picasso's *Guernica* or even Uccello's *Rout of San Romano* strikes one as wantonly irrelevant. Even mediocre art need not be pleasant in any ordinary sense of the word, though our 'enjoyment' of it will be pleasant. The pleasure of the enjoyment comes from the exercise of a skill to appreciate.

Something here should be said about the use of the word 'enjoyment',

which has become almost a technical term in the vocabulary of art appreciation and has not infrequently been the cause of misunderstanding. Enjoyment is a species of pleasure but we do not say that we enjoy everything that pleases us. I may enjoy watching a football match; I am pleased by (but cannot be said to enjoy) the result when my own side is victorious. Enjoyment implies attention to its object and if attention lapses for any reason, enjoyment fades. It also implies interest: if I attend to something from a sense of duty although I am bored, I cannot be said to enjoy it. If I cease to be interested, continued attention is not enjoyment. Not all enjoyment is aesthetic enjoyment: a child enjoys watching the circus but his experience is not an aesthetic one. Enjoyment may, but need not, result from the satisfaction of desires; if it does, enjoyment ceases when desire is satiated. It was indeed a prime dogma of the eighteenth-century English aestheticians and of Kant that aesthetic enjoyment does not consist of or include the satisfaction of any antecedent desire. We may have a generalized desire for beauty and for the enjoyment of beautiful things and we may suffer when this desire is denied opportunities of satisfaction; but the enjoyment of each concrete experience does not reside in the satisfaction of a desire for that particular object. Yet we continue to enjoy any aesthetic experience only so long as our satisfaction in the activity lasts; this is why, although our enjoyment of the 'aesthetic moments' which intersperse the practical business of life may be keen, it is usually brief. It may furthermore be noticed that although when I enjoy a work of art I must know what it is I am enjoying, I may not be able to render articulate or bring to awareness what are the features of the work which bring me enjoyment. Enjoyment in this context is the quality of an aesthetic experience which is successful and satisfying, and is often used as a synonym of it. It bears no very close analogies to the sensory pleasures of smelling and tasting.

Yet it is doubtful whether sensuous pleasure can be excluded altogether from appreciation as Kant wished. With greater consistency than plausibility Kant alleged that, for example, the sensuous appeal of fine tone in music and the delightfulness of colour in painting may have a justification in attracting the attention of a person of uneducated taste but that they do not belong to the excellence of a work of art and the pleasure derived from them is not a part of our aesthetic appreciation.

In painting, sculpture, and in fact all the formative arts, [he says] in architecture and horticulture in so far as they are fine arts, the *design* is what is

essential. Here it is not what gratifies in sensation but merely what pleases by its form, that is the fundamental prerequisite of taste. The colours which give brilliancy to the sketch are part of the charm. They may, no doubt, in their own way, enliven the object for sensation but make it really worth looking at they cannot. . . . The *charm* of colours or the agreeable tones of instruments may be added: but the *design* in the former and the *composition* in the latter constitute the proper object of the pure judgement of taste. To say that the purity alike of colours and tones, or their variety and contrast, seem to contribute to beauty is by no means to imply that, because in themselves agreeable, they therefore yield an addition to the delight in the form and one on a par with it. The real meaning is that they make this form more clearly, definitely and completely intuitable and besides stimulate the representation by their charm, as they excite and sustain attention directed to the object itself.

Here experience was lacking to the philosopher. Kant was theorizing within the limitations of his time, when most writers regarded colour as a mere accessory and decorative adjunct to painting and had not yet understood that colour may itself be an element (or even the most important element) in the visual material which is organized into pictorial form by the artist. Still less was it understood that musical form may (as in some of the music of composers such as Boulez and Martinů) include or consist of the organization and articulation of timbres. None the less Kant here touches on what is one of the more puzzling problems in the practice of appreciation.

Those senses which offer the greatest opportunity for strong and immediate pleasure-tone are taste, smell, and touch. But these senses do not provide a vehicle for art works. Yet we do derive sensuous pleasure from colours and sounds also, and where such sensuous appeal occurs it does not seem to be wholly irrelevant to appreciation. We evaluate a musical work independently of this or that particular performance and judge it irrespective of whether it was played competently by an amateur on a cottage piano or by a virtuoso on a Steinway grand. A member of a concert audience who harps too insistently on the beauties of vocal or instrumental 'tone' may not have apprehended the music. Yet there is a difference for appreciation whether a violin concerto is played on a Stradivarius or on a factory-made fiddle. Enormous pains and energy are devoted to the production of 'good' musical sounds and the pleasure we take in hearing good intonation, whether of the voice or of the flute, is not entirely alien to appreciation.

A painter cannot make a good picture by putting together on one canvas as many patches of pleasant colour as he can crowd in, or by putting in a large number of pleasant colour harmonies, or by adapting many of his shapes to the Golden Mean. The brilliant colours of a butterfly's wings and the feathers of the humming bird are attractive in themselves; but pictures made from preserved butterfly wings or from feathers rarely achieve more than a modicum of aesthetic worth. Nevertheless the sheer pleasantness of pigment colour cannot be entirely ruled out. Some painters have gone to great pains and have worked out their own techniques for making the most of the sensuous qualities of their pigments.

The older painters of the sixteenth and seventeenth centuries [says Maurice Grosser] had few bright colours and preferred to use them in the deeper tonal ranges where these pigments could be shown at their highest intensity and beauty. . . . A picture with much blue sky would be painted dark enough so that the costly ultramarine could be exhibited at its greatest beauty, as can be seen, for example, in the sky of Titian's *Rape of Europa* in Boston. The older painters considered that their pigments were only substances, with precise character and limited possibilities, and used every trick they knew to set them off to their best advantage.[4]

Great store was set too by the sensuous appeal and brilliance of the pigment colours used in enamels and illuminated manuscripts. In direct contrast with all this certain modern schools of painting— notably the Cubists—deliberately eschewed the sensuous appeal of fine colour, calligraphic line, surface texture, and alluring subject-matter lest these should deflect attention from the formal qualities and the austerely intellectual aspects of their work, which they regarded as more important. More recently still some artists have become interested in the sensuous allure of surface texture and there are paintings in which this appears as the most prominent feature.

As Kant hinted, in the most successful masterpieces of art the sensuous qualities of the materials from which each one is made serve to clarify its structure and render it more luminous for apprehension. But this is only part of the story. The sharp divorce which he proposed between sensuous charm and our apprehension of structural qualities is too abrupt and does not correspond with the general experience of those most versed in appreciation of the arts or indeed with the most general practice of artists. Fine art has always had a close link with that

sort of connoisseurship which enables the craftsman to assess and exploit the qualities of his materials. In cultivating the art of appreciation it is not otiose to make onself alert to the sensory qualities of the materials which artists use, so that we are as it were impelled to stroke a statue with the hand and a passage of pigment colour with the eye. In the early stages of appreciation immediate delight in sensory appearances may, as Kant also suggested, act as a stimulus to induce us to pass from the practical to the aesthetic attitude of percipience, and it may help us to divert attention from the subject represented in a picture to the representation itself so that it becomes 'opaque' instead of transparent and we begin to attend to the work of art rather than the slice of external reality which it mirrors. This represents the first step into an aesthetic attitude of attention and, unless it is taken, there are few pictures with which appreciation can proceed. When this has been granted, however, it still seems certain that sensuous enjoyment does not always rest here but rather persists as an integral part of full and more complete appreciation in many cases at least. Nevertheless it can be stated as a general principle that as appreciation matures into richer and more luminous apprehension, direct sensuous pleasure recedes from the forefront to the perimeter of awareness. If it intrudes, it will hamper and impede correct appreciation of the art object. But persons who are not at all alert to it are inclined to remain arid and jejune of appreciation. Indeed it is common to find that such persons have no natural interest in the arts and little or no talent for their appreciation.

It must be added that in certain Oriental aesthetic traditions far greater austerity is expected of the observer than has been usual in the West. Rabindranath Tagore, for example, is quoted by Ananda Coomaraswamy as saying: 'Our master singers never take the least trouble to make their voice and manner attractive . . . Those of the audience whose senses have to be satisfied as well are held to be beneath the notice of any self-respecting artist.'[5] In this, as in their attitude to emotion arousal, Indian aesthetics have been most at variance from our own. But the austerity which condemns sensuous or emotional indulgence is a different thing from the lack of a capacity for enjoyment. It is the latter which renders a man impervious to the aesthetic and useful only for other things.

Taking pleasure as their index, writers have been both arbitrary and inconsistent as regards the modes of sensation which they were prepared

to treat as aesthetic. If you regard the direct pleasure attendant on sense perception as the paradigm of aesthetic experience, then pleasurability must be your criterion and every sensory mode has a right to be considered as potentially aesthetic. Urmson, in the article already referred to, is consistent in this regard. Most writers, however, have preferred to remain closer to the common and accepted conventions of language, which restrict words such as 'beauty' and other primary aesthetic terms to a narrower range of sensation. In so far as they have retained pleasurability as their criterion of what is aesthetic they have involved themselves in arbitrariness and inconsistency in doing so.

Perhaps the most commonly accepted convention is that which was set out by Dugald Stewart in his *Philosophical Essays* (1810).

We speak [he says] of beautiful colours, beautiful forms, beautiful pieces of music: We speak also of the beauty of virtue; of the beauty of poetical composition; of the beauty of style in prose; of the beauty of a mathematical theorem; of the beauty of a philosophical discovery. On the other hand, we do *not* speak of beautiful tastes, or of beautiful smells; nor do we apply this epithet to the agreeable softness, or smoothness, or warmth of tangible objects, considered solely in relation to our sense of feeling. Still less would it be consistent with the common use of language to speak of the beauty of high birth, of the beauty of a large fortune, or of the beauty of extensive renown.

The French sociological aesthetician J.-M. Guyau, however, maintained that the sensations of taste, touch, and smell may be aesthetic.[6] The Polish aesthetician Ossowski regards the pleasures of sight and sound and smell as aesthetic but rejects those of taste and touch. Professor C. W. Valentine, speaking from the point of view of modern experimental aesthetics, says that the colour of a patternless wall-paper and the sound of a bell may properly be called beautiful, but that the taste of toffee cannot, although it may give keen pleasure to some.[7] In experimental aesthetics generally, a good deal of attention has been devoted to ascertaining statistical preferences for simple qualities of colours and shapes and sounds while the other senses have been tacitly neglected. Dr. Munro has recommended a definition of art according to which 'products and services appealing aesthetically to the lower senses are included'. He points out that the terms 'art of perfume', 'art of cooking', etc., are in common use and declares that they imply 'an aesthetic appeal to the senses of smell and taste'. He also asserts that 'a

tactile "art of love", *ars amatoria*, has been elaborately worked out in theory and practice by Greek and Roman, Renaissance, and Oriental writers'. [8] This whole argument is based on a mistaken inference from the historical fact that the Latin word *ars* (the equivalent of the Greek *techne*) applied to any handicraft or trade with its own skills and expertise but without any implications corresponding to what we now term 'aesthetic'. So in this wider sense of 'art' we speak of the 'art of medicine,' the 'art of fencing', the 'art of fishing'; but when we do so the word 'art' carries its older sense of 'craft' and has no aesthetic implications. Whether or no the 'lower' senses can ever properly be called aesthetic must be decided on other grounds. Dr. Munro wrongly thinks that the exclusion of the pleasures incidental to the lower senses from the realm of the aesthetic 'is largely a result of ascetic Christian morality' which 'has operated to condemn all physical pleasures, especially those connected with sex'. The question whether the pleasures of sex in particular can be aesthetic is of practical importance, not least in connection with the laws of obscenity. But it is a matter which cannot be decided in this way and we are begging the question as long as we take it as axiomatic that the immediate pleasure taken in a sensation is an index of its aesthetic quality.

If this is regarded as a dictionary matter pure and simple—a matter of how widely the scope of the word 'aesthetic' is to be extended—its interest is slight. But deeper issues are involved. I have taken the view that 'aesthetic' in its application to our enjoyment of the fine arts is not continuous with the direct pleasure we derive from any sensory experience. It has affinities and continuity rather with a different attitude of mind: with our percipience of the intrinsic quality of any experience, attention to the experienced quality of sensation rather than its pleasurability (which may even be a distracting influence), and the bringing of this experienced quality into more luminous awareness. In this sense any sensory experience can be attended to aesthetically: it has, indeed, already been said that an attitude of aesthetic attention can be taken up towards anything at all which can become an object of awareness. But intense and sustained aesthetic contemplation cannot be undertaken towards anything at all: with most things, if we attempt it, the attempt will be frustrated. Those things—chiefly works of art— which are beyond all others capable of sustaining contemplation in the aesthetic mode are constructs of visual or auditory sensations. It is this

empirical fact of experience which demands explanation and which cannot be explained by the hedonistic hypothesis.

The suggestion is sometimes made that sight and hearing are 'higher' senses either because they are more cognitive and objective, being our main sources of sharable and interpersonal knowledge about our environment, or else because they are more finely discriminative than the other senses. But it is not at all clear by what standard of comparison they could be said to be more discriminating, while their alleged cognitive superiority is of doubtful relevance to the present context. The aesthetic attitude is a cognitive attitude in so far as attention is concentrated on the mental object with a view to bringing us into more and more luminous awareness of it rather than on our own affective and emotional response to it. But we do not in appreciation use works of art as a source of further knowledge about anything other than themselves. So with all aesthetic experience. The difference that is relevant for art appreciation is one which must concern the suitability of the experienced object to sustain contemplation as we have described it. That difference would appear to be the following. Sight and hearing alone impart sensations capable of being organized and articulated into complex structures which display 'emergent' properties and so are able to sustain prolonged and alert contemplation, whereas smells and tastes and tactile sensations cannot be so organized. Examples of such 'emergent' qualities are gracefulness, clumsiness, daintiness. Unitary sensations do not have these qualities. Shapes, movements, and constructs of musical sound can be described as graceful, clumsy, dainty, etc.; but sensations of smell, touch, and taste cannot be organized into constructs which are describable in such terms. The reason for this is that sights and sounds alone can furnish us with sensory *continua* susceptible of structuring. Without working out its implications Adrian Stokes is one of the few writers who appears to have had an inkling of this fact when in an article entitled 'Strong Smells and Polite Society'[9] he wrote: 'We are little interested in the composite nature of smells, their parts and correspondences. We tend to think of each olfactory experience as unrelated, although our noses, deprived of much practice, preserve the capability for considerable analysis. Consequently, for this reason alone, there is no art of smell, since art depends on an additive or balancing process between the parts.' Although our sensations of smell and taste are most deeply rooted in feeling, the idea of using them for the con-

struction of works of art has remained a fantasy. The 'taste-piano' of Huysmans's *A Rebours* has been a recurrent dream, but has remained a pipe-dream.

This matter is not merely a theoretical curiosity but is fundamental to the cultivation and practice of appreciation in its more advanced stages, at which it involves concentrated awareness of emergent qualities themselves built into structures which support a complex hierarchy of such qualities emerging at different levels of structural complexity. It will therefore further our purpose to pursue it. The importance of sensory *continua* for the coming into existence of art objects—that is constructs designed to evoke and sustain advanced appreciation—can be illustrated most clearly by an analysis of the sensory basis of music. When we speak of the songs of birds or the music of rippling streams, we are using language metaphorically. Music as an art begins with the manufacture of special instruments for the production of artificial and 'purified' sounds which (usually) give maximum prominence to a *continuum* of pitch with continuous gradation between high and low. The pitch *continuum* is then structured by imposing on it artificial scales, which are sets of permitted intervals of pitch gradated according to conventional rules. (In wind and keyboard instruments the scale is built into the instrument; with the voice and unfretted string instruments it has to be imposed by the performer.) Music is composed within the limits of such conventional structuring of the pitch *continuum*. The use of a scale cannot ensure good music, but without it you cannot have music at all. In addition to pitch musical sounds have the independently variable sensory qualities of volume, duration, and timbre. Both volume and duration form *continua* of their own. In the *continuum* of volume the musical sounds are susceptible of variation from what is just barely audible to the very loud. But in known music the dimension of loudness is not structured: there are no artificial 'phon' scales imposing conventions of permitted intervals and variations of loudness. Variations may be continuous, as it were a *glissando* of volume, or of any physically achievable jump between soft and loud according to the taste of the performer and the clues given by the composer. Changes of volume within any piece of music are not multiples of a common module. The time-*continuum* may be fairly strictly structured or it may be semi-structured. The structuring of the time-*continuum* is the main source of rhythm in music (other sources may be emphasis by volume

49

changes, recurrence of a theme, the echoing of voices in contrapuntal music, and so on). Some musical traditions—African and Indian traditions are examples—have developed structuring of the temporal *continuum* to a degree of complexity and sophistication which the average European is incapable of apprehending without special training. Several complicated rhythms may be maintained simultaneously and the main— or indeed the sole—sensory basis of the art work may in some cases consist of rhythmic interplay. In modern, but not always in ultra-modern, European music any piece or part of a piece has a module of duration and time-intervals bear a simple and determinate relation to each other expressible in terms of the module. But by custom considerable flexibility is permitted in the execution, *ritardando* and *stringendo* outside the set patterns are allowed or even expected, and the clues given by the composer are general rather than exact. With the exception of some electronic music there is perhaps none wholly lacking rhythmic structure in time. Timbre (which may roughly be described as the characteristic sensory quality in regard to which the voices of the various instruments differ—the reediness of the oboe, the liquidity of the flute, etc.) is theoretically and physically analysable into complexities of pitch (ground note together with a specific set of harmonics and undertones at different degrees of prominence) but is *heard* as a simple and distinct sensory quality. There is no *continuum* of timbre. The modern orchestra is composed of families of instruments, those in each family having certain general similarities of timbre; but no continuous progression exists from one timbre to another within a family or between families, and there are no measurable or otherwise comparable intervals between different sensations of timbre.

It is a significant fact for our understanding of appreciation that the emotional index of these qualities of musical sound, their affective potentiality, varies inversely with their perceptible structuring. The dimension of pitch, which in European music is the most thoroughly structured for apprehension, carries in itself least impact on feeling. An unstructured scream may arouse strong feeling response, but if you play a melody without variations of loudness or time-rhythm, it is lifeless and dull. Where, however, in folk-singing and some violin-playing the executant introduces slight and barely perceptible departures from the conventional pitch-intervals permitted in the scale that is being used (such as quarter-tones or less), a strong feeling quality may result. Rela-

tively small variations of loudness are used partly to emphasize time-rhythm and partly to highlight the sinuosities and recurrences of theme and motif which belong to the form of musical compositions; but the main effect of the unstructured volume-dimension is emotional and it is most often employed to give dramatic colour. Variations of loudness are combined with duration intervals to produce rhythmic beat. A regular beat may be hypnotic or compulsive, as in jazz, military and some pop music, but slight irregularities of beat—*stretti* and *ritardandi*—are introduced for subtler emotional effects. When a young and inexperienced piano pupil is told 'to put in the expression' or to 'play with feeling' he introduces exaggerated and inept irregularities of volume and time. When, however, we listen to Indian music played on the tabla where intricately complicated constructions are built upon finely structured time-volume dimensions with little or no assistance from the dimension of pitch, the effect is the opposite; as attention is concentrated on bringing to awareness the apprehensible edifice of sound, direct feeling-tone and the grosser agitations and oscillations of emotion are recessive. In Western orchestral music timbre is used partly to help delineate the formal structure of a musical composition, but mainly for emotional effect. Nevertheless some modern composers (e.g. Boulez, Martinů, and Messiaen) have attempted, with differing success, to elevate timbre into a primary element of composition and a substratum of form. Their works do show at least that when relations of timbre are brought into the focus of attention and we are impelled to concentrate cognitively upon them in apprehension, they exert less than their ordinary affective impact.

This very cursory examination of the ways in which sensations of sound lend themselves to musical organization suggests, then, that the more a sense presentation holds the attention for apprehension in awareness the less obtrusive its feeling-tone is apt to be. It also suggests that sense qualities which are articulated into a structured *continuum* offer on the whole fuller scope to apprehension. This accords with what we know about sense-perception generally. The more perceptual experience invites cognitive attention (we do not of course mean discursive or analytical thinking but apprehension in direct awareness), the less emotionally coloured it tends to be. Taste and smell, which are not susceptible to organization into higher-level cognitive constructs, remain closely bound to feeling, and ordinary language attests the

connection between bodily sensations and feeling by naming them 'feelings'. Sometimes the sensory and affective aspects of an experience are so intimately merged that it is virtually impossible to separate them out, and sometimes the affect will as it were float off and become detached from its sensory basis so that we recall in memory a pulse of feeling and through it manage to recollect the elusive experience to which it was attached. Smells and tastes have notoriously a strong evocative power. As Stokes has said: 'An unparalleled sense of renewal, as of nostalgia, can be latent in a chance smell.' Yet even with these simple and unstructured sensations of taste and smell the feeling-tone will recede if in exceptional circumstances our attention is fastened upon them for cognitive purposes. When doctors and chemists use smells for diagnostic purposes they are no longer affected, or are affected in a much slighter degree, with delight or disgust.

I will now summarize some of the conclusions which have been reached. The feeling-tone of sense-perceptions is diminished if we employ them as we do in ordinary life pragmatically, as clues for conceptual knowledge of the environment, signs of objective things and situations in the world around us, or as signposts to action. We express this by saying that the perceptions become 'transparent'. We see *through* the sense presentation to the thing or situation of which it is a sign; and, as psychologists and lawyers know, even people who are normally alert to the practical significance of what they perceive may enjoy astonishingly vague and imprecise awareness of the intrinsic sensory quality of their perceptions. When on the other hand we are interested in a presentation for its own sake, not for any knowledge beyond it, feeling-tone gains vividness, may even become obtrusive. In such cases we say that the perception is 'opaque'. We do not look through it to something else which it signifies, but rather attention rests in the perception and we bring its intrinsic sensory quality to fuller awareness. When we listen to the singing of birds or the soughing of the wind in the trees, when we contemplate the immensity of blue in the sky or gaze at distant mountains, we tend to be more keenly aware of the sensory qualities of what we perceive and at the same time are more emotionally moved. Even people who are not as a rule poetically inclined may in such circumstances be moved to quasi-poetic imagery. In everyday life language is the most transparent of our perceptions: we attend directly to the meaning of which the words are signs and unless some unusual

feature captures attention momentarily, we have no awareness at all of the intrinsic sound of the words. But the incantatory use of language— in the nursery, in religious prayers, and in magical rituals—illustrates how, as the communicative function of speech rests in abeyance and our interpretative activities are lulled so that we now attend to the sound rather than the sense of the words, emotional effect is enhanced. The artistic use of language in poetry lies between these extremes. When we enjoy poetry we attend to the meaning, but at the same time it is our endeavour to bring to awareness the auditory and rhythmic qualities of the language-sound. And different styles of poetry demand different degrees of attention to these two aspects of language. Swinburne's

> Heart handfast in heart as they stood, 'Look thither,'
> Did he whisper? 'look forth from the flowers to the sea;
> For the foam-flowers endure when the rose-blossoms wither,
> And men that love lightly may die—but we?'
> And the same wind sang and the same waves whitened,
> And or ever the garden's last petals were shed,
> In the lips that had whispered, the eyes that had lightened,
> Love was dead.

is more incantatory than Browning's

> Grow old along with me!
> The best is yet to be.
> The last of life, for which the first was made:
> Our times are in His hand
> Who saith 'A whole I planned,
> Youth shows but half; trust God:
> see all, nor be afraid!'

The difference between transparent and opaque perception is familiar to everyone in practice and is not difficult to illustrate. The bird-watcher and the entomologist are less likely, while professionally engaged, to feel the beauties of shape and movement than is the nature-lover, and so on. But we must now pass to a third moment of percipience, which may seem more recondite and is sometimes disputed but whose importance for mature appreciation is fully attested. It is this: as has been said, when we turn our attention to anything in the aesthetic mode of awareness our sense presentations become opaque. We attend to the presented sensory qualities and bring them to awareness often with a strong

circumambient feeling-tone. But if we maintain attention, concentrating on apprehension without indulging in trains of imaginative musing or reverting to analytical thought, the feeling-tone again recedes from prominence and is submerged. With the 'aesthetic moments' which occur to us in the course of daily life, when familiar things suddenly appear to us in their true and unfamiliar being or when we suddenly notice some beautiful thing such as the ruff of a pigeon's neck, the presentation rarely has sufficient internal complexity to sustain attention in the aesthetic mode for long or to exercise our faculties of apprehension to the full. For attention can be held in this mode only so long as awareness is expanded. These moments are therefore fleeting and unstable. Art works, when successful, offer greater scope in their complex configurational properties for sustaining aesthetic attention at high levels of intensity. It is then that feeling is submerged in, or perhaps merged with, the activity of apprehension, the cognitive mode. The difference is analogous to that between pleasant indulgence in background musical sound which above all must not obtrude itself on the attention—'music while you work' or the restaurant orchestra or the music that is piped into elevators and so on—and the concentrated listening of the music-lover in a concert hall. The Mexican composer Carlos Chávez has recorded that whereas in his youth he used to listen to Chopin and Beethoven with sentimental emotion, now when he listens he hears music which does not evoke, or provoke, extra-musical thoughts or emotions. 'We are being educated', he says, 'to listen to music with a purely musical intention, and the growth of this capacity parallels the extent to which we develop our musical sense.'[10] Something very similar was said by Kandinsky about our enjoyment of colour:

If you let your eye stray over a palette of colours, you experience two things. In the first place you receive a purely physical effect, namely the eye itself is enchanted by the beauty and other qualities of colour. You experience satisfaction and delight, like a gourmet savouring a delicacy. Or the eye is stimulated as the tongue is titillated by a spicy dish. But then it grows calm and cool, like a finger after touching ice. These are physical sensations, limited in duration. They are superficial, too, and leave no lasting impression behind if the soul remains closed. Just as we feel at the touch of ice a sensation of cold, forgotten as soon as the finger becomes warm again, so the physical action of colour is forgotten as soon as the eye turns away. On the other hand, as the physical coldness of ice, upon penetrating more deeply,

arouses more complex feelings, and indeed a whole chain of psychological experiences, so may the superficial impression of colour develop into an experience.[11]

One thing remains to be added. It has been found by some people that the higher order configurational properties—the so-called 'aesthetic qualities'—as well as the simpler unstructured elements of sensation may obtrude into awareness first in the guise of feeling; only as the presentation becomes more luminous to apprehension does the feeling fade from the forefront of awareness and the quality which was first intimated through feeling comes later to be apprehended without emotional tone in a more penetrating and comprehensive perceptual act. Feeling, as it were, probes ahead of clear apprehension and later recedes, its task completed, when full apprehension is achieved in the expanding luminosity of direct, non-conceptual awareness. Examples of such cognitive feelings occur in daily life when, say, we are tuning a violin or comparing the colours of textiles and the last final match is conveyed to us by a feeling. There is some evidence that people of different training and temperament vary considerably in the extent to which cognitive feeling enters into their aesthetic apprehensions and those who are developing a skill to appreciate must follow their own bent in this, always remembering that indulgence in a tepid glow of feeling is not the aim.

It is a matter of great phenomenological interest and one which has concerned philosophers in recent years, that when apprehension takes over and we have learned to perceive a work of art as well as respond to it in a muddled welter of emotion, feeling is objectified as an 'emotional quality' perceived in the object. When a melody is sad or gay we hear sadness or gaiety as a quality of the melody. We see the dignity of Michelangelo's *Moses*, the dramatic tempestuousness of Bernini's *Habakkuk*. This is not a revival of the old theory of empathy. When we hear sadness in the melody there is no reason to suppose that we first unconsciously feel an emotion of sadness and then unconsciously 'project' our own sadness on to the melody. We are here reporting facts of the phenomenology of aesthetic perception. Their discussion will follow in its own place (pp. 100 ff.).

The foregoing discussion of feeling-tone in the context of appreciation leads us back to the question of hedonism and pleasure. On this it may be said in conclusion that it is the almost universal testimony of

those people who are best versed in the cultivation of the arts and least hidebound to conventional dogma that pleasure is not in any usual sense of the word a central feature of aesthetic enjoyment. There is an assumption in some philosophical literature that the actions of normal adult human beings are determined either by the desire for pleasure or by a sense of duty. Children and unsophisticated people know better than this. Human behaviour is the outcome of a vast variety of different and often conflicting impulses and drives; deliberate search for pleasure is rarely important among them. Except in the tautological sense in which all our deliberate actions are done because we please to do them, pleasure is not an important motive in our appreciative commerce with works of art. It is not a desire for the titillation of pleasurable emotions and sensations but some deeper impulse for self-fulfilment in the expansion of awareness that induces some people to devote energy and effort in the cultivation of the arts. And it is an obscure understanding of this fact which lies at the bottom of the high esteem which is accorded to the non-useful arts by general consent of most civilized societies. This matter will be discussed further in Chapter 8.

Aesthetic qualities

Philosophers and psychologists of the Gestalt school have recently given attention to those non-measurable properties of the environment which now commonly go by the name of 'aesthetic qualities' and their logic has been investigated by, among others, Frank Sibley and Isabel Hungerland. In a seminal paper entitled 'Aesthetic Concepts' Sibley divided the terms by which we refer to features of works of art and other familiar things around us into two mutually exclusive groups, which he called 'aesthetic' and 'non-aesthetic', using as his basis of discrimination that non-aesthetic features may be noticed by 'anyone with normal eyes, ears, and intelligence', while aesthetic terms apply to features where judgement requires 'the exercise of taste, perceptiveness, or sensitivity, of aesthetic discrimination or appreciation'. Among the examples he gives of aesthetic terms are: 'lovely', 'pretty', 'beautiful', 'dainty', 'graceful', 'elegant', 'delicate', 'unified', 'balanced', 'integrated', 'lifeless', 'serene', 'sombre', 'dynamic', 'powerful', 'vivid', 'moving', 'trite', 'sentimental', 'tragic'; and of non-aesthetic terms: 'red', 'noisy', 'brackish', 'clammy', 'square', 'docile', 'curved', 'evanescent', 'intelligent', 'faithful', 'derelict', 'tardy', 'freakish'. We are talking in non-aesthetic terms when we say 'that a novel has a great number of characters and deals with life in a manufacturing town; that a painting uses pale colours, predominantly blues and greens, and has kneeling figures in the foreground; that the theme in a fugue is inverted at such a point and that there is a stretto at the close; that the action of a play takes place in the span of a day and that there is a reconciliation scene in the fifth act'. The argument of the paper was to show

that aesthetic qualities are not in a positive sense conditional upon non-aesthetic qualities. In a negative sense they may be so conditioned: for example, a picture which is uncoloured or which consists of only a few pale colours cannot be fiery or gaudy or garish. But, Sibley maintains, 'there are no non-aesthetic features which serve in *any* circumstances as logically *sufficient conditions* for applying aesthetic terms'.[1]

In an early paper Hungerland described non-aesthetic features of things as those 'about which any normal people in normal circumstances can agree by employing the methods of science' and aesthetic features as those 'the presence or absence of which is not determinable by scientific methods and which require a special sensitivity and training to apprehend'.[2] She later rejected both the requirements of special sensitivity and the criterion of measurement, introducing as the basis of her discrimination that non-aesthetic statements are intersubjectively verifiable in a straightforward way, while aesthetic statements are not. In the case of non-aesthetic ascriptions like 'red' or 'blue', 'we can always in principle specify normal observers and normal conditions in such a way that there is a difference between the use of *looking red* and *being red*'. But an ascription of an aesthetic property 'cannot have the force of a contrast with "X looks A, but perhaps really isn't" '.[3] It does not make sense to say that such-and-such a thing looks elegant or dainty (or any other aesthetic ascription) but isn't. There are, it is true, certain cultural stabilities, certain trained ways of looking at things, common tastes and antipathies, within which we can expect a measure of agreement in aesthetic ascriptions regularly to occur. But these are limited within any group and with regard to aesthetic, as distinct from the non-aesthetic, features of things it is not possible to achieve intersubjective checking by reference to a standard observer operating in standard conditions. Hungerland agrees with Sibley that there are no generalizations, either deductive or inductive, from non-aesthetic to aesthetic properties; and also that, negatively, non-aesthetic properties 'do seem to establish some sort of reason, or basis of a necessary rather than sufficient sort', for the presence of aesthetic qualities. Both agree with Stuart Hampshire that the work of the art critic consists not in trying to prove his own judgements and ascriptions to be correct but, often by talking about non-aesthetic characteristics, in enabling other people to notice those qualities in works of art which the critic himself has seen. Hungerland also makes the important point that the critic does this by inducing

his readers to take up 'a certain perceptual stance or viewpoint', which she also calls 'a certain pattern of attention', favourable to the apprehension of aesthetic qualities. In this connection she says: 'Special sensitivity, training, as well as special interest, and certain kinds of past experience may be required to enable us to take a perceptual viewpoint from which we can see what the critic sees.'

Aesthetic qualities are sometimes regarded as a sub-class of 'tertiary' properties—properties, that is, which are dependent on or emergent from configurations of primary and secondary properties of things. They generally—perhaps always—belong to the class of Gestalt properties since they come to attention as objective features of configurations to the parts of which in isolation they do not belong. As examples of non-Gestalt aesthetic qualities of simple sensory properties there have been instanced the cheerfulness of a uniform yellow and the plangency of the oboe. But in the latter case 'plangency' is the name of the timbre, timbre of one sort or another being a quality of all distinctive sound. And it seems doubtful whether uniform patches of single colours do have emotional qualities out of some context or another. Provisionally, therefore, one may regard aesthetic qualities as emergent in the Gestalt sense.

It is doubtful, however, whether the sharp division between aesthetic and non-aesthetic qualities can be substantiated, and indeed Sibley has himself inclined to the view that the properties of things and their logical relations with each other are much more complex than his early paper supposed. I want, then, to suggest that qualities ordinarily regarded as non-aesthetic have in fact far closer affinities with the aesthetic than would be allowed either on Sibley's or on Hungerland's criteria. I shall illustrate this with the example of a supposedly typical non-aesthetic quality, squareness. Imagine I am looking at the surface of my desk and notice in my visual field a white patch, which I then judge to be square. I do not mean—or do not mean primarily—that if I apply a measuring rod and a set square to the piece of cardboard which is the physical stimulus of my presentation, I shall find that all the lines are equal and all the angles 90 degrees. If I think about it, I will probably realize that owing to the well-known optical illusion whereby verticals look longer, comparatively, than horizontals the piece of cardboard will not in fact measure up as a square. But when I say it is square I mean, or mean primarily, that this visual presentation, this bit of my present

phenomenologically objective visual experience, has the property of being square. And if it looks square (i.e. if the visual presentation looks square), it is square, whatever the dimensions of the cardboard. When in ordinary life we say that something at which we are looking is square we do not mean (as an engineer might mean) that, to the best of our judgement and after taking account of optical distortions, if the physical stimulus were measured up it would be found within prescribed limits of tolerance to have four right-angles and four equal sides. We mean first and foremost something like this: that the visual object gives an impression of all-round symmetrical stability, equilibrium, poise, non-directionality, etc. (qualities which an architect takes into account in his building components), with the corollary that it does not appear asymmetrical, unbalanced, slender, lissom, or curvilinear, etc. All these features are implicit in the squareness we see. It is, no doubt, this aspect of squareness which to the Greeks of Theophrastus's day caused a 'square' to be slang for a solid citizen and causes it in modern slang to apply to an old-fashioned puritan. In the daily ascriptions made in the course of practical life there are probably rather few perceptual judgements which do not carry a penumbra of the aesthetic in this way.

It is also important to notice that the distinction between 'looking' and 'being' upon which Hungerland relies for her differentiation of qualities into aesthetic and non-aesthetic does not at all enter into our appreciation of works of art or other beautiful things. We are there concerned with appearance and with appearance only, not (so far as attention is engaged appreciatively) with the physical stimuli which cause the appearance and not with any discoverable discrepancies between the appearance and the measurable qualities of the physical object. This is the case equally with the non-aesthetic properties which are ascribed to aesthetic objects. If we say that the theme is inverted at such and such a point, we are talking about what we hear, not saying something about the physical waves of sound. If we admire a beautiful passage of colour, our attention is solely engaged with the appearance of our visual field; we are not concerned with the physical properties of the pigments which give rise to the colours we see. The artist may—indeed must—be knowledgeable about the physical means by which he produces the aesthetic appearance. But the observer, so long as he is engaged in appreciation, can only be concerned with appearance. And here there is no distinction between looking and being. In her latest

exposition of her theory Hungerland does, indeed, seem less concerned with a distinction between the qualities of the appearance and the measurable properties of the physical object; her concern seems to be rather between those qualities of the appearance on the one hand about which we can expect universal agreement (or those for which we can at least find a standard observer and standard conditions) and the qualities on the other hand whose apprehension demands an aesthetically competent observer. But to base a sharp dichotomy on this distinction seems an even more hazardous undertaking.

The aesthetic qualities recognized by both Hungerland and Sibley are, as they both admit, a very mixed bag. They are not all of one class and they may not all have the same logic. Disregarding the sharp dichotomy which has been proposed, I shall regard as 'aesthetic qualities' any properties which are of regular importance in our aesthetic commerce with works of art and in what follows I shall suggest a classification whose prime consideration will be its relevance for the understanding and practice of appreciation. Aesthetic qualities are classified into four groups: 1. First-order sensory qualities, including emergent Gestalt qualities; 2. Intersensory qualities; 3. Emotional or expressive qualities; 4. Qualities incidental to the aesthetic apprehension of artistic wholes ('formal' qualities).

1. SENSORY QUALITIES

In this class I propose to group words by which we record and describe the sensory content of our perceptions in a single sensory mode. I shall illustrate from the language of shape, taking 'shape' in a very broad sense.

Language was fashioned pragmatically, evolved to meet practical needs, and it soon becomes obvious that sensory qualities apprehensible to perception exist almost indefinitely in excess of the words available to name them in any language. There is a small number of regular, conceptualized shape-qualities enshrined in the language by common names such as squares, circles, ellipses, cubes, triangles, parallelograms, and so on. We draw on a moderate stock of epithets whose primary application is to visible shape: we describe the things we see as short, long, slim, slender, straight, bent, crooked, sinuous, bulbous, bloated, pinched, spare, tapering, undulant, crimped, angular, pointed, blunt. . . . There is another set of names which belong primarily to prominent

shape-patterns of the human body (and evidence the extent to which interest in the human body compelled attention to its variations of shape during the formative stages of language) but which are applied by metonymy to shapes in general: obese, lank, gaunt, svelte, plump, chubby, squat, dumpy, snub, flaccid. . . . But even so we soon run out of words. Specialists who habitually attend to the shapes of natural objects or artifacts for their own purposes know a multiplicity—indeed an almost indefinite multiplicity—of shapes for which they have no names even in the esoteric vocabularies which they invent. Those people who attend to the shapes of pots and other artifacts, animal and plant forms, become aware of innumerable recurring shapes and characteristics of shapes for which they have no words. These shape-characters are directly perceived, but any attempt to name or describe them must involve either the use of esoteric neologisms or elaborate recourse to metaphor, analogy and suggestion. The vocabulary for talking about three-dimensional shapes is even much more jejune and when we wish to talk descriptively about the shapes of sculpture there is only make-shift language available. But shapes do not become subjective when language is no longer productive of names by which to give them a label. They present themselves to perception as phenomenal features of the things we see and they come to awareness as objective qualities of our sense-presentations. But when we need to talk about them we are at a loss and begin to use the language of metaphor, analogy and emotion.

The language available for describing the perceived qualities of colour configurations is poorer still, and it seems probable that during the formative period of many languages now spoken the qualities of colour most prominent in attention were those which serve principally the practical function of indicating materials and objects—that is, qualities of brilliance and lustre rather than hue. We describe colour configurations as bright, dim, dull, pale, gaudy, garish, harmonious, shrill, harsh, blending, variegated. . . . These terms are all general and not particular; they are in the main borrowed from other modes of sensation or they carry an emotional and valuational aura of implication.

Music has a fairly extensive technical vocabulary for naming the simpler shape-elements built up from units of pitch: intervals, chords, scales, arpeggios, are all named or are capable of being described. The most prominent phenomenological shapes in European music—though not in all music everywhere—have been the 'horizontal' pitch-patterns

which we call 'melodies'. There are no words for varieties of melody-shape corresponding, for example, to such names as squares, circles, oblongs for visual presentations. The similarities and contrasts which we detect among melodies are more fleeting and imprecise. They cannot easily be conceptualized and if we want to talk about them, we are driven again to the language of metaphor and emotion. Nor do the shapes of time-volume which we call 'rhythms', although they are capable of endless subtlety, give rise to nameable shape-qualities such as those of visual shapes. One may speak of the 'four-square' rhythms of Prokofiev or the jazz arabesques of *Portsmouth Point*, but this again is the language of metaphor and analogy. The shapes built up from musical elements give rise to a considerable range of emergent qualities which have no very exact analogies in other art forms, whose sensory base is less precisely articulated than musical pitch. For these emergent musical qualities there exist only a few general terms: concord, discord, resolution, tension, etc. Their apprehension is often strongly coloured by feeling and they tend to be described metaphorically in orectic language. It should be remarked here that the shapes of music offer potentialities of subtlety and planned ambiguity which are denied to the visual arts, where two colours or shapes cannot be in the same place at the same time. For a musical sound may at one and the same time be heard phenomenologically as itself, as an element in a 'vertical' sound pattern (chord) and as an element in one or more 'horizontal' sound shapes (melodies or themes). One can hear simultaneously *both* a distinctive chord-quality *and* the component notes, and the latter may also be heard as elements in a melodic structure. A chord may be sustained or broken into an arpeggio, intervals may be filled by runs and glissandos, and so on. The lack of exact parallelism between the basic sensory materials of music and painting is often overlooked when too facile analogies are drawn between the arts. It is a fact which has fundamental importance when one comes to study the functioning of 'intersensory' qualities as elements of style.

It is not unimportant that some shape-epithets carry a built-in relational aspect. It makes no sense to say that something is long (short, tall, thin, etc.) except in a context of relation: your talk must imply the *kind* of thing it is and your statement must be understood to mean that the thing in question is noticeably longer (shorter, etc.) than the average for that kind of thing. Many terms have an imprecise range of application

(gaunt, dumpy, obese) while at the same time carrying a built-in relational reference: a woman who is correctly called 'dumpy' among Scandinavians will not be so among Eskimos. This characteristic they share with such words as 'intelligent', 'courteous', 'capricious'. It is impossible to agree or disagree with the ascription 'intelligent' unless one knows whether it is made in reference to an ape or a human being.

It has been mentioned that many of these terms (particularly those descriptive of colour presentations and the non-technical musical vocabulary) are tinged in some or all contexts with emotional and valuational implications. With many people the apprehension of un-named sensory qualities is particularly inclined to be charged with feeling and most people sometimes achieve awareness of the more recondite sensory qualities, recognize and pinpoint them, in the first instance at any rate by means of feeling. It is the experience of many people who have habitual commerce with the fine arts or who otherwise attend to the sensory qualities of things beyond the ordinary needs of daily living that perceptual qualities which transcend the ingenuity of descriptive linguistic devices obtrude into awareness first as feeling-tone: only as they become more familiar, or clearer to cognition, the feeling fades and the quality which was first intimated through feeling is later apprehended without affective tone in a more penetrating and lucid perceptual act. Feeling seems, as has been said, to grope ahead of perception and to put out cognitive tentacles in advance of clear apprehension. Later, competent appreciation apprehends perceptually without the misting haze of feeling. It is perhaps only in feeling that one can apprehend certain most recondite visual properties, such as dynamic symmetry, which some theorists believe can be imparted to art objects by constructing them in accordance with complex geometrical principles of proportion involving the use of incommensurables. I do not believe that a painting can have these properties because the effects of optical illusion are more than sufficient to distort out of recognition the subtle relations of dynamic symmetry. For the same reason dynamic symmetry and cognate qualities cannot be apprehended in a pot or a cathedral at a single view from one position. But pots and cathedrals can be looked at from many positions and many angles: indeed they must be so viewed if they are to be apprehended as they are. Therefore I think it is possible that in the course of familiarity gained by combining and amalgamating many visions from various sides and angles,

many different positions, one may come to visual apprehension of a quality such as dynamic symmetry. If so, the apprehension is by way of feeling. I do not believe that it could ever be perceptually achieved.[5]

Everyone overlooks most easily qualities which lie outside the scope of his personal vocabulary unless some special interest forces attention upon them. We notice most readily what can be clothed and circumscribed in words, at least until the quality becomes 'transparent' with familiarity, whereas what we cannot describe to ourselves or name in our minds tends to pass us by as part of the formless unknown in a misty penumbra of emotion. Language not only helps us to feel at home with the world, it helps to render the world visible to us. What we do not notice we cannot attend to. And where we have no words, training and application are necessary in order to cultivate the inclination to notice and the sensibility to see. Such training, deliberately undertaken, is for almost everyone an essential part of developing a skill to appreciate. Artists are on the whole, within their particular sphere or sometimes more generally, more sensitive and more alert than the average person to a wider range of recondite sensory qualities of shape. It is part of their job, and constant attention to these aspects of things in the course of their creative activities sharpens a natural talent. In their art works they make use of an expanded range and clarity of observed shapes without thought of linguistic convenience, and they create new variations on and new combinations of the shapes they observe. We no longer think, as people once thought, that the aesthetic merit of a painting bears any direct relation to our aesthetic valuation of its contained shapes: we are not tempted to praise a painting if the women in it are slender and sinuous or to condemn it if they are ugly and obese. Nevertheless we cannot appraise a painting at all unless we have seen it, noticed and attended to the sensory shapes and patterns upon which the whole aesthetic superstructure rests. They are the bricks from which the edifice is built. And a person whose apprehension is jejune because he is sensitized to notice only a limited range of shapes in any sensory field is unlikely to prove successful in appreciation or to pronounce an opinion worth hearing.

2. INTERSENSORY QUALITIES

In the appreciation of art perceptual qualities which straddle more than one sensory mode—sometimes called 'intersensory qualities'—come

into prominence. They are not unique to art objects but are pervasive also in our ordinary everyday perceptions. They are emergent tertiary qualities attaching to fairly high level sensory configurations, but not attributable to the elements from which these configurations are composed. Some of them appear to be common to all sensory modes, others are more limited. Colours, movements, sounds, poems may all be 'gay'. Non-vocal music and poetic rhythms can be 'solemn'; colour configurations, on the other hand, can be 'sombre' but not 'solemn'. Examples of epithets corresponding to intersensory qualities are: pretty, delicate, dainty, elegant, stately, sprightly, majestic, austere, flamboyant, turgid, bombastic, jejune, decorative. . . . Some of these belong primarily to one art form and are applied to others with a smatch of metaphor: 'staccato', for example, is primarily a musical term; 'turgid' and 'bombastic' apply primarily to literary style. Some of the terms which are common counters in art criticism have a primary application outside this field, as 'delicate', 'majestic', 'flamboyant'. The existence of a common term does not always imply a single intersensory quality and mistakes have been made in this regard. For example, Heinz Werner says that we may speak 'in a very real sense not only of the softness of velvet, but also of a colour or a voice'.[6] It is very easy to be led astray by linguistic habits of ingrained metaphor. In this case the opposite to softness of touch is hardness or roughness; the opposite of soft sound is loud sound; the opposite of soft colour is vivid or contrasty colour. It is doubtful whether there is any quality common to the three instances other than a low degree of intrinsic obtrusiveness. Intersensory qualities are descriptive terms denoting perceptual qualities which are none the less objective because a certain imprecision attaches to the language by which we speak of them. They are less stable and less uniform than simple sensory qualities of shape, varying from instance to instance.[7] They are elusive and sometimes evanescent; yet they are objectively descriptive of perceptual experience and they are recognizable when they occur. When critics discuss whether an object is 'pretty' or not, they are talking about objective sensory facts and (if they are in accord about the meaning of the word 'pretty') they should not disagree. Emotional preference should not enter in to influence the descriptive content of the term. One critic may like his art to be pretty and may respond with a welcoming emotion to prettiness; another may dislike and despise it. One may think it appropriate and another inappropriate

to this or that art object or theme. But about the prettiness itself there should not be disagreement unless one or the other is inhibited from fully actualizing in perception the work of art before them—in which case they would be talking about different perceptual objects.

Although intersensory qualities are objectively descriptive, a strong flavour of emotional association lingers around many of them. The line of demarcation between descriptive intersensory qualities and emotional qualities, which are in fact also intersensory, is not easy to draw. Much of the language we use combines descriptive with emotional implications in proportions which depend on the individual writer. One of the needs of criticism is to overhaul the vocabulary of intersensory qualities, purging out—or at the least identifying—the emotional flavour which lingers and illuminating the descriptive content of its terms.[7]

It is to some considerable degree in virtue of these intersensory configurational qualities that works of art require their individual characters. And it is by reference to intersensory features to a very large extent that critics describe and demonstrate artistic styles and make stylistic comparisons between the various arts. Without them such comparisons would not be possible. When we speak (perhaps inexactly) of the serene reposefulness of Greek art, the mannered austerity of the Palladian style, the restless theatricality of the Baroque, we are applying intersensory terms. Groups of intersensory qualities form the basis of those definitions of style upon which many art historians rely. Such general characterizations of style as were proposed, for example, by Wölfflin in his *Principles of Art History* and applied more systematically by Wylie Sypher in *Four Stages of Renaissance Style* over the arts of poetry, painting, architecture, sculpture, and theatre are justified only in so far as there are high-level configurational properties common to more than one sensory mode. But the intersensory qualities which we discern outstrip the fertility of language to name or discriminate them and where language falls short we communicate perforce by metaphor and analogy.

Since the teaching of Henri Focillon, summarized in his *Vie des Formes* (1934), one of the recognized methods of art history has been to investigate and describe the morphology, genealogy, and evolution of particular patterns which enter into the structure of works of art. These patterns, called 'forms', can be ostensively indicated by instance and example but cannot in most cases be adequately formulated in discursive language. They are complex arrangements which are often

supposed to be common to several sensory modes so that by their means stylistic comparisons are possible also between the literary and visual arts and music. According to some art historians preferences for some of these form-patterns and characteristic methods of combining or assembling them may be taken as distinguishing features of different artistic cultures, epochs, schools, and styles. In one sense of the word 'style' (that, for instance, in which it was used by A. L. Kroeber) style is analysable wholly or mainly into characteristic combinations of form-patterns. The label 'formal' or 'formalistic' has often been applied to the method of art history which concentrates on the changes and fluctuations of form-patterns in so far as they are contributory to style.

In the sense in which these 'forms' are distinctive or constitutive of art styles their occurrence is not a criterion of aesthetic excellence. There can be good and bad art in every known style. Indeed the distinguishing features of a style are often more prominent in mediocre works than in great and original masterpieces. It would not be difficult to find artifacts highly typical of Rococo, Classical, Art Nouveau, streamlined, and a hundred other styles but artistically derivative or second-rate. Nevertheless practical knowledge of a wide variety of artistic styles, while certainly unable of itself to guarantee a competent skill in appreciation, is an accomplishment which can be a great furtherance to appreciation. It supplies the sort of background experience which is needed and helps to prepare and condition us to notice the sort of things which it is important that we should notice. Properly utilized and applied, such experience can render a man alert and sensitive to features to which he might otherwise well be obtuse and thus enable him more fully to realize the art object in apprehension. But such experience over a diversity of art styles, if it is to be useful in this way, must be gained from practical contact with works of art and not—or not merely—from the distant descriptions of books.

Although intersensory qualities are objective features of perceptual presentations, our awareness of them is often mediated by feelings. We *feel* that a work is dainty, austere, florid, etc., before we are able to notice and specify concrete characteristics which account for or contribute to these qualities. But the feeling we have is not an awareness of an emotional response in ourselves, deflecting attention inwards; it is an outward-directed, cognitive feeling. The extent to which apprehension of complex intersensory qualities is mediated by feeling varies from

68

person to person; but in general, as appreciation becomes more competent and sure, reliance on feeling diminishes and percipience is cleared of immediate feeling tone. In this sphere also feeling seems to probe ahead of perceptual awareness and as our sensitivity expands our dependence on feeling recedes. People of the greatest talent and experience appreciate for the most part by lucid and discriminative insight of high-level emergent qualities. A rather similar point was made by Archibald MacLeish about the apprehension of poetic meaning. In *Poetry and Experience* (1960) he wrote:

> Emotion *knows* the difference even though mind is defeated in its busy effort to pinch the difference between the thumb and finger of reason and so dispose of it. Emotion—and this is perhaps the point precisely—cannot dispose of it. Emotion stands there staring. . . . And the shape of total meaning when it begins to appear is a shape not in the understanding mind but in the recognizing perceptions—those fingers which can *feel*.

3. EMOTIONAL OR EXPRESSIVE QUALITIES

Emotional or expressive characteristics, as they are indiscriminately called, are for the most part—perhaps always—intersensory qualities (the same quality can be ascribed to things existing in different sensory modes) and are emergent features observed as belonging to the things we perceive in virtue of their primary qualities of shape, colour, etc. As sensory qualities merge without any sharp dividing line into intersensory qualities, so there is no fixed boundary between the latter and expressive qualities. The vocabulary for naming these qualities is crude and in much critical writing it can only be decided from the context, if at all, whether such terms as 'serene', 'pompous', 'majestic', 'stately', 'solemn', 'lugubrious', 'sprightly', 'comic', and so on are being used primarily to denote intersensory descriptive qualities or with an expressive implication or whether the meaning they carry represents some uneasy combination of both. Furthermore some terms which seem at first sight to carry an obvious emotional implication, and which may in origin have done so, are so conventionalized in the language that their emotional and expressive implications have been lost and they have degenerated into purely descriptive terms.

In order to throw some light upon what is still a very murky, if much discussed, field I believe it is necessary to make a distinction (which, however necessary, is obviously not an absolute one) between two

classes of emotional qualities and to indicate characteristic modes of perception which are appropriate to each type.

(1) Human beings express, in the sense of manifesting or giving outward evidence of, their emotional states, even of their emotional dispositions, by bodily and visible signs—in particular by the set of their features, by gestures, posture, vocalizations, the rhythms of their movements, and so on. These outward displays of emotion have been frequently studied by psychologists since Darwin published his *Expression of the Emotions in Man and the Animals* in 1872. (Before that they were chiefly the prerogative of artistic handbooks.) When we observe such outward signs of emotion in another person we become aware of that person's emotional state, not of an emotion or feeling in ourselves—or not primarily so. It has sometimes been maintained, especially by psychologists of the Gestalt school, that our apprehension of emotions in others is direct and not by inference, that the emotion is somehow inherent in the pattern of the bodily conformation which we perceive. Certainly the sympathetic awareness of feeling and emotion which accompanies all our intercourse with other people is so habitual as to be in most cases unconscious and for the most part it is not the result of conscious and deliberate inferences. Yet emotional expression is a very complex thing and conventional modes of expression certainly play a part. Indeed there are conventions of expression which are restricted to particular social traditions or milieux. A Chinese widens his eyes in anger, a European in amazement. And so on. Again, when we come to apprehend some delicate nuance of emotional expression in another person our understanding, which goes beyond the expressive power of words, may often be helped by a sympathetic reverberation of feeling in ourselves. But basically this mode of perception conveys awareness of emotional states and states of feeling in other persons, not in ourselves. In the jargon of psychology it is sometimes called 'physiognomic perception' and the qualities by which emotional disposition is expressed are called 'physiognomic' qualities of things.

The depiction or description of external emotional expression (physiognomic qualities) has been a prominent feature of much of the world's art, particularly art produced in the tradition of naturalism. Artists have been praised for their success in depicting accurately and unambiguously the outward manifestations of emotion in the figures which their pictures displayed. Such expression and our perception of it

operate according to the same principles in the simulated figures of art as in real life. A person with a delicate sensibility for emotional expressions in life, one who can read them with more than ordinary perceptivity and sympathy, will be for that reason better qualified to appreciate this kind of art. Accurate and convincing depiction of emotional expressions (as in a photograph) is not indeed an aesthetic goal in itself; it is no more than a part of the raw material for the construction of a work of art and cannot alone guarantee the excellence of the finished work. Yet wherever the expressive qualities of emotion are prominent in the representational content of an art work a person who is uninterested in them or who lacks the subtlety to read them will hardly be able to achieve appreciation of the formal and structural edifices which are built from them. This matter has been well put by L. R. Rogers in his book *Sculpture* in this series, where he says:

There are some qualities of sculpture which may be appreciated without much effort. They are almost universally recognizable and immediate in their appeal. Consider, for example, the overwhelming pathos of the Perpignan Crucifix, the dignity and power of Michelangelo's *Moses*, the tenderness of the gesture of the man's hand in Rodin's *The Kiss*, the warm radiance of Maillol's and Renoir's sculptures of women, the erotic appeal of an Indian apsaras, and the youthful charm of the choirboys in Lucca della Robbia's *Cantoria*. All these are qualities to which most people can readily respond because, although they are raised above their normal intensity, they are all qualities to which we habitually respond in everyday life. The deeper our ordinary feelings are, and the sharper our emotional responses in life, the more keenly do we appreciate such qualities of sculpture. Certainly we need no special kinds of perceptual skills, attitudes, and sensibilities in order to apprehend and enjoy them. There is only one way to develop our responses to this aspect of the art of sculpture and that is by becoming more generally sensitive human beings.

It is by recognizing and responding to these straightforward 'human' qualities that most people first make contact with the art of sculpture and become interested in it. But important though these qualities are where they do exist, they are only as it were the first and most easily reached layer of meaning or significance in sculpture, the merest fringe and superficiality of what it has to offer.

Since we do not seriously believe that feelings and emotions are experienced except by sentient beings, we cannot sensibly ascribe emotional expression in this sense to anything which is not a sentient being or for the time being regarded as such. Even the depiction of

animals in emotional situations is apt to incur the stigma of sentimentality, since we lack the sympathetic rapport to 'read' their outward signs as we read the signs of human emotion. With children and primitives indeed the separation between sentient and non-sentient is less sharp than it is with sophisticated adults, but in so far as the distinction is there emotions are not attributed to insentient things except by analogy or phantasy. Literary artists, however, and particularly poets, delight to personify natural objects and most literary traditions of the world have a long and pervasive habit of animistic language. In antiquity the importance of animation for literary metaphor was well known to Aristotle, who regarded it as a particularly effective device for achieving that vividness of imaginative impact (*enargeia*) by which he and subsequent critics down to Dionysius of Halicarnassus and Longinus set such store. Aristotle himself gives two examples from Homer: 'the *remorseless* stone rolled down again towards the plain' (*Odyssey*, xi, 598) and 'the spears stood in the ground *longing* to devour their fill of flesh' (*Iliad*, xi, 574). As an example of a case where meaning is expressed with greater lucidity and more exactly by metaphor than it could be expressed in literal language Dionysius instances 'the battle shuddered' from *Iliad*, xiii, 799. 'No change', he says, 'could by the use of literal language convey the meaning with greater truth or vividness. The poet has indicated by the term "shuddering battle" the thronging tumult of the spears and the continuous sound which they make.' Animation and emotional projection are still natural instincts very prevalent in ordinary life and they are inexorably shrined in the common language. But such conventional expressions as 'weeping willows' and 'angry sunsets' no longer carry implications of animism, if ever they did. Perhaps in origin they implied no more than the recognition of similarity between the drooping shape of the willow and the posture of a grieving man, between the glaring colours of a gaudy sunset and the suffused appearance of an angry person. Now they can hardly be classed as 'emotional' terms at all and seem only to indicate recondite sensory or intersensory qualities. In visual art animation of the inanimate plays little part at all except in certain special genres such as the illustration of children's stories and for special purposes such as fanciful satire. Landscape painting can express a generalized mood of pantheistic unity in feeling with the surrounding world, such as permeated much Romantic art and is present in a more subtle form in a good deal of Chinese painting. For

those who would appreciate the visual art of the world over more than a very narrow range it is necessary to be able to enter sympathetically into this mood of oneness and sympathetic rapport with the inanimate environment—and that perhaps not only in appreciation but also in life.

(2) Nowadays we are less interested than formerly in vivid and convincing depictions in art of human displays of emotion. This form of realism, by which the critics of antiquity and Vasari and others of the Renaissance set such great store, bulks far less large in our enjoyment of art today. When critics use expressive language in talking about works of art as such, or about their abstract and formal properties of line, texture, colour, composition, etc., they are not usually applying emotional terms in the sense we have been describing; for these are applicable to works of art only in virtue of their representational content, or more narrowly to the figures depicted in them. Total works of art, and the abstract, formal features of any works, are not sentient beings or depictions of sentient beings and cannot manifest emotion in the sense we have been considering. Yet the expressive character of art is a most important factor in contemporary habits of appreciation. Nor is the expressive character of art a thing entirely unrelated to our everyday experience, but continuous with it. It is not only in our experience of art that things are perceived as expressive even when they are not sentient beings and do not display emotions by which they themselves are moved. There is a manner of perceiving the world different from the coolly objective and impersonal perception which leads to scientific knowledge and it is a manner of perceiving which not only plays an important role in the practical ordering of life but has a particular significance for the appreciation of the arts. I propose to call this perceptual mode 'emotional perception'. It was with this way of experiencing the world in mind that J.-P. Sartre said in an essay written in 1939 under the influence of Husserl: 'L' émotion est une certaine manière d'appréhender le monde.' In his genetic study of value judgement W. M. Urban spoke of 'affective-volitional meaning' in this connection. Heinz Werner used the term 'signal things' to denote 'things whose characteristics are determined by the condition of the perceiver, not by their physical properties or relationships to other objects'. And a useful study by· Sylvia Honkavaara explicitly distinguishes this type of perception by the name 'dynamic-affective attitude' from the perception of 'physiognomic' properties.[8]

There is a more elementary, less differentiated manner of perceiving, in which the thing perceived is not held aloof from the percipient and his concerns, not apprehended as something distinct with attributes and qualities possessed independently in its own right, but is apprehended in its relation to the percipient, in terms of the significance it bears for him as part of a total situation fraught with emotional meaning for him. Whenever we become aware of something as awesome, ominous, sinister, menacing, touching, reassuring, stimulating, exhilarating, interesting, horrible, disgusting, delightful, thrilling, gruesome, disturbing . . . we are *perceiving emotionally*. Words belonging to this class have a primary reference not to qualities or conditions which a thing has out of relation to the speaker, but to its bearing as perceived on the emotional condition of the speaker or some implied group of persons to which the speaker belongs. The anger of an angry man, the remorse of the penitent, belong to them whether or not I or anyone else perceive the signs of their manifestation or correctly interpret what we perceive. On the other hand we call something 'dreadful' not because we think of it as manifesting an emotion of dread but because it is apt in the perceived situation to induce an emotion of dread or dismay in us and in people of similar disposition to ours. If you say something is cheerful, you are ascribing to it a quality which it has or has not in its own right whatever its effects on you and other people may be. If I call something 'exhilarating', I mean—roughly—that its contemplation is inclined to make me feel exhilarated, buoyant, cheerful. It does not make sense to say something is exhilarating but that I and people I know are not exhilarated by it. In practice, of course, such nice discriminations of usage are not always observed; but it remains true that the difference in kind between the two classes of emotional terms which have been described is inherent in the concept of the language.

Words of the second class, which we are now discussing, do in practice acquire a certain measure of interpersonal objectivity as the implied reference to the subjective emotional responses of the speaker is widened to include the emotional responses of men in general, through a tacit assumption that all or most men, or most men in a particular cultural group, respond in a similar way. Thus I can sensibly say that a thing is 'charming'—meaning that it has power to charm most men I know—but that it leaves me personally cold. Even so vague and subjective a term as 'interesting' may acquire a certain flavour of objec-

tivity.[9] To the extent that these terms acquire objectivity they lose their first impact as emotional terms and become descriptive terms. A good example of this is the modern term 'thriller', which has changed its meaning from 'that which thrills' and has become the name of a literary genre; so that it now makes good sense to say: 'Anyone would find that thriller dull.'

In so far, however, as emotional terms of this sort retain their 'expressive' character they carry an implied reference to the affective reaction of some responsive observer not to an emotional state in the object described. I shall call the emotional qualities denoted by these terms 'affective' qualities.

To these two ways of perceiving there correspond in a very general way two conceptions of appreciation and criticism. There is one very widely held view of criticism according to which it is the job of the critic to observe as carefully as possible his own affective experiences when in appreciative commerce with a work of art and to communicate these experiences in words which help his readers to enjoy a similar response. As Gibbon wrote in his *Journal*: 'I was acquainted till now only with two ways of criticising a beautiful passage, the one to show by exact anatomy of it the distinct beauties of it and whence they sprang; the other an idle exclamation or a general encomium, which leaves nothing behind it. Longinus has shown me that there is a third. He tells me his own feelings on reading it, and he tells them with such energy that he communicates them.' According to this idea appreciation consists essentially in experiencing an appropriate emotional response in contact with any work of art; criticism of the right sort can help us in this because the critic, it is supposed, will be a man with experience and natural talent for responding to works of art and a man too with a gift for putting his own emotional responses persuasively into words. There is, however, another conception of criticism prevalent today, according to which the critic, not talking about his own inner moods and emotions, purports to indicate emotional qualities objectively discerned in works of art in no different way from the ways in which he indicates the sensory and intersensory qualities he has discerned in them. He speaks of the qualities he has descried in the art object, not of the feelings he has experienced in contact with it, and by the manner of his speaking he causes his readers to be able to descry the same qualities that he has descried in it. This way of talking also seems to correspond with our

experience of appreciation. When we say that a piece of music is sombre or a pattern of colours gay, we do seem to be speaking about qualities which we have perceived in them and not merely, if at all, about their effects on our moods. Admittedly, our linguistic habits are loose and fluid; yet for all the looseness of language it remains true that we do seem to perceive emotional qualities, or some of them, as phenomeno-logically present in the object of attention independently of our sub-jective moods and emotions at the moment. This has been summed up by Huw Morris-Jones, when he says:

> The connection between a work of art and feeling must be described in such a way that one can legimately talk of discovering and discriminating the feelings appropriate and relevant to it. So when we say a play or music or sculpture is tragic or happy or sombre, we are not describing what the artist felt like nor are we describing how we feel when we look at or listen to them. It is not I who am tragic or happy or sombre, but the play, the poem, the song, the painting or whatever it is. What I do in saying they are such is to *recognise* the sadness or happiness, and I implicitly claim that others should recognise them too if they have undergone those perceptual and imaginative experiences which constitute an exhaustive appreciation of these works of art.[10]

In this study I have presented the idea of appreciation as a mode of percipience—emotionally coloured percipience, perhaps—rather than a subjective response to the object perceived. But whichever view is taken we come up against antinomies and contradictions when we attempt to explain the apprehension of emotional qualities in works of art.

On the one hand emotional qualities in the former of the two senses which have been distinguished—in the sense of 'physiognomic' proper-ties—can be attributed to works of art only in virtue of their represen-tational aspects: they can be attributed to the persons depicted or des-cribed in works of art when by a recognized convention we speak of them as if they were real persons, or they can be attributed to animals and inanimate objects depicted if these are animistically endowed with the characteristics of persons. But we can hardly personify or attribute emotional states to total works of art or to abstract features in them. Yet this is precisely what we seem to do. We speak of music as sad or serene, of colours as gay or gloomy. Moreover critics often notice relations of congruence or contrast between the emotional character of the formal

aspects of works of art and the emotions expressed in the representa-
tional content. Such language is not patently metaphor. When we call
music sad we do not mean, for example, that it makes us feel sad, or at
any rate this is not our only or primary meaning. The language seems
to correspond with the phenomenological experience of emotional quali-
ties objectively perceived 'in' the art work.

If we turn to emotional qualities of the second type, those which I
have named 'affective' qualities, other difficulties arise and it is not
plausible to suppose that the emotional qualities we perceive in works of
art are entirely of this class. The objects presented in works of art may
indeed be depicted as awesome, sinister, threatening, friendly, charming,
etc. These qualities to some extent attach to the appearances of things
and may belong to the images of art as to the things of real life. Yet
since their emotional character depends on and is bound up with our
perception of them in their relation to ourselves and other people, we
would expect their emotional qualities to become etiolated and depleted
almost to extinction by the awareness that these are not in fact real
things but painted or otherwise fictitious images which cannot in fact
have any real-life significance for us. For however intimately we project
ourselves into a work of art, realizing imaginatively the emotional
implications of the situations it presents, we always remain residually
aware that we are in the presence of a fiction and that we are contem-
plating something which is unreal. This is inherent in the aesthetic atti-
tude towards a work of art. But contrary to what one might expect, the
emotional character of the art-presentation is more vivid, more clearly
articulated and often more intense than the emotionally tinged percep-
tions of life.

When we 'perceive emotionally' in ordinary life the emotional
character of the object perceived is bound up with its significance for
the situation in which we stand and its implications for action in that
situation. A 'threatening' sky carries intimations of a storm, evokes
thoughts of shelter, umbrellas, etc. And the emotional qualities of the
things we perceive change as their involvement in our situation changes.
As is implicit in the famous lines of Lucretius beginning 'Suave mari
magno', we see a stormy sea differently according to whether we are
safe on land or at peril in a boat. We look on the sinister quality of a
fierce dog differently once we know that it is safely tethered by a chain.
Sometimes, as the urgency of the practical situation recedes, we are

77

able to take up an aesthetic attitude to emotional qualities as we do towards sensory qualities. What happens on such occasions bears a close analogy to the sort of experience which Bullough named 'psychical distancing' (see p. 24). Bullough describes how we may concentrate attention on the sensory qualities of a fog at sea, savouring them aesthetically and enjoying the perception of them while 'bracketing off' our awareness of their practical concomitants of danger and inconvenience. In a curious kind of way we can do the same sort of thing with emotional qualities, divorcing ourselves from the practical implications and attending to them for their own sakes. Emotional qualities float off, become detached from the immediate situation and as it were anchored in the object and can be savoured and enjoyed for their own sake. This may occur exceptionally in real-life situations. In our experience of art it is the norm and as the practical urgency of the situation recedes and its implications are 'bracketed off' by the awareness that the art image is unreal, our percipience of the emotional qualities may be heightened and enriched. It has indeed often been remarked that in tragedy we can even enjoy emotional aspects of situations which in reality would be too painful, too poignant or too horrific for an attitude of aesthetic 'distance' to be possible towards them. Something of the same sort runs through all our emotional experience of art. It is a mechanism by which, once we have succeeded in bringing ourselves into imaginative identification with the work, we can savour its emotional qualities more vividly for this detachment rather than directly responding to them as we customarily do in life.

This still does not explain how it is we seem to perceive emotional qualities objectively present in non-representational art, in total works of art or in the formal aspects of art works (e.g. in music and non-figurative painting and sculpture). Two solutions to this dilemma will now be discussed briefly, the theory of empathy and that of Gestalt psychology. We are not interested in these as abstract theories of art. But in so far as they purport to tell what the essential nature of aesthetic experience is, they have an inescapable relevance for any discussion of appreciation and the attitudes and mental set which are appropriate to it.

The theory of empathy was first formulated by Theodor Lipps in 1891, although the word *Einfühlung* had been used by Robert Vischer in 1873. But the facts upon which the theory was based were not new. At its simplest, starting with the assumption that feelings and states of

emotion cannot belong to insentient things, the theory maintains that when we ascribe emotional qualities to inanimate objects—when we say the music is sad or the scenery is gloomy—we are projecting upon the object of attention the feelings which it arouses in us as we attend to it.[11] For example, in *Language as Gesture* the literary critic R. P. Blackmur said of church steeples: 'Bad spires weigh a church down . . . A good spire is weightless, springing, an arrow aimed at the Almighty, carrying, in its gesture, the whole church with it.' According to the theory of empathy the feeling of soaring lightness (or of cumbersome heaviness) which we all have had when looking at a church spire is indeed a feeling of lightness, a kinaesthetic sensation of soaring, which we project upon the spire whose contemplation is its source in us. Projection may be conscious, as with deliberate metaphor, or more often unconscious. In the latter case, it is agreed, we do actually seem to be perceiving in the object qualities which really exist as feelings only in ourselves.

The theory of empathy has been stated in two different forms. According to one formulation we identify ourselves imaginatively with the object of perception, ascribing to it feelings and emotions which we should ourselves experience if we were in its place. According to the other we project upon the object feelings which we ourselves have actually experienced, perhaps unconsciously, in the act of perceiving it.

In some accounts the former of these processes has been proposed as the distinguishing feature of aesthetic experience, the feature which discriminates it from other kinds of experience. For example H. Siebeck (as reported by Listowel) held that the peculiarity of the aesthetic attitude, that which distinguishes it from normal perception, is that when we perceive an object aesthetically we regard it as in itself expressive of human personality, or instinct with some mood analogous to that of a real person. Vernon Lee thought that 'it is the attribution of our vital modes, of our movement, conation, intention, will, and character to assemblages of lines and sounds that explains preference for certain forms rather than others; and this selection among visible and audible forms constitutes *art*'.[12] There is no doubt that empathy of this sort occurs. But it extends far beyond experiences which are ordinarily called aesthetic. It lies at the root of animism, in life and in art, and it is the basis of that emotional sympathy with other people which, as Hume saw, is the source of understanding between men and the cement of

social relations. It is by sympathetic insight, by the power to put ourselves imaginatively into another man's shoes, that we can know the emotions of others and share them in understanding although we do not experience them in ourselves. But it is not a distinguishing feature of aesthetic experience. Nor does it account for our perception of emotional qualities in abstract organizations of shapes and sounds. We animate *things*, both in life and in our experience of art, but we do not animate works of art as such or the abstract and formal features of works of art. As an explanation of the emotional characteristics of abstract art such as music it is no more than a statement of the facts to be explained.

The explanation by projection is more to the point, but it postulates a complicated process of unconscious transference which is far more difficult to justify. Criticism of empathic projection as an explanation of aesthetic experience has come mainly from certain psychologists of the Gestalt school, who have claimed that emotional qualities are a class of 'tertiary' qualities which are present objectively not only in our perceptions of art objects but in our perception of things generally.

When we speak of an angry, threatening sky we don't first unconsciously become angry and threatening on sight of the sky and then project these emotions of our own on to what we see. Angry persons do not in fact make us feel angry: they may cause us amusement, alarm, embarrassment, but not anger, although by sympathetic insight we apprehend the anger in them. Some emotions of other people we apprehend by sharing, others by responding with an appropriate counter-emotion. So it seems much more likely *a priori* that we call the sky angry because its appearance looks to us angry in the way that an angry man looks angry than that the sky makes us first unconsciously angry ourselves and we then unconsciously project our anger upon it. Nor would it make more sense to say that we call the sky angry because we imagine that we ourselves would feel anger in its place. We call it angry simply because it looks angry. Even in more plausible cases such as our perception of the soaring of a spire, the buoyancy of a bird, it could as well be argued that we apprehend these qualities as much by contrast with a sense of our own earth-bound heaviness as by projection of an emotion aroused unconsciously in ourselves.[13] We do in fact attribute emotional qualities to things because that is how they look and sound.

This is the core of the criticism of the theory of empathy which came

mainly from psychologists of the Gestalt school in the context of an attack launched against basic assumptions of the traditional theory of expression. These psychologists were not prepared to accept the assumption, which had held the field until then, that the relation between physical sign and mental state in the expression of the emotions is an external one of association and inference. The classical doctrine of expression was neatly stated by Berkeley (1685–1753), who pointed out that although the 'passions' are invisible, they are 'nevertheless let in by the eye along with colours and alterations of countenance, which are the immediate objects of vision, and which signify them for no other reason than barely because they have been observed to accompany them: without experience, we should no more have taken blushing for a sign of shame than gladness'. In its more sophisticated form (in which it is compatible with belief in an innate power to recognize emotional expressions) the classical theory assumes that we interpret the physical manifestations we see in others by analogy with the feelings we know to accompany similar bodily movements and gestures in ourselves. And, it was thought, we attribute emotional qualities to inanimate objects in consequence either of observed analogies between their appearances and the signs of emotional expression in sentient beings or (and this is the empathy theory proper) because we project into them the emotions they arouse in us. The Gestalt school rejected these explanations, maintaining on the contrary that the meanings we find in the expressions we perceive, the emotional qualities which we ascribe to things, are not due to unconscious processes of association, inference or projection but are immediately apprehended as observed qualities of the presentation itself. Our apprehension of emotional qualities not only *seems* phenomenologically to be immediate and direct, but is so. We do not make an inference from the physical sign to the mental state of which it is a sign, but we see the emotional characteristic directly as a property of the physical thing we perceive. The facial expression looks sad—is apprehended with the emotional quality of sadness—whether it is seen on a bloodhound or on the face of an actor whom we know from other clues to be jolly. This aspect of the Gestalt theory of emotional expression—and it is the foundation upon which the rest was built—has been summarized by Rudolf Arnheim as follows:

The perception of expression does not therefore necessarily—and not even primarily—serve to determine the state of mind of another person by way of

externally observable manifestations. Köhler has pointed out that people normally deal with and react to expressive physical behaviour in itself rather than being conscious of the psychical experiences reflected by such behaviour. We perceive the slow, listless, 'droopy' movements of one person as contrasted to the brisk, straight, vigorous movements of another, but do not necessarily go beyond the meaning of such appearance by thinking explicitly of the psychical weariness or alertness behind it. Weariness and alertness are already contained in the psychical behaviour itself: they are not distinguished in any essential way from the weariness of slowly floating tar or the energetic ringing of the telephone bell. . . . Particularly the content of the work of art does not consist in states of mind that the dancer may pretend to be experiencing in himself or that our imagination may bestow on a painted Mary Magdalen or Sebastian. The substance of the work consists in what appears in the visible pattern itself. Evidently, then, expression is not limited to living organisms that we assume to possess consciousness. A steep rock, a willow tree, the colours of a sunset, the cracks in a wall, a tumbling leaf, a flowing fountain, or in fact a mere line or colour or the dance of an abstract shape on the movie screen have as much expression as the human body, and serve the artist equally well. . . .

The fact that nonhuman objects have genuine physiognomic properties has been concealed by the popular assumption that they are merely dressed up with human expression by an illusory 'pathetic fallacy', by empathy, anthropomorphism, primitive animism. But if expression is an inherent characteristic of perceptual patterns, its manifestations in the human figure are but a special case of a more general phenomenon. The comparison of an object's expression with a human state of mind is a secondary process. A weeping willow does not look sad because it looks like a sad person. It is more adequate to say that since the shape, direction, and flexibility of willow branches convey the expression of passive hanging, a comparison with the structurally similar state of mind that we call sadness imposes itself secondarily. The columns of a temple do not strive upward and carry the weight of the roof so dramatically because we put ourselves in their place, but because their location, proportion, and shape are carefully chosen in such a way that their image contains the desired expression. Only because and when this is so, are we enabled to 'sympathise' with the columns, if we so desire. An inappropriately designed temple resists all empathy.

To define visual expression as a reflection of human feelings would seem to be misleading on two counts: first, because it makes us ignore the fact that expression has its origin in the perceived pattern and in the reaction of the brain field of vision to this pattern; second, because such a description unduly limits the range of what is being expressed . . .[14]

This statement of the Gestalt theory of expression brings into the open a basic difficulty inherent in the theory of empathy. Why, we may ask, do the shapes of insentient things, why do abstract shapes and patterns, arouse in us the particular emotions they do, emotions which (according to this theory) we then project upon them? Why does the church spire arouse in us a feeling of soaring and lightness unless because it *looks* so? We must, it would seem, apprehend the expressive character of the pattern first in order for it to evoke in us the appropriate emotion to be projected. But of course if the emotional or expressive quality has already been apprehended we do not need to invoke the clumsy theory of projection in order to explain its apprehension. Yet the Gestalt view comes up against a similar difficulty in reverse. If, as the Gestalt psychologists assert, emotional or expressive qualities are apprehended directly as features of abstract shapes and patterns and shapes of insentient things, and if their relation to human emotional states is fortuitous only, then we are in a quandary to explain how it is that emotional language seems so appropriate and fits so well when we speak about them. We are left without an explanation for the close relation that exists between these qualities of abstract shapes and the emotions of human beings. We can, and critics do, speak not only about the emotions expressed by the human figures depicted in paintings but also about the relations of congruity or incongruity between them and the emotional qualities of the abstract and formal aspects of the painting (see Appendix II). To be able to apprehend such relations is an essential part of appreciation.

Gestalt theory has offered one explanation for this relation between the expressive qualities of things and human emotion, namely that the configuration or structure of an expressive shape is identical with the configuration of the emotion corresponding with it. In the words of Paul Guillaume: 'If the two aspects (inner and outer) are expressions of one and the same psychophysical dynamism, profound analogies should be encountered between them. The parts of the body in which this dynamism is manifested most obviously are often those in which it is most vividly felt. . . . The temporal course is parallel. Expansion, contraction, quiescence, fluctuations, follow the same curve. The mental or central part of the emotion obeys the same dynamic law as the peripheral part; the same rhythms can be detected in the conscious feeling of a man during emotion as in his muscular reactions; the hidden

movements of the psyche and the visible or invisible movements of the body image one another; in the language applied to emotions there is often no difference between the terms applied to the internal feeling and those applied to the external symptom.' The shape-patterns we observe in the deportment and behaviour of other people are therefore expressive because they are identical with the shape-patterns of subjective feelings we ourselves have experienced.

In the inflections of an agitated voice I hear directly the crescendos and decrescendos, the abrupt leaps or continuous variations of pitch, the sudden bursts and attacks, which express directly the dynamism of the emotion independently of all personal experience or any contact with a complex situation which could contribute new features, and if this dynamism belongs also to my lived personal experiences, these are not the key to it. Our understanding of human comportment can be enriched and rendered more precise by associations based on our personal recollections but these are integrated with formal properties which suffice in themselves.[15]

From this theory it would follow that when I say the music is sad, etc. I mean (as Mr. Bouwsma has indeed suggested)[16] that in the sad music I have apprehended pattern qualities which are in relevant respects identical both with the pattern of my feelings when I am sad and with the pattern I observe in the demeanour of people who are sad. This is presumably the sort of thing that is meant when we are told that the music sounds the way an emotion feels.[17] If I understand her aright, this is one of the theories of aesthetic expression which has been formulated by Mrs. Susanne Langer.[18]

If the theory of empathy is accused of making psychological assumptions away beyond verifiable facts, the assertion of psychophysical parallelism cannot be absolved of a similar charge. I am profoundly sceptical of the notion that a tonal or visual structure can be isomorphic with the structural pattern of an affective state. Besides specific emotions (fury over the loss of a penny), we have introspective knowledge of unattached, 'objectless' feelings or moods which while they last colour the whole content of conscious experience like a floating charge on the furniture of the mind. Moods of sadness or joy, elation, depression, serenity, restlessness (Locke's 'uneasiness'), apathy, irritability, and so on, are not directed upon any particular outside stimulus or tied to any impulse towards particular action. Their causes are often obscure. The mood fills the whole mind and tinges our attitude to whatever our

experience is. These vague moods of feeling become qualitatively articulated and more precise when they enter into this or that concrete emotion as its affective element, when they are linked to a specific stimulus involving a tendency to action (as sadness becomes grief when linked to the news of a death) or tied in with some situation appraisal (as despondency becomes contrition when joined with a belief that one has committed a sin). But when we use emotional language about works of art we attribute to them qualities of moods, not the feeling-tones of concrete emotions. We say that a tune is merry or gay, lively, languorous, melancholy or serene. We do not hear in the music emotions of regret, remorse, shame, disappointment, jealousy, fear, amazement or (*pace* Otto Baensch) of anger. Music may express yearning but not home-sickness, amorousness but not love. But our moods are not highly structured as works of art are structured. So far as I can observe, my feelings of sadness or elation are as nearly structureless as anything I know. While they last they are here and everywhere, like an atmosphere or an odour, or a diffused toning colour, lending a special flavour of melancholy or joy to anything that comes into my mind. A mood has duration, but no internal structure. And the word 'rhythm' seems inappropriate to describe the fluctuations and interplay of the various moods in experience. I can find nothing useful in postulating that the higher-level emergent configurational properties of works of art, the emotional or expressive qualities of their abstract forms, resemble patterns or rhythms of feeling. It is a statement hard to refute but incapable of proof. It may seem prematurely plausible but it takes us nowhere.

We come back, then, to the original problem of the emotional and expressive qualities which we apprehend as objective features of abstract patterns and shapes and as presented characteristics attaching to the formal and abstract aspects of works of art. I propose now to offer partial and tentative suggestions which are in some respects new and which I believe have crucial relevance for determining the attitudes of mind and attention which conduce to successful appreciation. The exposition will consist in part of gathering together hints which have been dropped already in the foregoing discussion.

(1) When we are attending to the figures portrayed in painting or described in novels and plays, to the narrative element, to the emotional situations and predicaments, our apprehension of feeling and expression

is on the same lines as in practical life and raises no special problems. There must, of course, always be added the proviso that in our contacts with works of art we are in the position always of spectators without complete involvement. However engrossed we are we never undergo full illusion but always retain a residual awareness that we are in the presence of a representation, an 'imitation' of the real thing. If we responded, practically or emotionally, as to real-life situations, we should have abandoned the aesthetic attitude.[19] Allowing for this, our manner of interpretation and recognition is as in life. The same may be said of the animism which plays a not inconsiderable part still in painting and poetry, when animals, trees, rocks, etc. are endowed with the expressive qualities of human beings.

Explanation is needed for the ascription of expressive qualities to abstract patterns and shapes, to the abstract or formal aspects of representational art whether literary or visual, and to works of art as a whole. For the qualities of a work of art, when we speak of it as a single thing and ascribe expressive qualities to it, cannot be reached by totting up the expressive qualities of the various figures or personages represented in it.

(2) As has been pointed out on various occasions in this study, our apprehensions of sensory qualities and still more of emergent configurational qualities are often by way of feeling, which takes on a cognitive character. Indeed the sharp division of feeling from perception and cognition, which was introduced by the old faculty psychology, does not accord with the facts of experience or the manner in which sentient beings make themselves at home with their environment. There is no sharp division. Attention normally involves the coming into play of the whole mind and person: perception and apprehension are emotionally coloured and feeling may well facilitate cognition. This is especially the case at certain stages of appreciative awareness in our contact with works of art.

Attention always involves a particular mental stance, an attitude which to some extent controls what aspects of things we notice and the way in which we bring them to awareness. In the attitudes of attention which ordinarily prevail in practical life, and still more when these are purified and sterilized for the purposes of science, the emotional and affective stirrings of the percipient are separated out from perception and attention is fastened on those aspects of the presentation which

serve as signs of the properties an object has independently of the relation in which it stands to the person perceiving it. In contrast to this, when we enter the aesthetic attitude attention 'rests' with the presentation itself; the presentation becomes 'opaque' as its qualities are savoured for themselves and not simply used as clues to eventualities and occurrences of practical significance in the world of things beyond. As attention grips the appearance with no ulterior motive apart from the sole purpose of fuller apprehension, the emergent configurational properties and the emotional qualities come to prominence and are enjoyed in their own right. As we bring these to awareness we perceive the object as menacing, louring, exhilarating, comic, sombre, etc. (Some works of art even make a point of emphasizing such qualities while blurring or suppressing the sensory qualities of the things they depict.) But because in aesthetic experience one is not only in an attitude of detachment from practical interest and concern but also detached from emotional involvement, the emotional qualities themselves appear detached in perception and enter into awareness as it were cut off and anchored in the object. For in aesthetic percipience I cut adrift from emotional involvement just as I cut adrift from practical involvement. When I see something as menacing I savour and enjoy its menacing quality as a feature presented to me and attaching to the presented object of attention, not as involving danger to myself. When spontaneous practical concern is held in abeyance the close fusion of mood and object which is characteristic of emotional perceiving in ordinary life is disrupted and the feeling qualities of the presented object are enjoyed without subjective vicissitudes of feeling.

(3) Our affective life may be likened to a surface texture of waves and ripples, currents and eddies, patterned on a fathomless and poorly differentiated sea of basic feeling-moods such as anxiety and calm, serenity and restlessness, elation and dejection. These basic moods of feeling become articulated into specific and sometimes nameable feelings in the context of concrete emotions involving reference to an object, situation appraisal and at least incipient tendencies to action. Without awareness of an objective situation and some rudimentary involvement we cannot at all experience or know our own emotions or what they are. Objectless feelings, as they are called, are vague, evanescent, and ill defined. But by taking up an aesthetic attitude towards anything we do, by detaching ourselves from practical involvement,

we inhibit the progression by which a structureless mood of feeling is taken up into a concrete emotion and rendered specific. Aesthetic contemplation provides an alternative way of rendering feeling specific. As we concentrate upon awareness of the sensory qualities of a thing for their own sake our feeling becomes individualized and the highly structured formal configurations of art works afford the most effective known means for achieving delicate and precise articulation of feeling. The feeling quality of each great work of art is both specific and unique: whether we enter into commerce with it by responsive reverberation of feeling in ourselves or by perception of objective emotional quality, the feeling we experience or the expressive quality we contemplate must be moulded and articulated to the structure of the object.

The expressive character of works of art is much more highly particularized than the resources of language can describe. The serenity of a Raphael Madonna is not the serenity of a Khmer Buddha or the serenity of a Morandi or a Mondrian. The eroticism of an Indian apsaras differs from the eroticism of a Boucher as the latter differs from a Van Dongen or a De Kooning. The dramatic vigour of the *Isaiah* at Souillac is different from the dramatic quality of Giovanni da Bologna's *Samson and a Philistine*, as that differs from a Bernini or a Rodin. In every case the precise expressive character is determined primarily by the formal and structural organization of sensory qualities. For subject and theme can always be common to more than one work of art with different expressive qualities in each, while expressive qualities of non-representational art can be sufficiently like those of representational works as to be describable only by the same terms. It is thus apparent how the formal or abstract features of a work of art can stand in relations of congruity—'concinnity', to use a medieval term—with the subject or theme. The situations, scenes, personnages or objects which make up the subject-matter of a painting have usually an emotional reference and the emotion they carry is, as in life, concreted from an underlying mood of feeling. The feeling attaching to an abstract configuration of form may also be very precisely articulated, although not articulate in words; this too is related to an underlying mood of feeling. The concinnity—or the clash—exists between the subject as a representation from life and the abstract formal qualities of the created configuration of sensory qualities.

(4) We have a vocabulary of the moods, vaguely discriminated as the

moods are themselves vague and interpenetrating. And we have a rough and ready vocabulary of the emotions, unevenly discriminative according to the importance arrogated to each emotional sector in the turbulence of our daily lives. But there is virtually no language by which we could describe the crystallization of feeling into concreteness and precision which gives their expressive characteristics to aesthetic objects. Vocabulary is rarely available for differentiating the emotional quality of an art work from the corresponding emotional response evoked in an observer. We do not indeed apply the word 'merry' to an object of merriment: we call that 'comic', 'ludicrous', or 'funny'. But we call a field of daffodils 'gay' and a lively melody 'cheerful', although these terms properly apply to an emotion aroused in us rather than to an emotional quality of an object. We often call music 'sad' although the appropriate correlate of sadness is properly 'sombre'. Some part of the difficulties we have noticed earlier is due to the absence of linguistic terms by which to denote the emotional qualities of aesthetic objects as distinct from the emotions of life; part by linguistic inaccuracy as displayed by the tendency to use 'sad' when we should say 'sombre', 'cheerful' when we should say something like 'exhilarating', and so on. The French language has an added resource in its distinction between *sentiment* (which approximates to what has here been called 'expressive character') and *émotion*. Thus speaking of the cognitive nature of aesthetic appreciation, Mikel Dufrenne has said:

Et dans tous les cas ce sentiment en qui s'achève la perception n'est pas émotion, il est connaissance. Ainsi l'émotion de la peur n'est pas le sentiment de l'horrible: elle est une certaine façon de réagir à l'horrible lorsque'il a été saisi comme un caractère du monde présent, et de se débattre dans le monde de l'horrible. De même la gaîté n'est pas le sentiment du comique, mais la façon dont nous pénétrons dans le monde du comique et usons de lui. De même la terreur ou la pitié ne sont pas le sentiment du tragique, mais des réactions qui tiennent à la façon dont nous nous engageons dans le monde du tragique en nous associant aux héros de la tragédie.[20]

4. FORMAL QUALITIES

Among the aesthetic qualities recognized by Sibley and Hungerland are some which belong to complete works of art or to major sections of such works. They are denoted by such terms as: 'unity', 'balance', 'integration', 'harmony', 'proportion', etc. Others are qualities of

texture, line, and other non-representational elements of art. This class of aesthetic qualities, which may be called 'formal qualities', will be discussed in the following chapter. To conclude the present chapter a word must be said by way of caution about the distinction between 'form' and 'subject' or 'content' which has been introduced in the discussion of expressive qualities.

For the purposes of exposition it has been necessary to speak as if a work of art was made up of two aspects, 'form' and 'content', which interact. This is, of course, an over-simplification. It is nowadays commonly accepted that in a successful work of art form and content are so intimately 'fused' that it is impossible for any change to be made in the form without changing the content and it is impossible for the content to remain the same without being changed if it is clothed in any other form than the form in which it is clothed. Even this is perhaps an over-simplification, since the assertion of such intimate 'fusion' of form and content implies that theoretically at any rate, and conceptually, form and content can be distinguished as two separate things however closely knit. From the point of view of appreciation I would suggest that the antithesis 'form' and 'material' is more to the point than 'form' and 'content'. The contrast of form and content has seemed specious partly because we sometimes think of a work of art, say a painting, to have the *purpose* of expressing a subject, which is its 'content' (the Dormition of the Virgin, the Life and Legends of the Buddha, the Death of Socrates, Napoleon Crossing the Alps, etc.). Content, in the sense of subject-matter, is something which may be common to a number of pictures. One can detail the respects in which the theme, the figures and objects and scenes depicted, and their disposition, are alike or different between one painting and another. And of paintings with the same or very similar content one tends to say that this one is good, that one mediocre, not in virtue of the content which they have in common but in virtue of their formal properties, in which they differ. This way of speaking fits in with our ordinary way of talking and thinking about pictures at a commonsense level. But it becomes misleading if it implies that 'content'—whether the fact that there is representation at all or the fact of what it is that is represented—is irrelevant to the form or that the form could be adequately appreciated and described as if a representational picture were abstract.

The raw material of painting consists of coloured areas with size,

shape, and position. These areas and the patterns they make up may, but need not, represent things other than themselves. If they do not, then the painting is called 'abstract'; it has no content but is akin to music in that it is a structuring of sensory material without references to anything beyond itself. The picture may be thought of as a structuring of (a giving form to) material which, in the former case, is representational in itself: the 'content' is inherent in the material to which the artist gives form. The difference in the way of thinking is important. The fact that the raw material represents something, when it does so, cannot be discounted when we are talking about formal qualities or appreciating form. A curve which represents a woman's breast or the head of a child has a different force and impact in the formal structure from the impact exerted by the same curve in a context where it represents a door-knob or a context where it represents nothing at all. The interplay, echoing, recurrences and modulations of lines and shapes are modified by the impact of representational meaning where it exists. It is wrong to set form in antithesis to content in any sense which neglects or obscures this important fact.

Appreciation is a complex activity of apprehension, which takes place at many levels concurrently. A picture may, and to some extent every picture must, be apprehended as if it were an abstract structure of visual shapes and in apprehending it so attention to content will be recessive. If a picture *is* representational, attention must be given to subject-matter. In some pictures the subject itself may be structured as if it were an artistically arranged *tableau vivant* so that even a photograph of it would have had some aesthetic interest.[21] This too, when and as it occurs, must enter into appreciation. The relations of congruence or concinnity between the emotional nature of the content and the expressive qualities of the abstract elements must be apprehended in feeling. Finally, as the culmination, it is quite necessary to see and appreciate how the elements as content-bearing material are themselves structured into form.

In pure music there is no 'form–content' dichotomy because there is no content in a straightforward, non-metaphorical sense. It was partly for this reason that Walter Pater and others, wishing to stress the importance of formal structuring over content or any other values which the material elements of a work of art might have independently of their relationships within the structure, used to speak of music as the

paradigm of all the arts.[22] Musical critics do indeed sometimes speak of 'content' and mean by it elements of informed musical material (thematic, melodic, rhythmical) which could occur in more than one musical composition and in this sense they contrast 'content' with certain specifiable types of over-all structure, which are called 'form'—sonata form, fugue, rhapsody, etc. But in this sense 'form' is not an aesthetic quality. A composition may be a faultless example of sonata or fugue form and yet be an aesthetically worthless exercise.

The material of literary art is language and since language necessarily carries reference beyond itself—otherwise it would not be language—there can be no literature without content. Content is built into the raw material from which literature is constructed. Form never occurs in literature divorced from content. Yet in literary criticism 'form' is used in a twofold sense. On the one hand one speaks of it in the sense of verbal structure when such terms as 'sonnet', 'rondel', 'heroic couplet' apply. These terms do not name aesthetic qualities. Yet even at this level sensitive critics have emphasized that meaning has an inescapable bearing on the rhythmic forms, as rhythm has a bearing on meaning. The traditional doctrine that the function and criterion of literature is to communicate and commend sound philosophy in effective language has gone out of favour and most modern theorists hold that in successful poetry the meaning cannot be adequately stated in any set of words other than the words in which it is stated. On the other hand we commonly speak of literary form in the sense of the structuring of content—the images, events, thoughts conveyed, the way in which characters and story are presented, and so on. This is the meaning when we speak of the 'form' of a novel or a drama. In this sense literary form is a structuring of meanings, of verbally presented thought. And in this sense it may be an aesthetic quality.

Art as expression

The metaphor comparing visual art with a language for the communication of feeling and emotion came to the fore during the Romantic age and under the stimulus of contemporary interest in semantics has blossomed into a full-blown theory—or group of theories—of art. Together with the idea of creativity the assumption that expression is either the central and necessary criterion or at any rate the most important function of art is ubiquitous and automatic in popular literature and criticism of the arts. In formal aesthetic theory it has also played an important part. One of the earliest—and the most lucid—statements of the theory was made by the French author Eugene Véron in his book *Aesthetics*, which was published in 1878 and translated into English in the following year. Véron describes a work of art as an 'emotive symbol', something by means of which the artist expresses his feelings and his emotions. He contrasts this with the 'cognitive symbol', by which one expresses what one knows or believes in contrast to what one feels. The theory assumes that if feeling and emotion are to be expressed a symbol must be created to embody them, to act as the vehicle for their communication: art is defined as the activity of creating these symbols for emotional expression. It is possible to regard later formulations of expression theory as developing one or another aspect of the theory as put forward by Véron. In 1928 Croce published his *Estetica come scienza dell'espressione e linguistica generale* (Aesthetics as the Science of Expression and General Linguistics), which had a considerable influence and set the tone for many years. A good example of the influence which this conception of art has had in practical criticism may be found

in René Huyghe's book *Art and the Spirit of Man*. In his Preface he sets out the plan of his interpretative survey of world art in terms of the concept of art as the language of the human spirit, 'of our feeling as well as our thinking nature, our nature as a whole in all its complexity'. From the theoretical and philosophical angle the concept of expression forms a major topic of Richard Wollheim's study, *Art and Its Objects*.

The idea that art is essentially an instrument for the expression of feeling has seldom been put forward deliberately as a rival and alternative to the concept of art as creation. The two functions of creating and expressing are usually admitted conjointly, the relative emphasis accorded to each varying from one writer to another and from one context to another. Whether both are necessary conditions for a work of art, whether indeed any work *can* be both expressive in some of the senses in which art has been said to be expressive and at the same time creative, are questions which have not been seriously discussed. In general, however, writers whose sympathies rest with the expressive functions of art often tend to take the view that if art is regarded as the *mere* creation of visual patterns without expressive force, it descends to the level of little more than an amusing game. Something has already been said about expressive aspects and possibilities in the discussion of emotional qualities (Chapter 4), but the modern preoccupation with expression bulks so large both in theoretical and in general literature of the arts, and its implications for appreciation are so far-reaching, that it must now be discussed in somewhat greater depth.

In its most basic form this is a theory that art exists as an instrument for the transference of emotional states from the artist to his public. The classical formulation of this form of the theory was made in Tolstoy's *What is Art?*, published in 1898, where he defined his conception of art in the words: 'Art is a human activity consisting in this, that one man consciously, by means of external signs, hands on to others feelings he has lived through, so that other people are infected by these feelings and also experience them.' The theory was also taken over by Kandinsky, the father of Abstract Expressionism who was influenced by Tolstoy. In his book *Über das Geistige in der Kunst* (Concerning the Spiritual in Art), published in 1912, Kandinsky wrote: 'A work of art consists of two elements, the inner and the outer. The inner is the emotion in the soul of the artist; this emotion has the capacity to evoke a similar emotion in the observer. . . . The sequence is: emotion (in the

artist)—the sensed—the art-work—the sensed—emotion (in the observer).'[1] The obvious weakness of the theory in this crude formulation lies in its failure to distinguish art as a vehicle of emotion from the many other means by which men both communicate and transmit their emotional states to their fellow-men. The more elaborate forms of the theory can be regarded by and large as attempts to surmount this shortcoming.

I propose to discuss the theory in its three phases: the artist's expression of his own emotions; the embodiment of emotion in the art work; and the supposed reverberation of embodied emotion in the feelings of those who successfully appreciate the work of art. But first a few words must be said about emotional expression generally.

In ordinary language we understand by the expression of emotion the overt and visible bodily movements, chiefly of face and bodily gesture, together with vocalizations and other signs, which accompany the experience of some inner perturbation of feeling and by which another person may augur the presence of the emotion in experience: the blush of shame, the sneer of disdain, the pout of peevishness, the self-inculpatory oath, the cringing of obsequiousness and an armoury of more subtle signs. This is the sort of thing which Charles Darwin investigated in his work *Expression of the Emotions in Man and the Animals*, published in 1872, and it is this which has interested a long line of experimental psychologists since his day. In this sense emotional expressions have been the stock-in-trade of poets throughout the ages.

Emotional expression has both a public and a private aspect. Popular wisdom believes, and most psychologists agree, that the act of expression relaxes nervous tension and brings relief to emotional excitement. The curative value of 'a good cry' is widely recognized. We become less keyed up when our accumulated feeling obtains overt manifestation. Therefore both in connection with artistic creation and in other walks of life we commonly say that a man 'expresses himself' or 'expresses his personality' when he indulges in some form of activity which derives from a deep-seated impulsive urge and leaves him afterwards soothed and fulfilled. This is the private aspect of emotional expression. But since man is a social animal, most men obtain added satisfaction from expressing themselves if the expression does convey to other people an understanding of the sort of persons they are and the sort of emotions and motives which prompt them. The element of communication can

add to the effectiveness of expression in bringing relief; consciousness of a failure to communicate can bring a sense of frustration. Darwin pointed out that although expressive behaviour may serve to reveal a person's state of emotion, that is not its primary intention or original object. (Darwin, of course, thought that in origin expressions of emotion had a biological function and that they became innate as vestigial survivals after their function was gone.) Others (for example, F. H. Allport in *Social Psychology*, 1924) have laid more emphasis on the continuing social usefulness of emotional expression in extending the modes of communication and facilitating social intercourse among men. This is its public aspect.

Closely related as they are, however, the two concepts of expression and communication are not identical. If a man reports in cool and unemotive descriptive language that he is experiencing or has just experienced an emotion, we do not say that he is expressing emotion though he is communicating. And it is not impossible that a man obtain satisfaction and relief from emotional expression although he makes no contact in communicating with others. It is not nonsense to say that a man expressed himself in a work of art which was not understood by anyone until after his death.

With this in mind I shall discuss first what it means for a person to express himself in a work of art and what significance it has for appreciation whether he has or has not expressed himself in the work.

I. ART AS EXPRESSION OF THE ARTIST'S EMOTIONS

When after introspection a man reports in cool and collected language that he is experiencing (or has just experienced) an emotion we do not say that he is 'expressing' that emotion. But some utterances, such as exclamations of grief, angry threats, enthusiastic eulogies, excited rooting at a ball game and the like, are reckoned to be part of emotional expression. Some oral expressions of emotion have even become stereotyped in literary tradition (Pshaw! Eheu!). We therefore distinguish between language used for communicating information and language used to express emotion. The distinction cannot be made absolute. There is an element of statement in much emotional language, and even the driest and most objective scientific statement has implicit an attitude of affirmation and a demand for acceptance. As Polanyi has said: 'The affirmation of a great scientific theory is in part an expression

of delight. The theory has an inarticulate component acclaiming its beauty, and this is essential to the belief that the theory is true.'[2] Yet as far as it goes the principle of distinction is valid and important.

In the early decades of this century there used to be popular a theory that the artistic use of language is language expressive of emotion in contrast with scientific language for conveying information. The theory was persuasively argued by C. K. Ogden and I. A. Richards in *The Meaning of Meaning* (1923). A typical formulation is usually quoted from Rudolf Carnap, who in *Philosophy and Logical Syntax* wrote: 'Many linguistic utterances are analogous to laughing in that they have only an expressive function, no representative function. Examples of this are cries like "Oh, Oh," or, on a higher level, lyrical verses. The aim of a lyrical poem in which occur the words "sunshine" and "clouds" is not to inform us of certain meteorological facts, but to express certain feelings of the poet and to excite similar feelings in us.' Such formulations, however, fail to distinguish between language expressing an emotion of the speaker and language for the evocation of emotion in the hearer. Both are called 'emotive'. Yet clearly one may use emotional language without wishing to arouse similar emotions in others (it may be pity that one wishes to arouse by the expression of grief) and one may endeavour by the use of language to arouse in others an emotion which one is not experiencing oneself. Indeed, as has been remarked, it is considered to be one of the gifts of the artist that by imaginative sympathy he is able to extend the emotional range of his works beyond the boundaries of his direct personal experience. A male painter can depict the emotions of mother love. Malraux, D'Annunzio, and Saint-Exupéry are not the only or necessarily the best poets of the emotions of aviation.

Moreover, in classing lyrical poems with exclamations of anger or grief the theory fails signally to offer an explanation of what makes the one a work of art and another not. In order to understand art and its appreciation it is necessary not only to give attention to the similarities that exist between the arts and other 'life-forms' but also to pinpoint the significant differences.

Artists and their interpreters often speak as if mere self-expression were justification enough. In a catalogue to his Amsterdam exhibition in 1958 Roger Bissière wrote: 'Ma peinture est l'image de ma vie. Le miroir de l'homme que je suis, tout entier avec mes faiblesses aussi.'

After an exemplary investigation into the sources of Picasso's imagery in *Guernica* Sir Anthony Blunt says: 'but all this would add up to very little without the impulse of external events which enabled the artist to use his accumulated wealth of ideas and skills to express his feelings about a theme greater than anything he had treated in his earlier works'.[3] But if we are being invited to contemplate works of art for the reason that they are expressions of an artist's personality or his feelings, certainly we need to know whether that personality or those feelings are more worth our while than the average. A whole school of psychological criticism has been built up on the idea that a work of art expresses the character of the artist. In the sense that everything men deliberately do from conviction is an indication of the sort of men they are, so also works of art are in this sense expressions of the artist's character. But far from being a simple and straightforward indication of character, the ways in which art works must be used as evidence of personality traits are almost indefinitely complicated, and this is one of the matters about which many critics seem to be most obviously faulted.[4] In *Enjoying Art* Sarah Newmeyer tells her readers that although Toulouse-Lautrec's paintings and lithographs supply an almost day-by-day record of his life, 'they do not reflect his inner self'. Vuillard's, on the other hand, 'offer a pictorial psychoanalysis of the subconscious impulses and tendencies that moved and ruled him'. Bernhard Berenson finds the religious emotions embodied in the pictures of Perugino so strong that 'the haunting quandary of commonplace minds is how Perugino could have painted pictures so profoundly religious and yet have been an atheist and a villain'. He makes the naïve suggestion that a villain and an atheist might paint sweet, holy people because he preferred them in real life, finding them easier victims. But Thomas Bodkin finds no such contortions necessary to the interpretation of Watteau, for: 'In almost everything that Watteau painted a melancholy is clearly, if not obviously perceptible.' At least it is clear that an artist's works do not express his emotions in the same straightforward way that a man's transitory facial movements express the emotions by which he is swayed from time to time or his more permanent physiognomy expresses his emotional dispositions and qualities of character. Therefore, if the theory is to have any importance at all except as a playground for scholarship, it is necessary to find an explanation how a great work of art is more fully expressive of the artist's personality than a poor work, how it is that a creative

artist is more deeply implicated in his products than an inferior hack. It has sometimes been suggested that an artist—or perhaps one should say an artistic genius, since many of the theories derive ultimately from the Romantic conception of genius—is a man with unusually strong drives which find release in his works. In fact, however, it has not proved possible to differentiate on psychological grounds the mental processes which go to the making of splendid works of art from those which lead to the worthless products of frustrated geniuses.

Again it has been suggested that the structures of great art works take shape at the lowest and most inaccessible regions of the unconscious mind and therefore carry echoes and reverberations of the whole psychical being of the artist more fully and completely than consciously controlled productions from a more superficial level. Some of the writings from the Surrealist school also bear an implication that anything which is a symbol of the artist's unconscious must be regarded with approval as art. But so do the products of psychotics and backward children express the contents of their subconscious minds. They form part of the clinical data of psychological literature and are used by pathologists both as clues for diagnosis and as a therapeutic device. The methods of interpretation applied to them differ in no significant ways from the methods that have been applied to the subject-matter of works by accomplished artists—the ladders of Picasso, the hermaphrodite of Leonardo, the insectival forms of Miro, etc.—and the results have not always been vastly dissimilar!

The plain facts are that artists are not all of a type and there is no tittle of evidence that by and large and on the whole they are better men or emotionally more balanced or profound than the generality of mankind. Belief that the art work expresses the character or the emotions of its maker does not give grounds for differentiating the fine from the poor or indeed for the expenditure of time and energy on appreciation. It would rather seem to be structure and form, elements of creativity, which constitute the difference. From the evidence of autobiographical writings and the writings of critics it is not clear how the works of artists acknowledged to be great express the minds of their makers differently from the productions of untalented artists, psychotics, and ordinary men.

There seems little doubt that from the point of view of appreciation at any rate the importance of the artist's self-expression has been over-

played in much modern writing. It is a legacy from Romanticism which could hardly have appeared sensible before that time and which runs counter to the outlook most commonly found outside the European tradition. None the less, in the appreciation of any great masterpiece of art it is not a matter of indifference, but certainly adds enrichment to the appreciative experience, that we know or feel the work was not a casual thing or an accidental product of nature but the creation of an artist deeply engaged in its formation.

2. EMBODIMENT OF EMOTION IN ART

Depiction of emotional expression as part of the representational content of a work of art plays a very different role in the different arts and misunderstandings have been caused by failure to distinguish between them. In music and in architecture it has no conspicuous part.

Because the patterns of emotional expression are 'Gestalten' or emergent and therefore cannot be analysed into elements which can be adequately described in words, literary artists are at a disadvantage in comparison with visual artists if they wish to introduce them into the content of their works. In literary art (except for acted drama) the portrayal of emotional expression can seldom become more than an adjunct to the main devices. It may be introduced for decoration, for emphasis or for vividness, but good writers use it sparingly and do not allow it to obtrude beyond the position of an accessory. Certain expressive elements have come to be associated with named emotions, largely in consequence of a tradition created by literature itself: a pout for sulkiness, a sneer for contempt, a flush for shame or anger, and so on. But these associations are rough-and-ready, not susceptible of subtle discriminations. The naming of emotions is clumsy and crude, lacking precision: yet even so it is in most cases more accurate than indications derivable from verbal descriptions of the physical manifestations of emotion. Hence the usual practice of literary artists is to *suggest* the emotions they wish to portray by describing the behaviour and the predicament of their characters, naming the emotion intended and mentioning overt manifestations of emotion for additional vividness.

Thus Shakespeare, in specific situations intended to be made visible on the stage, describes the anger which Aristotle also regarded as an element in martial ferocity:

But when the blast of war blows in our ears,
Then imitate the action of the tiger:
Stiffen the sinews, summon up the blood.
Then lend the eye a terrible aspect;
Now set the teeth, and stretch the nostrils wide,
Hold hard the breath, and bend up every spirit
To his full height.

Henry V, III. i

Fear is described as follows in a situation made visible on the stage:

Canst thou quake and change thy colour,
Murther thy breath in middle of a word,
And then again begin, and stop again,
As if thou wast distraught and mad with terror?

Richard III, III. v

Spenser depicts terror as follows:

He answered nought at all; but adding new
Fear to his first amazement, staring wyde
With stony eyes and hartlesse hollow hew,
Astonisht stood, as one that had aspyde
Infernall Furies with their chaines untyde. . .
 who nought to him replyde:
But, trembling every joynt, did inly quake,
And foltring tongue at last these words seemed forth to shake.

Faerie Queene, I ix. 5, 24

The classical example of the physical manifestations of emotion being made the subject-matter of poetry is a fragment from Sappho preserved by Longinus as an illustration of sublime writing:

That man seems to me to be as fortunate as the gods, who sits before you and hears close by your charming voice and your lovely laughter. This has made my heart flutter in my breast. I look at you but a moment and I am bereft of speech. My tongue is broken, immediately a fine flame runs beneath my flesh, my eyes are darkened, there is a reverberation in my ears, a cold sweat grips me, I am paler than grass and I seem to be near to death . . .

A modern editor has noted that all but two of the symptoms she mentions have a counterpart in Homer; but in Homer they are introduced as symptoms of other emotions than love, which is rare in Greek literature before the Alexandrine age.

Modern writers sometimes seek to secure an effect by describing some out-of-the-ordinary emotional gesture or feeling, which none the less strikes the reader as familiar. Or by description and suggestion a writer may attempt to portray an unusual and unfamiliar emotion and make it real to his readers. In his novel *Wild Conquest* Peter Abrahams describes thus the deep emotional longing for freedom which may be experienced by a slave:

> What is freedom? He tried to think about it. He knew it was something he felt, something deep inside him. Having it or not having it made all the difference to the way a man felt about the food he ate, about the words he spoke, about the wind and the rain on his face, about the way he looked at children in their play, about the way he kissed his woman and the way he walked and the look in his eyes. That he knew, but how to tell them that, how to make them understand that, that was the difficulty.

This is emotion presented rather than expressed or evoked.

At the other extreme there has grown up, especially in the novel, a curious convention of assuming that a person's emotional states may be recognized from his facial expressions with far more exactness than is the case. Abandoning the attempt to describe facial expressions, and regarding it as too pedestrian simply to name the emotions his characters are supposed to be experiencing, a novelist may assume that quite complicated mixtures of emotion can be read in a person's face and simply state that such and such a personage expressed this or that complex of emotions in his face. This is a new and retrograde literary convention, which seeks vividness at the expense of verisimilitude.

Drama—which we might think of as literature made visible—stands at the other extreme. The possibilities of emotional expression on the stage are more or less the same as in life, with the added emphasis of the 'close-up' in the technique of cinema. In theatrical history there have been two main trends. That which has been predominant in Western tradition since the Renaissance leans in the direction of naturalistic illusionism. Its main aesthetic aim has been to encourage psychological projection and all the devices of stagecraft are brought into play to help the audience forget that they are spectators of a drama and identify themselves imaginatively with the characters of the play. They are given the impression of looking in upon a room the front wall of which

has been removed. Therefore, with certain conventional exaggerations for the purpose of greater crispness and precision, good acting has been considered to be that which achieves the maximum fidelity in reproducing the emotional expressions of life. The opposite tradition is exemplified in Greek drama, the Japanese Noh plays and Indian religious dramas. The theatre of convention does not aspire to fidelity in representing the emotional expressions of life: indeed realism may be inhibited by the use of masks, stereotyped postures and other conventions of performance. The theatre of convention has more in common with ritual than realism and its aesthetic aim is something other than the encouragement of emotional projection. As L. H. G. Greenwood has lucidly put it in *Aspects of Euripidean Tragedy* (1953): 'Greek drama did not attempt to produce in the spectators' minds any sort of illusion, any feeling, however temporary, that they were seeing and hearing what, in the distant past, actually took place. . . . Just as the recitation of an epic by a single rhapsode, in which illusion was plainly impossible and was in no way attempted, could nevertheless cause the hearer to imagine vividly the scene and the various persons acting and speaking, so drama could do this; and this was all it did, all it could do, and all it sought to do.' Of the Indian theatre Coomaraswamy says: 'Indian treatises constantly emphasize that the actor should not be carried away by the emotions he represents, but should rather be the ever-conscious master of the puppet show performed by his own body on the stage.'

Dance also shows a similar contrast between the realistic reproduction of emotional expression in mime and the stereotyped movements of conventional dance traditions such as those of Greek and Indian dance and to a rather lesser extent the Russian ballet. Athenaeus preserves a tradition that Telestes, Aeschylus's dance-leader, had so accomplished a technique that he could exhibit the whole action of the *Seven Against Thebes* by silent dancing alone. Yet this was by conventionalized hand and body movements. Conventional dance traditions such as the Indian combine symbolism of hand and body movements, which is esoteric to the tradition, with the intrinsic 'expressive qualities' of rhythmic movements and postures.

The naturalistic theory of painting has always set the highest store by accurate and lively depiction of the external signs of emotion and passion. In classical times and again at the Renaissance this was considered to be the culmination of the painter's art and also the most

effective means of arousing emotion in the spectator (see Appendix IV). Leonardo led the way in making a deliberate study of emotional expression and its mechanisms. From this beginning the related sciences of physiognomy and emotional gesture were developed largely in the context of visual art. Rules were systematized by Le Brun, whose *Conférences sur l'Expression des différents Caractères des Passions*, published in 1667, remained the standard basis of teaching in the academies for two centuries. It would be difficult to exaggerate the importance attached to depicting the external manifestations of emotion throughout most genres of European painting until recently. Nowadays the pendulum has swung in the opposite direction and this is not what is meant when we talk of the 'expression of emotion through art'. As has already been said, the emphasis is now upon the creation of 'emotional qualities' which are inherent in abstract patterns of colours, shapes, and lines.[5]

Painters today are uninterested in the 'theatrical' style of painting and the naturalism which relied on faithful rendering of the visible signs of feeling. Part of the reason for this is the reaction against 'literary content' as expressed in the following sentence by Gilson: 'A painting begins to become a book at the very moment it uses lines and colours to relate a story or to describe human emotions, human passions, human thoughts—in short, whatever could as well be expressed by means of words.' But the exact reproduction of external signs of emotion is precisely a thing which the painter can do and the writer can not do. Feelings and emotions can be only clumsily and blunderingly described in words; no literary artist can produce a word-picture of the delicacies of facial expression. As we move among our fellow-men in their daily avocations we constantly become aware of their changing expressions and the significance of their postures and gestures. It is a knowledge we have in advance of words. As we listen to them speak we hear not only the sentences but the meaningful modulations of the voice. Travelling in buses and trains, in the shops and streets, in restaurants, in church, at the theatre, at concerts and at work we watch the people around us—we see a quirk of the lips here, a twist of the mouth which conveys so precise a shade of irony, humour, satire, deprecation, that no words could begin to do it justice; we see a corrugation of the forehead, a turn of the eyebrows, a smile, a pout, a mere pursing of the lips —and each subtle movement holds for us a message which we under-

Pablo Picasso: CÉLESTINE. *Courtauld Institute of Art.* © SPADEM, Paris

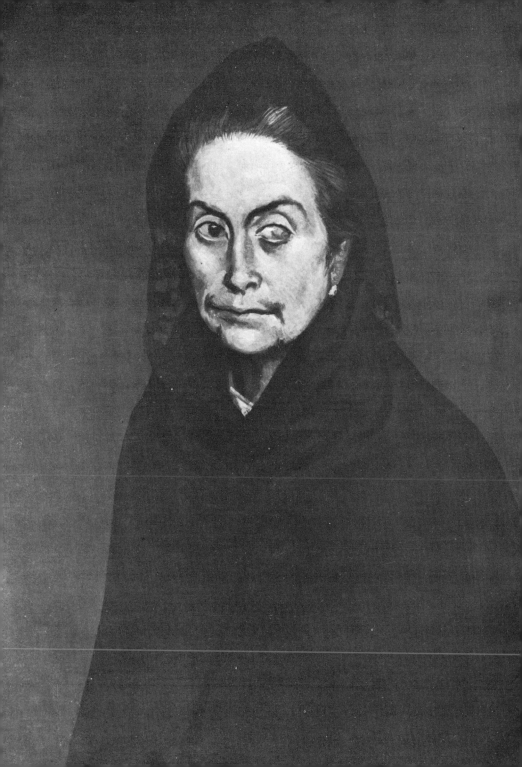

stand or seem to understand, though we have no words with which to tell what we see. Do we in fact understand the meaning of these shades of expression which seem so characteristic, so individual, so much more fraught with speaking significance than any language can propound? The matter is not easy to put to the test since the observer is without language adequate to communicate the significance he seems to see in the expressions which he observes and the person observed has no words by which to tell what he really felt. The painter alone can catch and perpetuate these delicate and evanescent turns of expression whose import bulks so large in everyday social intercourse. Is it perhaps such an expression which was snatched from oblivion in the *Mona Lisa*, in Picasso's *Célestine*, in John's *Smiling Woman*?

While intolerant of the naturalistic style which represents persons displaying the external marks of emotion as if the spectator were looking on to a theatrical stage, contemporary taste looks more favourably on the representations of permanent dispositions which reflect general qualities of character. Pictures such as the portrait of *Vrouw Bodolphe* by Frans Hals, Holbein's *Sir Thomas More*, Picasso's *Gertrude Stein*. Henry Lamb's drawings for his portrait of Lytton Strachey, Graham Sutherland's *Portrait of the Hon. Edward Sackville-West* are admired not only for their formal and painterly qualities but also for their insight into certain universal characteristics of human personality. Of the Sackville-West portrait Douglas Cooper has said: 'In him Sutherland has seen a hypersensitive, refined and vulnerable human being, who has become sick through coping with the battle of life. Precariously perched on a high stool, his hands neurotically clasped, he seems literally to shrink into his clothes.' Yet how much more does such a picture tell than any words can say!

The extent of the modern dislike for including external signs of emotion in the representational content of a picture may be a passing phase. It is tied up with the suspicion of narrative painting as such. Yet this is a thing which painting alone can do. No subtlety or fineness of expressive representation can of course take the place of configurational properties without which there can be no object for aesthetic contemplation at all. And there is always some danger that interest in subject may stimulate the sort of attention which prevents one looking at the picture. But if the artist can guard against this by rendering incident sufficiently self-contained, there seems to be no good reason

why the depiction of emotional expression should be for ever excluded. The same cannot be said for sculpture. The sculptor's task is a different one from the painter's. A piece of sculpture is a solid object in three-dimensional space and for that reason is already closer to the mode of being of that which it represents than is a painting which exists in two dimensions. To maintain a basis for the aesthetic attitude the sculptor, therefore, must weigh more strictly the balance between formal properties of construction and representational interest.

By the embodiment of emotion in art works what has often been meant is the creation of formal or abstract configurations with expressive or emotive power—as in the words of Van Gogh often quoted: 'J'ai voulu représenter par les couleurs les terribles passions humaines.' This was the basis of Kandinsky's theory and all similar theories of art. The matter has already been discussed (Chapter 4). Abstract and formal elements of visual art do not express the precise articulations of emotion and feeling experienced in ordinary life any more than do the forms and rhythms of music. They do embody equally precise articulations of basic moods of feeling, and they are connected as congruent or conflicting with the emotions of life (which may be expressed equally by depicted figures) by the common element of feeling mood. A person who would cultivate powers of appreciation beyond the most elementary stages must not only be imaginatively sensitive to the emotions of other men but must also acquire a delicate and true sensibility for the precise crystallizations of mood and feeling which are embodied in the formal and non-representational aspects of visual art.

3. THE AROUSAL OF EMOTION

Not only within the ambit of Expressionist schools but much more generally it has been assumed that either the sole or at any rate the most important function of successful works of art is emotion arousal. And it has usually been taken for granted that the arousal of emotion is by *transmission*: that is, an emotion experienced by the artist and somehow embodied in the art work is then evoked in anyone who makes appreciative contact with the art work. There have been those who, like Tolstoy, have believed that the arousal of emotion, or a particular class of emotions, is the *criterion* of art. From Archibald Alison to Clive Bell there have been those who have maintained that there are special *aesthetic* emotions, a class of their own, and that it is the criterion of any-

thing being a work of art, as also the criterion of successful appreciation, that these emotions are aroused. But quite outside formal theory it is a very widespread assumption that appreciation of art is emotional in character, indeed that appreciative commerce with any work of art consists, or mainly consists, in experiencing an appropriate affective response towards it. Assumptions of this sort are as ubiquitous today as assumptions about the didactic or edificatory functions of art have been in the past. Their force derives from the simple and undeniable fact that people do, naturally and without special training, react emotionally to works of art, not only to literary and dramatic art but also to music and the visual arts of painting, sculpture, and architecture. But natural though it is, the assumption that appreciation is in its essential nature affective reaction is a superficial one and I have put forward the contrary view that it is most fruitfully regarded as a mode of percipience. It is usually, if not always, percipience that is emotionally coloured and the kind and the intensity of the emotional colouring will vary with the sort of art work being enjoyed, with the personality type of the observer and with the extent of his experience and expertise in the art of appreciation.

It will be convenient here to recapitulate the respects in which appreciative percipience is subject to affective colouring, though it must always be borne in mind that the divisions I have drawn are logical and to some extent arbitrary: they are the result of reflective analysis and in the direct act and process of appreciation they are either fused or are generally much less clearly differentiated. But such reflective differentiation is necessary if we are to talk about the matter at all. Given this understanding, it seems to me that the following are the chief aspects of emotional or affective excitement which habitually colour aesthetic perception.

(1) Any delicate perception of sensory qualities may be tinged with feeling or in some cases even mediated by feeling. This is a phenomenon which is not peculiar to perception which we should ordinarily call 'aesthetic'. I have instanced the matching of colours or the tuning of a violin, where the final exactitudes of congruence are indicated by feeling. Similar feeling-perceptions could be instanced in many spheres of 'connoisseurship' such as the tasting of wine, the sampling of perfumes, and so on. They certainly occur in the delicate perceptions of sensory qualities which form the fundamental material of aesthetic appreciation.

But as has been mentioned, as appreciative skill in any art matures and a person becomes more accomplished, reliance upon feeling in most cases diminishes.

(2) Perception of formal aesthetic qualities, such as balance, harmony, proportion, fitness, may also be mediated by feeling. This too may occur, though perhaps more rarely, outside the appreciation of art proper. An engineer may *feel* the fine balance of a bridge, we may *feel* the fitness of a structure for its purpose even before working this out in conscious apprehension, and we may *feel* that the shape and proportions of a bird, or an aeroplane, or a speedboat, are congruent to lightness and speed, that the shape or proportions of a tree belong to stability and endurance, and so on. In aesthetic apprehension such affectively mediated perceptions play their part. And it seems likely that some formal qualities, such as dynamic symmetry in architecture and the complex rhythmic combinations of some Indian music, can be apprehended by most people *only* through feeling.

(3) When the representational content of a work of art includes depicted emotional situations we apprehend these situations in part by means of a sympathetic reverberation in ourselves of the emotions depicted. In the experience of a tragedy as in life our pity at distress presupposes some imaginative, if unconscious, identification with the grief or anguish of the object of our pity, indignation at injustice presupposes some sympathetic apprehension of presented emotions though less prominent, less assertive, than the fully-lived emotions we ourselves experience and I have compared them with the mental imagery which may in some people accompany recognition and understanding of situations that are described.

(4) The apprehension of expressive qualities of depicted things is different in aesthetic experience from the practical posture of attention which is characteristic of our attitudes in everyday life. In aesthetic apprehension we as it were distance ourselves from them, savour and enjoy them instead of responding directly to their implications for a practical situation in which they are perceived. Such apprehension of expressive qualities pervades most of our experience of art and although it differs from the practical, it also differentiates aesthetic percipience from the cool and unemotional perception which is the ideal of science.

There is no sensible reason for doubting that aesthetic enjoyment of works of art is a form of percipience transfused in various degrees with

feeling and that it may also include apprehension which assumes the form of feeling when feeling mediates cognitive insight. This after all accords with the general experience of most people who believe themselves to be enjoying appreciative commerce with art works. But there are strong reasons for believing that straightforward emotional response, in the sense of emotion arousal, to a work of art as if to a real-life situation is not central to aesthetic experience and may even be incongruous with it. For example, a tear-jerking film is not considered to be artistically good in proportion to the intensity of the emotions it arouses and those persons are not thought to have appreciated the aesthetic qualities of a film most adequately who have wept most copiously during its performance. When we read and enjoy a love poem we do not experience in ourselves the emotion of passionate love which was its inspiration although we may, as it is said, get the flavour and feel of that emotion. In the field of religious art, objects which by accepted aesthetic standards must be judged to be very inferior may nevertheless arouse strong religious emotions in the devotee whether as cult objects or as 'theophanies', and it does not make nonsense to say that even great religious art is often valued by the inartistic because it is religious rather than because it is art. Similar things could be said about patriotic art and about propaganda art generally. Works of art whose main ostensible purpose was propaganda are not reliably assessed as art objects by their effectiveness as propaganda. They can be appreciated aesthetically after the immediate occasion of propaganda impact has disappeared; and if much then seems tawdry and shallow, some (e.g. the orations of Demosthenes, the 'revolutionary' murals of Siqueiros) is still aesthetically valuable.

Yet there are some forms of direct emotion arousal which appear to be not only germane but central or even necessary to full appreciative enjoyment. I will instance two in particular. (i) The emotion of suspense (which is largely compacted of curiosity, the basis of our intellectual life, combined with imaginative involvement) plays a large part in our reactions to detective and adventure literature, to most drama, including even historical drama, to novels such as those of Dickens and Hardy which were written for serial publication, while the building up and resolution of suspense is quite fundamental to music, at least music in the European tradition. It plays no part in the static arts of painting, sculpture, and architecture. Suspense is an emotion directly aroused in

the observer as he comes gradually to awareness of the art work through a period of time. But the emotion of suspense cannot survive knowledge, or survives only in a weakened and reflected form to the extent that we are able to imagine ourselves back into our state of mind before we had achieved complete awareness of the work. Yet we can re-read some novels, attend repeated performances of some drama, listen again and again to some music, and we can do so often with heightened enjoyment, even after the element of suspense has been submerged or weakened by familiarity. The argument is that it is not the emotion of suspense itself which is germane to appreciation and enjoyment but rather a perceptive apprehension of patterns and configurations of suspense and resolution. Or else it is argued that *aesthetic* enjoyment is restricted to other aspects of the art work such as, in literature, the depiction of character, the formal qualities of a plot, wisdom and in-sight into human nature, felicities of language, and so on. This sort of argument is less plausible in the case of music, where the pattern of suspense is often a central feature of the structure, but even in the case of literature does not seem to be wholly convincing. (ii) As another case where direct emotion arousal seems to be central to the success of the art work so that failure in this respect may involve condemnation, we may cite the emotion of amusement. Humorous art which does not amuse is not good art. No amount of ponderous Teutonic exegesis will help: unless you *feel* the work to be humorous, unless you experience in yourself the emotion of amusement, no amount of explanation will bring you into a state of appreciation. This case is particularly interest-ing because our sense of the risible shows marked variation from epoch to epoch, between one people and another. There are works which we know from external evidence to have been considered wildly funny in their time but which are no longer amusing: such works have lost their piquancy and appreciation is frustrated. The opposite also happens, when something seems comic to us which was not to the sentiment of the people for whom an art work was created and it is then apparent that the intrusion of the unintentionally comic, with the arousal of an inappropriate emotion of amusement, may prove an intractable obstacle to appreciation. I have elsewhere argued that this has happened in the case of the *Prometheus Bound* and the *Suppliant Women* of Aeschylus, plays whose original grandeur has echoed down the ages and can still begin to thrill us through the fogs of misapprehension and all the

ambiguities of our response. But in both the myth of Io, calling up as it does the to us incurably comic images of a prancing heifer goaded by gadflies, simply will not couch with sublimity. Prometheus remains still a figure of potential grandeur. There is in both plays fine poetry, great themes clothed in glorious language. But the plays as unified wholes are shattered by the intrusion of the risible and grotesque. To an age and a generation unhabituated to theriomorphic mythology and perhaps more apt to visual imagery the sublimity of language and concept collapses in association with poetic pictures of the uncomfortable cow.

There are, then, considerations for and against arrogating to emotion arousal a central place in the appreciations of the arts and it seems certain that no general and unvarying rule can be laid down for all the art forms or one which would operate uniformly for every work in any one art form. I propose therefore to mention briefly some theories of emotion arousal which have been influential over long periods and then to consider the place of emotion arousal, emotion contemplation, and sympathetic empathy in the appreciation of drama, which is perhaps the most complex of the arts in this particular respect.

4. THE THEORY OF CATHARSIS

The doctrine of *catharsis* goes back to Aristotle and in one form or another has remained influential up to the present day. Aristotle did not develop an explicit theory of the emotional response to art and the doctrine of *catharsis*, which has exerted such a hold on men's imaginations through the centuries, derives from two short and almost casual references. In Book Eight of the *Politics* he appears to say that, either because the conditions of civilized living afford inadequate outlets or for some other reason, men are often in a state of pent-up emotion which can be distressing or even dangerous. Where ordinary life provides no relief, these emotions may be relieved or 'purged' by artistic means. The emotions may be pathological, as in the case of religious 'enthusiasm' which is purged by orgiastic music, or natural as in the case of pity and fear, which are purged by tragedy.[6] It is not certain whether Aristotle intended purification in the medical sense or in a ritualistic sense, as for example a man might be purified from the taint of blood-guilt. The question is not of fundamental importance to the influence of the theory down the ages. What seems clear is that, applied primarily to drama, it erects one possible function of art into a generalization purporting to

define the nature of art and its realization in appreciation. That art can have therapeutic effects and can be used for this purpose there is no reason to deny. Modern psychiatry provides ample evidence of the fact. Moreover there is every reason to suppose that by 'expressing himself' successfully through art the artist may obtain emotional relief, as every expression of emotion affords relief from a good cry to the self-immolation of the martyr. There is evidence, less strong perhaps but nevertheless sufficiently convincing, that men do obtain emotional relief, relaxation of emotional tension, in some cases from the appreciation as well as from the creation of art. But that this is the main function or a defining characteristic of art, or that men habitually indulge in appreciation of the arts in order to obtain relief from emotional stress, is clearly an unwarranted distortion of the facts. There is no reason at all to suppose that you will get nothing out of appreciation until you are afflicted by emotional distress and every reason to believe the contrary. We go to the arts for enrichment not for medication. Each man is, of course, his own judge as to this.

5. REVELATORY EMOTION

Many but not all people experience from time to time states of cosmic awareness during which they seem to themselves to be in apprehension of transcendental truths or in contact with a supersensible reality behind the everyday appearances of things. Schleiermacher, who first made these elusive states philosophically respectable, spoke about intuitions and feelings (*Anschauungen* and *Gefühle*) of the infinite and eternal, of something inexpressible which is, as it were, an overplus in addition to empirical reality. William James concluded: 'It is as if there were in the human consciousness a sense of reality, a feeling of objective presence, a perception of what we may call "something there", more deep and more general than any of the special and particular "senses" by which the current psychology supposes existent realities to be originally revealed.' These states have the sort of noetic quality which belongs to mystical experiences. While they last they seem to be conditions of illumination or revelation, insights into depths of truth unplumbed by the discursive intellect, pregnant with significance and high importance. Their cognitive character is essential to them; they could no more occur without it than an emotion of remorse could exist without an implicit belief that one had done wrong. James has also rightly emphasized

their characteristics of compulsiveness and ineffability. They carry a strong conviction of knowledge and yet that which is known cannot be formulated in discursive language: the manner of knowledge seems to be direct acquaintance rather than knowledge by description, yet the object of knowledge appears rather like a general proposition than a particular perception.

It is well known that numinous, metaphysical or quasi-mystical feelings, in which the subject undergoes a conviction of being intuitively acquainted with a reality beyond appearances, may be induced by a diversity of stimuli. They may accompany absorbed contemplation of natural scenery or they may result from the absorption of certain drugs. That feelings of cosmic illumination or of insight into the essential reality of things have been aroused in the appreciation of some works of art and the existence of such feelings, within the ambit of appreciation, seems to have been the incentive of those philosophers, such as Plotinus, Schopenhauer, and Heidegger, who have put forward a 'revelatory' theory of art. Schopenhauer, for example, declared that 'not merely philosophy but also the fine arts work at bottom towards the solution of the problem of existence'. It is not always clear whether those who have put forward a theory of this sort have intended to claim 'revelatory' character as a criterion and defining characteristic of art or whether they have meant that it is a thing which some but not all kinds of art may do. Painters such as Kandinsky, Malevich, and Mondrian have claimed that their forms of abstract art, through arousal of emotion, afford insight into a supramundane reality beyond the empirical reality of visible things. From an empirical and commonsense point of view it would appear that not all kinds of art evoke 'noetic' feelings or induces revelation. But philosophers have often taken the contrary view, as in the following statement by Schopenhauer: 'Every genuine and successful work of art answers this question [the nature of life and existence] in its own way with perfect correctness.' The answer, of course, is one which is strictly ineffable and cannot be formulated in the discursive language of propositions. 'We are only perfectly satisfied by the impression of a work of art when it leaves something which, with all our thinking about it,' says Schopenhauer, 'we cannot bring down to the distinctness of a conception.'

It is not often clear when philosophers or artists have spoken in this way about art whether they have intended to maintain that art, or some

art, is able to induce in suitable observers noetic emotions akin to certain forms of quasi-mystical experience in which the observer is strongly, though perhaps mistakenly, convinced that he has access to occult truths or whether they have intended to assert that some or all art does indeed communicate recondite knowledge of supersensible being. And from the point of view of practical appreciation at any rate the difference is of no importance.

It has also been asserted that through the experience of great drama one receives an emotion of enlightenment, understanding, or revelation, although no one is able to put into words what the revelation is. There is no reason to doubt that such a response in feeling is a possible and genuine effect of appreciation in some cases of literary and visual art, and similar feelings are almost certainly evoked by music as well. It is not plausible to suppose that such emotion is aroused, or would be appropriate, in all cases of successful appreciation where we judge a work of art to be good. And certainly this cannot be regarded as a comprehensive account of the emotional nature of appreciation.

6. GENERALIZED EMOTION

Another form of emotion-arousal theory holds that in the aesthetic experience emotions aroused are not the ordinary emotions of daily life but 'generalized' emotions experienced in an 'impersonal' attitude of mind. It is not clear in what sense these terms are used or in what sense 'generalized' emotions can be 'impersonally' experienced by those in whom they are said to be evoked. I shall therefore mention three typical statements of this sort and then turn to a discussion of the matter.

The idea that art and literature are concerned with the communication or transmission of generalized emotion rather than with particular emotions of everyday life, was one aspect of the interest taken by neo-Classical theory in the general rather than the particular. For Dr. Johnson, it has been said, 'the thing to be communicated was not emotion in all the flux and flurry of its original presence in the human soul. It is never a stream of consciousness. It is emotion selected and generalized into the simple universals that move all men everywhere. To generalize an emotion was not, as the romantics tended to believe, to evaporate it but rather to make it available.'[7]

Generality and impersonality are also claimed by the very different

theory of 'synaesthesis' which is associated with the name of I. A. Richards. By responding to the particular emotions suggested by a work of art, he says, 'we need not have experienced Beauty, but it is here that our emotion assumes a more general character, and we find that correspondingly our attitude has become impersonal'. He explains this generality and the impersonality of our attitude by postulating the arousal of a balanced set of mutually compatible impulses which are, however, subliminal and not introspectible. 'The various impulses before alluded to have become further systematized and intensified. Not all impulses, as usually excited, are naturally harmonious, for conflict is possible and common. A complete systematization must take the form of such an adjustment as will preserve free play to every impulse, with entire avoidance of frustration. In any equilibrium of this kind, however momentary, we are experiencing beauty.'[8] It has not been possible to render this notion of a balanced system of subliminal impulses at all plausible in relation to the artistic facts or to explain in what sense a set of impulses can be said to have 'free play' when overt activity is denied to all in aesthetic contemplation.

The most complex and the most subtle of the emotional theories of appreciation is the Indian doctrine of *rasa*. According to this doctrine, as it is usually expounded, emotions and emotional situations—'the actual passions in the world'—provide the material of all art. But by the use of imagination the artist represents particular emotions and emotional situations in such a way as to suggest permanent or dispositional modes of emotion.[9] In a successful work of art the particular emotional situations presented are unified by a single emotional mode or group of congruent emotional modes. For example, Bharata said: 'When, in the midst of diversity of psychic states, all transfigured by the imagination, there is one master-passion unifying all of them like a thread, that is to be regarded as the ruling sentiment of a work of art, the rest are but momentary.' The spectator does not respond as he would to the corresponding emotional situation in ordinary life, either by empathic sharing of the depicted emotion, or by recollection of a similar emotion experienced at some time in his personal life, or by normal reactions to the depicted emotions (pity at grief, anger at injustice, etc.).[10] It is sometimes said that the spectator experiences a 'generalized' or 'universalized' emotion. Part of what is meant by this is that the particular emotional situations represented suggest to the spectator permanent or

universal modes of emotion. But even these are not evoked in a simple, straightforward way as if he were put in a joyous mood or a sad mood and that alone. Rather, what is meant seems to be that through the particular emotional situations presented to him he apprehends and at the same time gets the flavour of universal modes of human affective response without actually experiencing them as moods, rather as one may apprehend concrete situations described in words by means of mental imagery. Some of the exponents of *rasa* theory do indeed use language very suggestive of the apprehension of emotional qualities as described in the foregoing section of this chapter.[11]

A vaguely similar view may be intended by Mikel Dufrenne in the passage already quoted (p. 89). He is here saying that the specific emotions experienced in appreciation are cognitive feelings whereby we become aware of emotional characteristics objectively present in the art work: by fear we recognize the 'sentiment' of the horrible, by amusement we recognize the comic, by pity and terror we apprehend the tragic. Both the Indian doctrine and that of Dufrenne were developed primarily from concern with our appreciation of drama; but the Indian doctrine of *rasa* denies the propriety of experiencing the particular emotions by which Dufrenne supposes we apprehend the emotional characteristics objectively presented by the art work.

7. AESTHETIC EMOTION

Some writers have sought the criterion of successful appreciation in the arousal of a specific and unique kind of emotion which they call the 'aesthetic' emotion. In the Introduction to his *Essays* (1790) Archibald Alison defines taste as 'that Faculty of the Human Mind, by which we perceive and enjoy whatever is Beautiful or Sublime in the works of Nature or Art'. He then goes on: 'The perception of these qualities is attended with an Emotion of Pleasure, very distinguishable from every other pleasure of our Nature, and which is accordingly distinguished by the name of the Emotion of Taste.' It is surprising that this anticipation of Clive Bell's 'aesthetic hypothesis' has gone unnoticed. More than two centuries later Clive Bell wrote: 'The starting-point for all systems of aesthetics must be the personal experience of a peculiar' emotion. The objects which provoke this emotion we call works of art. All sensitive people agree that there is a peculiar emotion provoked by works of art. . . . This emotion is called the aesthetic emotion.'

Bell himself was not of an analytical turn of mind and offered us little material for a phenomenology of appreciation. In his early and most influential book *Art* he was content to describe appreciation as a recognizably distinct kind of emotional thrill, experienced only in awareness of the formal properties of works of art, and to leave it at that. (There is a suggestion, not followed up, that in some cases we may perceive intellectually the rightness of forms without experiencing their emotional significance, and that the aesthetic emotion may be caused by our perception of the rightness and necessity of the forms.) In the later book *Enjoying Pictures* he attempts, though not entirely successfully, a closer analysis of appreciation. He distinguishes the aesthetic thrill or transportation from the more enduring aesthetic mood. He is prepared to admit that the happiness which is characteristic of the aesthetic mood is to some degree sustained and augmented by adventitious pleasures arising from professional education, connoisseurship and general culture, the pleasures of memory, correlation, comparison, and recognition, constatations whether historical, literary, or technical, the discovery of affiliations and postulation of comparisons and connections. He will not admit an increment of pleasure from the narrative or anecdotal features of pictorial art. But he grants that the pleasure of the aesthetic mood is in part due to the power of 'all good artists to present statements of a startling economy which, nevertheless, are recognized at once as adequate and convincing equivalents for a jungle of details'. Yet all these subsidiary pleasures are possible only to 'a mind already rendered susceptible and receptive'. This state of receptivity is induced by the 'aesthetic thrill' and that is a shock which only formal beauty can cause. 'All of which may be summed up thus: only works of art possessing some modicum of pure aesthetic significance—pure beauty of form and colour—are capable of provoking the aesthetic thrill; only that thrill can induce the perfectly receptive state of mind; and only in that state of mind is one capable of enjoying all that a work of art can give.'

Bell identifies his 'aesthetic thrill' with that *shock* which many critics before and after him have noticed to be characteristic of appreciative contact with great works of art. It seems to be a feature most noticeable in the appreciation of visual art—perhaps because the element of time is here less prominent, since a shock prolonging itself through the experiencing of a symphony would be something of a contradiction in

terms. But it is disconcerting to find that other writers who speak of this characteristic aesthetic shock do not necessarily attribute it to the formal properties which Bell regarded as all-important. Callistratus seems to refer to something of the sort when he says: 'We stood gaping and struck speechless at the sight [of a bronze statue] when we saw the bronze leaving its proper province and accomplishing the works of nature. For though bronze, it blushed; and though hard by nature, it melted into softness yielding to the artist's skill; and though devoid of living sensation, it created the impression that sensation dwelt within it. . . .' More closely still, John Brown wrote in *Horae Subsecivae*: 'You get from this work that strange and delightful shock which asserts at once his genius and power. You are not *struck*, but you get a shock of surprise, of awe, and of pleasure, which no man who once gets ever mistakes for anything else.' It would be rash to deny that this was a description of the 'aesthetic thrill', if indeed the aesthetic thrill is a fact of experience. Yet this was written about Delaroche's painting of Napoleon at Fontainebleau before his abdication, and few now would contend that this was a work of genius.

Bell's theory has come in for much criticism and many people have denied that there is an 'aesthetic' emotion, unique and *sui generis*, such as he describes. Others have found that the contemplation of a splendid work of art arouses an emotion of calm serenity akin to ecstasy. I believe that this matter has been most convincingly dealt with in Indian aesthetics and the reader is referred to the exposition on pp. 204 ff.

8. THE ONLOOKER THEORY

In order to understand emotion arousal in the appreciation of art we must, I think, distinguish more carefully than has usually been done between the various aspects of the art work in their bearing upon the emotional condition of the observer. In experience, of course, the emotions of appreciation are not divided up into categories and sections and components. But for the purposes of reflective understanding it is necessary to draw distinctions which are not immediately experienced in the act of appreciation. I shall deal first with emotional response to the representational content of art and I shall concentrate (as has usually been done) on drama because here the phenomena to be considered are more pronounced and more in evidence than elsewhere.

But what is said has relevance for fiction in general, including the fictive depictions of painting and sculpture.

I want to suggest that the most fruitful analogy for understanding the attitude demanded by fiction in general, including the stage-fiction of drama, is that of the *onlooker* in life. In this I follow an unusually perceptive article by D. W. Harding, in which he describes the mental state of the onlooker as follows:

> Part of everyone's time is spent in looking on at events not primarily in order to understand them (though that may come in) and not in preparation for doing something about them, but in a non-participant relation which yet includes an active evaluative attitude. We can say two things of the onlooker: first that he attends, whether his attention amounts to a passing glance or fascinated absorption; and second that he evaluates, whether his attitude is one of faint liking or disliking, hardly above indifference, or whether it is strong, perhaps intensely emotional and perhaps differentiated into pity, horror, contempt, respect, amusement, or any other of the shades and kinds of evaluation, most of them unlabelled even in our richly differentiated language.[12]

There are two elements in the emotional behaviour of the onlooker, both of which are basic also to our attitudes to fictional and dramatic situations whether in works of art or in amusement literature. The one is empathic or sympathetic 'identification' with the emotions of the person observed or the emotions inherent in the situations presented. When I see another person engulfed in an agony of despair, whether he be an acquaintance in real life or a character in a drama, I to some extent enter into his feelings of hopelessness, despondency, and grief without experiencing these feelings fully in myself. In a way difficult to specify I 'understand' his feelings differently and in a more intimate way than by having a bare intellectual knowledge *that* he has such feelings. One could draw a partial analogy between such sympathetic 'entering into' another man's emotions and having visual or kinaesthetic mental images. It is the basis of sympathetic understanding among men. Such empathic identification with presented emotions is natural and spontaneous with children absorbed in a fairy story. It is a necessary foundation for the emotional reactions of persons who go to the cinema for a 'good cry' and who use the theatre and novel fiction for purposes of wish-fulfilment or escapism. It is present to some degree in all aesthetic commerce with fictional situations presented in works of art.

People who lack the powers of sympathetic imagination necessary to achieve some degree of empathic identification with presented emotional situations are not capable for the appreciation of dramatic or fictional art, if any art at all.

To the extent to which identification is achieved the presented emotions are treated *as if* they were real and there is at any rate nothing which would conflict with illusion. It is otherwise with the responsive or, as Professor Harding calls them, the 'evaluative' emotions. These are, of course, in principle the emotions which we should experience as an onlooker in real life—pity for suffering and grief, indignation at injustice, joy at deserved good fortune, and so on. But from the fact that we do *not* undergo complete illusion, remaining always marginally and peripherally aware that the people and situations presented are fictional, certain consequences flow which are essential to the complete experience. Firstly, we are never in doubt that our position of onlookers can be maintained. However harrowing or alluring may be the presented situations, normal impulses to intervene are inhibited from the start and we do not have to fight against them. As the child listening to a fairy story puts himself into the 'story-situation', so the audience at a drama is bound to the conventions of audience-behaviour. Since, therefore, the feeling-tone of emotions is often allayed by appropriate action, this inhibition of activity has a tendency to maintain feeling-tone at an unusually high level of intensity. (In this connection it is interesting that private manifestations of emotion—weeping, clenching the fists, etc.— are conventionally less strictly inhibited than overt behaviour.) Secondly, although this is not continuously to the forefront of our minds, we are none the less aware that giving reign to our responsive emotions will not be attended by real-life consequences—pity for the distressed will not lead either to our putting our hands in our pockets to relieve his distress or to any feeling of shamefastness that we have not done so. For this reason, I believe, the restraints which we ordinarily quite unconsciously impose upon our sympathetic emotional responses to the predicaments of others are weakened or removed in fictional situations. Thirdly, by a convention which we all unquestioningly accept, in fiction and drama we tolerate a more intimate revelation of other people's emotions than we would accept in life unless it were in situations of close friendship where intervention would be inevitable since failure to act in such situations would itself be a form of action. Where the display

of a person's passions, anxieties, hopes, and despairs would cause acute discomfort in reality, we accept it with equanimity on the stage or between the covers of a book.

In these respects the situation of the audience or fiction-reader differs from that of the onlooker in life. But the responsive emotions that he feels, perhaps at a different level of intensity, are the same as those he would feel in life. He responds as his character and past experience would dictate. But when the drama or the fiction is a work of art the 'evaluative' responses—using the term in the wide sense of Professor Harding—are not free. On the contrary, they are rigidly controlled by the art work and this, precisely, is the point of difference between literary or dramatic art and amusement literature. It is the very essence of literary and dramatic art that by subtleties of suggestion, implication, irony, sarcasm, and a host of known devices the evaluative responses of the observer are directed and controlled. And it is the criterion of a competent observer that he has the sensibility and the skill for the time being to put into abeyance his own natural evaluative responses and accept those inherent in the art work. In this way a person enjoying aesthetically a piece of dramatic or fictional art can savour evaluative emotional attitudes other than those which are natural to him in ordinary life, putting himself for the time being under the direction of the art work. A piece of fiction or a drama which presents emotional situations but does not offer such guidance and control of evaluative responses is not a work of art. But as the observer accepts this control, the evaluative responses are not, or are not necessarily, experienced in vital fullness (as when we weep at the cinema) but are savoured and tasted and contemplated. We experience them as it were in imagination, enjoying their full flavour, in a way analogous to that in which we enter empathically in to the grief of another without experiencing that grief in vital fullness in ourselves.

In the art of painting the situation is basically similar as regards appreciation of narrative or anecdotal content. The beholder is in the position of an onlooker in real life but with the knowledge that the scene before him is not a reality of life but a representation or counterfeit. There are nevertheless some important differences between the attitude of appreciation towards narrative scenes depicted in painting and appreciation of literature and drama. They arise primarily from the fact that a painter is restricted to displaying a single and static scene

from a complete story. He can, indeed, display the external signs of emotion more vividly than the literary artist, who can only describe them in words, though the latter can describe many vicissitudes of emotion and feeling which are not manifested by external signs. He can depict emotion with less vividness than the dramatist since movement is denied him. But the fundamental difference lies in the fact that the story itself, of which the depicted scene is but an incident, can be no more than suggested by the painting and must be supplied by the beholder. This enormously weakens the painter's powers to guide and control the evaluative emotional reactions of the beholder to a series of emotional situations connected in a narrative. For this reason very largely it has been a common practice for artists to select well-known narratives—historical, mythological, religious—as the framework which gives anecdotal context to the situations which they depict. Apart from this, if the story has to be built up by the beholder with no other clues than the situation depicted in the painting, it has usually been found necessary to keep to fairly simple and sentimental emotional predicaments.

Where an artist has relied on the framework of a known story, this outside knowledge is important for full appreciation. The scene depicted is not just the situation as it appears on the face of it but is the situation in the context of the complete story. Even so, the artist's availabilities for guiding the emotional responses of observers are far less subtle than those of the literary artist. It is for this reason that emphasis in appreciation is far more strongly on formal properties in painting than in literary art. And this is the chief justification if not the chief cause for the dislike and suspicion with which 'literary content' is nowadays regarded in painting.

To summarize. As regards the representational aspects of art, emotional response is analogous to that of an interested but non-participating onlooker in real life, subject, however, to certain modifications arising from the fictive character of artistic depictions.

With regard to the formal and non-representational aspects, configurations of shapes and colours, patterns of musical sound, there is no reason to doubt the common opinion of both artists and connoisseurs that these not only have emotional expressive characteristics but do stimulate emotions in many people. There is evidence from experimental psychology to the same effect. The affective states aroused are not

true emotions in that they do not carry with them discernible impulses to action, but in this respect are more like the 'objectless' moods of gaiety, sadness, elation, depression, etc. Nevertheless they are linked very closely to the aesthetic object by which they are aroused and they appear to be not less but possibly more specific and determinate than the majority of emotional states experienced in ordinary life. Yet though specific, they cannot be described in generalizing language. People of different temperament and experience appear to differ considerably in the extent to which the emotional qualities of abstract configurations are experienced as feeling or emotion aroused in the observer and the extent to which they are apprehended and savoured as qualities in the object. There is a good deal of evidence that in unpractised and unsophisticated appreciation they are experienced as emotions aroused, whereas with greater sophistication and experience they tend to be apprehended objectively as qualities of the aesthetic object. When they are so apprehended there appears still to be considerable difference in the extent to which they are apprehended through or by means of cognitive feeling. This is a difficult matter on which to speak with assurance because introspective evidence (and there can be no other) is obscured by the fact that successful aesthetic contemplation requires an outward-turning attitude of mind, with attention focused outwards upon the aesthetic object, and it is distorted or broken when attention is turned inwards upon the emotions or feelings of the percipient.

For a Note on Music, see Appendix V.

Subject and representation

I. THE IMPORTANCE OF THEORY

Anyone interested in appreciation is inclined to be impatient of theory. And the impatience is justified. For it is the aesthetician's and the theorist's job to understand the operation of appreciation in the context of a general philosophy of mind, not to give directions on how it should be done. Appreciation and its modes are data for the theorist. Nevertheless theories about the nature and function of art do have relevance for the cultivation of a skill to appreciate. They are relevant because what we believe about this has a very potent influence in conditioning our awareness, predisposing us to certain attitudes of attention and percipience rather than others when we make contact with any work of art. Everyone who approaches a work of art with serious intent necessarily does so with the some sort of tacit beliefs about it and some sort of tacit expectations about what he may find in it, what he may get from it. These unconscious expectations and beliefs regulate the kind of features which we are sensitized to notice and attend to, whereas what we have no interest to look for is more than likely to pass us by. The kind of conditioning wrought in us by unconscious beliefs and assumptions, latent expectations and unexamined interests, comes to all of us from the social environment, from education and from upbringing. Nobody can approach a work of art quite neutrally; some mental 'set' is inevitable. Therefore either we must be content to remain the passive creatures of our social conditioning for better or for worse, or we must bring to the light the tacit beliefs we have inherited as a first step towards actively moulding our attitudes and interests. It is from this

point of view that prevalent theories, past and present, have practical importance for cultivating a skill to appreciate. The sort of theory which is important in this context is the undigested tangle of belief and assumption which is imbibed from critical writing and popular art literature rather than the considered analyses of philosophers.

(1) The Theory of Naturalism

From the time of the ancient Greeks the most widespread assumption among unsophisticated consumers of visual art in the Western tradition has been the tacit belief that it is the function of the artist to provide an accurate and convincing copy of something in the world we see and that to the degree in which his copy is a veridical simulacrum of its original he is to be praised for his skill as we praise a conjurer for some feat of legerdemain. In the medieval phrase, art is *simia naturae*—the ape of nature. This belief has lost something of the grip it used to have, but it is still implicit with all those who exclaim at the faithful reproduction of the lively glance, the recognizable scene, the soft sheen of silk or satin, and who praise a portrait with the words 'How like!' and a novel because the background detail is true to fact, based on experience. It is implicit in the outlook of all these who are still worried by what used to be called 'distortion', who think to display their acuity by pointing out that a figure has more or less than the orthodox number of limbs or fingers or toes (the artist can't count!) or who are puzzled by an abstract and ask to be told what it 'means'. Though it is still far from uncommon, this attitude may now safely be taken as the mark of the crass insensibility which attends absence of a power to see. This book and the series to which it belongs are not written for the blind but for those who have capacities of vision which can be developed. Equally it is unlikely that persons who lack powers of vision will read the book or willingly expose themselves to visual art unless it were for the purpose of derision.

The 'imitation' theory never took root in China, where a concern for photographic realism and superficial verisimilitude were considered to be an error of the vulgar. The ideal of the Chinese artist was to reproduce nature by working as nature works, making himself a channel through which the cosmic Tao flows and is made manifest. 'The Chinese were concerned with what are now called the "physiognomic properties" of things or rather with the class of physiognomic properties which are most indicative of the individual and the type—the featheri-

ness of trees, the spikiness of reeds, the characteristic placing and pos-
ture of vegetation in a landscape, the textures and conformation of rock
formations, the hairiness of animals, the lightness of birds and butter-
flies; with expressive poise or gesture, the attitude of deprecation, the
dignity of an eagle or an emperor—all those qualities of things for
which no exact words exist and which are for that reason sometimes
loosely said to express the "spirit" or "essence" of the thing.' (As
I said in my book *Aesthetics and Art Theory*, 1968.) The Chinese painter
absorbed himself in the subject of his painting, seeking to identify him-
self with the spirit of Tao that was in it and to allow that spirit to
reproduce itself in his work. Thus an ink painting of a bunch of bamboos
did not aspire to be a photographic simulacrum of bamboos but to reveal
in its brush-strokes the characteristic growth pattern of the bamboo. It
is from this point of view that much Chinese art is to be enjoyed.[1]

In its Western form the 'imitation' theory trivializes art by denying
the artist any convincing purpose and reducing his activities to the
minor and extra-aesthetic functions of documentation and reportage—
fields in which his usefulness has now been taken over by the camera.
It condemns him to counterfeiting the appearances and externality of
things, necessarily a self-defeating aim because no pictorial counterfeit
can reproduce the life values of its original. The tenacity with which
this theory has survived refutation and criticism has been due not to any
inherent plausibility but rather to the fact that with all those people who
have taken the matter seriously it has been modified by other, incom-
patible theories. Greek art of the classical period was idealizing as well
as naturalistic, and from that time until the neo-Classical revival in the
eighteenth century it never ceased to be regarded as part of the artist's
function to idealize nature by disregarding the accidental and transient
aspects of things, correcting the variations and imperfections of the
individual, while giving body and substance to an invisible norm. It was
believed that nature is never fully revealed in the individual things of
the actual world, which are all subject to imperfections and 'deformities'.
Only the generic types are truly natural and truly beautiful. By studying
the principles of nature inherent in the imperfect world of actuality,
great artists can—so the theory goes—'correct Nature by herself' and
create in their works an ideal beauty to which nature points the way
but which it never achieves. 'By nature,' wrote Fuseli, 'I understand the
general and permanent principles of visible objects, not disfigured by

accident, or distempered by disease, not modified by fashion or local habits.' 'By the ideal,' said the painter Mengs, 'I mean that which one sees only with the imagination, and not with the eyes; thus an ideal in painting depends upon selection of the most beautiful things in nature purified of every imperfection.'[2] According to one theory ideal beauty could be achieved by means of mathematical principles of proportion, which might enable the artist to reconstitute in his art work the invisible and intelligible reality which lies behind the objects of sense perception, in medieval language the 'nature of Deity'. This theory had its origins with the Pythagoreans and Plato, enjoyed a prolonged hey-day at the Renaissance, and is still influential both in contemporary attempts to find a mathematical basis for good design and in comparisons between artistic form and the forms of organic and inorganic matter.[3]

When you assume that the object of painting is to provide a replica of the visible world—whether the actual world of appearances or the ideal world of types—it follows as a natural corollary that, once mechanical skill and craftsmanship are taken for granted, the value put upon any picture will depend upon the importance you ascribe to its subject-matter. This idea can be found adumbrated as early as the conversations of Socrates reported in the *Memorabilia* of Xenophon. It was the germ from which developed the theory of pictorial genres, with historical painting at the summit and still life at the bottom, which dominated academic teaching in Europe and—together with the concept of the ideal—formed the core of the doctrine of the Grand Manner as it was advocated by Sir Joshua Reynolds in his *Discourses on Art*. Reynolds disliked Dutch and Flemish realism both because in its close attention to detail it stood in opposition to his doctrine of the ideal norm and perhaps even more because the undoubted skill of these artists was devoted to subjects which were in his eyes vulgar and trivial. While he could not but admit their skill in reproducing natural appearances, he regarded this as no more than a mechanical and the least important part of the painter's trade and he condemned them both for misusing their skill on unworthy subject-matter and for their concentration on individual detail instead of the 'ideal'. He also condemned the Venetian school for cultivating 'all those parts of the Art that gave pleasure to the eye or sense' without using them in the service of lofty and 'intellectual' themes. 'The powers exerted in the mechanical part of the Art', he says, 'have been called the *language of Painters*; but we may

say that it is but a poor eloquence which only shows that the orator can talk. Words should be employed as the means, not the end: language is the instrument, conviction is the work.' (*Discourse Four*)

The appraisal of subject-matter lies outside what we should now call the aesthetics of art. It has a lot to do with the class of patron for whom the artist hopes to cater. Reynolds, of course, had in view a cultured aristocracy who took pride in their knowledge of classical mythology and European history, whereas the Dutch and Flemish realists painted for a self-satisfied bourgeoisie who really did prefer to decorate their houses with lifelike paintings of loaded breakfast tables or trophies of the hunt. In our own day the tendency to repudiate the importance of subject-matter, reducing even the representation of the human figure to the status of still life, is in almost complete contradiction to Reynolds's assessment of the Venetians. To most critics of the past this would seem like excessive attention to the 'language' of painting with disregard for any purpose to which linguistic skill could be put. Yet the problem of the importance of subject-matter has not disappeared in our time. It is not difficult to feel superiority over those artistically uneducated persons who, lacking the gift of natural taste, take pleasure in flower pieces because flowers are 'pretty' and delight in conventional representations of conventional beauty spots. But the aggressive defiance with which Pop Art repudiated all that Reynolds meant by the 'language' of painting and the provocativeness with which it presented commonplace subject-matter entirely without 'eloquence' brought the problem of subject-matter again to the fore. Yet in such earlier modern movements as Surrealism, Futurism, Expressionism, and even more obviously in sociological art such as Mexican mural painting, the relevance of subject and the way in which subject is treated is patent. Even such movements as Cubism, which deliberately subordinated the importance of subject in relation to pictorial and technical aims, and Abstract Expressionism, which abolished it, raise prominently the question of the status and function of subject-matter in those styles of art which do represent visible nature. Our attitude to the question is likely to be much more sophisticated than was that of Reynolds and the advocates of the Grand Manner. But the question remains and has relevance for our attitudes in appreciation.

The valuation of subject-matter as such is not nowadays regarded so much as an aesthetic concern, but rather as a matter of individual

preference. Such preferences do in fact occur—one man likes landscape, another still life, another paintings which illustrate and comment on the social scene—and they do have a bearing on appreciation. Yet the importance they assume is apt to diminish as connoisseurship and the skill to appreciate are perfected and no rules can be laid down for such preferences. Something can indeed be said about the part played by representation and its implications for appreciation and this will follow. First I shall discuss the theory that art, considered as a visual language, should have what Reynolds called *intellectual* content and that it should communicate a message or a moral.

(2) *The Theory of Moralism*

Concurrently with and hardly less pervasive than the mimetic theory, the conviction that painting, like poetry, is justified by its didactic role also goes back to classical antiquity. The catchword *ut pictura poesis* (poetry resembles painting) came from Horace,[4] but the comparison itself went back to the lyric poet Simonides of Ceos, who is quoted as saying: 'Poetry is speaking painting and painting is silent poetry.' With the onset of the Renaissance the analogy between the two arts became a favourite topic of discussion and was developed primarily in the context of the doctrine that it is the function and the excellence of both to render sound philosophy pleasing and painlessly to inculcate good moral principles. Horace had taken from the Hellenistic critic Neoptolemus (3rd century BC) the lesson that the best poetry must both please and instruct: 'That poet has everything who mixes the profitable with the pleasant, delighting the reader while instructing him at the same time.' Wisdom (*sapere*) is the source and inspiration (*principium et fons*) of good writing. Popular manuals of philosophy will provide the poet with his subject-matter; the words will readily follow. The sort of 'philosophy' Horace had in mind is shown by his examples: 'What a man owes to his country and what to his friends, the love one should have for a parent, a brother or a guest, the duties of a senator and those of a judge. . . .' This view continued to be propounded by argument and aphorism wherever the influence of the classics survived. Poetry is useful, said Boccaccio, because 'it lures away noble souls from those foundering under moral disease'. And Vasari puts in the mouth of the painter Buffamalco the words: 'We think of nothing but painting saints, both men and women, on walls and pictures . . . we thereby render men

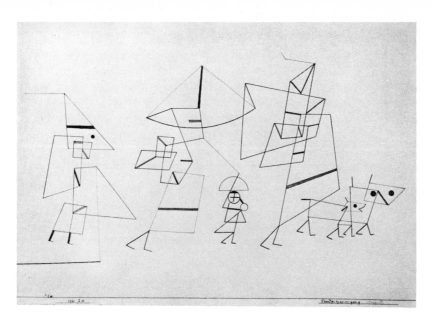

Paul Klee: FAMILY PROMENADE. *Kunstmuseum Bern; Paul Klee-Stiftung.* © SPADEM

better and more devout to the great despite of the demons.' Moliére believed that: 'Le devoir de la comédie est de corriger les hommes en les divertissant.' Le Bossu described the function of epic 'pour former les moeurs par des instructions déguisés sous les allégories'. Leonardo in his *Paragone* draws out the comparison: 'Painting is mute poetry and poetry is blind painting. Both aim at imitating nature as closely as lies in their power, and both can be used for expounding divers customs and morals, as Apelles did in his *Calumny*.' For the age of the Enlightenment the matter was summed up by Diderot: 'To make virtue attractive, vice odious, ridicule forceful: that is the aim of every honest man who takes up the pen, the brush or the chisel.'

Such was the theory which tended to supply canons and justification for the subject-matter rather than the visual qualities of pictorial art. It explains the prominence which used to be given to theme both in the criticism of art and in the training of artists and provided a theoretical ground for the high estimation accorded to historical, mythological, and religious art. As an example of the sort of paintings which seem now to

fit most admirably into the framework of this conception we may instance David's *The Oath of the Horatii*, an historical painting in which the artist also endeavoured to inspire his contemporaries with enthusiasm for an idealization of the civic virtues of the ancient Romans. By the nineteenth century, however, the 'thought' or 'intellect' which Reynolds required great painting to embody had degenerated to the level of the elementary moral or cautionary tale, the depiction of anecdotal situations which gave vent for the more superficial social and sentimental emotions. Even the Old Masters were subjected to interpretation in terms of story-telling and the interpretations were popularized by sentimental engravings which managed by trivializing subject and theme to debase a Raphael or a Turner to the level of mid-Victorian or Edwardian popular taste. Painting, responding to the theory, 'created a drawing-room dream-world of anecdote and cautionary tale, of coy passion and tepid tragedy, a hypocritical morality that allowed pornography to masquerade as the antique and encouraged a sugared genre of happy-family poverty for the assurance of the cosy conscience'. The titles themselves make a fascinating study for social historian and psychiatrist alike: *A Roman Orgy, Tickled with a Straw, On the Brink, Too Late, A New Light in the Harem, No Walk Today, Jealousy and Flirtation, The Light of the World, Bubbles*, etc. Many of these paintings were well planned, usually to mock-Renaissance canons of composition, were technically proficient, and made pleasantly decorative patterns. To the modern eye they lack most of what is necessary to satisfy appreciation. It was unfortunate that this debasing of pictorial 'content' occurred at a time when public museums and galleries were beginning to make the fine arts available to a wider public. This may have been a contributory cause for the prejudice against 'literary' and anecdotal subject-matter as such which has influenced appreciation and criticism in the twentieth century.

The assumptions in art theory which made possible a vogue for the sort of painting which had popularity in the nineteenth century were most clearly voiced by Ruskin at the beginning of *Modern Painters*. It will be of interest to summarize them in order to see the contrast with the assumptions and attitudes which have gradually come to dominate appreciation in the first half of the present century.[5]

Ruskin here reproduced Reynold's doctrine that the painter's craftsmanship and his skill to represent natural appearances are no more than

a 'language' for the conveyance of 'thought' and he believed that the excellence of any painting depended on the quality of the 'thought', given adequate technical ability to communicate it.

Painting, or art generally, as such, with all its technicalities, difficulties, and particular ends, is nothing but a noble and expressive language, invaluable as the vehicle of thought, but by itself nothing. He who has learned what is commonly considered the whole art of painting, that is, the art of representing any natural object faithfully, has as yet only learned the language by which his thoughts are to be expressed. . . . It is not by the mode of representing and saying, but by what is represented and said, that the respective greatness either of the painter or the writer is to be finally determined.

He concedes that it is not always easy to determine where the influence of 'language' stops and where that of 'thought' begins, and he admits that many thoughts are so dependent on the language in which they are clothed that they would lose half their beauty if they were otherwise expressed. But he claims that the greatest and loftiest thought is the most independent of 'language', so that in its case the painter's skills and techniques can do no more than bring adornment to that which needs no adorning.

But the highest thoughts are those which are least dependent on language, and the dignity of any composition and praise to which it is entitled, are in exact proportion to its independency of language or expression. A composition is indeed usually most perfect, when to such intrinsic dignity is added all that expression can do to attract and adorn; but in every case of supreme excellence this all becomes as nothing.

In the last resort 'thought' and 'ideas' outweigh pictorial eloquence —that is, the manner of expression—and must sway the verdict of the critic.

It must be the part of the judicious critic carefully to distinguish what is language, and what is thought, and to rank and praise pictures chiefly for the latter, considering the former as a totally inferior excellence, and one which cannot be compared with or weighed against thought in any way, or in any degree whatsoever. The picture which has the nobler and more numerous ideas, however awkwardly expressed, is a greater and a better picture than that which has the less noble and less numerous ideas, however beautifully expressed.

Ruskin accepts that art has the subsidiary aims to give pleasure, to

teach, to imitate or to create. But he will not allow them importance as contributing to the greatness of any art work in comparison with the 'thought'. He concludes:

> But I say that the art is the greatest which conveys to the mind of the spectator, by any means whatsoever, the greatest number of the greatest ideas; and I call an idea great in proportion as it is received by a higher faculty of the mind, and as it more fully occupies, and in occupying exercises and exalts, the faculty by which it is received.

> If this, then, be the definition of great art, that of a great artist naturally follows. He is the greatest artist who has embodied, in the sum of his works, the greatest number of the greatest ideas.

Although Ruskin comes forward in *Modern Painters* as the champion of Turner at a time when the latter was generally misunderstood, his own appreciations were conformable to his theoretical outlook and the taste of the time. He commends Landseer's *Old Shepherd's Chief-mourner* as one of the most perfect pictures of its generation on account of its 'thought'! (See Appendix III.) He condemns the Dutch school (excepting only Rubens, Vandyck, and Rembrandt) for their 'ostentatious exhibitions of the artist's power of speech, the clear and vigorous elocution of useless and senseless words'. And he calls the early works of Cimabue and Giotto 'the burning messages of prophecy, delivered by the stammering lips of infants'. Further than this from the spirit of present-day appreciation it would be difficult to go.

One could pretty well encapsulate what is most distinctive of the twentieth-century aesthetic revolution in a set of propositions which would be almost in direct opposition to Ruskin. How any work of art is to be appreciated and assessed, it would now be agreed, has more to do with the way in which its subject or theme is presented than with what is presented. As a corollary of this it would, nowadays, generally be taken as a matter of course that no subject or situation or theme can of itself guarantee the aesthetic quality of a work of art by reason of any such qualities as nobility or grandeur ascribable to it independently of the work in which it is presented. As has been proved again and again, the most sublime themes can become the subject-matter of trivial and mediocre works of art. Conversely no subject or theme, however trivial or unattractive it may be, is precluded from becoming the topic of an aesthetically admirable work of art. Whereas the naturalistic conception of art, which was dominant in the West from classical antiquity onwards

is bound up closely with a habit of mind which regards the work of art as 'transparent', as if it were a window *through* which attention is focused on a segment of reality—actual, idealized or fictional—which is faithfully reflected in the art work, the modern outlook encourages the opposite tendency to engage attention on the art work as a thing existing and to be experienced in its own right. In line with this attitude it might be accepted today that the thought is what redounds to the greatness of a work of art, but it would be necessary to insist that the 'thought' which makes for greatness is thought within the medium of the work and not thought which can be conceptualized and verbalized. The 'thought' of a great painting is not something which could by any possibility be expressed in words any more than the 'thought' of music can be put into words. Both are inseparable from the medium in which they are embodied.

At the root of this aesthetic revolution, which has wrought so profound a change in our habits of appreciation, we may find the repudiation of the importance once attached to subject-matter. This took place in two logically distinct phases, which it will be useful to trace briefly.

The first phase may be seen in a reversal of the attitude to realism, which expressed itself by a new interest in the individual and actual at the expense of the ideal norm and a consequent repudiation of the established hierarchy of subject-matter which formed the basis of the Grand Manner advocated by Reynolds. By and large the classical tradition regarded the actual world which enters awareness through the senses as an imperfect manifestation of another, ideal world behind it; medieval thought looked on the world of the senses as a symbol of divine reality, apprehensible by reason. It was with Flemish art that reality was first transposed from a transcendental world of abstract ideas and ideals to the substantial actuality of the senses, and it was only as this reversal of interest came to be accepted and appreciated that the modern attitude was born, in art as in science. With it went a new regard for the particularity of the individual, dominant in Flemish realism and most marked in the work of the Portuguese artist Nuno Gonçalvès. A contemporary critic and historian, René Huyghe, has written as follows about this change of outlook:

Actually, the conception of reality as the totality of material things perceived by the senses has been current for only a relatively short time and over a relatively restricted area of the planet: for approximately five centuries, and

only in Europe. The arts of other civilizations have treated concrete reality as mere appearance, often no better than a mirage—sometimes even as vanity, illusion (Maya). What was called reality was not, as in modern Europe, the substantial sensory aspect of things, but on the contrary, what lies beyond matter, what matter covers and conceals. ... Only one school of painting surrendered exclusively and totally to reality in all its concreteness and substantiality—Northern painting. ... The moment Van Eyck appears and Flemish art emerges, there springs full blown a masterly definition of the world as substantial, as made up of materials. It is represented in terms of sensory perception, by appeal to visual sensations and evocations of textures. It is as though we were watching some landscape lying stony and lifeless coming suddenly to life. A great draught of fresh air blows through European art. ... Such terms as 'texture', 'brilliance', 'transparency', and 'dullness' at last take on meaning. The geometry of the universal gives way to an infinite particularity. Form was made matter![6]

Another French critic, Eugène Fromentin, has written with perceptive insight about the realistic artists as follows:

Just as there are in the most practical lives motives and influences that ennoble the behaviour, so in this art, held to be so positive, among these painters, held for the most part to be mere copiers of detail, we feel a loftiness and a goodness of heart, an affection for the true, a love for the real, that give their works a value the things do not seem to possess.[7]

I am not now at all concerned with the correctness of these interpretations and appraisals. The fact that they could be made at all is evidence of the complete reversal of outlook which has taken place since Reynolds and one which Ruskin, for all his attachment to 'nature', did not share or understand. One of the most significant symptoms of the change has been the rise in estimation of still life—and above all the fact that the human figure has come to be treated within the ambit of still life. For the concept of still life does not admit of anecdote, nor does it present the ideal of a type; at its most successful it imparts a sense of the material *presence* of an individual thing. The object is taken out of its everyday context for contemplation, its practical values, whether trivial or important, cease to have relevance, and we see it anew as a particular existent with the fresh eyes of revelation. It is this revelation of the individual which we value in the painting.[8]

A second phase in the aesthetic revolution of today stems from the 'new realism' of the Impressionists. The Impressionists were in revolt

not only against anecdotal painting but against the conception of the planned composition as such. They were provocatively indifferent to the 'dignity' of subject-matter and imagined the painter as a disinterested spectator of the casual scene, which his eye recorded with no more preference or selectivity than a camera. In one Impressionist trend outline was sacrificed to the changing patterns of colour and light, while interest in things and objects disappeared as the painter sought only to record his own optical impressions. 'For the Impressionist,' writes Maurice Grosser, 'the world he paints is the world of the eye's sensations. A painter in the classical tradition, on the other hand, considers the primary reality to be the object's solid form, which intercepts the light and casts a shadow.'[9] 'Peindre d'après nature', Cézanne is quoted by Fernand Léger as saying, 'n'est pour un impressioniste peindre l'objet, mais réaliser des sensations.' And Léger himself writes: 'Une pomme verte sur un tapis rouge n'est plus pour les impressionistes le rapport de deux objets, mais le rapport de deux tons, un vert et un rouge.'[10]

In this second phase we may already see the theoretical justification for abstract and non-figurative art, one of the most striking developments of the present century. For when you take away interest in the particularity of the individual object and discount all associated human values, you are left with only the abstract patterns and relations of shapes and colours which all visual objects have in common. As interest in the visual sensation supersedes interest in the material object, representation is deprived of its function and the world of perception has no priority, for art, over free patterning with the abstract elements of shape and colour. Moreover a strong stimulus in the direction of abstraction was given by another and perhaps the most profound of the convictions which have lent its special character to the aesthetic outlook of the twentieth century, namely the conviction that the essential function of the artist, without which he does not merit the name of artist, is not to imitate or to teach or even to please, but to *create*.

(3) *The Theory of Creativity*

Creativity is not a new concept of this century. It prevailed during the Renaissance. In a treatise entitled *De Perfecta Poesi*, written about 1623, the Polish poet and theorist Kazimierz Maciej Sarbiewski expressed the idea that poetry belongs to the sphere of creativity: the poet invents

(*confingit*) and acts in a god-like manner (*instar Dei*) in that he creates from what is new (*de novo creat*). Leonardo compared the inventive faculty of the artist with the creative power of God: 'that divine power which lies in the knowledge of the painter transforms the mind of the painter into the likeness of the divine mind, for with a free hand he can produce different beings, animals, plants, fruits, landscapes, open fields, abysses, terrifying and fearful places'. At this time, however, 'creativity' still meant only the faculty of 'invention'—setting a positive value upon fiction—or the ability to transform the actual into the ideal. It was during the Romantic era, when it came to be associated with the notions of originality, genius and uniqueness, that the creative imagination of the artist came to be understood in a new sense. It involves repudiation of representation as an end in itself and it involves much more than fiction. The concept is ubiquitous in contemporary literature of the arts.[11] According to modern ideas first, foremost and necessarily the painting sets up a new and independent reality alongside and in substitution for the reality of the external world of perception, a reality designed specifically for the exercise and satisfaction of aesthetic percipience and appreciation. 'In the case of painting,' says Gilson, 'art is not nature seen through a temperament; rather, it is the ability to create a new being that nobody would ever see, either in nature or otherwise, unless the art of the painter caused it to exist.'[12] The implications of this will be worked out in later chapters.

The conception of a work of art as a new creation to be judged in and for itself reduces the difference which has existed between representational and abstract art in appreciation. In our commerce with abstract art the whole of our attention is focused upon the visual presentation which is there before us: there is nothing else to occupy or divert attention. We see what is, as it is. But when art is representational always, to some extent, we see *through* the work of art to the reality other than itself which it represents and always some fraction of our attention is deflected from the art work on to the represented reality. Part of what is meant by saying that the work of art is a new creation to be enjoyed in and for itself is the claim that it is to be looked at in some respects as we look at an abstract: we enjoy it and appreciate it *only* for what it is in itself, not in any degree for what it represents. This has been strikingly put by André Malraux in the epigrammatic fashion of which he is a master: 'No more of Chardin's velvety peaches; with Braque it is not

the peach that is velvety, but the picture.' We do not see the painting as reproducing or representing the sensory qualities of the things we know in life, the things represented in the picture: we see the sensory qualities which are actually there in the painting. This is a change of attitude which is not unimportant. Painting is not thought of as an 'imitation' or even as an 'idealization' of reality, but as a new creation of artists which for certain purposes (i.e. appreciation) is offered to us as an alternative to reality. Again in Malraux's words, painting is 'the metamorphosis of the world in pictures'.

This conception raises the whole question of representation, its function, its importance and its justification.

2. REPRESENTATION

In order to speak coherently about representation and its bearings for appreciation it is necessary to consider what sort of thing a work of art is. While it is not necessary to go at all fully into the philosophical question whether a work of art is a physical thing or a mental thing, some distinctions must be drawn. I shall use a *picture* as exemplar but with the proviso that similar things can be said about other forms of representational art. In the sense in which the word is used, music and architecture are not in their nature representational arts, the literary and dramatic arts are essentially representational, the visual arts of painting and sculpture may be but need not be representational.

In the most obvious and primary sense a picture is a physical thing—let us say a piece of canvas or board one side of which is covered with a flat arrangement of pigment washes. As a physical object it has the sort of visual, and other, properties than any similar physical object would have: size, shape, colour, etc. In order to ascertain these properties we proceed as we would with any other physical thing, applying appropriate methods of scientific mensuration and analysis. But a picture is distinguished from other physical things by the fact that it *depicts*. By this is meant that if we look at the physical picture under appropriate conditions we become aware of a visual impression—which I shall call the 'depiction' or the 'depicted object'—which will manifest visual properties different from those of the physical picture and perhaps conflicting with them. For example, the physical picture is flat, extending in only two dimensions. But the depicted object may (though it need not) extend into three dimensions and it may contain objects, such as

trees and cows, not forming any part of the physical picture, which are related to each other in a depicted three-dimensional picture space. The depicted object is likely also to possess qualities, both sensory and emotional, qualities such as delicacy, flamboyance, serenity, calm, and formal qualities such as balance and harmony, qualities of a sort which are either inappropriate or impossible to a physical object such as a pigmented board.

It has been said that the depicted object 'emerges' when the physical picture is looked at 'under appropriate conditions'. This means, roughly, when it is looked at from far enough away so that all parts of it can be seen simultaneously and it can be seen at a glance as a single unified thing, when the individual blobs and patches of pigment merge into larger, significant unities; at the same time it must be looked at from close enough to enable us to see the depicted object with the maximum of clarity and detail. How far away this is can be found out only by trial and error in each individual case. It is a part of the technique which every artist must acquire that there is an optimum position, and that a suitable one, from which his picture can be seen. As a special trick—almost a gimmick—in search of piquancy artists have sometimes deliberately constructed a picture so that some parts can be seen best, or be seen at all, from further away and other parts from more close at hand. In such cases appreciation is composite—rather like appreciating a cathedral, which demands to be seen from both inside and out. The modern practice of randomly changing the sizes of pictures in reproduction in order to bring them within the format of a book is the source of serious distortion and misdirection to those who become familiar with pictures in the first place through book illustrations.

In other respects also the distinction I have drawn between the picture as a physical thing and the picture as a depicted object is not merely academic but has important bearings for appreciation. As will be shown in a later chapter (pp. 176 ff.), when we look at a picture as an art work for the purpose of aesthetic enjoyment we look at in a twofold way, seeing it both as the surface of a physical object, with the surface texture which the physical object visually has, and we look at it also, and simultaneously, as a depiction. In this twofold manner of looking individual patches of pigment may be seen both as elements in the surface texture of a flat physical object and also at the same time as elements in the depicted object with different and perhaps inconsistent properties of

spatial location, dimension, colour, etc. Aesthetic percipience runs counter to logic, at least if you think of the picture as a single thing in perception. In older European traditions of painting emphasis fell chiefly on the depiction and the creation and perception of a depicted object was commonly, though inappropriately, spoken of as 'illusion'. In several schools of contemporary painting particular importance is attached to preserving the aspect of the picture as a physical object, 'preserving the picture plane', and preventing the perception of the physical surface from being completely submerged in perception of the depicted object. It is characteristic of those schools which set most store by the 'creative' aspect of art that they seek to diminish the gap between the visual qualities of the surface of the physical picture and those of the depiction: as Malraux said (see pp. 138–9), the bloom in a Braque belongs to the physical picture not to the depicted peaches only. The more abstract a painting is, the more prominent this tendency usually becomes.

It is important, however, to recognize that the distinction between the physical picture and the picture as depiction is not an aesthetic one. All graphic 'art' is not art in the aesthetic sense and all depictions are not aesthetic objects, good or bad. Everything which has been said about the discrimination of physical picture from depicted object (but not, of course, what was said about the twofold manner of aesthetic contemplation) applies equally to documentary, advertisement, illustrative, and other sorts of depiction which we do not classify as fine art and do not seek to contemplate aesthetically.

Nor does the distinction coincide with the distinction between representation and abstract art. When a picture is abstract it also depicts and the distinction between physical object and depiction also holds good. Even a relatively simple arrangement of pencil marks on a white sheet of paper may give rise to a depiction which exists in three dimensions. A depiction may be abstract in that it represents nothing other than itself, it is non-representational. We say that a depiction is representational when in virtue of certain visual similarities it points to something other than itself and in a particular sense stands for that other thing. That which a depiction represents may be a real thing which exists, or once existed, in nature or it may be an unreal, imaginary thing. A portrait is a depiction representing a real person who exists or once existed; Chirico's picture *The Jewish Angel* is a depiction of an imaginary

thing. One finds every possible gradation between representation of the real and representation of the imaginary, and every possible combination of the two.

The concept of representation is much wider than that of pictorial representation. A lawyer represents his client when he takes his client's place and speaks for him. When children play a game of pirates an upturned table may represent a desert island and a chair may represent a boat. A map represents a portion of country although it bears only a tenuous visual likeness to what it represents. One man can represent but one man cannot be a representation (in the pictorial sense) of another. Pictorial representation is a particular kind of representation which we can recognize pretty well though it is not easy to define. It combines both visual similarities and elements of conventionalism. Visual similarity has been most prominent in the ideals of naturalistic art and expressions such as 'illusion', 'illusionistic realism', 'magical realism' have been used to indicate that the visual characteristics of a depiction are very like those of the real thing which it represents—or, if it represents an imaginary thing, that the visual characteristics of the depiction carry such conviction that it is easy for us to forget that the thing which it represents is not real. When conventions of representation play a larger role there result innumerable forms of stylization, mannerism, decorative distortion or near-abstraction.

Whether or not a depiction is a work of art is a different question from the question whether it represents or what it represents. Depictions may be works of art whether they represent or do not represent anything. Whether or not they are works of art depends upon their capacity to stimulate attention and sustain contemplation in the aesthetic mode given a suitably endowed observer.

Since the lead given by Impressionism in the middle of the last century the many creative movements in art have followed each other with almost bewildering variety. The neo-Impressionists led by Seurat, the Nabis inspired by Gauguin, the Fauves, the Futurists, the Metaphysical school of Chirico, French and German Expressionism, Cubism, Purism, Abstract Expressionism, Tachisme, the New Realism, Pop Art, Op Art, Kinetic Art—each movement and each group has had its own interests, its own problems and preoccupations, and its own basis in aesthetic theory either overt in debate and manifesto or implicit in the character

of the work produced. It is possible to appreciate and enjoy paintings of all these schools without knowing the theories by which they were inspired. Nevertheless some knowledge of the ideas and aspirations which were common to each group and school is a useful adjunct to appreciation because it helps one to condition attention to notice and realize in awareness those features of each type of painting which are most significant. In addition, however, to the particular theories which have given direction to these various movements there are certain more fundamental changes of aesthetic outlook which are common to large sectors of contemporary art production and which are often claimed to be valid for the appreciation of all art everywhere, art of the past as well as the present. To discuss the particular theoretical framework of the various movements would be impossible within the scope of this book, but we shall scrutinize certain of the more basic changes of outlook which seem to be most characteristic of the twentieth century with a view to elucidating, if possible, their bearing for the appreciation of art from all ages and of all styles. We shall assume, unless the contrary becomes manifest, that the art of appreciation has certain essential features in common for all styles and traditions and that similar faculties and skills are called into operation whether one is contemplating contemporary art or art from prehistoric times, whether European art in the Renaissance tradition, Chinese, Indian, Mexican or modern abstract art. I will first consider the problem of representation.

The violence of the reaction against the nineteenth-century conception of the artist's role as illustrator and social moralist has led to statements which seem to imply a virtual repudiation of the importance formerly ascribed to representation in visual art and its appreciation. The new outlook was formulated as early as 1890 in an often quoted statement by the artist Maurice Denis: 'Se rappeler qu'un tableau—avant d'être un cheval de bataille, une femme nue ou une quelconque anecdote—est essentiellement une surface plane recouverte de couleurs en un certain ordre assemblées.' In the same vein are such forthright statements as that of Matisse, who said: 'In looking at painting one has to forget what it represents', and Braque, who said: 'The subject is the painting.' Yet the plain fact remains that by far the greater part of the world's art *is* representational and it seems merely petulant—or certainly premature —to say that this is a pity and we should look at it as if it were not. It is necessary but by no means easy to recognize when the rejection of

representation is put forward as a particular dogma expressing the special interests and aspirations of a particular movement and when it is propagated as a fundamental feature of modern aesthetic outlook valid for all art of all time. It is certainly not self-evident that if a work of art *is* representational, whether it should have been so or not, the fact that it is so can be disregarded in appreciation.

In fact the opposition to representation is maintained in a stronger and a weaker sense. In the stronger sense it is claimed that representation as such is irrelevant and that all art, whether it represents or does not represent, should be appreciated as if it were abstract. In the weaker form it is conceded that the fact of representation has a bearing for appreciation but it is claimed that the nature of the subject—what it is that is represented—is a matter of indifference.

Before discussing these two versions of the antipathy against representation it is necessary to clear up a very prevalent confusion which lumps together the modern reaction from naturalism with the repudiation of figurative art. Representation and naturalism in art are, of course, by no means identical. The naturalistic tradition which stems from classical antiquity and was revived and perpetuated at the Renaissance, the sort of naturalism which directs attention primarily upon the subject-matter and has verisimilitude as its chief criterion, has not been a very general ideal among the art traditions of the world. Representation on the other hand has been almost universal from Palaeolithic cave art to the present day. The repudiation of representation is a much wider thing than a reaction from the European naturalistic tradition. In so far as the modern 'retreat from likeness' is a repudiation of Renaissance naturalism it can often be regarded as a reversal to older, more universal traditions in art. For example, the 'magic realism' of Surrealism and other modern schools, where the image grips the imagination with almost obsessive force, has affinities with traditions in which the art object is regarded as a power-imbued symbol and substitute for reality rather than a mirror-image of it. Some aspects of Cubism and related styles have affinities with 'noetic' art. Indeed Picasso is reported by Gilet to have said about the Cubists' use of *papier collé*: 'We tried to get rid of *trompe-l'oeil* to find a *trompe-l'esprit*. We didn't any longer want to fool the eye; we wanted to fool the mind.' Modern non-figurative art, which creates self-subsistent abstract objects for appreciation and not as decorative adjuncts to architecture, is something new, virtually

without parallel and it may turn out to be a transient vogue—although the superb quality of some of the non-figurative work that has been done cannot be challenged. But I have not seen it seriously maintained, and I am sure it could not be substantiated, that the non-figurative painting and sculpture of the first half of this century has achieved a *higher* category of excellence or interest for appreciation than the painting and sculpture of the past.

I will now consider the stronger version of the reaction against representation, the one which can be expressed in terms of the claim that all art, whether representational or not, is to be looked at as if it were merely a structured organization of visual forms—as if, that is, it were abstract. When we are in the presence of an abstract work we contemplate the visual reality which is presented there, in and for itself, as a configuration of lines and shapes and colours with no ulterior significance. Each element of line, colour, and shape has its own intrinsic insistence, makes its own impact as an element in that particular configuration, and their interplay is uncomplicated by any implications beyond their immediate optical qualities. It must be conceded—I would, indeed, emphatically insist—that this way of seeing is *part* of the appreciation of any work of visual art. All painting must be contemplated in this way among others—for what it is in itself as well as for what it represents—and this sort of awareness is an element in our apprehension of all visual art from the moment that our attitude becomes aesthetic and as long as it remains so. Perhaps the ability to see in this way constitutes the most elementary difference between a person who can appreciate and the person who is without that skill. But appreciation is not uncomplicated seeing at a single level: it is here precisely that it differs from the way we look at things in ordinary life and the way we look at non-artistic graphic representations. Appreciation is a complex way of seeing which takes place at several levels simultaneously. We see a representational painting as an abstract configuration of forms but we also see *through* the forms to the reality which they represent. Moreover the representational significance of the forms exerts a dual influence, both optical and psychological, on their character as forms and these various ways of seeing fuse and coexist. An oval has its own character as form. But an oval in a representational picture may represent a perspective view of a circular wheel and what we see is a circular wheel. Yet the oval does not wholly lose its intrinsic character

in the abstract organization of forms which is the picture. In ordinary real-life perception we see a world of things with more or less determinate shapes separated by indeterminate spaces (we see the things but don't see the spaces between them). In looking at a painting as an organization of forms the spaces between the figures are as important as the shapes of the figures. Yet we none the less simultaneously (and even inconsistently) see the painting as a representation of things separated by indeterminate spaces. This is an optical influence of representational significance on form. There is also a psychological influence deriving from the *interest* of the representational significance. When any pictorial element—any shape, line or patch of colour—has representational import, its psychological impact is changed and therefore the prominence and insistence it has in the whole system of formal relations which build up the structural configuration which is the work of art are different from what they would be if the same elements carried no suggestion of representation. An oval which represents a face or a breast makes a different impact in the formal structure from an oval which is just an oval. A circle which represents a runaway chariot wheel or one which represents a mirror has a different dynamic force in the system of abstract relations from a circle which is no more than a casual space between figures. In these ways representation has its influence on formal structure. Aesthetic appreciation combines several levels and modes of looking which fuse and interact, while each retains a relative independence. A person who has not seen a picture as an abstract has not seen it as a picture; but one who sees a representational picture only as an abstract has missed much of its aesthetic content.

When formal qualities and the represented content are most intimately fused we sometimes receive a vivid impact of 'presence', as though we were no longer looking at a painted image of some familiar or unfamiliar thing but as if the image itself had come to life, dominating us by the urgency of its present reality. It is in these experiences that we achieve the fullest realization of those fleeting 'moments of aesthetic vision' (pp. 20–3) which in practical life are the prototype and paradigm of aesthetic experience. The dependence of such effects on formal qualities can be demonstrated if, for example, you 'trim' Van Gogh's painting of a kitchen chair so as to alter the area of the background and change the pattern of the floor or if you cut or add to a still life by Chardin. So we see that the picture is made not merely by a sudden

revelation of aesthetic vision into the visual essence of the object but also by its placing on the canvas, by the construction and formal qualities of the whole work.

In its weaker form the reaction against representation has given rise to the view that, although a representational work has different values for appreciation from an abstract, *what* it represents is a matter of indifference. This view comes close to demanding that the attitude taken up in appreciation to all works of representational art be similar to that which we take up towards a neutral still life. In this view too there is at least a negative truth. No subject, however elevated, can guarantee the aesthetic worth of any work of art: it is not possible to think of any subject of representation which has not been made the theme of bad and unsuccessful works in every style. Without excellence of formal aesthetic qualities a work of art is not made. Contrariwise triviality of subject-matter does not in contemporary opinion render a painting trivial. Many of the world's paintings which are most highly esteemed today have themes which are trivial or uninteresting in themselves. Subject and theme are the element which can be common to many works of art. It is in the treatment and the formal properties that one work differs from and excels another. Yet it would be pedantic in the extreme and contrary to ordinary experience to claim dogmatically that when the subject *is* interesting this remains still a matter of indifference in our appreciative commerce with the work. To exclude the interest of subject-matter in Surrealist painting, to demand that we treat the religious paintings of Stanley Spencer as though they were paintings of lay scenes and to put on one side the apotheosis of the disgusting in Francis Bacon would be too artificial to carry conviction. Some contemporary movements have relied heavily on a particular category of subject-matter for its special interest; others—like the Cubists and the masters of still life—have in general deliberately eschewed interesting subjects. The appeal of subject-matter to our interest is apt to be more evanescent than that of formal qualities, as is evidenced by the perplexing metamorphoses which propaganda and didactic art often undergoes when interest in the theme has vanished. But so long as interest is there, it cannot be completely divorced from the total experience in appreciation.

This is a complicated matter and it will be useful here to draw a distinction between *subject* and *theme*, which have so far been treated as

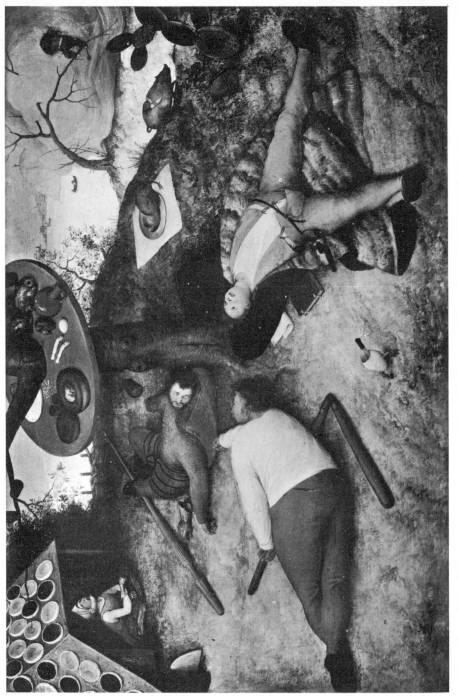

Pieter Bruegel the Elder: LAND OF COCKAIGNE. *Bayerische Staatsgemäldesammlung; Alte Pinakothek, Munich*

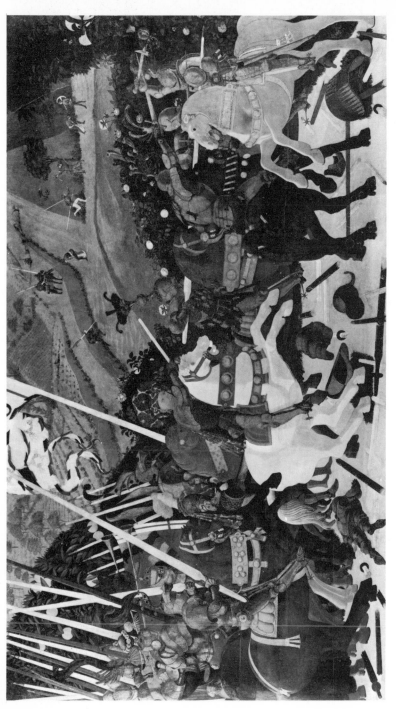

Paolo Uccello: ROUT OF SAN ROMANO. *National Gallery, London*

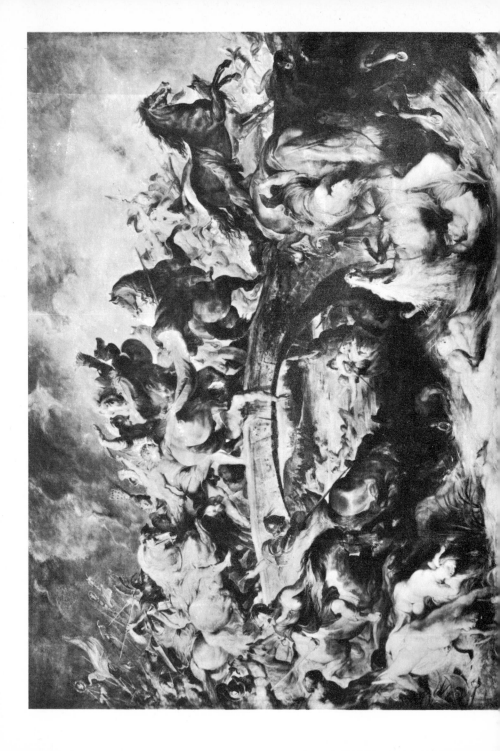

identical. By 'subject' we shall mean that portion of the visible world which the artist actually depicts—a man, a dog, a hunt, or a battle. What is meant by 'theme' can be illustrated at its simplest by the patron's commission: a picture of the Crucifixion, the Annunciation, the Death of Wolfe, Rape of Helen, Napoleon Crossing the Alps, etc. It is not a matter of indifference that the figure in the Isenheim Altar exemplifies the concept of the 'Suffering Christ' or that the chief figure of David's picture represents Napoleon. The theme may be extra-aesthetic, as in the foregoing examples, or it may be aesthetic, as when an artist uses his subject as a means for investigating and displaying the formal structures of nature and art. The relation of subject to theme may be close or loose, and often an artist has used an extra-aesthetic theme as a pretext for an aesthetic theme in which he had more interest. Bruegel's theme in *Land of Cockaigne* was gluttony and indolence: his subject, the sur- 148
feited sleep of bloated figures through a drowsy afternoon, fitted closely with it, and through this we are led to perceive the slow-turning rhythms and the masterly engineering of design by which the scene is celebrated and a mood of indestructible and sensuous calm is established. Rubens, however, treated a commission for a Nativity and a Birth of Venus as equally occasion for exploring problems of spatial and organic movement. The feeling of boisterous wellbeing which his compositions transmit to us owes little to any sympathy with the ostensible theme of each. Indeed, in the Prado *Birth* a fully mature Venus strides from the water on to the beach to a conch-shell voluntary trumpeted forth by a Neptune herald and wrings her hair as if she had just completed a cross-Channel swim. A Virgin and Child may be treated by Raphael as a 232–3
statuesque set-piece with an Italianate matron as subject, by Rembrandt
as the tenderly miraculous illumination of a peasant mother and baby in a shabby kitchen and by Rubens as a symbol of fertility throned in the splendour of a harvest-stacked Flemish barn. War is the theme of many paintings by many artists but with enormous variety in the presentation of subject. Compared with the tragic intensity of *subject* in Goya's *Disastros de la Guerra* and *3rd May, 1808*, *The Rout of San Romano*, described by Michael Levey as a 'bloodless pageant battle', is not more a tragic subject than the break-up of a carnival by a hailstorm, while against the screaming protest of Picasso's *Guernica*, whose subject is 264–5
built up from personal and symbolic images so ably analysed by Sir Anthony Blunt (see Appendix IV), the slaughtered women in Rubens's

Peter Paul Rubens: BATTLE OF THE AMAZONS. *Bayerische Staatsgemäldesammlung; Alte Pinakothek, Munich*

151

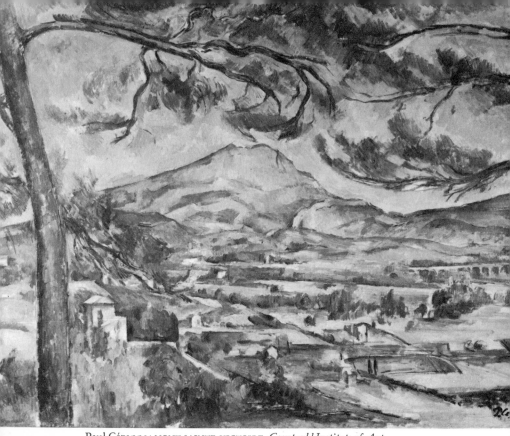

Paul Cézanne: MONT SAINTE-VICTOIRE. *Courtauld Institute of Art*

150 *Battle of the Amazons* are falling with athletic expertise, banners waving and trumpets braying—perhaps because we have seen these same Flemish actors and actresses performing for him before in happier themes, we know that, as in a cowboy serial, they will be able to pick themselves up, dust themselves down and live to act another day and in place of tragic horror we are led to joyous enthusiasm for the tremendous rhythms and looping boisterous movements which the subject has invited.[13]

Cézanne is a classical example of an artist whose theme was, almost consistently, the solution of problems connected with the interpretation of visible things in terms of spatial structure. His subject *is* virtually a matter of indifference, If you hang together still lifes, portraits, landscapes, and figure studies by him, you find that the difference of subject

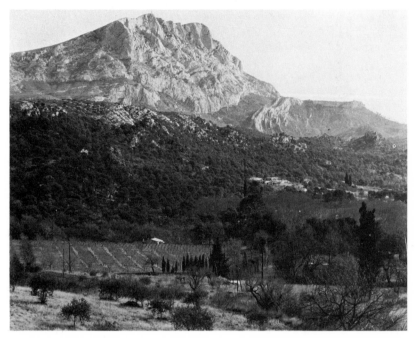

The Arc Valley and Mont Sainte-Victoire. Photo: *Gilles Bruneton*

is of minor importance because all are dominated by his struggle to realize spatial structure by certain technical means common to all and to build it into a composition of spatial planes. The planes of a head, for example, are described as if they had formed the sides of a mountain, an arm as if it had been a tree trunk and a still life may have the formal properties of a landscape. On his attitude to landscape Cézanne himself is quoted by Joachim Gasquet as saying:

Here is my motif. (He put his hands together . . . drew them apart, the ten fingers open, slowly, very slowly brought them together again, clasped them, squeezed them tighter and tighter, as though meshing them into one.) That's what you have to try to do. If one is higher or lower than the other, all goes to pieces. Everything has so to mesh with everything else that there is no way for the feeling, for the light, for the truth to escape. You must try

to understand that I work on the whole canvas, on everything in it at once. With one impulse, with undivided faith, I bring all the bits and pieces together. Everything we see falls apart, vanishes, doesn't it? Nature is always the same, but nothing in her, nothing that appears to us, lasts. Our art renders the thrill of nature's permanence along with her elements, the appearance of all her changes. It must give us a taste of her eternity. What is there underneath? Maybe nothing. Maybe everything. Everything, you understand. So I bring together her wandering hands. From here, from there, on this side and that, everywhere, I take her tones, her colours, her shadings, I set them down, I bring them closer together. They form lines. They become objects, trees, without my planning. They take on volume, value. If these volumes, these values, correspond on my canvas, in my sensibility, to the planes, to the spots which I have, which are there before our eyes, then my canvas has brought its hands together.[14]

Contrary to what is sometimes supposed, the attitude of an artist whose theme as well as his main preoccupation derives from technical problems of form and construction is not cerebral to the exclusion of emotion. We know that Cézanne was deeply committed emotionally to his work. In a letter to Émile Bernard, for example, written while he was working on a picture of Mont Sainte-Victoire, he said: 'I am in such a state of cerebral agitation, in an agitation so great, that at one point I was afraid it would engulf my frail reason.'[15] But whereas an artist of Cézanne's temper is emotionally moved by the problems which engage him, artists have perhaps more commonly been emotionally stirred by their subject itself and in some artists this emotional rapport with the chosen subject is so momentous as to become the theme of their work. Zola defined a picture as 'un coin de la nature vu à travers un tempérament'. When an artist is so dominated by his emotional engagement with his subject that he as it were *uses* the subject as an instrument to express and communicate his emotion towards it, in this case emotional expression can be said to have become the theme. Van Gogh is an outstanding example of this artistic type. Of the painting *Night Café* (1888) he himself said in a letter to his brother Theo that the picture, 'one of the ugliest I have ever done', was painted in harmonies of red, green, and yellow, 'colour not locally true from the point of view of the stereoscopic realist, but colour to suggest any emotion of an ardent temperament'. It was with reference to this painting that he made the frequently quoted remark that he 'had tried to express the terrible passions of humanity and the idea that the café is a place where one can ruin oneself,

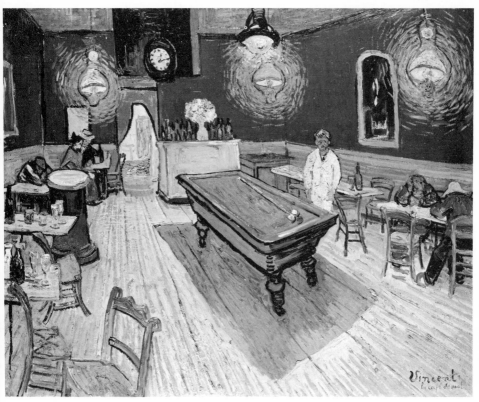

Vincent Van Gogh: NIGHT CAFÉ. *Yale University Art Gallery; Bequest of Stephen Carlton Clark, B.A., 1903*

run mad, or commit a crime'. In Van Gogh's paintings the artist's emotional apprehension of his subject is central. They reveal with the impact of a knock-down blow the impact made by these ordinary or even sordid subjects upon a strongly visual, humourless, and even neurotic personality. Because of the artist's engagement with his subject these pictures have a powerful effect upon even an untrained observer. Once we have apprehended the pictures in appreciation it is difficult ever again to see the subjects uninfluenced by Van Gogh's vision of them.

Landscape and still life have a special interest because in them subject and theme are usually closely linked. The artist's theme *may* be to

express his own feeling for landscape; still life *may* have a special purpose; but in general and over a very wide field in these genres the theme *is* the presentation of the subject in an aesthetically valuable construct. Moreover the subject is usually obvious on the face of it and seldom requires erudition or exegesis for its apprehension. It is, however, at this point worth saying something about two main differences in the mode of presenting landscape and their significance for appreciation.

Landscape art does not consist in the reproduction of picturesque nooks and vistas or the sort of beauty-spots advertised in holiday brochures. The artistically ignorant are constantly surprised at the disinterest shown by a genuine artist in the natural 'beauties' pointed out to him. What we do notice is that in great landscape art the presented scene is often more ordered, more balanced, more coherently articulated and structured than it is in reality. The way in which an artist *utilizes* rather than reproduces landscape can be seen from photographs of an actual scene which are sometimes printed alongside reproductions of paintings done from the scene. (See Illustrations, pp. 152, 155.) Sometimes this structuring is so deliberate, so prominent a concern of the artist that—as we saw in the case of Cézanne—it may be regarded as his theme. But often—perhaps more generally—it is a concomitant of those moments of aesthetic vision about which I spoke earlier (pp. 20–3), flashes of insight when familiar objects are seen fully for what they are and no longer half-seen only as clues to things and action in a practical context. When this occurs in our vision of landscape we see the essential form and structure beneath the accidentals of picturesqueness and allure, discounting considerations of usefulness and serviceability. It is likely that many people have a rudimentary power of seeing natural scenery in this way, although the tendencies of contemporary propaganda do not encourage its recognition or cultivation. Artists may have a greater aptitude for it or they may be more susceptible to the feeling of exaltation which it brings in its train and so make greater efforts to cultivate the mode of percipience involved. Above all, the artist has the power to sustain the flash of insight for the time necessary to build a formal structure in pigment upon the basis of it, and is able to concentrate it and deepen it by repeated experiences of insight. Constable once remarked: 'I almost put my eyes out' by the intensity of his persistent perceptivity for the effects of atmospheric changes on the formal characteristics of landscape. I think that this way of seeing is what Clive

Bell had understood and tried to describe (though in no longer fashionable language) in his essay 'The Metaphysical Hypothesis':

Occasionally when an artist—a real artist—looks at objects (the contents of a room, for instance) he perceives them as pure forms in certain relations to each other, and feels emotion for them as such. These are his moments of inspiration: follows the desire to express what has been felt. . . . All of us, I imagine, do, from time to time, get a vision of material objects as pure forms. We see things as ends in themselves, that is to say; and at such moments it seems possible, and even probable, that we see them with the eye of an artist. Who has not, once at least in his life, had a sudden vision of landscape as pure form? For once, instead of seeing it as fields and cottages, he has felt it as lines and colours. At that moment has he not won from material beauty a thrill indistinguishable from that which art gives?[16]

It would be misleading to suggest that there is an absolute distinction between the artist who works with a deliberate structural aim and the one who relies on the inspiration of aesthetic vision. Even Cézanne received his impetus from aesthetic insight; and given the flash of aesthetic vision and the power to perpetuate and deepen it, every artist then has the task to convert it into an artistic construct built up in the medium of coloured pigments. In order to do this with the limited resources at the artist's disposal, a complex variety of techniques and conventions has been used. The artist's problem is to translate a vision of three-dimensional structured and coherent form on to a two-dimensional surface in pigments which allow a scale of *brightness* many times smaller than that of nature, much more restricted in the range of saturation, while other qualities such as lustre and translucency can only be suggested by artificial means. Many of these limitations have been converted into positive advantages by the greatest artists. But in the immediate matter with which we are now concerned—the embodiment in painting of aesthetic apprehension of natural scenes—they are not an advantage. As Walter Sickert suggested in his autobiographical work *A Free House!* (1927), there seem to be two distinct psychological types among artists who are faced with this problem. Some artists obtain their formal vision of a natural scene and then search for means and techniques to render it as may be, with such compromises and modifications as can in no way be avoided, with the restricted resources of pigments on to canvas. Other artists as it were 'think in paint', and their vision of the natural scene before them is a vision of nature transformed into

pigments. It seems to me that the cultivation of a power to recognize these two approaches is a vital part of the skill to appreciate landscape painting.

The power to see nature at all as landscape or scene is not an automatic or a universal gift. There is evidence that the ancient Greeks were without this power: they saw nature as an aggregate of objects—trees, hills, river, temple—but not as a *scene*. Most of Egyptian art lacks this power and it is absent (or manifested only in a rudimentary degree) throughout most primitive and tribal art. Without it landscape art is not possible, nor is an interest in nature as landscape possible. This may be a reason why landscape as an independent and self-sufficient subject for pictorial art developed late in the West, rather earlier in China. Before leaving this topic I want to distinguish two different ways of appreciating landscape which two different modes of seeing and representing nature as landscape invite and demand. In the tradition most prominent in Western art landscape is seen from without and the observer is invited to look out on a pictured scene as if from an open window. But there is another, rarer style, which as it were draws the spectator into the landscape so that as concentration increases and his absorption becomes more complete his whole awareness seems to be concentrated in an eye placed centrally within the pictured scene, which encompasses him about and extends in all directions around him. In this experience the sense of limitation imposed by the frame of the picture may fall into abeyance, and he may have the feeling that the skies and vistas extend infinitely and without bounds in all directions.[17] Sometimes interiors are painted so that they give the impression not that one is observing them from without like a spectator at a play but that one is situated visually within the painted scene. Technically this effect is partly dependent upon the extent to which an artist uses or does not use the edges of the canvas—or the picture frame—as co-ordinates against which the system of space-relations constituting his picture is built up. But ultimately the matter is a very complex one and cannot be fully analysed here. It is nevertheless of importance in appreciation to be able to recognize the effect. In much Chinese landscape the spectator is drawn into the picture in a rather different way. Partly, the scene may start visually at the very feet of the spectator instead of some twenty yards ahead of him as is usual with Western landscape; partly as different parts of a landscape scene are executed *as if* seen from a point somewhere

within the scene itself, the viewer is as it were invited to enter the land-scape, journey within it and look out from this point and that. It appears that this method of composing has been influenced by the Chinese custom of scroll paintings, which are made to be viewed section by section successively without fixed edges. But the inclination to see and depict landscape in this way rather than externally as in the West may derive from the greater feeling which the Chinese had for unity with the inanimate environment in contrast to the predominant Western view of nature as something alien and external to be dominated and mastered both practically and spiritually.

This discussion of landscape art may, I hope, serve to demonstrate that even in a genre where subject is least recondite, most readily apprehended without adventitious aids, and where subject and theme are for the most part closely allied, nevertheless artists have had different attitudes to both subject and theme, have been trying to do different things with both of them, and knowledge of these differences is germane to appreciation. But in a great deal of surviving art the subject is not so readily apprehensible: there may be elements of symbolic significance, features of the subject depicted may have meanings which derive from special social contexts or religious or other traditions, gestures and postures may have conventional import, and when these things belong to cultures other than our own, whether past or present, they will not be immediately apparent to the eye. In a similar way theme may be obscure. It is a matter of no small practical importance to decide the extent to which such external, non-aesthetic information about subject and theme is necessary to appreciation. For this brings in the whole question of how useful, or how necessary, is the kind of knowledge which the historian and expert have to offer.

We are living at a time when a far wider and more varied range of objects from vastly different periods and cultures than ever before lies open to us for appreciation. And it is quite certain that over a large part of this range appreciation owes more to formal and expressive qualities than to subject or theme or social significance. This is necessarily so if only because knowledge of theme is in many cases lost beyond recovery (e.g. Palaeolithic cave art, the Pre-Columbian art of Central America and the Andes, most Etruscan art, much tribal and primitive art) or is only very partially known (e.g. Mesopotamian art or Minoan art). In other sectors it is so complex that it usually remains the province of the

scholar and the specialist. It often happens that a great painting within our own cultural tradition first arrests attention by its subject or theme but with more intimate acquaintance it is the more universal features, the emotional and expressive qualities and the qualities of construction and design in relation to subject, which live and dominate our experience. The work becomes *more* abstract as interest in subject and theme recedes. This is particularly the case with propaganda art (and a goodly amount of religious art was propaganda in its origin and intention), when interest in the message is no longer urgent or vital. It is not essential to put oneself imaginatively into the state of mind of a Christian believer in order to be able to appreciate Byzantine or Coptic art. Yet where subject and theme are closely related, something, and perhaps a great deal, may be lost to appreciation if one is unable to do this whether it is owing to ignorance of what the theme is or through defective powers of sympathetic imagination.

The relation of subject to theme may be close or loose. There is no rule. Particularly in religious and civic art the artist's interest in subject has often over-ridden his interest in a commissioned theme and subject preponderates. On the other hand subject itself may acquire complexity and become difficult of interpretation whether it is integral to theme or divorced from it. The three miles of relief carvings at Borobudur, a symbol in stone of the cosmic system of Mahayana Buddhism, were designed to serve the purposes of worship, veneration, and meditation; but even when our primary commerce with them is aesthetic, it is not irrelevant to appreciation that their meaning and intention is apprehended. In the appreciation of Leonardo's cartoon *The Madonna and Child with St. Anne and St. John the Baptist* it is not irrelevant to full appreciation of theme if one knows that the upraised forefinger of St. Anne—the traditional gesture of the Baptist—is intended to remind the spectator of St. Anne as the forerunner and that it is, by taking over the Baptist's gesture, a sort of shorthand reference to the Way and therefore to the future Passion. This constitutes an enrichment of appreciation additional to perception of Leonardo's innovation in solving a structural problem in the posing of the group. It is not entirely irrelevant to appreciation to know that the empty dish so prominent in the foreground of Dürer's engraving of the Last Supper has a dogmatic significance.

Even subject may not be patent on the surface, although by and large

it is usually more obvious to uninstructed seeing than is theme. But in order to apprehend subject at all a background of visual experience is necessary: a man who had never seen a woman's body or a horse or a tree might be at a loss before a picture in which these were portrayed. So when the subject contains recondite symbolism, allegory or emblem some theoretical study may well be necessary in order to apprehend its full import. The subject of works of art has usually some intellectual content and whenever this is the case understanding of the intellectual content is a part of apprehending the work of art, perceiving it fully and getting it complete in awareness. This is particularly obvious in the case of literature, where there is inevitably an intellectual aspect to understanding the meanings of words and sentences, the interplay of images, allusions, associations, etc. An imperfectly understood set of words is an imperfectly apprehended poem. Music and the visual arts may also have intellectual content and ordinarily do have it in some degree. The importance to appreciation of clarifying every obscurity in the subject-matter and understanding it fully varies almost with every work and it is impossible to generalize. But probably it always has *some* importance. It has been shown that in all representational art the subject of representation does not stand quite separate from the formal and abstract properties but has a bearing upon them. It follows that, however marginally in some cases, a failure to understand obscurities of the subject-matter, involving as it necessarily does less than complete apprehension, must have some effect upon the perception of the formal and expressive qualities of the work. This is where the method of art history known as iconography can contribute positively to appreciation instead of remaining a dry and tediously esoteric branch of scholarship. It is, as has been said, possible to go a long way in the appreciation of visual art without clarifying the more intricate ramifications of significance in subject-matter: we constantly do this with works which have survived from past civilizations whose representational conventions or ideological import is no longer open to recovery. But any such failure of understanding to some extent, however small it may be, leaves our *perception* of the work, our complete and rounded apprehension of it, defective. Even historical and sociological information *about* the work of art may have relevance to understanding and will therefore be to some extent conducive to full appreciation. But extraneous facts are not a substitute for percipience or for the task of understanding the specific

intellectual content of each work of art. Except in so far as they subserve this end they may be both dangerous and frustrating. Knowledge *about* works of art is nowadays too frequently purveyed in place of direct contact with them. Anyone who has attempted to teach appreciation to students whose acquaintance with art is limited to the current art journals and picture books in a college library will realize the futility of theoretical knowledge which is not directly ancillary to understanding the content of the particular work. The illustrated books of art history which are now in vogue can have a pernicious rather than a helpful effect on the cultivation of appreciation if they purvey secondhand appreciative judgements and heterogeneous information about ranges of art works with which the reader is not expected to make direct appreciative contact. Historical and technical information is valuable only when correctly applied. It is not every art historian who could endorse the following words of Roger Fry:

> I fear that you will think that in these lectures I have done little but point to the immense complexity of art-history, to the inadequacy of those generalizations under which it is generally subsumed—and more than that I have shown how much too profound is our ignorance of the nature of artistic creation to enable us yet to make fruitful generalizations at all. But if along these lines I have been sceptical and discouraging. I hope I may have suggested what fascinating problems of the relations of art to other vital functions of our intellectual and emotional life there are waiting for future solution. But even this has not been the chief end I have had in view. Only very incidentally have these lectures contributed, even if they have at all, to your knowledge of the history of art in its strict sense. Not that I want to deprecate that study. We want every scrap of knowledge we can glean from archaeology, from political and social history and from the study of documents. We want to know all we can about the origins and circumstances of a work of art. But besides this knowledge you have to practice an art, the art of looking at works of art with the most sensitive and vivid response possible. And perhaps the most important part of that art consists in the power to maintain your spirit in a condition of tense passivity, a state of passive receptiveness in which you are alert to its appeal, ready to vibrate in harmony with it. This is a faculty which nearly everyone possesses in some degree, but which can be increased almost indefinitely by constant exercise and training. The aim I have had in view has been to suggest to you possible methods of such a training of aesthetic apprehension.[18]

I have discussed the reaction against representation in its stronger

and its weaker forms and have suggested that, although representation is not necessary to visual art (abstract painting and sculpture are realities for appreciation), yet when a work does represent something other than itself concern with its representational content *is* necessary to full appreciation and cannot be discounted without impoverishment to aesthetic experience. It remains to say something very briefly about an allied dogma which, while allowing representational art, repudiates 'literary' content. The arguments upon which this doctrine is based have been well formulated by Étienne Gilson in *Painting and Reality*.

By 'literary content' is meant, of course, narrative and anecdote, but sometimes much more than this is implied. Under the heading of 'literary content' the depiction of particular scenes and occasions—such, for instance, as Frith's *Derby Day*—has been condemned, and sometimes the theory has been formulated so widely as to exclude even emotional expression in either or both of the senses which I have distinguished.

The strongest case can be made out for the exclusion of story and anecdote on the ground that painting and sculpture are static. Time-duration does not enter into the medium from which their rhythms and formal configurations are constructed; nor do we apprehend them step by step through time as we apprehend music and literature. Therefore any element of story or anecdote, involving as it necessarily does a sequence of incidents in time, must stand outside the formal structure which is the art work, loosely attached to it but unstructured for appreciation. In principle this does seem to be true, and narrative in the manner, say, of the strip cartoon does seem to be foreign to these arts. Yet there are narrative works in each which we would not be without. Similar considerations can be advanced rather less convincingly against the depiction of scenes which envisage story and incident. Obviously one could not reject the depiction of any scene which is tied to a particular incident in a known story on the ground that this involves 'literary' content, for that would mean repudiating a large part of the world's pictorial art which is admittedly of high aesthetic worth. On this ground one could not condemn *Derby Day* without also condemning Géricault's *Raft of the Medusa* and Raphael's *School of Athens*. I would suggest that one criterion may be if the trivial and mundane is suppressed and the scene is lifted out of associations of time and place and given universal import. We would also wish to differentiate between a picture whose main appeal depends on some story which the observer

is as it were invited to attach to the scene depicted and the picture whose main interest lies in the universal human significance inherent in the depiction itself. On such grounds as these it would be possible to distinguish between paintings such as Masaccio's *Expulsion from Paradise* and Wilkie's *Distraining for the Rent*. But the difference lies more in the manner of treatment, the expressive qualities present in the one and absent from the other, than in the mere fact of the depiction of a scene which is an incident in a story. Different considerations apply again to caricature, satirical, and humorous art. The matter is less simple than it has been represented to be and a great deal of thinking remains still to be done.

246

In an interesting footnote to his book *Enjoying Pictures* Clive Bell has discriminated three types of humorous artists. There are the typical *Punch* artists, who 'do no more than illustrate a funny legend'. Their vision is banal and their treatment would serve as well to illustrate a sentimental anecdote or a moral story. Their work hardly merits serious consideration as art. But 'on a far higher level' are artists with 'witty vision' who are still what Bell calls 'impure' artists. He instances Forain, Charles Keene, Rex Whistler, Max Beerbohm, the younger Tiepolo in this class. 'Their fun is supplied partly by what they see, partly by how they render it, and partly by what we know. In such art there is always a literary element—references, recollections, allusions, for the joy of the initiated. Suppose Whistler were to discover some resemblance, not purely physical, but moral, intellectual, or historical, between Osbert Sitwell and Louis XIV, he would as likely not give us a portrait of the former, not precisely in the manner of Bernini, but with sly references to baroque sculpture in general and to Bernini's portrait in particular, such as would prevent our ever quite forgetting a possible kinship between the poet and, not so much the monarch himself, as that figure of the monarch at Versailles. As examples of the greatest sort of humorous art he instances Tiepolo and Degas, whose humour is purely visual and depends not at all on extraneous information. 'Tiepolo and Degas,' he says, 'saw wittily and are deliciously sly in execution; but what they perceived was a purely visual comedy pertaining to forms alone, a joke that can be rendered only in lines and colour. All the wit of Degas lies inside the frame; and no word of explanation will help anyone to see it. It is a joke about forms told in forms, and it could be told in no other way.'

It is not only wit that can be specific to visual experience. Above all else emotional expression can be conveyed visually with a delicacy and precision that are possible in no other way. Subtle but meaningful movements of the features, expressive conformations of gesture and posture, can barely be described in words; clumsy and tedious verbal expositions still fail to convey their expressive significance; visual art alone is capable of reproducing them. (See further, pp. 104 ff.) It would be preposterous for the sake of academic dogmatism to deny to visual art this which it alone can do, and we must regard the repudiation of emotional expression as a dogma of particular schools which are interested in other things rather than defend it as a universal principle.

Perceiving the art work

Philosophers have discussed the mode of existence which belongs to works of art, debating whether they are material things or mental constructs or whether perhaps they are more correctly to be described as 'types' of which the mental objects which come to the awareness of this or that observer in moments of appreciation are the 'tokens'. To sturdy common sense it seems at first sight obvious that some works of art are material things: pictures and sculptures are transported from place to place in lorries; they are hung on walls or set up on pedestals; they are weighed and measured, their physical properties can be tested and verified. Yet when we consider such arts as poetry, music, and dance the case is different. Wordsworth's *Prelude* and Verdi's *Requiem* are unique entities which we agree to be works of art: but there is no one material thing anywhere, and no one happening, which can be identified with either of them. Moreover, as has already been seen (pp. 139 ff.), even in the case of painting and sculpture we ascribe to the art work properties which are incompatible with its being merely a material thing. There are important senses in which the picture which we talk about and enjoy as a work of art is not identical with the material piece of pigmented canvas which is crated and carried about in a lorry.

At the other extreme Croce, followed in England by Samuel Alexander and R. G. Collingwood, have argued that the work of art is properly regarded as a mental, not a material entity, an 'imaginary object' which exists complete in the mind of an artist independently of being embodied in any physical substance. According to these thinkers

the physical embodiment of the art work, whether in a single material object as with painting and sculpture and architecture or otherwise in the case of other arts, serves only the incidental purpose of giving it durability and rendering it a 'public object' accessible to a multiplicity of consumers. This theory also has its implausibilities, not least of which is its failure to do justice to the role of the physical medium. The physical materials of sculpture, the technical manipulation of the physical pigment in painting, play their part in the totality of appreciation and the physical differences which distinguish one musical performance from another are not entirely irrelevant to appreciation of the composition.

Fascinating as they are, these philosophical problems are not of direct concern to a practical study of appreciation. Yet they lurk in the background and are apt to cause misunderstandings if they are not properly segregated. For they arise out of vital facts of experience which, although in the main they are sufficiently familiar to people conversant with the arts, are sometimes difficult to formulate neutrally without philosophical implications. As a preliminary, therefore, I shall indicate the facts of experience which are basic for a discussion of the appreciation of art works and I shall try to do so without philosophical presuppositions, remaining in the realm of experience.

(1) Works of art fall naturally into three main groups.

(a) Some works, of which paintings and sculptures may be taken as typical, are closely associated with material things, which in the words of Roman Ingarden we may call their 'physical substrates'. Works of this kind can be appreciated only when we are in the presence of the material thing which is their physical substrate or of a satisfactory replica of it. When the physical substrate is damaged or destroyed the work of art is damaged or destroyed: in the sense that there is no further possibility for anyone to apprehend it in experience either at all or as it was in its pristine state, the work has ceased to exist. At the most it is possible to recollect previous apprehensions of it. In very many cases the work of art is associated in this way with a single material object (a painting or a carving). It has a unique physical substrate. In some cases, however, there exists a set of material things each of which has an equal claim to be regarded as the physical substrate of a work of art which we think of as a single and unique work. Examples of this are engravings which are produced by the artist in limited editions,

terracottas and metal casts of modelled sculptures which are produced from a single mould. There are other cases where there are very large numbers of material things which correspond to a single work of art. This occurs chiefly with the useful and industrial arts, when a utensil or tool or other object of use is artistically designed and is machine-produced. The idea of designing non-utilitarian art works for mass production is still in an experimental stage.

(*b*) In the case of the 'recorded' arts, of which music and poetry are typical, the material recording is much less closely associated with the entity which we think of as the art work than a physical material canvas with the picture. Recordings may be multiplied indefinitely and the degree of their physical resemblance to any prototype is a matter of indifference. We apprehend the art work in experience not by contemplating a recording but by contemplating a physical 'happening' which is called a 'performance'. Material recordings help to make possible a number of successive or simultaneous performances, each of which must differ in some respects from all others but all of which will have sufficient features in common to make it natural for them to be spoken of as performances of 'the same' work of art. This work of art to which individual performances are notionally related is never concretely present to anyone's experience. Most people's conception of it is a composite constructed from a number of recollected performances. Yet the recording may also serve in a certain sense as a norm and from it an experienced connoisseur may obtain a notion of what an ideal performance would be. It is not nonsense for a man to say that he has never heard a completely satisfactory performance of such and such a musical composition or to say of a particular performance that it was incorrect or false to the art work.

In the literary arts the prominence of performance is at a minimum. Appreciation consists essentially in the apprehension of a construct of recorded verbalized meanings. But in so far as the rhythm and sound of the language has some part to play, performance enters into appreciation and the solitary reader is in a sense his own performer, reconstructing in imagination the sound of the spoken words. Works of architecture are usually closely associated with a single material thing and they are therefore more closely analogous to paintings and sculptures. But it is often the case that a work of architecture is constructed by mechanics in accordance with recorded instructions drawn up by an archi-

tect. To this extent, therefore, they may be compared to a single and unique performance of a recording.

(*c*) In a third class we may place unrecorded arts of performance such as dance, unwritten folk poetry, folk song, and certain traditional rituals which have aesthetic character. Systems for the recording of ballet and dance have recently been devised, but they are still extremely esoteric and have far less precision than literary and musical recordings. Continuity and therefore the continuing identity of the art work still depend primarily on the memory of performers and connoisseurs. Yet there is an important sense in which people think of *Petruschka*, for example, as a unique art work despite the absence of recording and the great variety among performances.

The new art of cinema may be thought of as an unrecorded art of single performance. The script of a film is not the basis for a large number of simultaneous or successive performances but is simply a convenience for the bringing about of a single, unique 'happening'. The unique performance is multiplied mechanically so as to become accessible to a large number of consumers, but every 'showing' of a film is mechanically identical with every other showing of the same film and there exists no work of film art other than the single performance which is the prototype of all the mechanically produced showings.

It is a characteristic of the arts of performance, whether they are recorded or not, that the element of time enters into their construction and for that reason has a different function in their appreciation. We may look at pictures or sculptures for a longer or a shorter time at a stretch and we may come back to them repeatedly. But this is a matter of individual choice and convenience. Duration in time is not a feature of the art work and such works may be apprehended, as it is said, 'in a flash'. Performance, however, is a 'happening', which requires time for its occurrence and appreciation must be extended in time for the length of the happening. In music and the dramatic arts the length of time is dictated by the work itself, and appreciation must be maintained for the time which it takes for a performance to be completed. In literary works which are read, although time is necessary to apprehension, the length of time taken is to some extent at the discretion of each reader.

(2) In order to become aware of a work of art it is necessary to attend to the existential substrate, whether that is a material thing or a particular

'happening', in a special sort of way which has already been partially described. When we are in the presence of the thing we call a painting we all know without philosophical sophistication that here is a flat pigmented canvas which we can manipulate, roll, inspect through a magnifying glass, cut to pieces, varnish or re-pigment. We know too that when we stand a certain distance away from it and turn our gaze towards it, confining our attention within the limits of the canvas, we see say a landscape with trees and cows, extending into three dimensions and having the qualities of serenity and calm which we should ascribe to a real landscape if we were seeing such a landscape in reality. This is what our visual experience is and this is how it is appropriately described. It is a first and necessary, though not yet sufficient, step to seeing the picture as a work of art. In a study of appreciation we are interested solely in such visual experiences (or analogous experiences in the case of the other arts), with the characteristics they really have and with the various ways in which they can be most successfully and completely brought to actuality on the basis of the physical objects or happenings which are their necessary ground. Having in mind the relation of an experienced work of art to the material ground which gives it durability and renders it accessible to a plurality of consumers, I wrote in an earlier work: 'A work of art is not a material thing but an enduring possibility, often embodied or recorded in a material medium, of a specific set of sensory impressions.'[1] This statement makes no assumptions about theoretical questions of the mode of existence which does belong to works of art but is deliberately neutral, stating concisely what we take a work of art to be on the level of experience. It is a phenomenological definition and as such will be adopted for the purpose of this investigation into appreciation.

Since the term 'work of art' is commonly used of existential substrates (material pictures and sculptures, performances of dramatic or musical compositions, etc.) as well as the artistic image which is actualized in awareness when an observer contemplates such a physical substrate aesthetically, when greater accuracy is required I shall use the term 'aesthetic object' of the latter. I shall avoid the term 'appearance', which was used in discussion of the theories of Hungerland and Sibley, because in the case of some art forms, notably music, it is not clear what would be the reality of which the appearance would be an appearance. When we listen to music the sounds we hear are both the audible reality

and the appearance. There is nothing else. An 'aesthetic object' as I use the term is a sub-class of 'perceptual' or 'phenomenal' objects. It comes into actuality when a suitable observer contemplates the physical substrate of a work of art in a suitable manner. But its coming into actuality is not necessary or automatic when anyone observes a physical substrate. It is always possible to perceive a physical substrate without becoming aware of an aesthetic object and there are people who are constitutionally unable ever to experience aesthetic objects or whose experience of them is restricted to certain modes.

In the choice of the foregoing terms I do not want to subscribe to a particular philosophical theory or to claim, say, with phenomenologists as against realists some kind of real being for 'perceptual objects', and for 'aesthetic objects' as a sub-class of them. In the complicated and confused terminology of artistic discourse I employ these terms as reasonably neat and concise descriptions of what we know at the level of experience and prefer not to introduce any philosophical implications at all. Some agreed terminology is necessary and the terminology I use could, at some cost—I believe—to brevity, be translated into accordance with any philosophical theory of perception and being.

(3) It is common experience that our appreciation of any great work of art is progressive. We look at a picture repeatedly. We attend many performances of dramatic or musical compositions, or we observe and enjoy the same performance repeatedly in the case of a film (which is a single unique performance) or a musical performance which is recorded on tape or gramophone records. In such repeated contacts with a work of art our experience does not remain uniformly the same as when we smell a rose for pleasure or enjoy a fine claret. As familiarity increases we come to know the work better, our insight into it is enhanced, we see more in it, become more fully aware of it, our experience of it is enriched. In the terminology I have used, the 'aesthetic object' which is actualized in our awareness is progressively changed. I want now to show that this change in the aesthetic object is an actual change, not just a metaphorical manner of speaking, that it takes place in the direction of greater clarity and discrimination, from the relatively indeterminate to the more fully determinate, and that it is irreversible.

I have spoken of the sudden and dramatic change which takes place in the content of vision at the point when 'depiction' emerges, between

what we see when we look at a Van Gogh from close at hand as a welter
of blobs and streaks of pigment and what we see when we look at it
from some ten feet away and become aware of, say, an apple orchard.
This is not in itself an aesthetic change: the same sort of change takes
place when we look at pictures which are not works of art and even
some advertisement hoardings must be seen from an appropriate dis-
tance before we become aware of what they depict. Becoming aware of
the depiction is a necessary step towards aesthetic experience of a
picture but is not restricted to aesthetic experience. I want now to notice
an equally dramatic change which sometimes takes place in the depicted
object when we are looking at a canvas from an appropriate distance
away and when we see it first as a puzzling and meaningless assemblage
of unrelated areas and shapes then suddenly, without physical move-
ment on our part, the shapes may cohere into an ordered and consistent
system of inter-related patterns, with articulated planes, perhaps reces-
sion into depth, inter-acting colours and rhythmical movements per-
vading the whole. It is crucial to understand that this represents a real
change in the object of vision. We are not using a metaphor or a manner
of speaking when we speak of change. It is not a matter of seeing the
same visual object differently, as we may see different aspects of a
material thing: the content of our visual field, our visual experience has
in sober fact become different. And this may occur without any change
in the material thing that is there before us or any change in the position
of the observer. To bring about such changes of the right sort is a major
part of the art of appreciation.

I have spoken of the 'dramatic change' which takes place when we
'suddenly' see the aesthetic object as a unified system of interrelated
shapes and patterns instead of a chaotic welter of meaningless impres-
sions. This is an experience with which all connoisseurs are familiar.
But the change may, of course, be gradual rather than sudden. Or an
experienced observer may from the start see the picture as a coherent
aesthetic object and the changes which take place in his experience of
the art work as a result of repeated commerce with it will take the form
of gradual enrichment and a more complete apprehension of recondite
aesthetic qualities. With people who are not gifted for aesthetic appreci-
ation it commonly happens that no such change takes place at all. They
see the picture as a depiction—it is for them a picture of a field of such
and such a size, with so many cows, so many trees, in such and such

spatial relations to each other, and so on. It is not seen at all as a pattern of shapes and forms. No aesthetic object emerges. Such persons are unaware of their failure to actualize an aesthetic object and are notoriously difficult to convince that they have had no visual experience of (have not seen) the work of art about which critics and connoisseurs speak to them. This is why discussion between those who see and those who do not see is usually futile; unknowingly the two parties are speaking of different, and incompatible, visual objects.

It is not only in aesthetic seeing that changes come about in the visual object without corresponding changes in the physical thing to which attention is directed. Our ordinary perceptual experience is vague, imprecise and jejune, keyed to the practical needs of life. When a situation is familiar the slightest perceptual clues suffice for object recognition and in the stress of practical affairs we do not bring to awareness more detailed perceptual data than we require. We do not notice exact shapes, attend to the exact sonorities and rhythms of sounds. Most people see colours as bright or dull but don't trouble to distinguish shade, hue, intensity, saturation, luminosity, and the other qualities which colours have. In describing this sort of thing it is usual to say that we did not notice or did not attend to what we saw. And for many purposes such language serves well enough. But it is a more accurate statement of experience to say that the perceptual object of which we were aware, our perceptual experience, was in many respects indeterminate. It is no more than a fiction arising from latent philosophical presumptions to suppose that our perceptual experiences are always determinate, as the physical things which are their source are determinate, and that they seem indeterminate only because we fail to notice many things about them. In this respect the phenomenological philosophers are closer to our present aim of describing experience without introducing unacknowledged presuppositions into the description. In the words of Merleau-Ponty: 'We must recognize the indeterminate as a positive phenomenon.'[2] He points out that for the first nine months of their lives infants see the world only as coloured or uncoloured; later comes the distinction of coloured areas into 'warm' and 'cold'; later still the separation into hues. It would make little sense to say that young children do not notice or do not attend to what they 'really' see. A perceptual experience which comes indeterminate into awareness is an indeterminate experience not a determinate experience imperfectly

attended to. A visual experience is what it is in awareness: we can compare it with qualities of the physical stimulus which was its occasion, but we cannot sensibly compare it with some hypothetical unnoticed experience which did not penetrate to awareness. There are persons so perceptually obtuse or so uninterested in perceptual experience for its own sake that they never clarify their perceptions beyond the bare requirements of practical life and it is correct to describe their perceptual objects, that of which they are aware in perception, as permanently indeterminate like a world seen through a haze of fog. Others constantly clarify and interrelate their perceptions for the sheer joy and exaltation of perceptual experience itself. Aesthetic perception is a process of clarification, rendering the indeterminate determinate in directions which will be more fully described.

When a work of art is successfully apprehended in appreciation the new aesthetic object which is actualized to awareness is perceived with more lucidity, as if a caul had been removed from in front of it. It is sharper and more vivid in detail as if it had been removed from the periphery to the focus of vision and it acquires a structure by which it is compacted into a unified configuration. Relationships, patterns, and higher-order qualities which before had been invisible leap into prominence and become organized into the whole. Though much more complicated and more intricate, the process is akin to what happens when from seeing a picture as a chaotic assemblage of unrelated colours and shapes we see it as a coherent whole with new structural and expressive qualities permeating the whole. The crystallizing out of the aesthetic object and its subsequent enrichment are a one-way process. The analogy of the duck–rabbit figure, which has been popular with philosophers since Wittgenstein, is misleading rather than helpful. When we look at an ambiguous drawing which may be seen either as a duck or a rabbit, both perceptual objects are at the same level of complexity and we switch from one to the other with a jerk, never seeing both at the same time. Neither object is a development or enrichment of the other and the process is reversible. In appreciation, on the contrary, the aesthetic object which is actualized is an object of a different category. It will be better articulated, more fully determinate and more unified than that which preceded it. It is richer and more complex in that earlier ways of seeing are not simply superseded but are taken up into and exist alongside the seeing of the aesthetic object. And the

process is irreversible; once the aesthetic object is actualized there is no switching back.

Appreciation, then, consists in bringing an appropriate aesthetic object into awareness to the fullest possible degree on the basis of the material thing or 'happening' to which we are attending. In previous writings, as here, I have used the word 'actualization'—making actual what is latent or potential—for this process. Roman Ingarden, who discusses the same thing, uses the word 'concretion' in order to emphasize that the process of actualization is one of rendering the indeterminate determinate or concrete.[3] What we mean by a work of art is, then, an entity which provides a more or less lasting possibility for a number of consumers to make such actualizations or concretions on the basis of a material thing or a series of physical 'happenings' which are the existential substrate of the work of art.

(4) Aesthetic experience, it has been said, comes into being together with a particular posture of disinterested attention when, extricating ourselves for the moment from our practical and theoretical involvement with our environment we attend to the quality of experience for its own sake. Any single thing, any simple quality of shape or colour or sound, any perceived relation of fitness or congruence, or any expressive quality such as the gaiety of a field of daffodils ruffled by the wind or the slender majesty of a birch, can become the object of an experience which we call aesthetic. Such incipient aesthetic commerce with the environment enters into the daily experience of many people, although for the most part subordinated to—if not swamped by—the more clamorous claims of living. Yet such experiences, although incipiently aesthetic, cannot properly be regarded as contemplation since they are necessarily short, fleeting, and incapable of development: even when they are highly pleasurable, so that we welcome their recurrence, they cannot hold our attention for long or command complete concentration of our faculties: if we try artificially to keep our minds fixed upon them, we find ourselves either beginning to think about something else, making comparisons and drawing analogies, indulging in a train of private associations, reminiscences, and imaginings, or attention lapses willy-nilly. This has been described in Chapter 2.

Aesthetic contemplation needs an object adequate to sustain it. Like all aesthetic experience it is a cognitive faculty consisting of direct or intuitive awareness of its object and excluding analytical reasoning, the

drawing of inferences, conceptual classification and other forms of thinking *about* the object. It differs from the more elementary moments of aesthetic experience in that it is deliberate, sustained, involves a more than ordinarily intense effort of concentration and in favourable circumstances it is capable of indefinite enrichment. Of all the things we know in the world around us works of art are for most people those most propitious for sustaining successful aesthetic contemplation and I have suggested earlier an analogy between the spontaneous moments of casual aesthetic vision which occur to most people and the moments when an aesthetic object emerges to awareness in the actualization of a work of art, when we see a material surface, hear an assemblage of sounds, not as a haphazard aggregate of unrelated units within the sensory field but as an organized system of unified configurations. The actualization of a work of art is, however, a much more complex matter than has sometimes been supposed, occurring at several levels of perception simultaneously, and I propose now first to illustrate this complexity primarily from the sphere of visual art, and then to draw certain conclusions about the relation between the actualization—the bringing into awareness of what I have called an 'aesthetic object'—and the vaguer notion of the enduring work of art which affords the possibility for such actualizations to be made. In a subsequent section I shall discuss in more detail the special manner of perception and attention which are necessary for a physical object or happening to emerge into awareness as a unified system of perceptual configurations.

When we see a picture *merely* as a 'depiction' (whether it is representational or not) the sensory qualities of the material pigmented canvas are irrelevant and tend either not to be noticed or to be noticed only as a disturbing factor. This occurs chiefly when we look at a picture with interest only in the information it conveys or when an aesthetically imperceptive person is interested only in seeing what it is a picture *of*. But when we look at the picture as an aesthetic object we see it simultaneously *both* as the surface of a material thing and as a depiction having qualities which are not attributable to the material surface. The material medium does not become wholly 'transparent'—lost to notice—but contributes to the total impression. So too when we read a newspaper article or a scientific pamphlet we attend to the meaning of the sentences and do not notice the words (we may even be unaware of the language in which they are written); but when we read poetry the words cease

to be wholly 'transparent', they are noticed in their own right—their sound, rhythm, personality, associations obtrude to attention in some degree even while the meanings shine through them, and they have a sensory substance of their own. The perceived qualities of the physical surface contribute to the sensuous quality of a painting and this is the case even when they are apparently least obtrusive. The immaculate smoothness of tempera, the luminous enamelled brilliance of a Persian miniature, the porcelain smoothness of an Ingres, the loaded brush-work of Velasquez, and the deliberate texturing of a Pollock or a Tobey each has its own character which is not lost to sight in the aesthetic impression of the whole. The physical picture surface, seen simply as the surface of a material object (pigmented canvas) and neither as a depiction nor as a representation, has expressive qualities and is automatically described in emotional expressive terms in the language of criticism. Its expressive influence is never wholly absent when we see a work of art as an aesthetic object and in some cases it may be a primary instrument of expression. The expressive qualities of the material surface may combine with and enhance those of the depiction and the emotional qualities of the representation or in other cases they may enhance by contrast or contribute an air of piquancy and strangeness. The deliberate suppression of expressive qualities in the material surface of Picasso's *Guernica*, for example, heightens the terrible anguish of the 264–5 symbols and the tortured, desperate brush-strokes of Van Gogh contribute a feeling of perfervid intensity even to his most idyllic subjects.

The fundamental importance of the material surface has usually been neglected in theoretical discussions, although it is familiar enough to practical criticism, and it will perhaps be helpful to give an example of how it works. I shall quote a comment by René Berger on Renoir's *Le Moulin de la Galette*, one of the most highly reputed paintings of the Impressionist school.[4]

In its material aspect, the paint appears as an agglomeration of strokes—long or short, broad or narrow, closely packed or separate, but all in harmony with each other. Treated thus, it is not unlike wool that is being carded, a comparison that is all the more useful in that it takes account of the impression which is offered to the sense of touch; might one not say that it is full of little tufts of variable thickness, which have not yet been gripped in the loom —tufts which preserve the quirks of the original fleece? The wool is supple and abundant, smooth and fine-textured. This is a tactile property.

The physical appearance of the pigmented surface has not *only* an expressive function but links intimately and inextricably with the aspect of the picture as depiction and can by no means be divorced from its representational character. Of the same picture Berger writes:

Taken over-all, the paint is fairly thin, a film that scarcely covers the canvas, but this fluid pigment is applied in a very special manner. Note, for example, the brush-strokes of Margot's pink dress and on Solarès's trousers—like handwriting that is sometimes upright and sometimes sloping. In this way the silhouette is expressed without use of outline; by simple changes of angle, the touch of the brush fills it out, without going round it and without compromising the continuity of colour—just as the direction of the threads in certain fabrics produces perfectly discernible decorative motifs . . .

Proceeding like this, with wisps, firm strokes and flecks of paint, Renoir discovers new material qualities in painting. For him its purpose is not to evoke the delicacy of woman's flesh, the roughness of bark, the weight of a bench or the soft bloom of a human face; it renounces habitual associations to adopt qualities of malleability, transparency, lightness and fluidity which invite both creatures and objects to enter a new life.

In this picture Renoir has created a strange, almost magic picture space, which despite its unreality strikes with the impact of reality and an immediacy of presence. He has done this by using linear perspective —the more distant objects are reduced proportionately in size according to classical principles of perspective vision—but abandoning aerial perspective. In the distance objects—or rather the pigmented areas which represent objects—are more precisely outlined, more varied and intense in luminous colour and more individualized than in the foreground areas. To this effect the material texture of the pigmented surface makes an essential contribution.

When we examine the foreground figures closely, we observe that, although their stature is relatively larger, their outlines are relatively vaguer, that Renoir has muted their colours, and that he employs here a fairly limited colour range. In the second plane the figures are proportionally reduced in stature, but one notices that they are more firmly drawn, that the colours are heightened with luminous accents here and there (as on the straw hats), and finally that the scale of colours is extended, (for example in the two different blues of the striped dress). In the background, figures and objects—though reduced to a mass of indistinct patches—are far from disappearing as one might expect, but—on the contrary—are even more distinctly affirmed, not so much by drawing as by colours which assert themselves in a positive way.

Similarly, it can be seen that the paint is rather fluid in the foreground, that it gets somewhat thicker in the second plane (on Margot's dress and the straw hats), and that in the background it is applied in crisp little strokes that really stand out from the canvas.

The appearance of the material pigmented surface has become of increasing concern to some schools of painting during the last thirty or fifty years and some artists (Pollock, Tapiès) have given it predominant importance in their works. But the creation of an interesting physical texture is not sufficient of itself to produce a picture and one may perhaps say that aesthetic contemplation begins when the material surface is seen concurrently with the depiction.

At the point where depiction emerges the picture is seen as an assemblage of areas which fall into sets of interlocking patterns which are linked by formal relations of harmony and tension, balance, symmetry and contrast, with rhythmic repetition, echoing and compensation. Patterns are formed and related by similarities and contrasts in a variety of respects—spatial contiguity or separation, repetitions, likenesses, remote echoes or contrasts of shape, of colour, of tonality or of texture. Any and every sensory quality functions in the creation of pattern. The mechanism of this pattern formation has not been systematically studied although much useful spade-work has been done in such works as *Foundations of Modern Art* by Amédée Ozenfant, in some of the writings of Kandinsky, in the pedagogical writings of Paul Klee and in the books *Painting* and *Drawing* in the series to which this book belongs. The actualization of the work of art consists in apprehending these patterns in various modalities as a system of hierarchical configurations unified organically by over-all qualities. The point I wish to make here is that every picture exists as an organized configuration of flat patterns of lines and shapes in the picture plane or in planes very close to that of the canvas surface and simultaneously as pattern in a notional three-dimensional picture space. In some pictures the structure of two-dimensional pattern is more prominent—one thinks of Romanesque and Gothic manuscript illustrations, Persian miniatures and some abstract paintings by Stella and Vasarely. Matisse usually makes emphatic use of two-dimensional patterning and since Cubism it has been a dogma of certain schools of modern painting to organize their pictures in two-dimensional pattern so as to preserve intact the picture plane. Other styles of painting—and notably those done in the Renaissance tradition of

naturalistic perspective—give prominence to three-dimensional pattern formations with the illusion of pictorial depth and many are constructed on a scaffolding of interlocking pyramids going back in depth on a receding horizontal ground plane. The areas which form the units of pattern tend to convey the impression of sculptural solidity and existence in three-dimensional space. When two-dimensional pattern is prominent the pattern units and their lines of interconnection tend to be closely related to the over-all shape of the canvas; pictures constructed primarily in three-dimensional pattern have often greater independence of design, the frame which limits the canvas having a function analogous to that of a barely noticed window-frame through which a scene is observed.

But whichever modality predominates *every* picture is an organization both of flat pattern and of three-dimensional pattern in an illusory picture space and every picture must be actualized in both modalities simultaneously. The two pattern systems interact, merge and conflict; their interplay adds to the aesthetic richness of the actualization. It is important to understand that at this stage all actualizations are not compatible and all cannot be realized simultaneously. There are logical incompatibilities, which have been noticed from time to time. For example, a particular area of colour—say a single brush-stroke—cannot logically be a part of the seen surface of a physical object (pigmented canvas) and also an area in a flat pattern of a depiction lying within the same plane as the canvas and also at the same time an area in a three-dimensional pattern carrying it into a plane far behind the plane of the canvas. Yet these logical contradictions do not in fact apply in perception. We see *configurations* in each case and we may—aesthetically we *must*—see the picture simultaneously as a configuration of textured surface, as a configuration of flat pattern and as a configuration of deep, three-dimensional pattern; and the same pigmented area is seen differently as it forms part of various configurations. Similar complexities arise as patterns are constructed in terms of shape, colour, texture, line, and so on. What is seen simultaneously and appreciated as contributing to the complexity of the total actualization is not always or necessarily theoretically reducible to the strict laws of logical coherence. On the other hand there are *practical* limitations to the possibilities of simultaneous actualization which do not necessarily arise from logical incompatibility. It is no doubt impossible to perform a Beethoven sonata in

such a way as to give ideal expression at once to the melodic line, to the contrapuntal intricacies and to the dramatic force. Emphasis on the one aspect can only be at the expense of the others. Some virtuosi are notable for the clarity and perfection with which they bring out the dramatic qualities, others for the lucidity and logic which their performance demonstrates for other aspects. Our conception of the work of art—the sonata which is not identical with any one performance but underlies them all—is a composite concept taking in both the performances we have enjoyed and our own ideas of how these performances fell short of perfection and the insights which each revealed.

When a picture is seen not only as depiction but as representation there emerge other sources of enrichment too manifold to deal with in detail, though some of them have been hinted at already (Chapter 6). They fall into two main groups. The emotional associations which attach to the subjects of representation are stirred to activity and overtly or subliminally colour the emotional and expressive qualities apprehended in the depicted pattern configurations. New dimensions of imaginative identification and empathy give fullness and body to the actualization of the art work. On the other hand, on a more formal level, as has already been said, representational meaning changes the prominence and emphasis of particular shapes and areas from which the configurations are constructed. As *pattern* we see the spaces as important as the figures: as *representation* we see figures with unformed spaces between them. These are both legitimate and necessary ways of seeing, which though logically incompatible combine with mutual enrichment in the aesthetic apprehension of pictorial art.

In the case of the arts of performance a twofold actualization is built into their appreciation. A performance involves interpretation and as it were a practical actualization of the recorded work on the part of the performers (or the producer). The performance itself must be actualized in attention and awareness by the audience. The audience achieve a conception of the art work by extrapolation from a number of performances, real or imagined, no two of which (except in the case of film) are exactly identical. It is not possible to see exactly the same performance twice—though in the case of music this restriction has been to some extent overcome by the gramophone recording of the performance. As each performance necessarily emphasizes some aspects of the art work at the expense of others, the observer can apprehend in appreciation

only those aspects which are brought to prominence in each perform-ance.[5] This situation contrasts with that which pertains with literature, painting, sculpture, and architecture, where the observer can have re-course repeatedly to an unchanging material substrate and ring the changes for himself in his mode of actualization.

Roman Ingarden makes the important point that there is no one legi-timate actualization of a work of art, no single 'correct' reading of a poem, rendering of a musical score, way of seeing a picture. There are *incorrect* actualizations: actualizations which do violence to the art work, which arise from false apprehensions of some of its features, which strain or distort others, fail to notice still others, or which incorporate personal fantasies, images, associations of the observer that have no adequate grounds in the work itself. But within the ambit of any con-siderable work of art there is a large, perhaps a very large, number of possible and legitimate actualizations. What Ingarden calls 'areas of indeterminacy' in the work can be filled out, plenished or made con-crete in a variety of ways, all of which are valid. And as the aesthetic object is a unified configuration, each of the alternative actualizations of its constituent parts has important repercussions throughout. He writes as follows:

Every work of art of whatever kind has the distinguishing feature that it is not the sort of thing which is completely determined in every respect by the primary level varieties of its qualities, in other words it contains within itself characteristic lacunae in definition, areas of indeterminateness: it is a schematic creation.

He adds:

To every work of art there pertains a limited number of *possible* aesthetic objects . . . we speak of possible aesthetic objects only where the concretions of a given work involve faithful reconstructions of it and also the plenishings of the work and the actualisations of its moments of potentiality lie within the boundaries indicated by its effective qualities. These concretions may differ among themselves in various respects because a work of art admits of diverse ways in which its areas of indeterminacy may be filled out and con-creted: some of these plenishings harmonize better and some worse with the fully articulated moments of the work and with the rest of the implementation of its indeterminacies.

We are all chiefly familiar with this in the reading of poems. We do not go to the critics to confirm our own 'reading' or to learn the right

from the wrong, but in the hope that from their suggestions our own apprehension may be deepened and enriched. We 'see more in it' and in the course of time—perhaps much time—our appreciation matures, our vision becomes more profound and our awareness is extended to embrace a more and more meaningful, complex and multiform object. The same thing is true of music. We hear many performances of the same composition and from each performance we hope for new insight, for the revelation of hitherto unperceived possibilities, for the actualization of latent potentialities of structure and expressive relations. When further performances no longer expand our apprehension by the revelation of new 'concretions' we tend to become bored and say we have 'outgrown' this music. Similar principles pertain in the appreciation of visual art. Interpretations, or ways of seeing, are as many as there are connoisseurs. Criticism is valuable for appreciation in so far as it suggests new things to be noticed, new postures of attention and directions of interest, and enables us to see more in the picture, to actualize it in new and congenial ways. Indeed it is nowadays coming more and more generally to be recognized that there is more in great masterpieces of art than was present to the conscious intentions of the artist. In this connection I have quoted elsewhere and quote again here some words of Pierre Boulez, who in *Penser la musique aujourd'hui* (1963) argued that the attempt to interpret a work by tracing the creative processes of the artist cannot lead to finality because

it circumscribes the work within the limits of the composer's creative imagination: a paralysing restriction, for it remains fundamental in my view to safeguard unknown potential which lies enclosed within a masterpiece of art. I am convinced that the author, however perspicacious he may be, cannot conceive the consequences—immediate or distant—of what he has written and that his insight is not necessarily more acute than that of the analytical critic.

Every work of art needs competent observers in order to achieve actualization and to emerge from the dim shades of potentiality. Where there are not such observers the work remains unperceived or misunderstood: in a very real sense it does not become actual. And this is not entirely a matter of individual taste and temperament and education; it depends also upon historical, social, and environmental conditions.[6] In certain historical periods, in certain societies, even within certain

social groups or classes, people have been conditioned to perceive some kinds of art rather than others; they are emotionally in sympathy with some and impeded by prejudice from making sympathetic contact with others. Even today the arts of Egypt, the Cyclades, Archaic Greece, are sometimes written about by scholars as if they were tentative and blundering stages of a progress which culminated in the naturalistic sculpture of classical Greece. Medieval Christian art became invisible after Giotto and Masaccio. From the fourteenth century until the Romanticism of the eighteenth the word 'Gothic' was synonymous with the barbarous, ugly, and uncouth. It was assumed that the medieval sculptors were trying to do what Donatello, Leonardo, and Michelangelo did, that they failed because they were unskilled and lacking in 'science'. The capacity to see and apprehend the Christian art of the Middle Ages was hardly recovered before the beginning of the present century. The thousand years of Byzantine art remained invisible still longer. Hegel, and after him Theodor Vischer, whose *Aesthetik der Wissenschaft des Schönen* (1847–57) in six large volumes set the coping stone on German Romantic aesthetics, thought that 'mummy-like' was an apt description of the 'ascetic and ossified' forms of Byzantine painting.[7]

It is easy nowadays to forget how very restricted was the visual knowledge of those critics of the past whose writings have until recently had most influence on the development of aesthetic theory and critical sensibility. Winckelmann had seen nothing Greek, although his writings became authoritative for neo-Greek taste. The English 'Grecians' Joseph Nollekens and John Flaxman knew nothing but a few vase-paintings not of the best. Shut off from the Middle Ages and blind to almost everything outside, the Romantic critics of the nineteenth century were confined to post-Renaissance European art and only a small segment of that was open to any one of them. Théophile Gautier, who helped to launch the 'art for art's sake' movement in 1835, visited Spain but did not see Italy until he was thirty-nine and was never in Rome. Charles Baudelaire had been neither to Italy nor to Spain and knew nothing of the works of Michelangelo, Masaccio, El Greco, Titian, Hals or Goya apart from what could be conveyed in engravings. In the twentieth century the art of the world has for the first time become available over a wide range. Rapid advances in photography and the techniques of colour reproduction have wrought a change which in

their own sphere is no less momentous than the electric telephone and the internal combustion engine. As with all advances, this one too has had its drawbacks: in making a far greater range of art works accessible to an ever-expanding public it has introduced the temptation, almost the inevitability, that many people not only rely upon reproductions as their source for acquiring knowledge of art works but also fall into the mistake of using them as material for forming their habits of appreciation. Although our experience of art today, whether in the original or in reproduction, is wider than it has ever been in the past, there are still noteworthy limitations of both vision and sympathy. On the score of vision we pride ourselves that we can now direct our attention to those formal qualities which are universal and necessary to all art in all styles and periods, not being distracted by the variable and inessential. Yet the widespread prejudice against narrative and anecdote, against 'literary' content in general, may well blind us to much in the painting of the past which would repay more open-minded appreciation. On the side of sentiment our perhaps exaggerated dislike for the sentimental, the heroic and the grandiose may well put us out of sympathy with much which merits closer contact.

Ingarden has written as follows about the fluctuations which art works undergo with the swings and changes of taste:

The emergence of the possible concretions of a work of art obviously depends not only on the work itself but also on the presence of competent observers and on its being apprehended by them in one way rather than another. This in turn depends on various historical conditions. Hence any work of art (and this operates differently for the different arts) passes through various periods of brilliance, that is periods in which it attracts frequent and correct aesthetic concretions, and other periods when its attractiveness is weakened or even disappears if it is no longer 'legible' to its public. Or again it may meet with observers who have a completely different manner of emotional reaction, who have become insensitive to certain values of the work or frankly hostile to them, and who therefore are unqualified to produce the sort of concretion in which these values shine forth and act upon the observer. When this happens the work of art is not only unreadable but as it were dumb.

The study of these ebbs and flows of appreciation constitutes the history of taste, a discipline which has been too little seriously pursued except

occasionally in the context of sociology. The assumption which has dogged sociologists of art since the eighteenth century that by taking some sort of a statistical average they will be able to arrive at a norm or standard of correct judgement is misconceived. But the 'pure' history of taste such as was initiated by F. P. Chambers in the 1930s can be of substantial help in laying a basis for a wider preview and predisposing a person to break out from the narrow parochiality of time and place by which most people are conditioned in matters of taste. In this way by imaginatively savouring and testing other habits of attention than one's own it is possible to enrich and expand one's powers of appreciation.[8] But it is an excessively difficult matter to know how either to reconcile or to decide between conflicting judgements of taste whether the conflict is between two historical eras or between contemporary critics of apparently equal experience and sensibility.

In developing one's own powers of appreciation no precise rules can be given. It is perhaps well to concentrate upon a sector where a person's sympathies spontaneously lie and to expand experience by extending the periphery. In making contact with particular art works no single rule is more important than that of flexibility and complete adaptability to the demands of each work. Appreciation is a matter of seeing what is there—all that is there. Imagination is needed of the sort which facilitates rapport. But the active fantasy which puts imaginary subjects into an abstract as we see pictures in the dancing flames at dusk is quite foreign to the art of appreciation. That art demands the strict subordination of all that is personal and fanciful, and a willingness to be subjected to the art work. To see what is there to be seen is not an easy thing but the most difficult of all, requiring practice, experience, and a rigid discipline over the individual whim and wish. This is how a modern painter describes his experience of Bruegel's *Mad Meg*:

I sat on a bench in front of the Bruegel and let it, as it were, take over. At first I had a sense of confusion in the design; I seemed to be distracted by apparently unimportant accents of colour, and sharp contrasting lights and darks attracted my attention in a disturbing manner that I did not remember. I realized that I was looking afresh at the painting and discovering qualities which were there before, but which I had missed. You never know these great works entirely, for they have inexhaustible depths in them. As I continued looking, the complicated mass of content began to settle into a vast, but very simple plan.[9]

(5) In Chapter 4 the discussion of formal aesthetic qualities was postponed and it will be convenient to take it up here in conjunction with a fuller elucidation of the aesthetic contemplation of works of art.

It has been said that aesthetic contemplation requires an object adequate to sustain it. Ideally such an object must be capable of being organized into and apprehended as a single configuration of contained patterns and the perceptual object must be sufficiently complex both in the particular qualities of the contained patterns and in the emergent properties of the over-all configuration so that percipience can be extended to capacity and prolonged or repeated attention can be sustained without loss or weakening of interest and concentration. (I am taking visual and auditory experience as exemplary, but what is said will apply in principle also to the kinds of apprehension which come into play when we appreciate a poem or a novel or enjoy a mathematical theorem or a chess problem for their beauty and elegance.) The perceptual object must be capable of being apprehended as a single over-all configuration because otherwise, to the extent that we attend to it as a plurality of configurations standing only in external relations to each other and unless these contained configurations are apprehended as perceived elements in a high-level configuration, to that extent our apprehension of the object of attention will not be aesthetic but theoretical or discursive. A configuration of pattern is perceived with emergent qualities not present in its unitary parts, with a *character* of its own, and when we speak of the formal aesthetic qualities of a work of art we refer to the emergent qualities of the higher-level configurations which are actualized in awareness when we contemplate the work aesthetically. What cannot become an aesthetic object in contemplation is a group or aggregate of simultaneously perceived pattern units which do not unite into a single configuration with directly apprehensible emergent qualities. For as soon as we become aware of two or more pattern-groups related to each other but not assimilated into a higher embracing configuration, we build up knowledge discursively about them and our experience is contra-aesthetic. Equally resistant to aesthetic apprehension is a pattern which is wholly analysable perceptually into such discursive elements and their relations—a pattern, for example, such as the Union Jack. In order for an aesthetic object to be actualized two things are necessary: first the material substrate must be such that it *can* be organized perceptually in the way that has been indicated;

and, secondly, the observer must be competent to apprehend it in this way.

In order to obtain a clearer insight into the manner of aesthetic contemplation, and to understand why some things are suitable to evoke and sustain it but others not, it will be useful to compare in rather more detail aesthetic percipience with practical or scientific perception. The contrast goes back a long way in European thought. The concept of scientific perception may be illustrated from Hume's notion of 'delicate taste'—although strangely enough he thought he was describing *aesthetic* percipience. In the essay 'Of the Standard of Taste' he introduces a story from *Don Quixote*. Two kinsmen of Sancho Panza were called upon to give an opinion of a hogshead of wine. One of them 'tastes it, considers it; and, after mature reflection, pronounces the wine to be good, were it not for a small taste of leather which he perceived in it'. The other also approved of the wine but distinguished in it a taste of iron. There was found at the bottom of the cask an old key with a leather thong attached to it, and thus both wine-tasters were vindicated. 'The great resemblance between mental and bodily taste', says Hume, 'will easily teach us to apply this story. . . . Where the organs are so fine as to allow nothing to escape them, and at the same time so exact as to perceive every ingredient in the composition, this we call delicacy of taste, whether we employ these terms in the literal or metaphorical sense. . . . It is acknowledged,' he goes on, 'to be the perfection of every sense or faculty, to perceive with exactness its most minute objects, and to allow nothing to escape notice and observation. The smaller the objects are which become sensible to the eye, the finer is that organ and the more elaborate its make and composition. A good palate is not tried by strong flavours, but by a mixture of small ingredients, where we are still sensible of each part, notwithstanding its minuteness and its confusion with the rest. In like manner, a quick and acute perception of beauty and deformity must be the perfection of our mental taste; nor can a man be satisfied with himself while he suspects that any excellence or blemish in a discourse has passed him unobserved. In this case, the perfection of the man, and the perfection of the sense of feeling, are found to be united. A very delicate palate, on many occasions, may be a great inconvenience both to a man himself and to his friends. But a delicate taste of wit or beauty must always be a desirable quality, because it is the source of all the finest and most innocent enjoyments of

which human nature is susceptible. In this decision the sentiments of all mankind are agreed.' Hume thinks of beauty as an aggregate of all the particular excellences and blemishes which highly discriminating perception can detect; these excellences and blemishes are conceived as particular qualities among the many other qualities which the object possesses. A man of taste is one with acuity to detect and discriminate them as a wine-taster detects the smatch of a foreign flavour in a hogshead of wine.

Hume's way of thinking was in line with that of associationist psychology, which shared a common conceptual outlook with atomic physics. Perception was pictured as a chaotic welter of 'molecular' sensations conceived as neutral and featureless in themselves on the analogy of the physical atom and detectable if at all only by the utmost acuity of the sensory organ. The wealth and variety of perceptual experience was explained by hypothetical combinations among these atomic, imperceptible sensations in accordance with supposed general laws of association. It was an outlook which encouraged the pursuit of ever more minutely discriminable units of perception at the expense of interest in the actual qualities of experience. Its ideal and culmination is the pointer reading of physical science, where the human element and the direct apprehension of sensory content are eliminated in the interests of exactness. This is not a valid paradigm of aesthetic percipience, in which the felt content and the uniqueness of living experience are all-important. Precise and exact discriminations among particular units of sensation are not enough for aesthetic awareness: it does not have that character. The person with an exact ear for pitch is not necessarily a good critic of music or a sensitive musician. You cannot appreciate beauty by aggregating excellences and blemishes each of which is imagined under some 'general rule of beauty' in the Humian way.

A model of perception quite opposite to Hume's was expressed by the Abbé Dubos, who in his *Réflections critiques sur la Poésie et sur la Peinture* compared our feeling for a work of art with the enjoyment of a ragout: in neither case do we analyse and isolate the various sensory ingredients in separation but we savour and give our verdict upon the 'emergent' taste of the whole. This idea of perception, which is much more congenial to aesthetics, goes back to Leibnitz, who in his theory of monads held that perception is not mere passive receptivity but the central activity and being of every monad, the point at which the

potentialities of its own nature are crystallized into actuality and the universe reflected in it. Perfection, he said in his paper *Von der Weisheit*, is the actualization of potentialities leading to something over and above normal healthy activities, as illness is a deficiency.[10] This tradition was implicit in the writing of Alexander Baumgarten (1714–62), who regarded the apprehension of beauty as perfected perception.[11] In keeping with this idea Baumgarten contrasted the vital fullness of perception which is caught and communicated by the artist and the poet, retaining all the richness of the original experience, with the analytical and discursive methods of science. By breaking down experience into its elements, searching for physical laws and causes, analysing and generalizing, much useful practical knowledge is gained: but the wealth of original experience is dissolved. Geologists can tell us much in a scientific way about the landscape we see, but in the process the landscape has disappeared. Conceptualization and reduction to law sacrifice the life of experience by reducing it to those features which are common and repetitive, but aesthetics is the science of experience as given and as perfected by fullness enhanced.[12]

When we look at a colour reproduction we do not examine with a magnifying glass each almost imperceptible dot left by the printer's screen, but we stand back and see the general effect. We cannot hear a melody by listening to each note separately on so many different days; we must hear the whole in our minds and perceive it as a whole. This is the principle of configuration. It is the sort of perception which in earlier writings I have called 'synoptic' vision. By 'seeing the whole thing together' we become aware of over-all or configurational qualities; qualities which do not belong to the elements seen in isolation but 'emerge' when we see the presentation as a unitary whole. Nevertheless when we take up the synoptic attitude of attention to a work of art, attending to it aesthetically as a configurational whole and bringing to awareness its configurational properties, when we savour instead of analysing the taste of the stew, we are not less but more alert to the detail. Because the finer elements are seen not in isolation but in the context of a configurational pattern to which they contribute we are more not less sensitive to minute discriminations, failures of fit, deviations from a larger expressive or structural plan, or subtle relations of harmony and contrast. Wittgenstein remarked that in an expressive pattern a very minute deviation will be noticed if it changes the expres-

sive character or if it is out of key with the expressive quality of the whole. Our percipience is more not less acute in such cases. And, as Ehrenzweig has demonstrated, the same thing is true when we discern over-all structural or formal qualities.[13] When we perceive configurations in ordinary life and attend to them for the practical purpose of recognition only, it is the over-all structure or the expression that we notice, not the details. We recognize a friend's face by the general conformation without noticing the colour of the eyes or counting the pimples. We may be struck by an expression on a stranger's face and notice very little else about it except the expression. When we see a figure against the skyline at dusk we will recognize it by the posture and the rhythm of the gait. But aesthetic vision is not for the practical purpose of recognition, and when a work of art is fixed in attention and an aesthetic object successfully actualized in its contemplation, both detail and general properties receive their due, neither obscuring the other. Synoptic vision perceives the whole in a single undifferentiated view which takes in the detail as well as the general lines. Attention does not rapidly scan the work detail by detail, relating the separately observed details conceptually to one another; but each detail or part is perceived in the context of the configuration to which it belongs as contributory, while the configurations are perceived as comprising and made up from their component and detailed parts. The process of synoptic vision differs from theoretical apprehension and when one attempts to describe it in coherent, logical language it sounds unlikely or even contradictory. For example, we see a painting both as pigmented canvas with certain surface textures and we see it simultaneously as a field with cows, solid, voluminous and in three-dimensional space. Logically, it can be argued that it is impossible for any small area of the canvas to be seen at one and the same time both as part of a flat surface and part of a solid object distanced in space. Empirically it is impossible to see it so if any small area is isolated from the rest. But we do in fact see the picture as a whole both as flat surface and as a scene in 'virtual' space simultaneously; and this double seeing enhances the aesthetic effect.[14] Because it cannot be fitted neatly into the framework of logical categories of description, Ehrenzweig and others have assumed that the synoptic vision of aesthetic appreciation is a sort of *unconscious* manipulation. But such a view is neither necessary nor plausible. There is no reason why we should expect that a mode of percipience which excludes conceptualization

should itself and in its results be entirely amenable to conceptual description.

The idea of unitary wholes concretely describable in terms of emergent properties which belong to the whole but not to its parts in isolation has been made familiar by Gestalt psychology. There are many affinities between the language used to describe such wholes and the language which formalistic aestheticians use when they try to describe artistic wholes. They too allege that a competent observer looking at a good picture sees an integrated and undivided, though structurally complex presentation manifesting qualities which are not discursively built up from, or analysable into, the qualities and relations of the separable parts observed individually in isolation. In appreciation the art object is isolated from its environment and framed apart for attention, to be apprehended as a single complex individual, not as an aggregate of independently existing parts. For when anything is apprehended as an aggregate it is apprehended discursively as a manifold of externally related parts, each part and set of relations being articulated independently of the whole in which it occurs and remaining identically the same as the aggregate is built up discursively. But an aesthetic object, being an artistic whole, is apprehended in direct acquaintance by a single act of synoptic awareness when the whole and the parts are perceived together and the whole is something different from the sum of its parts. The emergent qualities of the whole permeate and determine the parts and the parts are what they are only in the context of the particular whole in which they are apprehended. The properties of the whole determine the nature and the function of the parts in the sense that if you segregate the parts in perception, their sensible qualities are different from the sensible qualities they display when seen as functional elements in the complete picture.

The metamorphosis of the parts into the whole is not a simple loss of identity. The parts may suffer a more or less violent change when perceived in context. A delicately modelled shape of radiant blue may become an irregular patch of dirty grey pigment when the surrounding areas are covered up so that it is seen alone. But by and large the contained parts of an aesthetic whole have a distinguishable character of their own and the part as seen in the context of the whole will often bear a clear resemblance to the same part in isolation. In certain artistic styles the independence of the parts is even emphasized in order that the trans-

formation which occurs when at first sight disconnected and incongruous elements are apprehended synoptically within a single whole shall have the impact of a revelation. In such cases it is germane to the aesthetic experience that the parts are apprehended simultaneously in isolation as clashing and together as functional elements in the transforming whole. An example of this is the style of 'juxtaposition' as exemplified in the works of Apollinaire, Cendrars, Delaunay, and Gertrude Stein.[15] Musical elements have a distinct identity which recognizably persists out of context to an extent far greater than in most other arts. The same melody or theme may be used by different composers or by the same composer in different compositions and repetition of theme is an important structural device in most musical composition. The repetition is repetition only because the part retains its identity. And yet for appreciation the 'same' melody or theme is qualitatively different each time it recurs. We say that it is different in feeling; but the difference is in fact one of apprehended quality. Sometimes when you return to the street in which you live some unusual quality of light or weather, or a silence, or simply a mood of heightened perceptiveness, will cause you to see it through new eyes with the force of an illumination, thrusting upon you a freshness of beauty which transfuses with glory the hebetudes of familiar vision. I have felt that in fine music the impact of recurrence may bring with it some such revelation of a metamorphosis. Or when the theme re-enters near the end of a movement it may be perceived with the deep sense of familiarity and repose that belongs to childhood scenes revisited in later life. The experience demands both a recognition of persisting identity and the apprehension of contextual transfiguration. But it is an experience which is mediated only by music which we call fine. The music of Telemann and Dussek contains repetitions but rarely revelation.

It goes without saying that every act of appreciation does not achieve the complete unification which has been described. Nor is every work of art so welded into configuration as to permit of the actualization of a fully unified aesthetic object. Furthermore some art forms are susceptible of more tightly knit configuration and others must by their nature be more loosely constructed. Despite all that has been written about the 'form' of a novel, it remains one of the least compactly organized art forms and a great part of the interest of any novel is inevitably extra-aesthetic. A lyric poem is susceptible of more compact structuring than

an epic and a still life can be more tightly constructed than an anecdotal mural. Appreciation must discern the degree of structural compactness and interlocking which is present in every case.

There are, however, two ways in which Gestalt perception of ordinary life conflicts with aesthetic perception.[16]

(i) In ordinary life we see the environment as a world of things standing out against a formless background and separated by empty space; we hear significant sounds against an unnoticed background of amorphous noise. This aspect has been studied by Gestalt psychologists and is regarded as basic to all awareness. 'This difference', says Koffka, 'is fundamental and the figure-ground structure must therefore be considered one of the most primitive of all structures.' Every sensible object, visual or auditory, exists for perception only in relation to a ground against which it is defined. In comparison with the ground against which it appears the figure is bounded, has outline, shape, and structure; by contrast the ground is amorphous, unbounded, shapeless and less definitely structured. In visual perception the ground seems to continue behind or beneath the figure, which stands out in front and hides it. The figure is more prominent and insistent, has more liveliness and vividness, than the ground and in visual perception tends to take on the character of a 'thing'. It obtrudes itself upon and seems to approach the percipient, whereas the ground seems to recede. The figure tends to occupy the centre of attention and to remain in focus, whereas it is difficult to focus attention on the ground without causing it to lose its character of ground. As it has been put, we see things but not the gaps between them.

(ii) Gestalt psychologists have also noticed a 'dynamic' aspect of figure. Leaving aside the influences of education and experience, figures presented in perception tend, it is said, to fall into patterns in accordance with principles of similarity and proximity. But of all possible patterns there is a preference for stable and 'good' Gestalt, a concept based on simplicity, regularity, and symmetry. A closed and complete figure is 'better' than an open and incomplete one, so we tend to see closed forms even when the physical stimulus is unclosed, and we tend to supply the missing parts. Some writers have spoken of an 'urge to completion' and have claimed that an incomplete figure exercises a compulsive influence to be perceived as complete. A perceived figure is said to be always the best possible in the circumstances and in memory it tends to become

still 'better' as it changes in the direction of greater precision, simplicity, or regularity.

The figure-ground principle is operative when we see a picture as a representation. But if we see it *only* as a representation, we do not see it as a work of art and the aesthetic object is not actualized in awareness. We must *also* see it as depiction, a configuration of patterns in the flat picture plane and to some extent organized as well in three-dimensional picture space. And here the figure-ground principle is not operative. It is tied up with our everyday habits of recognition and description and it becomes relevant to aesthetic observation only to the extent to which a picture is seen as a mirror of some segment of everyday perceptual reality. When we first make contact with a work of art it is isolated in attention; recognition is not part of the aesthetic act. Then when attention has been concentrated within the boundaries of the art object the figure-ground process is still held in restraint. We do not see it as so many prominent or significant perceptual chunks standing out against an undifferentiated and unmeaning background sinking towards oblivion on the fringe of attention. When we look at a work of art the 'holes between the shapes' are themselves shapes and visually as important as the 'things' they serve to separate. (Students are sometimes advised to look at a design upside-down so as to conquer the tendency to pay too exclusive attention to the shapes which hold representational significance.) In aesthetic contemplation attention is held evenly distributed over the perceptual object and a part of the effort of concentration demanded of us consists precisely in discounting the figure-ground way of seeing and forcing ourselves to hold it in check. The counteracting of the figure-ground manner of observation is one of the more fundamental aspects of aesthetic perception. Yet in so far as any art work is representational—and when it is so we are bound to include an apprehension of its representational significance in the total aesthetic experience of it—we look at it *as representational* in accordance with the same principles of perception as we employ in ordinary life. A double way of perceiving is brought into play and the total experience is thereby enriched. On the one hand we see the art work as a reflecting mirror revealing an image of some segment of reality other than itself: to that extent we look at the subject as we should look at the reflected reality, with the figure-ground principle operative. On the other hand we look at it as a configuration of presented forms (look at its formal properties,

as is sometimes said) and to this extent we discount the figure-ground principle: the spaces between the figures are as important formally as the shapes of the figures. The latter is often mentioned in popular handbooks. The necessity of seeing the work simultaneously in *both* ways is less frequently alluded to.

Neither is there in aesthetic vision any bias in favour of regularity, simplicity, and precision of form. The 'strong' configurations which, as psychologists claim to have shown, tend to impose themselves on perception are not well adapted for aesthetic manipulation. Precisely because they are so insistent and obtrusive they do not readily combine into larger or more complex unities. Artists do not find it easy to work with regular and symmetrical shapes in the constituent parts of a composition. It requires the virtuosity of a Dürer or a Klee to bring the regular solids into a picture. This is partly because geometrically perfect shapes are too obtrusive—they leap out from the background and kill it, refusing subordination into the total configuration which is the picture; partly also because regular geometrical shapes give rise to 'mechanical' relations which are the delight of the intellect but dull and profitless to perception.[17] In aesthetic contemplation we have to fight against the habit also to convert 'weak' or incomplete configurations into 'strong' or completed ones. This is inherent in seeing the work as a unified whole and it is consistent with the more general principle that in aesthetic contemplation the observer is *receptive*: his task is to actualize what is there, to see what is given to see and not to contribute material from his own fancy. The phenomenon of the incomplete configuration is of basic importance in music. It is discussed by many writers and interpreted in many ways. But what is clear is that we do not *complete* the incomplete configuration in our apprehension: rather do we hear it as *striving* for completion. What we hear, if we are able to listen to music, is the structure of sound that is given.

In contemplation the constituent shapes of a depiction must be noticed for their aesthetic rather than their mensurable qualities. If we are confronted with a square or a near-square we do not, when we notice that it is a square, make a more or less accurate guess that if it were isolated and subjected to measurement, the four sides would measure up equal and the angles would each have 90 degrees. We notice that *in the context of the pictorial environment in which it is seen* it has the aesthetic qualities of squareness—symmetrical stability, equilibrium,

poise, non-directionality, etc. This is true of all the many shapes, actual or implied, which enter into the structure of a depiction—squares, circles, triangles, pyramids, etc. We do not isolate them perceptually and judge them as geometers or engineers but become aware of their aesthetic qualities as contributory to the whole depiction of which they are parts. This is one reason why the geometrical analyses which are sometimes offered to illustrate the design structures of great master-pieces of pictorial art inevitably appear arbitrary and unreal: they invite attention precisely to those mensurable qualities which are not promi-nent to attention when we contemplate the depiction as an art object. Yet this way of noticing the shapes of an aesthetic object is not so far removed from the habits of everyday perception as has sometimes been supposed. In ordinary life too we do not—or do not primarily—see squares and circles, triangles and rectangles, as geometrical figures, judging them like an engineer for the mensurable qualities: we first see them as having a certain character, they make their initial impact for their aesthetic qualities. A much larger element of aesthetic perception than is often thought enters into our everyday descriptions and recog-nitions of the things we see in the world around us.

Similar considerations are important for music, When we *analyse* a musical composition the exact measurable relations of all intervals of time and pitch are recorded. But when we listen to a live performance, actualizing it in attention as a work of art, we are not interested to notice the exact measurable relations as such but rather the intrinsic sensory *character* of the intervals—a character which at the same time remains sensibly uniform and at the same time changes with the context in rhythm or melody or harmony of each occurrence.

The fact that attention is not directly fixed upon the measurable aspects of musical or visual shapes does not, however, imply that we are less alert to minute differences in aesthetic perception than ordinarily. As has been observed, when a shape is noticed as a constituent of an expressive configuration we tend to be more than usually competent to discriminate variations which would ordinarily escape attention.

When we talk, as we must, about the properties of constituent parts of any work of art in order to compare them one with another, contrast-ing, noting similarities and differences and so on, we use the language which is available to us: we say that this line or note is longer or shorter than that, this patch is larger than that, this is darker and that is lighter,

and so on. Such language, originating in our practical concerns with the manipulation of a physical environment, has primary reference to the measurement of physical stimuli. As such it is irrelevant and inappropriate to the perception of configurations. This may be illustrated even outside the aesthetic sphere from standard optical illusions. When I say that one line is longer than another, the straightforward implication of my statement is that if you apply standard measuring techniques to the *physical objects* (the ink marks on paper) which are the stimuli of my perceptions, the one physical object will measure up longer than the other. But in order to apply techniques of measurement you have to remove the lines from the position they occupy together in my visual field, destroy the configuration which is my visual object, and isolate the lines for measurement. Let us suppose that the lines in question are lines in a Müller–Lyer figure.

When I say that one line is 'longer' than the other I am mentioning a character of the phenomenal object which I observe and no amount of measurement can alter the fact that I *do* see the lines as different. This is a true feature of the phenomenal object of my perception. If I isolate the lines from each other by looking at them successively through a cardboard tube which excludes the surround, their appearance will change —they will look 'equal'. But in doing this I have changed the perceptual object, and once I restore this by bringing back the Müller–Lyer figure into my visual field the lines again look different. The fact that the *physical* lines on paper can also be measured up, by bringing one physical mark into contact with the other, and shown to be of equal length as physical objects is irrelevant to 'disprove' the difference I see whenever the Müller–Lyer figure occupies my visual field. For this reason terms whose primary application is to the measurable properties of physical objects are inappropriate for describing perceptual objects. This point is made by Merleau–Ponty: 'The two straight lines in Müller–Lyer's optical illusion are neither of equal nor unequal length; it is only in the objective world that this question arises . . . science forces the phenomenal universe into categories which make sense only in the universe

of science.' If it is irrelevant to ordinary perception of configurations, such language is even misleading in aesthetic appraisals. In aesthetic contemplation we do not deal with fragmented experience or isolate one or the other bit of a presentation for observation and judgement apart from the rest. We are not concerned with the physical measurement of the material things which underlie our actualizations of aesthetic objects. When you are holding a picture in attention for appreciation, if you mention 'that square bit', you do not mean that you have observed the indicated area in isolation from the rest and judged to the best of your ability that if you put a ruler and a set square to the corresponding piece of canvas, that would turn out to be a geometrical square. When we talk about the qualities of works of art we are talking about presentations in perception, not about measurable properties of physical things. The sort of properties we notice in the parts of aesthetic configurations are such as could be more aptly indicated by such words as 'prominence', 'insistence', 'impact', 'obtrusiveness', 'recessiveness', and such relations among parts as 'balance', 'tension', 'fit', 'echo', 'repeat', and so on. We may notice that 'something is out of key here', 'something is wrong there'; we don't affirm that 'this is too long', or 'this is too loud', unless we are prepared to do the artist's job for him and put his work right. The language we have available is intolerably vague for describing experiences which may be extremely precise, and I am not of course advocating that critics should stop using the language they do use in commenting about works of art. They have no other practicable language in which to express themselves. But it is essential to have constantly in mind that the words they use are words whose ordinary implications belong to a different mode of awareness and that unless we remain alert, the remarks which were meant to help us will insidiously lure us away from aesthetic contemplation into a different attitude of attention and a different mode of apprehension.

The coherence of a work of art in apprehension is not simply a matter of formal properties or a unified structure imposed from above. What used to be called composition or design grafted on to inchoate material cannot bring about a unity of aesthetic configuration. Aesthetic material is perspicuous through and through, though it will not lay itself open to the casual and hurried glance. In most of the art forms principles of structure have been to some extent systematized: we have sonata form, fugue, concerto, and the rest. The recognized: stylistic types—Classical,

Romantic, Baroque, etc.—have structural implications. In most of the arts, music and poetry in particular, structural types have to some extent been differentiated and reduced to rule. But good and indifferent or plain bad works are produced in each structural type and in every style: and the difference is *not* simply that the subject-matter of those which are good is more profound or more imaginative than the others. Very profound thought or exciting flights of imaginative insight can be put into formally correct structures and still the result may be aesthetically frigid and worthless. The unity of a work of art which renders it capable of being apprehended as a configuration in expanded awareness results from coherence among any or all of the aesthetic qualities which have been described.

Appreciation and value

In this final chapter I shall discuss what we mean by aesthetic values, what is meant when we say that one work of art is *better*, i.e. more valuable, than another, and the value which is attached by some people to the exercise of a cultivated skill to appreciate fine works of art. First I will summarize what has been said about aesthetic experience and say something further about the element of *enjoyment* which enters characteristically into aesthetic contemplation.

Aesthetic experience is a mode of cognition by direct apprehension and it consists of focusing awareness upon whatever is presented to the senses. It is a basic form of mental activity in so far as sensory awareness is fundamental to all our dealings with the world in which our lives are fated to be spent. We can only manipulate our environment to our needs and desires, whether physically or in thought, and we can only adapt our needs and desires to obduracies of the environment, to the extent that we become directly acquainted with it through our organs of sense. Sensuous awareness is the first step out from imprisonment within the solitariness which is the first penalty of individual existence, and from this step all else follows. Aesthetic experience is an amplification and an intensification of sensuous awareness. In everyday life we indulge awareness in the service of our practical interests but we allow it little latitude beyond that point. Aesthetic experience occurs when we pause in the stream of our practical and theoretical concerns to indulge awareness of some presentation and dwell upon it for its own sake. It is a mode of percipience by which our awareness of the world presented to sensation is expanded and made more vivid.

[margin handwritten note:] pertaining to perception by senses or intellect.

The *aesthetic attitude* is a posture of attention and interest involving detachment from practical concerns. In aesthetic commerce we do not utilize, or do not merely utilize, our presentations as clues to the recognition of things in an objective system of cause and effect or otherwise as mere indications and signs of something other than themselves. We are emotionally detached from the ordinary interests of life, impulses to action being held in abeyance. Our attitude is characterized by what has been called 'psychical distance': that is, instead of perceiving objects in their primary relations to ourselves we apprehend their emotional features (such qualities as menace, comicality, charm, triviality) as qualities of the object itself.

The aesthetic attitude carries with it an implicit tendency to absorption, to become engrossed in the perceptual object. Although aesthetic percipience may partake of the character of feeling, it is characteristic of the aesthetic attitude that attention is outwardly directed upon the object of apprehension rather than inwardly upon our own affective reactions to it.

Anything at all can become an object of aesthetic experience but not all things are equally likely to evoke it or equally adapted to sustain and occupy attention in the aesthetic modes. Works of art are objects specially designed to evoke aesthetic experience and to sustain prolonged aesthetic attention at a high level of concentration.

In *appreciation* absorption becomes deliberate concentration. Its primary characteristic is concentration within the aesthetic posture of attention. It is therefore a mode of percipience. Feeling and emotion may be percipient in their operation. Knowledge, reasoning, analysis, comparison, classification, conceptualization have a function to illumine the object in understanding as a logical preliminary to more adequate and penetrating apprehension in direct awareness.

Appreciation of a work of art involves bringing into being an 'aesthetic object' on the basis of the material thing presented to awareness. For this to be achieved two things are necessary: (i) special attention to supervenient qualities such as intersensory qualities, expressive or emotional qualities and structural or formal qualities; (ii) synoptic apprehension of the presentation as a configurational whole rather than discursive understanding of it as an aggregate of externally related elements and parts. The latter is possible only to the extent that any ostensible work of art is in fact such a unity of configuration. Different

art forms are susceptible of different degrees of unity and compactness of configuration.

Appreciation is an active mental operation, demanding intense effort of concentration in the exercise of skilled faculties of percipience. The indulgence of passive emotional response is not in itself a mode of appreciation. At the same time the state of mind required in appreciation is one of receptivity. The emphasis of training in appreciation is upon enabling a person to actualize as completely as possible an aesthetic object with truth, equipoise, and balance, avoiding idiosyncratic distortions and importations due to individual temperament or interest. Breadth and vigour of imagination are vitally necessary. But imagination must be held in leash and restricted to that sympathetic identification which facilitates the apprehension of what is there to be apprehended. Flights of individual fancy, trains of personal imagery, idiosyncratic thought and association, sparked off by some aspect of the presentation and then given free rein to take their own unguided course, are alluring, delightful, and innocuous. But they are foreign to the rigorousness of appreciation and should not be allowed to obtrude into objective criticism of the arts.

I have used the term *contemplation* for the holding of an aesthetic object in the centre of awareness with continued exercise of percipience. Contemplation involves concentration of attention and engrossment in the object. As contemplation proceeds the parts of the art work become more and more luminous to apprehension in their context within the aesthetic whole. While awareness of the parts is a precondition of apprehending the total configuration, the detailed awareness of the parts does not disappear in the awareness of the whole. The increasing complexity of the aesthetic presentation makes continually increasing demands upon expanding awareness, exercising capacity to the limit. With some qualifications we may say that when apprehension ceases to expand, contemplation in the aesthetic mode is terminated. We are either tired of that work of art—a little bored with it except for sentimental recollections of the pleasures it has mediated in the past—or we occupy attention with theoretical analysis or the accumulation of extrinsic information *about* it—which in turn may (though it need not) lead to further percipience and renewed contemplation.

The inner nature of aesthetic contemplation does not lend itself to anatomization by introspective analysis. Nor is this surprising, since it

[margin note, handwritten:] So what are we experiencing in our aesthetic attitude if how to do nothing with past + present personal experience? See quote p?

is a form of non-discursive percipience which is not transparent to discursive thought or directly expressible in reflective terms. The attempt to describe contemplation of any sort in the language of formal psychology has always run up against the difficulty that to do this involves first understanding processes which are only very partially amenable to the categories of the understanding. In view of the nature of its objects aesthetic contemplation is probably less amenable to such description than other kinds of contemplation. For this reason a number of writers have believed that in contemplation theoretically describable activities are taking place in the unconscious mind and that they are not introspectible because they are unconscious. I do not regard this assumption as a necessary one and I see nothing in it helpful towards reaching an understanding of the nature of contemplation—which is not, of course, to deny that works of art, equally with the drawings of psychotics and most other things that men deliberately do, can among other things be utilized as symptoms for the diagnosis of whatever may lie buried in each man's unconscious mind.

On the whole the Indian tradition in aesthetics has been more concerned with the inner, subjective aspects of appreciation than has been the case in the West. In India both the creative function of the artist and the practice of appreciation are ordinarily regarded as modes of personal devotion demanding systematic mental discipline akin to the various forms of psychic self-control taught by yoga in quest of spiritual enlightenment. The pleasures of art are often likened on a different plane to the delights of sexual intercourse and the stages of appreciation are treated as anagogic, culminating in transcendental bliss akin to the spiritual rapture of mystical or metaphysical union with the Absolute. But the metaphysical and religious framework is common to very much of Indian thought and even apart from it the doctrine of *rasa* is capable of supplementing the rather meagre insights of Western thought.[1]

Before speaking of the concept of *rasa* I will mention two quite general respects in which the outlook we find most prevalent throughout Indian aesthetic thought could well act as a corrective to a too rigorous austerity, a too rarefied exclusiveness, which at any rate until recently have lent a certain one-sidedness to most European aesthetic expositions.

(1) Indian thought regards entertainment as one of the legitimate functions of art at certain levels, despite the very close connection in

Indian tradition between art and religion. This seems to be no more than ordinary good sense. It is in fact patent that every art form has potential entertainment value and every art produces works in which entertainment clearly predominates. There are artefacts to which we ascribe entertainment value only—perhaps they are excellent entertainment—and others towards which we prefer to take up a more solemn attitude as works of art. In practice no sharp line can be drawn between what is entertainment and what is art, where entertainment ends and aesthetic appreciation begins. Many expositions of aesthetics and appreciation—including no doubt the present one—are too solemn and mirthless in tone, even to the point of pompousness. There is certainly much simple and uncomplicated pleasure, much entertainment, to be obtained from a cultivation of the arts without any intrusion of vulgarity or tawdriness. And it may well be that we aestheticians would be better advised to treat entertainment and amusement as a stage towards aesthetic enjoyment rather than something separated in principle from it.[2]

(2) Secondly, Indian thought has seldom lost sight of the fact that the artistic impulse in man is closely allied to the sheer delight in all created things. The *Natya-sastra* of Bharata (*c.* AD 500), which has been regarded as the most important source-book of Indian aesthetic thought, begins with the story that the gods approached the Creator with the request for a diversion which should delight their eyes and ears alike. A modern writer says: 'The conception of beauty is fairly old in India. The Rigvedic poet had revealed in his superb and inimitable manner the beauty of nature and man. The *Brahmana* conceived the whole creation, a brilliant piece of divine manifestation of beauty. The world according to this idea was created out of joy and pleasure, the contributory factors of beauty, And to look at this world was to participate in the enjoyment of this beauty.'[3] Recognition of the joyousness of beauty does not mean a reversion to the rather sordid doctrine of aesthetic hedonism which was repudiated in Chapter 3.

As the aesthetic concepts of classical antiquity were based primarily on handbooks of rhetoric and poetics, Indian aesthetics also was grounded at first on poetics, drama, and dance. The term *rasa* seems originally to have referred to the fundamental quality of excellence in drama. It was extended first to poetry and then to the visual arts. In Abhinavagupta its meaning was transferred from the objective to the

subjective and it became a general term for aesthetic enjoyment.[4] *Rasa* is essentially based upon the contemplation of emotional situations incorporated in art form. It is always pleasurable even if the presented situation displays a painful emotion. It is neither straightforward emotional response nor empathic identification with the presented emotion (see pp. 120–2). It depends upon evocation of basic emotional moods detached from the mundane self of the percipient. These are often called 'universalized' emotions in Indian literature and the state of mind resulting from their apprehension in particular artistic presentations is called self-fulfilment or liberation, leading ultimately to transcendental bliss. The state of mind of the percipient at this stage of appreciation is referred to as serenity or repose. The counterpart in the art work of *rasa* in the percipient is 'suggestion'. The essence of *rasa* is, then, distinct and lucid cognition, such as is not compassable by ordinary processes of knowledge, involving immediate apprehension freed from all obstacles (such as states of mind which obstruct sympathetic percipience: lack of imagination; predisposition to regard the action on the stage as mere historical fact; lack of interest; lack of experience; confusion of the emotion portrayed). *Rasa* itself is a 'relish' which was described by Visvanatha (in the fourteenth century) as a kind of expanding of the mind, also called 'wonder', an extraordinary pleasure inherent in contemplation itself.

Indian aesthetics distinguishes between the process of contemplation and its culmination in supreme insight. K. Krishnamoorthy writes as follows:

When a human situation is artistically presented, usually against the background of nature, the critic does not get himself transported to the peak of . . . repose. Leading up to it are the diverse impressions he is receiving from different angles, almost simultaneously. His imaginative sensibility helps him in reception while his intellect is at work all along sorting them out. When the intellect and the imagination slide into the margin, his heart is moved to an intense aesthetic state of repose which is an end in itself. . . . The critic is simultaneously aware of the earlier appreciation of the parts which finally fuse into *rasa* in one instant. Appreciation of the beauty of individual parts is a precondition for the realization of the beauty of the whole. The total grace of a picture cannot be realized without realizing the perfection of each part, though beauty of the parts is certainly distinct from the total beauty. . . . Thus though *rasa* is involved as the soul of aesthetic experience, and it never

206

loses sight of expert appreciation of the parts, the reverse is not true, as Anandavardhana himself points out. Mere appreciation of the parts will not ensure the appreciation of *rasa*.[5]

The final illumination in which the process of contemplation culminates is likened to the supreme spiritual bliss of the yogic experience in oneness with the Absolute. S. K. De adds:

> The last step in this idea was taken by the attempt to bring poetry to the level of religion by likening aesthetic enjoyment to the ecstatic bliss of divine contemplation. Visvanatha sums up the idea briefly thus: The *rasa*, arising from the exaltation of purity, indivisible, self-manifested, made up of joy and thought in their identity, free from the contact of aught else perceived, akin to the realization of Brahma, the life whereof is supermundane wonder, is enjoyed by those competent in inseparableness (of the object from the realization thereof) and, as it were, in its own shape.[6]

In his study *Yoga* (1959) Ernest Wood illustrates what is meant by yogic ecstasy or rapture by the example of aesthetic contemplation, and his account of the aesthetic experience is so closely in accordance with that which we have been describing and so clearly stated, that a final quotation is justified:

> This [i.e. yogic ecstasy] is not an emotional state, but an operation of seeing or knowing, in which there is nothing partial and nothing brought to the picture from memory, or from the past, to colour the present experience with any comparison or classification. If you were looking at a picture, and saying, 'How nice it is. See this group of trees here, and that little stream there, and that light on the hillside . . .', you would be experiencing the delight of meditative examination, which would gradually build the picture into one unit, as you grasped these various interesting items clearly and then combined them into one and discovered the unity of the whole. But if you 'took in' the whole picture at once, missing nothing, not flitting among the parts from one to another, you would undergo ecstatic discovery and experience of the unity. For this, the picture must of course be good; that is there must be no slightest mark on the canvas which is not necessary, just as, for example, in an excellent human body all the parts must be there, but there must be no redundancy, such as an extra thumb growing on the side of the proper one.

The language of religious mysticism is not entirely unknown to the West in talking about aesthetic experience—particularly the partly aesthetic experiences of pantheistic communion with nature. In that context, for instance, John Dewey speaks of: 'The mystic aspect of

acute aesthetic surrender, that renders it so akin as an experience to what religionists term ecstatic communion.'[7] Nevertheless language which is accepted as a matter of course in Indian descriptions of aesthetic enjoyment will seem exaggerated to most Western ears. It may still correctly describe the experiences of people educated in a cultural tradition where religious contemplation, yogic practices and metaphysical illumination are more indigenous than they are in most Western communities. The nature of each man's experience is in no small degree moulded by his cultural environment. But the intensity of experience indicated by Indian aesthetic writing would not be regarded as normal in the West. In itself the comparison between aesthetic contemplation and religious contemplation has points of interest. Both demand concentration with recession of ordinary external awareness and self-awareness, both involve direct intuitive apprehension rather than ratiocination, in both attention is directed outwards upon a mental object which comes to fuller realization as contemplation proceeds, and both envisage a culmination characterized by a sense of serenity and self-fulfilment. It is in the characteristic Indian accounts of enjoyment that their language sounds strange.

In the West aesthetic enjoyment has been recognized chiefly under two heads.

(1) Contemplation of great works of art is commonly said to be 'life-enhancing'. Indeed the concept of life-enhancement has gained such currency that in certain schools of criticism the power to communicate this feeling has come to be accepted as a criterion or even the final criterion of excellence in any work of art. It is worth while to recapitulate briefly in order to elucidate this concept (see also App. I). In speaking about aesthetic awareness it is customary to talk about the 'intensity' of attention although 'intensity' is not a term which has a straightforward application in this context. Ordinary psychological accounts indicate that we increase attention paid to any one thing by deflecting attention from other things and focusing our thoughts or perceptions on the thing in question. But it is also the case that there are times when the general level of our mental alertness is keener and times when it is more dull, from the lethargy which approaches unconsciousness or sleep to moments of most puissant and vital acuity. The contention is—and I believe it to be a true one—that when we concentrate attention on a work of art which is adequate and more than ade-

quate to extend our powers of percipience to the fullest extent in order to apprehend it synoptically and not analytically, on such occasions, given favourable conditions of mood, interest, and absence of distraction, we are keyed up to more than ordinary vitality and alertness. In this sense great masterpieces of art can appropriately be called 'life-enhancing' and in this sense they can mediate the sense of fulfilment which has often been noticed to attend successful aesthetic appreciation.

(2) Another source of aesthetic pleasure, whose recognition goes back to Kant's *Critique of Judgement* (1790), has also been mentioned (Chapter 3). It is the pleasure all men take in the activation and successful exercise of a trained skill. It is not unreasonable to suppose that this source of pleasure may be exceptionally keen in the case of aesthetic contemplation since it activates faculties of percipience which in practical life operate at a low level of semi-comatose apathy. Where alertness of perception is called for in practical affairs it is the acuity of particular discriminations which Hume described as 'delicacy' rather than the enlarged and fulfilled synoptic vision of aesthetic awareness. The successful exercise of the latter also brings in its train something akin to the sense of 'self-fulfilment' which Indian writers in particular regard as characteristic of aesthetic experience, for it demands the full activation of faculties which are habitually allowed to sink into torpidity.

By allowing that something is a source of pleasure one does not automatically subscribe to the view that it is pursued, or ought to be pursued, for the sake of the pleasure it brings. Nobody has seriously believed that mystics and metaphysicians have undertaken their very onerous pursuits for the sake of the 'bliss' which results from communion with the Deity or metaphysical illumination. These pursuits are traditionally regarded—and have been so regarded by their practitioners—as ends in themselves, self-justifying or, as we would now say, 'self-rewarding'. It is one of the most interesting, and important, features of Indian aesthetic literature that it has always assumed aesthetic enjoyment accruing from cultivation of the arts to be an end in itself, completely self-justifying. Although the assumption is so ubiquitous that quotations would be otiose, the following statement may be given as typical:

By helping to sharpen or heighten human senses and sensibilities and affording him enriching experience art seeks to contribute towards improvement of human personality. . . . Aesthetic experience is an end by itself, it is no means

to any further end. It may employ knowledge as it often does, and sometimes even large funded stores of it, to illumine the object or situation perceived, but it does not actively seek knowledge. Yet at the same time it cannot be ignored that the perceiver by the very fact of intent concentration and enriching experience, acquires more knowledge, indirectly though and perhaps unconsciously, of the object or situation. One who goes through an aesthetic experience naturally sees much more in the object or situation than one who does not have the same perceptual experience. Indeed intrinsic perception leads inevitably to increasing knowledge of the world of objects and situations.[8]

A similar conception was prevalent in China, where from a very early date the cultivation and practice of the arts were considered to be a means of bringing one's personality into harmony with the cosmic Tao conceived as a quasi-moral order of the universe and the source of all personal and social values. Typical is the following sentence from the *Analects* of Confucius, quoted at the beginning of the Catalogue of the Imperial Collection of Paintings (1119–25): 'Direct your endeavours towards the Tao, support yourself upon its active force, follow selfless humanity and indulge in the arts.' In European tradition the opposite assessment has been dominant: the arts have traditionally been regarded as an indulgence standing outside the serious concerns of life, as a frivolity and an amusement whether harmless or suspect; when they have been valued it has been primarily for the incidental, extra-aesthetic purposes which they served—didactic, moralistic, propagandist, commemorative, or as external symbols of wealth and power. By contrast the aesthetic attitudes of the twentieth century have begun for the first time to be dominated by a tacit assumption that appreciation of the arts is a self-justifying activity, one which carries its own value intrinsic to itself. I propose to examine this change in Western outlook and briefly to consider its implications.[9]

The concept of a self-justifying—or, as it is called, a 'self-rewarding' —activity has recently been worked out by certain psychologists in connection with the notion of the 'affluent society', that is a society at such a peak of material and technological development that its members, or a part of them, are no longer required to devote more than a fraction of their time and energies to the practical business of ensuring survival and comfort. In such a state of affairs, as the alternative to apathy and idleness, or general torpidity, men must find socially redundant acti-

vities with which to occupy themselves, and these will take the form either of amusements or of skills which call into play latent capacities and exercise faculties which no longer serve practical ends but are enjoyed for their own sake.[10]

Distinguishing fine art from handicraft, Kant wrote:

> We regard the first as if it could only prove purposive as play, i.e. as an occupation that is pleasant in itself. But the second is regarded as if it could only be compulsorily imposed upon one as work, i.e. as occupation which is unpleasant (a trouble) in itself, and which is only attractive on account of its effect (e.g. the wage).[11]

Taken up in a metaphysical sense by Schiller and in an evolutionary sense by Herbert Spencer and his follower Karl Groos, this became the source of a theory of art as play in the rather special sense of 'play' whose most recent manifestation is the notion of 'self-rewarding activity' which has been mentioned. But Kant's distinction was not quite on the target. It is not inherent to the concept of art that its practice or appreciation must be motivated by pleasure and it certainly is not inherent to the concept of handicraft that it must have some other motive than pleasure. Empirically it is obvious that appreciation can have other motives besides pleasure: it can be an occupation among others, as with the art dealer and the music critic. Nor does the concept of work necessarily involve unpleasantness: indeed, it was the ideal of William Morris and his school to transform industrial labour into something nearer the model of medieval craftsmanship where, they thought, the spirit of 'joy through labour' was paramount. But Kant's definition does in fact correspond with the notion of a hobby. For a hobby *is* always self-justifying, an end in itself; if it were not, we would not call it a hobby. Any activity in which a man engages repeatedly from interest, which he does from choice rather than necessity, because it keeps boredom away and because he likes doing it, which he continues to do despite the lack of any expectation that ulterior advantages will accrue to him any such action is from his point of view self-justifying. For him it is an end in itself. But hobbies have validity for the individual only. They do not depend on the nature of the activity or on the rewards it does or does not bring, but solely on the interests of this or that individual. Considered from the standpoint of hobby, the old Benthamite dictum 'quantity of pleasure being equal, pushpin is as good as poetry'

is self-evident. Yet we do mean something more than this—or some people sometimes mean more than this—when we speak of the self-justifying character of appreciation and certain other values such as the pursuit of knowledge for its own sake, pure science, the cultivation of religious or mystical experience, and so on. Nor is this something more simply a matter of counting heads. If it were only a matter of making sociological survey, statistics would not be necessary to prove that the number of people whose hobbies include cultivation of the arts for their own sake rather than for the sake of social standing is quite notably less than those whose hobbies are sport, betting, travel or gardening. The mere fact that 'social standing' can be mentioned in this context is an indication that this 'something more' is in some way an 'over-individual' or social valuation, and it is this aspect of valuation that I want briefly to pursue.

We do in our social attitudes make implied distinctions between hobbies. We regard stamp collecting, for example, as a suitable hobby for a schoolboy; but if we come across an educated adult whose hobby is stamp collecting, we tend to regard this as a case of delayed adolescence. On the other hand we accord a perhaps grudging approval, but nevertheless approval, to a man whose hobby consists in the pursuit of some quite useless form of knowledge such as, perhaps, metaphysics. These judgements fall short of being ethical imperatives. We do not consider a man immoral if he spends his leisure time playing golf or looking at television programmes. Nor do we consider it a moral duty for any man to spend his time on poetry rather than pushpin, to frequent art galleries rather than turf accountants. These tacit discriminations are supported by implied social assessments of personality. People tend to assume that a man who spends his leisure in the cultivation of the arts or in religious exercises or in social work from motives only of benevolence is in some undefined way a better sort of man than one whose interests do not go beyond playing patience to pass the time. Or if we do not assume quite this, we assume the related proposition that some hobbies in preference to others have the effect of calling into play and developing capacities and propensities in the individual which we hold in esteem. These attitudes of valuation—which play a not inconsiderable role in social adjustments—are grounded in a not very clearly formulated notion of culture, with which is associated a conception of human personality favouring the cultivation of some faculties rather

than others, approving an all-round development rather than a one-sided development, or some such tacit assumption. Some philosophers of the school of Hegel have held that the development of culture and the improvement of empirical values represent a progressive manifestation or actualization in history of an Absolute and Eternal Spirit. The theologian Eucken, for example, said: 'In reality all historical and social spirituality is only the development of a timeless spiritual life, superior to all mere human existence.' Speculations of this sort lie outside the purpose and purview of this study.[12] Nor are we interested in attempts that are sometimes made to institute a comparison in respect of absolute value among the various pursuits to which high social value is ascribed —in the claim, for example, which is sometimes made by humanists and denied by humanitarians, that a life devoted to the cultivation of the arts is the noblest form of life and aesthetic enjoyment the highest of human values. We are interested only in the empirical fact that some discriminations among 'hobbies' are socially accredited. All men do not accept these discriminations. But as social beings we are all under the pressure of strong and early conditioning to make such tacit discriminations and so strong are they that people often support them by approving financial subsidies, planning educational curricula, aspiring to easy and spurious connoisseurship, when they personally do not share the hobbies which they approve. If we do make these valuations, it is on the basis of a tacit approval of culture, however vaguely conceived, and approval for certain personality traits above others. If a man does not allow himself to be influenced by such social valuations, if he takes men and their hobbies as sociological data only, he will have no reason or ground for valuing pushpin below poetry. In such a case this book would not have hortatory character and would be written only for those people for whom cultivation of the fine arts has a recognized value.

I now leave the slippery question of comparative valuation as between the cultivation of the arts and other socially approved cultural values and I shall now discuss aesthetic values from the point of view of those persons for whom the cultivation of the arts is a hobby. For this group of people, to whom discussion will now be confined, the training and practice of appreciation is an ultimate value in the sense that their pursuit of it is self-justifying; it is undertaken for its own sake and not for the sake of any ulterior advantages which may be expected to accrue from it—or at any rate for the sake of no ulterior advantages other than

an enrichment of the personality which consists precisely in the sensi-
bilities and abilities inherent to appreciation itself.

Appreciation—that is, aesthetic contemplation and enjoyment—is the
ultimate value and the source of all particular values in aesthetics.
Particular aesthetic values are therefore said to be *instrumental* values:
they are values in so far as and in virtue of the fact that they facilitate
appreciation.

A work of art has instrumental value. Its *raison d'être* is to evoke and
sustain appreciation and it has aesthetic value in so far as it is adapted
to do this in a competent observer. Its value is, as it were, reflected upon
it by the ultimate value ascribed to appreciation. For the modern aes-
thetician, therefore, any artifact is a good work of art, is aesthetically
good or bad *qua* art, only to the extent that its qualities are such as to
make it well adapted to sustain successful contemplation. This has
sometimes been expressed in critical theory by saying that art is *autotelic*
—that it serves no end but itself (or, we should say, no end apart from
sustaining appreciation). As André Malraux has put it: 'L'oeuvre d'art
n'a plus d'autre fonction que d'être oeuvre d'art' (The work of art has
no longer any other function than to be a work of art). It would be a
mistake to confuse this position with the older 'art for art's sake' theory.
The latter theory used to be asserted to mean that a work of art *should*
not serve as a vehicle for any other values except the aesthetic, that any
extraneous function or usefulness was a defect in a work of art. Nobody
nowadays would be interested to assert anything of the sort or to deny
the patent fact that many splendid works of art throughout history have
been made for ulterior purposes and continue to serve non-aesthetic
values. But the necessity arises of distinguishing aesthetic assessments
from assessments made on some other basis and it becomes important
to make clear when a work of art is being judged aesthetically, *qua* work
of art, and when it is being judged in some other capacity. It is here
that confusion is particularly rife both in practical criticism and in art
theory. The student will have to find his way amidst an embarrassing
imbroglio of loose thinking and bad practice. Sometimes blunders
arising from the intrusion of irrelevant values are so blatant as to be
easily discounted: examples might be adduced in the outcry which
followed the granting of a Bollingen Award to Ezra Pound for the
Pisan Cantos in 1949 on political grounds or the assumption that every
display of nihilistic art deserves serious aesthetic consideration because

angry and disillusioned young men are a significant social phenomenon. As an instance of a rather more insidious and therefore more dangerous mistake one could suggest the masquerading of judgements about good and bad taste as if they were aesthetic judgements. A statement that something is in good or bad taste may represent a moral judgement or a snob reaction according to the circumstances; the facts to which it calls attention may well have a bearing on aesthetic appraisal. But it is not an aesthetic judgement. It makes good sense (whether you accept it or not) to say that Ben Nicholson might have been a greater artist but for an excess of impeccably good taste. It makes sense to say that frequent manifestations of vulgarity and bad taste are an added blemish in some of Kipling's work. It does not make sense to say of any art object that it is a bad work *because* it is in bad taste or that it is a good work on account of its good taste. A penetrating remark by Charles Peirce is in point here: 'Vulgarity and pretention themselves,' he says, 'may appear quite delicious in their perfection, if we can once conquer our squeamishness about them, a squeamishness which results from a contemplation of them as possible qualities of our own handiwork—but that is a *moral* and not an *aesthetic* way of considering them.'

In addition to repudiating the substitution of non-aesthetic for aesthetic criteria of value the 'autotelic' doctrine is an implicit rejection of the demand sometimes made that all art universally *must* serve other functions than appreciation. It rejects, for example, such demands as the following which are sometimes made in the name of Marxist theory:

In the first place, a new aesthetic ideal appeared, one which guided people in their judgements of the phenomena of life and their reflections in art. The viewpoint of the workers and peasants became the viewpoint of art. And this viewpoint dictates that art should take an active part in the transformation of the world.[13]

Alongside the belief in the autotelic character of art there runs through contemporary aesthetics and art criticism another assumption which is most commonly expressed by saying that art is *autonomous*. Just what is meant by this is left obscure. In many formulations the intention seems to be to assert that art objects can be appraised by general standards which are applicable over the whole field of art (and perhaps over the wider field of all beautiful things) and, negatively, that these standards are not derived from or applicable to any other field of human

commitment. Yet a positive affirmation of general standards of value has appeared difficult to reconcile with two other contemporary presuppositions about works of art. One is the belief that every good work of art is a unique individual in a sense which precludes the application to it of general aesthetic standards. The other is a vaguely felt intimation that aesthetic values do not fall to be graded on a scale however broadly the graduations are drawn. Even small and unpretentious works shine with a value of their own and one poem does not become obsolete or lose its aesthetic worth as soon as a better or more up-to-date poem is written on the same theme.

It is sometimes said that the concept of art has both a descriptive and an evaluative use. Morris Weitz, for example, writes: 'As we actually use the concept "Art" is both descriptive (like "chair") and evaluative (like "good"), i.e. we sometimes say, "This is a work of art", to describe something and we sometimes say it to evaluate something.'[14] This seems to make too much of a very ordinary linguistic device. If we are walking in the country and see a beautiful country mansion we may say: 'What a work of art!' and the words will be an exclamation of aesthetic praise. If, however, we are speaking in the context of things held out to be works of art—pictures in a gallery, for instance—we are more likely to say: 'This is good' or 'This is bad'. We may say: 'This is not art' with the implication that judged as art, it is very bad; and we can use this turn of expression because the object about which we speak was presumptive art, was held out to be a work of art. When we are talking in the context of fine art, or talking about objects purported to be fine art, to say that something is a work of art is the same as to say that it is apt for appreciation by a person competent in the skill to appreciate. When we ascribe aesthetic value to it we are not adding anything to this description but we are saying that it is adapted for sustaining appreciation in a competent observer to a greater or lesser degree, more or less richly or intensely, in virtue of these or those qualities in particular, and so on. When we value something aesthetically we do not necessarily assert that it is a good or useful thing absolutely or even that its aesthetic value is the most important thing about it. In some works of art we may think that the aesthetic value is subordinate to the entertainment value, in others (one thinks of some novels or some poems) that it is subordinate to the qualities of wisdom or edification. In critical literature there is usually an implication that other things being equal the power of

supporting aesthetic enjoyment is likely to confer abundant total value on anything; but such implications occur in criticism partly because criticism is commonly written by persons who do in fact set a high value on appreciation of art and who assume that those who read will set a high value on it too. But when criticism is written by people with little interest in appreciation, different implications and valuations may come to the fore. By and large there is an implication that if a thing has high aesthetic value, it will be conceded that its total value is likely to be high. But there is a contrary puritanical and ascetic tradition which is suspicious of aesthetic values as such.

When critics talk about particular aesthetic values what they ordinarily mean are the aesthetic qualities and particular groupings of them or certain very general properties ascribed to a work of art as a whole such as perfection, originality, coherence, or unity of form and subject-matter. Criticism exists in a kind of impasse and quandary when it wishes to determine or classify particular aesthetic values. On the one hand, every work of art has the aesthetic value it has in virtue of the particular aesthetic quality and combinations of aesthetic qualities which it has. On the other hand, criticism knows no particular aesthetic qualities or combinations of aesthetic qualities which guarantee any degree of aesthetic value to a work which possesses them. Even the most general qualities of structure cannot do this. Balance and symmetry may in some cases be out of key; a too exactly proportioned composition may be frigid and uninspired for that reason; even harmony between form and content may be out of place in works whose general effect is achieved through the poignancy of contrast. Originality has not been considered a value over the majority of the world's art or until it came to be associated with the notion of genius which came to the fore at the time of the Romantic movement; if it is to be considered a value now, it must be discriminated from what is merely novel and this does not appear to be possible without importing the idea of aesthetic value, as if we were to say 'originality is aesthetically valuable novelty'. It seems doubtful whether originality is in fact a necessary condition of value in a work of art: it certainly cannot be defined without circularity in a way which would make it a sufficient condition. The concept of perfection in an aesthetic connotation has a long history. Thomas Reid in his *Essays on the Intellectual Powers of Man* (1785) used it in his definition of rational beauty. The concept of perfection implies the idea of a type, to which

the individual instance conforms, and the apprehension of such conformity to type may indeed be a source of intellectual beauty. But conformity to type is an idea which is not applicable to works of art, each of which is admittedly unique. Works of art do not conform to a type. When applied to works of art as a value the concept of perfection would seem to imply first that the work carries on the face of it certain indications or suggestions of *intention*, and second that (*a*) all intentions are fulfilled and (*b*) there are no superfluous features, every feature in the work fulfils or helps to fulfil some intention. Such assessments, though not necessarily invalid, must be highly subjective.

We return, then, to the point that in aesthetic appreciation each man must see for himself. The expert and the critic have no possibility of proving their appraisals by argument, apodictically; the reasons they put forward in support of their assessments can only be of the sort to help and encourage others to see as they see. People with a non-professional interest in the arts cannot look to the professionals for demonstrative proofs which can serve them in lieu of direct contact with art works in appreciation. To accept aesthetic valuations on the authority of others is to take an unsigned cheque on a bank which never went into business. In the cultivation of the arts there is no body of knowledge which could enable a man to by-pass appreciation and the art of appreciation is the art of direct commerce in experience.

Assessment does not assume a prominent place in appreciation and enjoyment of works of art. Appreciation is a matter of apprehending, bringing an aesthetic object fully to awareness. It is not a matter of classification or assessment. Nevertheless there is an element of appraisal latent in our enjoyment of art just as evaluation is implicit in all our serious commerce with the world we know. One part of criticism consists in making explicit the attitudes of valuation which are implicit in appreciation itself, comparing and grading works of art or certain of their features on a notional scale of hierarchical value. This is not appreciation, but it is very close to appreciation.

In the case of the arts of performance we may value this or that individual performance and we may value it both as an aesthetic experience in its own right and also by reference to a notional work of art (*Hamlet*, the 'Emperor' Concerto) which is not identical with any particular performance. Alternatively we may value the work of art according to the idea we have of it from the performances we have known and from our idea

of how they should ideally have been performed. In the case of painting and sculpture we base our valuation on a composite idea we have derived from our experience of the work and the many appreciative contacts with it which we have enjoyed over the years. This too is the way in which we value literary art.

When, as too often happens, two critics propound different judgements about a work of art, in order to decide between them we must know first of all whether they have made the same actualization, whether they have apprehended in awareness the same aesthetic object. For if they have not, they are in fact talking about different aesthetic objects and their judgements are not necessarily conflicting, though they may be. There is no simple way of knowing this because it is precisely the aesthetic actualization of a work of art which cannot, except clumsily and inadequately, be described in words. What the critic must do who wishes to make his point of view about a work of art prevail—and perhaps all that he effectively can do—is by any means in his power, by verbal pointing and gesture and by indirect suggestion, to influence the posture and direction of attention in his readers until they see it as nearly as may be as he has seen it. The sensitive and eloquent critic helps you to actualize the same aesthetic object which he has actualized. This is the element of truth in Wittgenstein's contention that *reasons* in aesthetics are of the nature of further descriptions. If the reader comes to see the work as the critic has seen it, then, it is assumed, he will concur in the critic's judgements. This may, of course, be so and perhaps it is even likely that it will be so. But it is not necessarily or inevitably so. It remains possible that a reader may actualize the same (or very similar) aesthetic object as the critic and still judge differently about it.

If it appears that discrepant judgements of appreciation derive from conflicting actualizations—different aesthetic objects actualized upon the same work of art—and it must be remembered that every time we attend seriously to a work of art for purposes of appreciation the aesthetic object which we actualize will be different in some respects from every previous time—then it is a question whether these are alternative and equally valid 'concretions' of the same work or whether either or both is in whole or in part invalid.

An aesthetic object actualized on the basis of a work of art may be invalid owing to neglect or misunderstanding of certain representational or symbolic features, some misapprehension of its non-aesthetic aspects,

resulting in failure properly to appreciate structural features which depend in part on these aspects. It may be invalid because lack of emotional sympathy or emotional shortcomings in the observer have blinded him to some emotional qualities of the art object or caused him to distort and misapprehend some others. It may simply be inadequate owing to incapacity or lack of experience on the part of an observer. Or, finally, it may be distorted by the intrusion of private associations and interests of the observer which are not grounded in the art object although they are stimulated by his contact with it. I have mentioned the eighteenth-century idea of appreciation, expounded by Archibald Alison, as the arousal of trains of association, imagery, and thoughts. Even though Alison held that such trains of association should be controlled by a single emotion expressed in the object, such recommendation for the subjective and personal element is dangerous in the extreme. It is a main source of unresolved discrepancies among judgements of taste and criticism.

It must be borne in mind that a great masterpiece of art is susceptible of supporting an indefinite number of valid 'concretions'. It is not always a choice of this or that. The more of these we can make our own, or sympathetically and imaginatively savour for the time being as our own, the deeper and more comprehensive will be our percipience of the work. But there is no one hard and fast rule for discriminating valid from invalid concretions.

Finally, there will be cases where it is necessary to decide whether the object is in fact capable of supporting valid concretions of aesthetic objects, i.e. whether it is in fact a genuine work of art, or whether critics and others have been mistaken in taking it for a work of art. This is particularly difficult to decide about contemporary works in an unfamiliar style or about works which appeal because they so completely exemplify some style which we have become habituated to accept as fertile of important works. But difficulties of the same sort may arise over the appreciation of works from the past. For example, the *Laoccon* group was described by Pliny as 'a work to be preferred to all that the arts of painting and sculpture have produced'. Rediscovered in 1506, it had a profound influence on Italian sculpture from Michelangelo to Bernini and remained the most admired single work from classical antiquity until Lessing named his treatise after it. In Appendix IV there is quoted a passage from Kenneth Clark in which he tries to say

255

why this most famous of all sculptures no longer accords with contemporary taste. In this connection it is interesting that in his own *Laocoon* the sculptor Ossip Zadkine has, in the words of Wilenski, 'extracted the linear rhythms of the *Laocoon* and made a work of sculpture with the meaning of those rhythms divorced from the meaning of a man and boys repelling an attack of snakes'. The individual reader must decide whether this divorce of 'formal' from 'representational' meaning has itself any meaning.

The causes of diversity among the judgements of appreciation are many and diverse. They have led many theorists to a belief in the ultimate relativity or subjectivity of aesthetic judgements—a disheartening conclusion to which it is unnecessary to succumb.

Attention and related concepts

'Attention' belongs to a cluster of concepts including consciousness, awareness, interest, enjoyment, noticing, apprehending, which have been called 'heed' concepts (G. Ryle, *The Concept of Mind* (1949), pp. 135–49). Inevitably heed concepts turn out to be key tools in a discussion of appreciation which is conducted from the standpoint that apprehension or awareness is central to it while 'liking' and passive emotional affect, however usual a concomitant, are more peripheral to an understanding of its nature. Inevitably too in such a discussion these concepts are employed neither in an entirely specialized sense nor yet quite in an everyday manner. Therefore I feel that the following brief indications of the relations in which the concepts of this group stand to each other will be helpful to some readers, and will enable readers to familiarize themselves with the way in which I use the relevant terms through the remainder of the book. My debt to Professor A. R. White's book *Attention* (1964) will be obvious.

The relation between the concepts of attention and consciousness is very close. We attend by taking heed of something, and so long as we are conscious we are conscious *of* something. When we are attending to nothing at all, heeding nothing even residually, we are no longer conscious; so long as we are attending to something, however perfunctorily, some glimmer of consciousness remains. There is a sense in which heightened attention and heightened consciousness—sometimes spoken of as mental alertness or vivaciousness—go together.

Consciousness and attention are also closely related to awareness. When we are conscious of something, we are aware of it. When we attend to something, or when something impinges on our attention, we *become* aware of it, enter into awareness of it. In the case of obtrusive sensations or feelings, such as the ringing of a telephone bell or the pain of toothache, we remain aware of them so long as they engage attention, although our awareness of them does not necessarily change or develop.

But when we attend voluntarily, that is when attention results from or is accompanied by interest, so long as attention lasts we continue to notice and become aware of more features in the object of attention or more things about the relations in which it stands to other things. Unless our awareness of it is expanding in one or the other of these ways, attention lapses into reverie or is switched to some other object. We cannot for long continue voluntarily attending to one thing without expanding our awareness of it.

I have used the term 'apprehend' to signify becoming aware of something by paying voluntary attention to it. As I use it the term does not necessarily imply intellectual analysis or synthesis, although in fact apprehension does usually involve grasping in awareness some features of the object which can be made explicit discursively as well as features which can't. For example, when we apprehend a piece of music we may grasp in awareness fugal or contrapuntal features which could be analytically explicated although at the time their intellectual articulation is not present to our awareness. I have preferred often to use 'apprehend' rather than 'perceive' because in ordinary discourse the former term carries a less explicit reference to sensory awareness. It therefore seems more appropriate when we wish to speak of grasping in awareness such features as the plot or characterization of a novel, the suitability to function of an architectural structure or the economic elegance of a mathematical theorem, where sensory perception is not very prominent.

Interest is a determinant of attention and of the mode or posture of attention. We say that we are interested in something if we are inclined to pay attention to it voluntarily and the nature of our interest in it helps, along with other factors, to determine the features or aspects of it which we are inclined to notice or attend to. The posture of attention is equivalent to a mental set in virtue of which we are inclined to notice in an object one sort of features rather than another and, having noticed them, to maintain attention upon them and hold them in awareness. An expert in linguistics, an ethnologist and a literary critic may all attend to the same poem, the *Iliad*. But the interest of the first will induce him to take up a posture of attention inclining him to notice and ponder details bearing on the Ionic and Æolic dialects of the coast of Asia Minor; the interest of the second will incline him to attend primarily to indications of social custom, religious belief, weapons, costume,

disposal of the dead, and so on, in the Mycenaean culture; while the interest of the third will predispose him to bring to awareness primarily the aesthetic features of the poem as a work of art. It is possible to attend to a thing which is a work of art but without becoming aware of it as a work of art. An important part of cultivating the art of appreciation consists in training interest in ways which will predispose us to notice and attend to aesthetic features.

Attention, a 'heed' concept, is also an activity concept. It signifies something we do. Like all activity concepts, attention is occurrent: there is a time when we begin to attend to something and a time when we cease to attend. Attention occupies more time or less; it may be fleeting, intermittent, repeated, protracted. And like all activity concepts it is also susceptible of manner. It may be strenuous or weak, assiduous or remiss, scrupulous or perfunctory, reluctant or willing, emotional or calm, engaged or objective. (This point has importance for the discussion of appreciation where one person represents it as a strenuous exercise of willed attention, an activity demanding effort and concentration, while another pictures it as the reception of emotionally tinged impressions in a mood of relaxation.) But although it is an activity concept, 'attention' does not name any specific activity. We attend to something by looking at it, listening to it, by mental intuition, by manipulation, and so on. Attending is not an alternative to seeing or hearing as seeing may be an alternative to hearing. Things do not have special features discoverable by attending as there are features discoverable by seeing and other features discoverable by hearing. Simply to say that a person is attending gives us no clue (unless a context is implied) as to the sort of activity in which he is engaged, and even if we are told what it is to which he is attending, we still may not know what sort of features of that thing his mode of attention will incline him to bring to awareness.

Ordinary speech admits degrees of attention. We may be attentive or inattentive about something or in the performance of any activity, very attentive, rather attentive, and so on. Psychologists generally prefer to speak as though for each man there exists as it were a fixed reservoir of attention so that he would become more attentive in any one activity by deflecting his attention from other activities upon that one. In accordance with this idea A. R. White says: 'Degrees of attention are not to be explained as more or less intense engagement in one specific activity,

but rather as concentrating more or fewer of our activities on the one object. . . . Full attention to X consists not only in the range of activities centred on X but in the absence of activities concerned with things other than X.' This account is only partly to the point when we are considering attention in the appreciation of art objects. For an art object is a thing whose excellence is found precisely in its capacity to engage attention fully in the appropriate mode of activity. When we set ourselves, for example, to appreciate a splendid piece of music we concentrate our whole attention on listening to it and avoid being distracted by other things, including our own emotions; but we shall gain nothing by trying to smell and taste and touch it or by analysing it theoretically at the same time that we are listening to it. On the other hand it must be recognized, as Locke recognized (*An Essay on the Human Understanding*, 2, xix, secs. 3 and 4), that in waking life there are many degrees of mental vivacity from the highest pitch of alertness to a torpidity bordering on unconsciousness and sleep. There are occasions when the mind is stimulated to more than ordinary vivacity, as by shock, fear, or some pleasant news. And it is the experience of many people that moments of aesthetic vision, such as those described in Chapter 2, are normally apt to stimulate us to unusual vivacity in this way. If at the same time attention is concentrated on an object adequate to occupy it in the aesthetic mode and to hold it engaged, we can without impropriety be said to be intensely aware of the object upon which attention is strenuously engaged.

The relation between attending and noticing is important. Unlike attending, noticing is not an activity concept: it is something which comes to us, not an activity in which we engage. It is not something which we can decide or refuse to do at will or order someone else to do. By and large the sort of things which can be noticed are the sort of things to which we can attend. We cannot attend to something which we have not noticed and when we notice something we must have given it attention however casually or fleetingly. But we can see, perceive or be aware of something, in one sense of these words, without having noticed many features about it. We can perceive a friend's face without having noticed the colour of the eyes. There is a perfectly good sense in which we can be said to see a picture without noticing, and therefore without attending to, those aspects and features of it in virtue of which it is held to be a work of art. In an equally good sense of 'see' a person

in this state can be said not to be seeing, not to apprehend or be aware of, the picture.

We notice in particular whatever is intrinsically prominent in any perceptual field (e.g. a clap of thunder) or what holds emotional significance for us (a mother notices the cry of her child when others do not notice it). Other things being equal we often tend to notice what is unusual or unexpected and sometimes we notice a cessation or an absence. For example we may notice that it has stopped raining when the patter of the rain ceases, although so long as it continued we were not aware of it. Apart from this the nature of our interest, which determines the posture of attention, influences the sorts of things we notice. The converse is also true, at least in the negative sense that what we are not inclined to notice we will not turn our attention upon. Past experience and emotional habit are potent factors, irrespective of the intrinsic strength or insistence of sensory stimuli, in determining what features of a thing we notice and are able to give attention to. In the art of appreciation ability and inclination to notice features which have aesthetic bearing are all-important and for their cultivation we are assisted by accumulated experience, acquired habits and the assistance of critics and connoisseurs. The writings of the critics are a revealing indication of the way in which habit, training, and interest determine the kinds of things which are noticed in works of art and for this reason it is useful to compare the descriptions of critics from different periods or different schools of thought.

'Enjoyment' has become a central concept of aesthetics and of all the terms I here discuss it comes closest to being used in a technical sense. In ordinary language enjoyment is a species of pleasure: we enjoy only what gives us pleasure. But it is a commonplace in aesthetics that when we 'enjoy' a tragedy many of the experiences which we undergo in the course of apprehending it are not pleasurable, and even when we listen to great music or contemplate great painting pleasure in the ordinary sense of that word is peripheral rather than central to the experience. Of course there is a sense in which everything we do we do either because we enjoy doing it or because we believe we have a duty to do it—and if we do anything from a sense of duty, we do so because we enjoy doing our duty. But this carries us no further (see Chapter 3). And although there is undoubtedly much pleasure and much enjoyment in the highest sense to be derived from the cultivation of the arts,

enjoyment in the usual sense of the word is not central to the experience of appreciation. It is for this reason that in my language 'enjoyment' bears a quasi-technical sense, being applied to the process of coming satisfactorily to apprehend in awareness a work of art adequate to engage attention in prolonged or repeated contemplation in the aesthetic mode. There are, perhaps, in the background, implications of that sense of liberation and self-realization which has been best described by Indian writers on aesthetics as quoted in the last chapter of the book.

Emotional qualities in criticism

Emotionally loaded statements which occur in art criticism sometimes refer—or refer primarily—to the depicted subject and sometimes to qualities of the art work. The two things are not identical. It is, for example, possible to contrast the idyllic serenity of an apple orchard or the rustic dignity of the church at Auvers-sur-Oise painted by Van Gogh with the agonized and dramatic intensity of his painting. But in much criticism it is not made clear to the reader whether the critic intends his statements to apply to the painting or to the depicted scene or whether it is his intention to say that he has found the same emotional qualities in both.

When the critic is writing about animated figures depicted in a painting his statements may refer to emotions which these figures are represented as experiencing (as when we say of a man in real life 'he looks angry', etc.) or they may describe qualities which their appearance has to emotional perception (as we may say of a person in real life that he looks unreliable, hostile, menacing). In the latter case the critic's statements are analogous to statements which we make also about landscape and inanimate objects in real life (as when we say of a natural scene that it is serene, threatening, etc.). Again it is often difficult or impossible for a reader to know which of these two types of statement a critic intends.

The following three statements occur on a single page of Erwin Christensen's *The History of Western Art* about paintings by Raphael.

(1) Of the National Gallery (Washington) *St. George and the Dragon* he says: 'The mood is reposeful, hardly what one might expect of a life and death battle.' Here the writer expressly contrasts the emotional quality of the painting with the sort of emotional quality which is conventionally attributed to the depicted scene. 231

(2) *The Small Cowper Madonna*, also in the National Gallery, Washington, is described as 'calm and serene.... Mother and Child are emotionally 232

united, their minds fixed on the future, the Passion. A meditative, serious spirit and a sweet, subdued melancholy underlie the peaceful scene.' Here the first statement (calm and serene) refers to the qualities of the painting. That this is so is apparent not from the statement itself but because it is amplified in a following sentence: 'The dark cloth merges with the dark earth, and out of this dark tonality rise the light tints, the figures against a clear sky.' These *formal* qualities of the painting, the writer suggests, convey the emotional impression of calmness and serenity. The second sentence in the quotation refers to the experienced emotions and the thoughts which the critic invites the observer to attribute to the depicted figures as if they were real-life figures, and in this case his interpretation depends not only on the *look* of these figures but on his knowledge of who they are in real life and the circumstances of the Gospel story. The last sentence of the quotation seems to refer to the emotional qualities of the depicted scene as if it were a *tableau vivant*, yet there are unclear indications that the critic also refers to qualities of the painting. For he has written two further sentences: (*a*) 'A thin gauzelike veil encircling the arm and shoulders emphasizes the solidity of the figures, and the action of the child, momentarily halted, is opposed to the relaxed posture of the mother.' (*b*) 'This relaxation is but a foil against which Raphael suggests an inner tension that must have been readily felt in Raphael's own day, when thoughts of religion were uppermost in the minds of men.' It still is not clear, however, to what extent the critic attributes the 'inner tension' which suggests itself to men with a religious outlook to formal properties of the painting and to what extent it belongs in his opinion to the depicted scene as to a tableau vivant.

233 (3) Of *The Sistine Madonna*, where the Queen of Heaven descends from the clouds as the curtains are drawn back, we are told: 'Though a heavenly vision, she appears simple and unaffected; this unassuming quality is perhaps the secret of her appeal. The Christ Child's serious expression seems to reveal his divinity, as his unchildlike gaze is contrasted with the *putti* below. The Virgin, slightly embarrassed at presenting a divine Child, remains floating above the clouds. St. Barbara sinks into the clouds with eyes modestly removed from the Virgin. Pope Sixtus II, from whom the painting takes its name, points, as if to recommend mankind to the Queen of Heaven.' This last passage offers the writer's interpretation of the attitudes and demeanour of the depicted

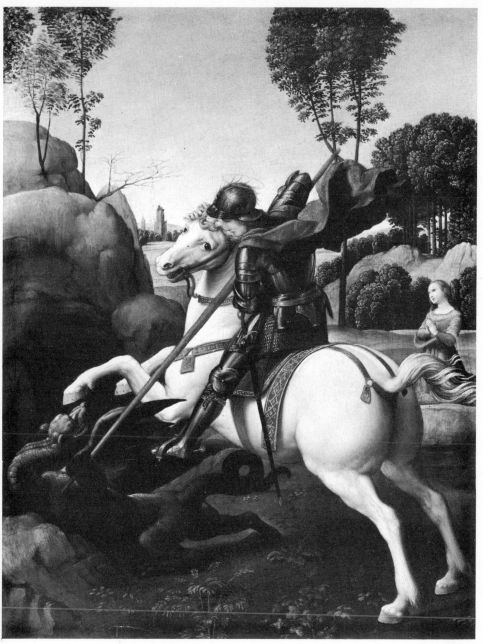

Raphael: ST. GEORGE AND THE DRAGON. *National Gallery of Art,*
Washington; Andrew Mellon Collection 1937

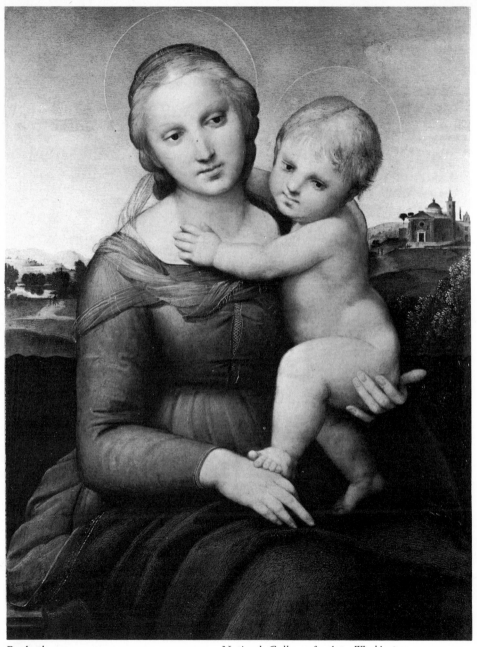

Raphael: THE SMALL COWPER MADONNA. *National Gallery of Art, Washington;*
Widener Collection 1942

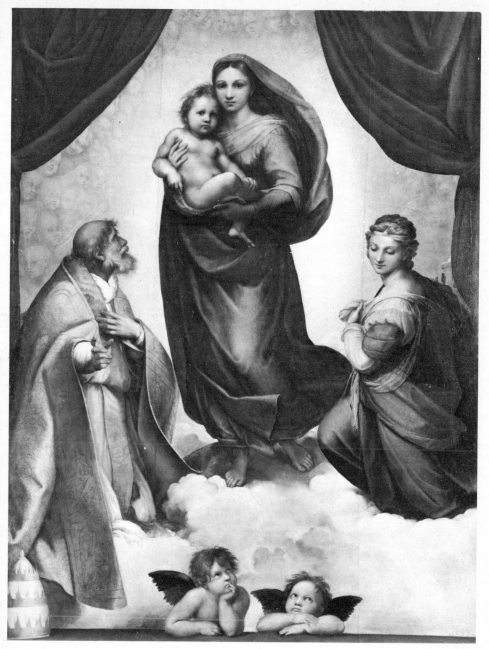

Raphael: THE SISTINE MADONNA. *Staatliche Kunstsammlungen, Dresden; Gemäldegalerie Alte Meister*

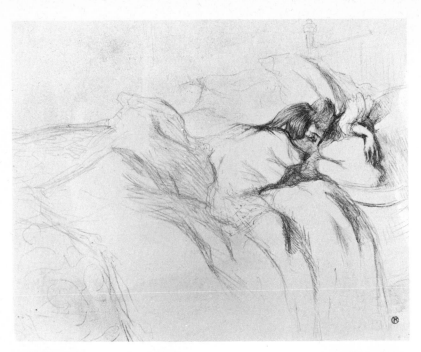

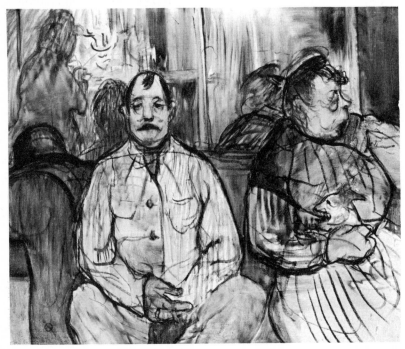

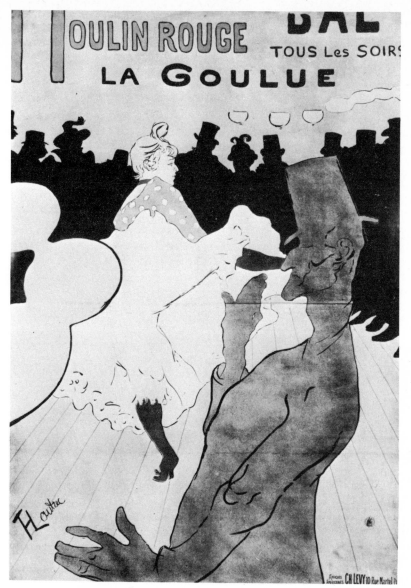

Henri de Toulouse-Lautrec: MOULIN ROUGE. *Musée Toulouse-Lautrec, Albi*

top left Henri de Toulouse-Lautrec: LE SOMMEIL (one of a series of lithographs entitled ELLES). *Musée Toulouse-Lautrec, Albi*
bottom left Henri de Toulouse-Lautrec: MONSIEUR ET MADAME. *Musée Toulouse-Lautrec, Albi*

figures and there is nothing in it which could not have been as well said of a *tableau vivant*.

In *Toulouse-Lautrec* (Eng. trans., 1928) Paul de Lapparent says of Lautrec's painting *Monsieur et Madame* (1895): 'These loathsome agents of vice are held up for ever as repulsive beasts.' He is speaking of his own emotional perception of the persons depicted in the painting, as if they were real-life persons, and is saying that they fill him with revulsion. Indirectly he is speaking in praise of the artist in that the words 'for ever' imply appreciation of the artist's ability to represent the repulsiveness of the vicious: but the way in which he does so—other than faithful depiction of ugly persons—is left obscure.

He says of the *Moulin-Rouge* poster (1891): 'We see La Goulue dancing in the full glare of the lights with her leg raised rather high, and then, standing in the foreground to set off the effect, we descry Valentin, with his hand to his mouth in so eloquent an attitude that we can almost hear him saying: "Shocking!"' De Lapparent is not now describing his own feeling in relation to the painting or the depiction but is 'reading' the emotions supposedly manifested by Valentin in his attitude and gestures He is telling the observer the 'story' of the painting, what it is depicting.

Elsewhere he writes: 'A drawing may represent a beautiful thing. With Lautrec the drawing is itself a beautiful thing, a separate entity, possessing a charm which makes you indifferent to the subject treated. . . . In *Slumber*, one of a series of lithographs entitled *Elles*, he traces round the shoulders, the arms and the left breast, although full in the light, a line which obviously did not exist in the model. It is perfectly evident that he did not work literally from nature. So much the better! He would never have conceived the bold idea of putting in that line attracting attention to the pretty inflexion of a curve, the line which says: "Look at this," or: "Print in heavy type."' De Lapparent is here pointing verbally to characteristics of the art work not the depicted scene.

APPENDIX III

Reflection of attitude and interest in critical writing

Up to the end of the nineteenth century criticism of the visual arts gave pride of place to descriptions of the scenes and situations depicted and accounts of the stories from which these scenes and situations were taken. Criticism was written mainly for persons who had not seen and were unlikely ever to see the picture in question, and until recent advances in photographic techniques made reproductions more accessible verbal descriptions of subject-matter were a main function of criticism. Although this kind of criticism has gone out of fashion, it has an interest in showing the aspects of painting which critics and their readers—the public for which the artists worked—were predisposed to attend to and the direction in which their interests mainly lay. The sort of attitude taken up generally towards pictures in the past was in many ways akin to the attitude which today we reserve for magazine illustrations: they are expected to fill out visually, or to make visual comment upon, a story set out in the text. In all the examples which follow, straightforward verbal description of what is there visibly for the eye to see is an important feature.

In historical and mythological painting particularly the artist usually assumed that his public would be familiar with the story in which the scenes and situations he depicted were incidents, and without such knowledge it would often be as difficult to 'read' the picture as to understand book illustrations without reading the text. It was considered to be one of the functions of the critic to supply such background information (Ex. 2). Pictures were prized for the originality, the imaginative vigour or the profundity with which artists conceived an incident in a well-known story and criticism would draw attention to this aspect of their pictures, writing about them in the manner in which one might write about a *tableau vivant* (Ex. 5). Where there was no familiar story it was considered proper for the observer to construct one from his own imagination and critics often undertook this function,

performing the job of imaginative embroidery on behalf of their readers (Ex. 4 and 6). Moral interpretations were read into the depicted scenes and moral lessons extracted from the pictures. In Victorian times moralistic sentimentality became a predominant vogue (Ex. 6 and 7).

Critics were also expected to suggest their own interpretations of the facial expressions and bodily gestures of the figures portrayed and to tell the reader what thoughts and feelings these persons were supposed to be displaying in the situations in which they were depicted. Both in their accounts of narrative situations and in their interpretations of expressions imaginative extrapolation was the rule and no sharp line was drawn between imaginative construction and what was visibly depicted in the picture.

In general, attention to formal properties, although not completely lacking, bulks far less important than in twentieth-century critical writing.

(1) In his account of the shield wrought by the god Hephaestus for Achilles Homer includes material (e.g. the subject of the litigation) which could not have been depicted.

Next he showed two beautiful cities full of people. In one of them weddings and banquets were afoot. They were bringing the brides through the streets from their homes, to the loud music of the wedding-hymn and the light of blazing torches. Youths accompanied by flute and lyre were whirling in the dance, and the women had come to the doors of their houses to enjoy the show. But the men had flocked to the meeting-place, where a case had come up between two litigants about the payment of compensation for a man who had been killed. The defendant claimed the right to pay in full and was announcing his intention to the people; but the other contested his claim and refused all compensation. Both parties insisted that the issue should be settled by a referee; and both were cheered by their supporters in the crowd, whom the heralds were attempting to silence. The Elders sat on the sacred bench, a semicircle of polished stone; and each, as he received the speaker's rod from the clear-voiced heralds, came forward in his turn staff in hand to give his judgement. Two talents of gold were displayed in the centre; they were the fee for the Elder whose exposition of the law should prove the best.

Iliad (trans. E. V. Rieu, 1956), XVIII, 490–508.

(2) Philostratus the Elder is describing a painting whose subject is the death of Ajax, son of Oileus. According to Homer, Ajax was captain of the Locrians at the siege of Troy. On his way home he was ship-

wrecked but swam ashore with the help of the sea-god Poseidon. He then boasted that he had escaped in spite of the gods. Thereupon Poseidon overturned the rock on which he stood and he was drowned (*Odyssey*, IV, 499 f.).

Philostratus's description is in two parts. The first purports to give the story, the second to describe what is actually in the painting. There is a genuine inability to distinguish between what is visibly there to be seen and what is imaginatively read into it.

The rocks rising out of the water and the boiling sea about them, and on the rocks a hero glaring fiercely and with a certain proud defiance towards the sea—the ship of the Locrian has been struck by lightning; and leaping from the ship as it bursts into flame, he struggles with the waves, sometimes breaking his way through them, sometimes drawing them to him, and sometimes sustaining their weight with his breast; but when he reaches the Gyrae —the Gyrae are the rocks that stand out in the Aegean gulf—he utters disdainful words against the very gods, whereupon Poseidon himself sets out for the Gyrae, terrible, my boy, tempestuous, his hair standing erect. And yet in former days he fought as an ally of the Locrian against Ilium, when the hero was discreet and forbore to defy the gods—indeed Poseidon strengthened him with his sceptre; but now, when the god sees him waxing insolent, he raises his trident against the man and the ridge of rock that supports Ajax will be so smitten that it will shake him off, insolence and all.

Such is the story of the painting, but what is shown to the eye is this: the sea is whitened by the waves; the rocks are worn by the constant drenching; flames leap up from the midst of the ship, and as the wind fans the flames the ship still sails on as if using the flames as a sail. Ajax gazes out over the sea like a man emerging from a drunken sleep, seeing neither the ship nor land; nor does he even fear the approaching Poseidon, but he looks like a man still tense for the struggle; the strength has not yet left his arms, and his neck still stands erect even as when he opposed Hector and the Trojans. As for Poseidon, hurling his trident he will dash in pieces the mass of rock along with Ajax himself, but the rest of the Gyrae will remain as long as the sea shall last and will stand unharmed henceforth by Poseidon.

Imagines (trans. Fairbanks, 1931), II, 13.

(3) In this description of a painting by Zeuxis Lucian finds its merit in the convincingness with which the artist has depicted imaginary creatures (centaurs) and given appropriate expressive qualities to the pictorial image. Formal qualities are regarded as a matter for the 'expert' alone.

The great Zeuxis, after he had established his artistic supremacy, seldom or never painted such common popular subjects as Heroes, Gods, and battle-pieces; he was always intent on novelty; he would hit upon some extravagant and strange design, and then use it to show his mastery of the art. One of these daring pieces of his represented a female Centaur, nursing a pair of infant Centaur twins. There is a copy of the picture now at Athens, taken exactly from the original. The latter is said to have been put on ship-board for Italy with the rest of Sulla's art treasures, and to have been lost with them by the sinking of the ship, off Malea, I think it was. . . .

On fresh green-sward appears the mother Centaur, the whole equine part of her stretched on the ground, her hooves extended backwards; the human part is slightly raised on an elbow; the forelegs are not extended like the others as if she were lying on her side; one of them is bent in the attitude of kneeling with the hoof bent under and hidden, while the other is beginning to straighten up and gripping the ground—in the attitude taken by horses when they are getting up from a lying posture. She is holding one of the cubs in her arms and suckling it at the human breast on the upper part of her body, while the other draws at the mare's dug like a foal. In the upper part of the picture, as if on a tower, is a male Centaur who is clearly the husband of the nursing mother. He is bending down laughing, but you cannot see all of him only as far as the middle of the equine body, holding a lion cub in his right hand and dangling it above his head, as if he were trying to frighten the children in jest.

There are no doubt qualities in the painting which evade analysis by a mere amateur, and yet involve supreme craftsmanship—as for example the great precision of line, the exact mixture of the colours and the felicity of the impasto, the correctness of the chiaroscuro, the proper use of perspective and the proportion and harmony of the parts to the whole (τὴν τῶν μερῶν πρὸς τὸ ὅλον ἰσότητα καὶ ἁρμονίαν.) These are matters for experts. But the quality of Zeuxis which most aroused my admiration was the skill with which he displayed all his many-sided and superlative technique in the one subject. He painted the male as a truly terrible and fierce creature, with wild and unkempt locks, almost completely covered with hair not only on the equine part but over the human body as well, his shoulder huge and although he was laughing his look was savage, wild and untamed. In contrast with him, the animal part of the female is lovely; a Thessalian filly, yet unbroken and unbacked, might come nearest; and the upper half is also a most beautiful woman, all except the ears, which are pointed as in a satyr. At the point of junction which blends the two bodies, where the equine and the human meet, there is no sharp line of division, but the most gradual of transitions so that the eye does not notice where the one merges into the other. It was perfectly wonderful

again to see in the cubs the latent fierceness in their air of childhood and the mixture of terrible and tender, how childishly they looked up at the lion cub, while they clung to breast and dug and cuddled close to their dam.

Zeuxis imagined that when the picture was shown the technique of it would take visitors by storm. Well, they did acclaim him; they could hardly help that with such a masterpiece before them; but . . . it was the strangeness of the idea, the fresh unhackneyed sentiment of the picture, and so on. Zeuxis saw that they were preoccupied with the novelty of his picture, skill was at a discount and accuracy of representation went for nothing. 'Come, Miccio,' he said to his pupil. 'Pack up the picture and take it home. These people praise the clay of our craft. They care not whether it is finely done or in accordance with the rules of good technique. Novelty of the subject counts for more with them than representational accuracy.' Thus said Zeuxis, not in the best of tempers.

Lucian of Samosata, *Zeuxis and Antiochus* (trans. Fowler, 1905).

(4) *Girl Weeping for her Dead Bird* by Jean-Baptiste Greuze
In this account of *La jeune fille qui pleure son oiseau mort* by Greuze, Diderot uses the picture as an excuse for imaginative play. Little or no change in the passage would be necessary if he were describing an actual scene which he had observed or a fictitious scene in the course of a novel.

What a charming elegy! What a charming poem! What a lovely idyll Gessner would make of it! It might be a vignette illustrating a piece by this poet. What a delicious picture! The most pleasing and perhaps the most interesting in the Exhibition. She faces the spectator; her head rests on her left hand: the dead bird is placed on the upper edge of the cage, head hanging, wings dangling, feet in the air. How naturally the girl is posed! How beautiful her face! How elegant her coiffure! What expression is in her face! Her grief is profound, she is quite obsessed with her sorrow. What a pretty catafalque the cage makes! What grace there is in that garland of leaves that twines around it! What a beautiful hand, what a beautiful arm! Look at the truth in the details of those fingers, those dimples, the softness, the touch of red with which the pressure of the head has coloured the tips of her delicate fingers. What a charm it all has! One would wish to kiss that hand were it not for the respect due to the child and her grief. Everything about her charms us, even her attire. Look at the lie of that kerchief about her neck! What lightness and softness! On seeing this piece one exclaims: 'Delicious! Delicious!' One could easily catch oneself speaking to the child, consoling her. So true is this that I remember myself talking to her as follows on a number of occasions.

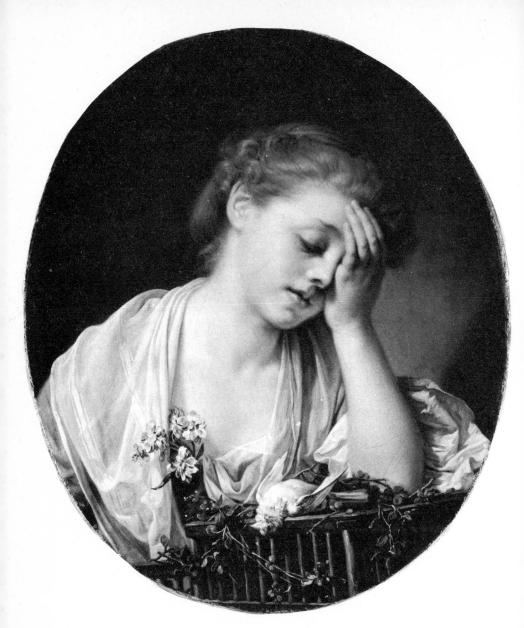

Jean-Baptiste Greuze: UNE JEUNE FILLE QUI PLEURE SON OISEAU MORT. *National Gallery of Scotland, Edinburgh*

But, little one, your grief is so very deep, so very profound. What is the meaning of this dreamy, melancholy air? What, for a bird! You do not weep. You are distressed and thought is mingled with your distress. Come, little one, open your heart to me, tell me the truth. Is it really the death of this bird which causes you to shut yourself up inside yourself so sadly? . . . You drop your eyes, you do not answer me. Your tears are ready to flow. I am not your father. I am not indiscreet, or severe. . . . Ah, now I understand. He loved you, he swore it to you and for a long time. He was so unhappy. How could one see a person one loved so unhappy? . . . Let me continue. Why close my mouth with your hand? That morning your mother was unfortunately absent. He came; you were alone. He was so handsome, so passionate, so tender, so charming! Such love there was in his eyes! Such truth in his features! He spoke the words which go straight to the soul, and while speaking them he was of course kneeling before you. He held one of your hands. From time to time you felt the warmth of the tears which fell from his eyes and flowed down your arms. And still your mother did not return. It was not your fault, it was your mother's fault. . . . See, you are weeping, but what I say to you is not to make you weep. And why weep? He promised you and he will fail in nothing that he promised. When one has been fortunate enough to meet a child as charming as you, to grow fond of her and win her affection, it is for the whole of one's life. . . . And the bird? You smile. (Ah, my friend, how lovely she was! If you could have seen her smiling and weeping together!) I continued. Ah, yes, your bird. When one forgets oneself does one remember a bird? When the time of your mother's return was at hand, your lover left. How happy he was, how beside himself! How hard it was to tear himself from your side! You look at me. I know all that. How many times he got up and sat down once more! How often he said goodbye without going! How often he went and came back! I have just seen him at his father's house. He is full of a captivating gaiety, a gaiety which takes hold of everyone willy-nilly. . . . And your mother? Hardly had he gone when she returned. She told you to do one thing and you did another. A few tears glistened on the edge of your eyelids; if you could not hold them back, you turned your head aside to wipe them away secretly. Your absent-mindedness tried your mother's patience. She scolded you and that gave you the excuse to weep openly. . . . Shall I continue? I am afraid that what I have to say may bring back your grief. You want me to? Well, your good mother blamed herself for making you sad, she took your hands, kissed your forehead and cheeks, and you wept still more freely. Your head drooped and your face, which was coloured by your blushes —as you are now blushing—hid in her bosom. How many tender things your mother spoke to you—and how those tender words hurt you! In vain your canary sang to attract your attention, called to you, flapped its wings,

complained of your neglect; you did not see it, did not hear it, your thoughts were elsewhere. No one renewed its water or its birdseed; and this morning the bird was no more. . . . You still look at me. Is there something more for me to say? Ah, I understand. It was he who gave you the bird. Ah, well he will find another as good. But there is something else. Your eyes fix themselves on me, full of sadness. What is there more? Speak, I cannot guess what is in your mind. Suppose the death of this bird was an omen! What should I do? What would become of me? If he were ungrateful. . . . What silliness! Don't be afraid. That won't happen, it is impossible. . . . But, my friend, do you not laugh to hear a grave and serious person console a child in a painting for the loss of her bird, for the loss of anything you like? But see how beautiful she is, how interesting! I don't like causing grief, and yet I would not mind myself being the cause of her distress.

The subject of this little poem is so subtle that many people have not understood it. They have thought that the little girl was only weeping for her canary. Greuze had already painted the subject once. He painted a grown up girl in white satin in front of a cracked mirror, filled with a profound melancholy. Don't you think it makes as little sense to attribute the tears of the little girl in this exhibition to the loss of her bird as to attribute the grief of the young lady in the earlier picture to her broken mirror? The little girl is weeping for something else, I assure you. You have heard her admission, and the pensiveness of her sorrow tells the rest. Such sorrow, at her age! And for a bird? How old is she then? How shall I answer you? And what is your question? Her face is the face of a fifteen-year-old, her arm and hand are those of a girl of eighteen or nineteen. It is a defect of this composition which becomes more noticeable since the head is leaning on the hand and the two conflict. If the hand were placed anywhere else it would be less noticeable that it is a little too strong and well defined. The fact is, my friend, that the head was taken from one model and the hand from another. Yet the hand is very realistic, very beautiful, the drawing and colouring are perfect. The head is well lighted and the colour as agreeable as it is possible to give to a blonde. Perhaps one could wish for a little more solidity of forms. The striped kerchief is broad, light, beautifully transparent. The whole is strongly drawn without damaging the fineness of the detail. The painter could not have done better. The picture is oval. It is two feet high.

Diderot, *Salon de 1765.*

(5) *Dante and Virgil in Hell* by Eugène Delacroix

Further, it is not without a keen pleasure that admirers of Eugène Delacroix will re-read an article from the *Constitutionnel* of 1822, taken from the *Salon* of M. Thiers, a journalist.

No picture better reveals, in my opinion, the future of a great painter than that of M. Delacroix representing Dante and Virgil in Hell. It is here particularly that one can see that flash of talent, that surge of budding superiority which brings new life to our hopes when they are a little discouraged by the too mediocre merit of the rest.

Dante and Virgil, conducted by Charon, cross the river of Hades and cleave their way with difficulty through the crowd which presses round the boat, trying to enter it. Dante, supposed to be alive, has the horrible complexion of the infernal regions; Virgil, crowned with a sombre laurel, has the colours of death. The damned, condemned eternally to desire the opposite bank, cling to the boat: one seizes it in vain and overthrown by its too rapid movement is plunged into the water; another hangs on to it and pushes away with his feet those who try to get a grip too; two more hold on to the wood of the boat with their teeth. There is in the scene the egoism of distress, the despair of hell. Yet in this subject, close as it is to exaggeration, one finds a severity of taste, a suitability to theme, which rescues a design which otherwise the severer critics (though in this case wrongly) could accuse of lack of nobility. The drawing is bold and firm, the colour simple and vigorous although a little crude.

In addition to the poetic imagination which is common to the painter and the writer, the artist has that pictorial imagination which one might almost call the imagination of visual design and which is quite different from the former. He throws his figures on to the canvas, grouping and moulding them to his will with the daring of a Michelangelo and the fecundity of a Rubens. At the sight of this picture I was gripped by a memory of the great artists; here I found once again that savage, ardent yet natural power which is carried effortlessly along by its own animation. . . .

<div align="right">Baudelaire, Salon de 1846.</div>

It is interesting to compare the following commentary by Walter Friedlaender on the same picture:

Delacroix's first large painting, 'Dante and Virgil in Hell' (*Dante et Virgile traversant le lac Dité*, 1822), was drawn from a passage of the *Inferno* and is charged with a Dantesque melancholy. The thematic arrangement obviously stems from Géricault's raft—a boat heavily laden with people, moving on the water—and this motive of the boat, in an even clearer and more daring form, was pursued by Delacroix into this very last period. The large figures moved up close to the beholder are perhaps reminiscent of Géricault in the way in which they fill the surface of the canvas and in their isolated monumentality. But the epic, restrained tragedy which traverses the whole grandiose composition of figures and binds them together is altogether new and personal.

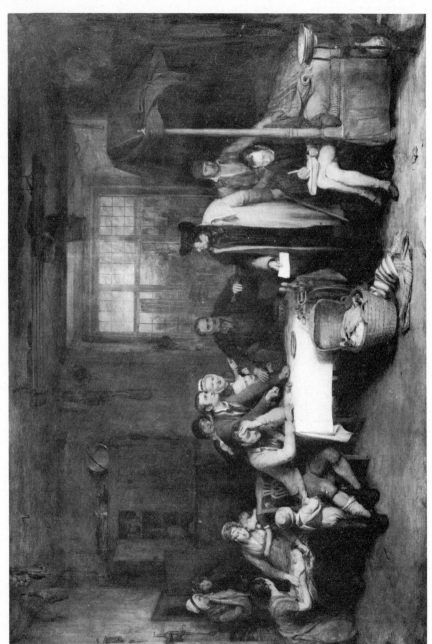

David Wilkie: DISTRAINING FOR THE RENT. *Collection, the Countess of Swinton*

Edwin Landseer: OLD SHEPHERD'S CHIEF-MOURNER. *Victoria and Albert Museum; Crown Copyright*

The colour as well contributes to this unity, and represents a decisive step away from Géricault's plastic, Caravaggiesque chiaroscuro, even though it does not yet have the brilliance that Delacroix later attained. It is astounding how this first work, done at the age of twenty-four, is lifted from the realm of naturalism into the artist's characteristic sphere of grandiose fantasy. Delacroix *fut grand dès sa jeunesse, dès ses premières productions*, said Baudelaire, referring precisely to this picture; yet it fell far short of the level that the mature and even ageing Delacroix was to demand of himself.

Walter Friedlaender, *David to Delacroix* (Eng. trans., 1963).

(6) *Distraining for the Rent* by David Wilkie

. . . It is, to our liking, Wilkie's most perfect picture . . . there is more of human nature, more of the human heart, in this, than in any of the others. It is full of

'The still, sad music of humanity;'

still and sad, but yet musical, by reason of its true ideality, the painter acting his part as reconciler of men to their circumstances. This is one great end of poetry and painting. . .

But to return to this most touching and impressive picture. What an immediate hold it took of us! How that sad family was in our mind for days after, and how we found ourselves wondering if nothing could be done for them! It is just about as difficult to bring the mind to criticize it, as it would be to occupy ourselves in thinking why and how we were affected, if we were ourselves to witness the scene in actual life. We would be otherwise occupied. Our eyes first fell on what is the immediate occasion of it all, the paper warrant: you feel its sharp parallelogram cutting your retina, it is the whitest, and therefore the first thing you see; and then on the husband. What utter sadness,—what a sober certainty of misery—how uncomplaining, as if he could not speak, his firm mouth keeping it to himself! His eyes are all but shut,—and how their expression is given, seems to us quite marvellous; and his attitude cast down, but not abject—bearing it like a man. How his fingers are painted, and his careless, miserable limbs, his thin cheek, with that small hungry hollow mark in its centre! What a dignity and beauty in his face! . . . Reason and steady purpose are still uppermost.

Not so with his poor wife: her heart is fast failing; she is silent too; but she is fainting, and just about to slip off her chair in utter unconsciousness; her eyes are blind; the bitterness of death is gathering on her soul. She is forgetting her sucking child, as she is all outward things; it is rolling off her knee, and is caught by her motherly daughter; while her younger brother, whose expressive back is only seen, is pulling his father's coat, as if to say, 'Look at mother!' Behind are two neighbours come in, and sympathizing

both, but differently; the meek look of the one farthest away, what can be finer than that! The paleness of the fainting mother is rendered with perfect truth. What an eye the painter must have had!—how rapid, how true, how retentive of every impression! Behind these silent sufferers goes on the action of the story. . . .

What a picture! so simple, so great, so full (to use a word of Wilkie's own) of intellectuality—and the result, though sad, salutary. How strange! We never saw these poor sufferers, and we know they have no actual existence; and yet our hearts go out to them,—we are moved by their simple sorrows. We shall never forget that enduring man and that fainting mother. . . .

They (pictures by Wilkie and Turner) elevate public feeling; they tend, like all productions of high and pure genius, to the glory of God, and the good of mankind; they are a part of the common wealth. We end our notice of this picture by bidding our readers return to it, and read it over and over, through and through. Let them observe its moral effect—not to make the law and its execution hateful and unsightly, or improvidence interesting or picturesque. . . .

<div align="right">John Brown, Horae Subsecivae (1882).</div>

(7) *Old Shepherd's Chief-mourner* by Edwin Landseer

Take, for instance, one of the most perfect poems or pictures (I use the words as synonymous) which modern times have seen: the 'Old Shepherd's Chief-mourner.' Here the exquisite execution of the glossy and crisp hair of the dog, the bright sharp touching of the green bough beside it, the clear painting of the wood of the coffin and the folds of the blanket, are language—language clear and expressive in the highest degree. But the close pressure of the dog's breast against the wood, the convulsive clinging of the paws, which has dragged the blanket off the trestle, the total powerlessness of the head laid, close and motionless, upon its folds, the fixed and tearful fall of the eye in its utter hopelessness, the rigidity of repose which marks that there has been no motion nor change in the trance of agony since the last blow was struck on the coffin-lid, the quietness and gloom of the chamber, the spectacles marking the place where the Bible was last closed, indicating how lonely has been the life—how unwatched the departure, of him who is how laid solitary in his sleep—these are all thoughts—thoughts by which the picture is separated at once from hundreds of equal merit, as far as mere painting goes, by which it ranks as a work of high art, and stamps its author, not as the neat imitator of the texture of a skin, or the fold of a drapery, but as the Man of Mind.

<div align="right">John Ruskin, Modern Painters (vol. 1, 1843).</div>

Comparisons in criticism

What we see when we look at a picture depends upon the nature of the interest with which we approach it and the habits of appreciation which we have formed. These things determine in a large degree the features of the picture which each observer notices and attends to. In order to illustrate the very different ways in which people look at pictures and the very different things they see when they are looking at the same physical painting, I have set side by side examples of the very various ways in which different critics describe the same art work.

The 'aesthetic object' which each observer actualizes and brings to awareness when he contemplates an art object will obviously vary roughly in accordance with the description which he is disposed to offer of it. This at any rate is an indication of what he sees. The variety of interest apparent from the examples needs no emphasis. In some interest in the narrative element is predominant, some approach the depiction as if it were a real-life scene or a *tableau vivant*, some are concerned with iconography or with deducing the mental processes of the artist. Interest in aesthetic qualities is relatively minor in most descriptions.

1. The following are three twentieth-century descriptions of the Alexander Mosaic. This mosaic (now in the Museo Nazionale, Naples) was found in the House of the Faun at Pompeii and dates from about 110 BC. It depicts Alexander the Great face to face with the Persian king Darius at the battle of Issus (333 BC) and it is thought to have been modelled on a Greek painting from the end of the fourth century BC, perhaps one by Philoxenus of Eretria.

(1) The moment is represented when Alexander, charging from the left, has just driven his lance through a Persian nobleman whose horse has fallen. King Darius is deeply agitated over the disaster and stretches out his hand as if to aid the victim. A second Persian has dismounted from his horse in an

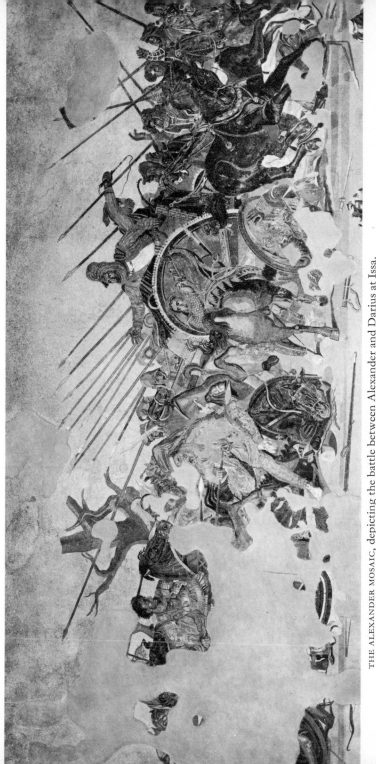

THE ALEXANDER MOSAIC, depicting the battle between Alexander and Darius at Issa. *National Museum, Naples. Photo: Mansell Collection/Alinari*

effort to help his distressed countryman. In the dangerous onset, the charioteer of Darius turns the King's chariot swiftly to the right. The impression of the violence and tenseness of battle is increased by the irresistible dash from the left; by the swerving of the King's horses to the right; by the overlapping masses of human beings and horses, and by the fallen armour. Although few figures are employed in the composition—some thirty in all—they are massed with great ingenuity. It is no longer a case of placing figures actually behind one another or above each other in space in order to represent the third dimension. The artist emphasizes depth by means of the foreshortened horses in the foreground, by giving the figures behind an abridged form—sometimes only the heads or helmets appear—and by the skilful use of the tree and spears in the background. We have a definite impression of various planes and of figures behind one another in space. The fallen armour in the foreground was undoubtedly intended to accentuate this effect. Again, the movement is not all in one direction, as in earlier works, so that the lines of movement and the intermingling of figures heighten the impression of seething masses of combatants. The mosaic is a gripping representation of a vital moment, done with the simplest means. Our emotions are engaged over the final outcome: our sympathy is aroused by the misfortune of the King; we are anxious that Alexander's boldness may succeed. He has evidently lost his helmet in the charge and the Persians press around him. He becomes a more heroic figure because of the nobility of the foes pitted against him. The composition is a balanced one with the figure of Darius uniting the two parts. The painter has not, like Polygnotus, chosen a high horizon line, but stands a little higher than his figures and close to them. Emotion is vividly expressed in the gestures and in the faces of the figures. . . . The artist shows little interest in nature; his concern is with men. Landscape is treated in the baldest manner imaginable with only a few elements from nature introduced, such as the gnarled tree, a rock here and there, or rough ground. In his employment of light and shade, slight use is made of cast shadows. Modelling is usually done with light tones as the foreshortened horse shows, but also with local colours such as Pausias used. High lights appear here and there. The real glory of the picture, however, for those who have seen this work in the Museum at Naples, lies in its emotional appeal.

Mary Hamilton Swindler, *Ancient Painting* (1929).

(2) We need not doubt that the artist and his patron intended to celebrate Alexander's triumph. But it is not only the triumph of victory which we are made to share but also the tragedy of defeat. The despairing gesture of the defeated King may ultimately derive from those tokens of helpless surrender we know from the chronicles of the ancient East but in the context of the eye-witness account it gains new meaning; it compels us to look at the scene of

slaughter not only through the eyes of the victors but also through those of the man in flight. We feel how he looks back in agony at the young Alexander who has just run his lance through a Persian noble; panic has seized the Persian army, the warriors have fallen, the horses shy. The bold foreshortening of the foreground figures, the frightened horse, the fallen Persian whose face is reflected in his shield, all draw us into the scene. We are forced to sort out the puzzling shapes to build up the image of events in our mind, and in thus lingering on the situation we come to share the experience of those involved.

E. H. Gombrich, *Art and Illusion* (1962).

(3) Far more than sculpture, painting demands a vivid sense of the relations of figures one to another and of their relation to the picture space, and we have seen all along how slow the Greek artists were to realize any relations going beyond the individual figure. From this [the Alexander Mosaic] we see that Greek artists had arrived at an understanding of the perspective foreshortening of individual figures—for example, the man and horse in the centre—but there is very little understanding of pictorial space. The figures are really imagined as spread in profile across a rather narrow stage. The one figure which contradicts this general law of frontality is so unfortunately placed that it blocks the diagonal movement suggested by the horses of Darius, which might have given some unity to the composition. Nor has the artist any grasp of chiaroscuro; everywhere there is the same clear delineation of detail; there is no attempt to group passages together by enveloping shadows, there is no system of subordination, without which so crowded a design can hardly be held into any sort of intelligible unity. It is a more or less successful dramatic illustration by means of rather conventional and rhetorical symbols. There is also an emphasis on trivial pieces of realism, like the carefully exposed reflection of the fallen soldier in the retina of his shield, which is very much in agreement with the puerile stories of *trompe-d'oeil*—like that of the 'Grapes of Zeuxis'—which were the stock in trade of art critics like Pliny.

Roger Fry, *Last Lectures* (1939).

2. *The Laocoon*

(1) The distinctive characteristic of all the Greek masterpieces of painting and sculpture is said by Herr Winckelmann to consist in a noble simplicity and calm grandeur, displayed in the posture as well as in the expression. 'As the depths of the seas', he says, 'always remain calm, however much its surface be disturbed, so the expression in the figures of the Greeks, under every form of passion, reveals a great and collected soul.

Such a soul is portrayed in the countenance of Laocoon, and not in the countenance alone, under the intensest suffering. The pain which is betokened in every muscle and sinew of his body, and which we almost imagine we ourselves feel on merely beholding the agonized contraction of the abdomen, without looking at the face and the other parts: this pain, I say, is nevertheless displayed without any violent stress, both in the face and in the whole attitude. He raises no terrible shriek, as does Virgil's Laocoon; the opening of the mouth does not admit it; it is rather an anxious and suppressed sigh, as described by Sadolet. The bodily pain and the greatness of soul are, as it were, weighed out and distributed with equal force through the whole frame of the figure. Laocoon suffers, but he suffers like the Philoctetes of Sophocles: his misery pierces us to the soul, but we wish that we could endure misery like that great man.

The expression of so great a soul far exceeds the painting of beautiful nature. The artist must have felt within himself that strength of spirit which he imprinted upon his marble. Greece possessed artists and philosophers in one and the same person, and had more than one Metrodorus. Philosophy gave her hand to Art, and breathed into the figures of the latter more than ordinary souls.'

The observation on which the foregoing remarks are founded—viz. that pain is not portrayed in the countenance of Laocoon with that stress which its intensity would lead us to expect—is a perfectly correct one. Nor can it be disputed that this very point, which would lead the half-connoisseur to conclude that the artist had fallen short of nature and had not reached the true pathos of pain, serves most of all to render his wisdom.

<div align="right">Gotthold Ephraim Lessing, Laocoon, ch. 1.</div>

(2) Of the once famous works of art which, in this study of the nude, I have tried to see with fresh eyes, the Laocoon is the most tarnished by familiarity. It is also the one whose fame can be least easily dismissed as an error of taste or the residue of earlier excitement; and the artists, poets, critics, and philosophers who have praised it have done more than read into it their own needs and poetic aspirations. In fact one of the greatest critics, Lessing, used it as an example of those excellences which are peculiar to the visual arts. That this work, so highly recommended, should have failed in its effect during the last fifty years, is due to a quantity of causes, of which two may be mentioned now, its elaborate completeness and its rhetoric.

Antique art has come down to us in a fragmentary condition, and we have virtuously adapted our taste to this necessity. Almost all our favourite specimens of Greek sculpture, from the 6th century onwards, were originally parts of compositions, and if we were faced with the complete group in which the Charioteer of Delphi was once a subsidiary figure, we might well experience

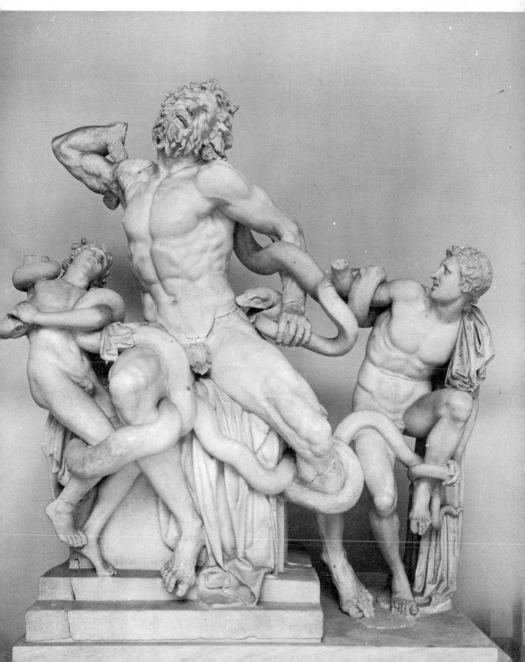

LAOCOON: *Vatican Museum, Rome*

a moment of revulsion. We have come to think of the fragment as more vivid, more concentrated and more authentic. The revelation of personal sensibility, the quality of the sketch, to which Croce has given a philosophic justification, is overlayed and smothered by labour. We can test this by imagining, or seeing in a cast, a fragment of the Laocoon, for example the father's torso and thigh. How life-enhancing they are when allowed to make their effect by formal qualities alone, without encumbering detail. There is scarcely another nude in which emotion is communicated with such absolute mastery of means. The accessory snakes and sons seem to lessen the immediacy of this effect. Now, I think we should be unwise to mistrust an aesthetic which habitually prefers the part to the whole and in this instance we know that the anguished strength of Laocoon's body is intended to gain effect by contrast with the exhausted relaxation of his younger son. The criticisms of Winckelmann and Lessing are not mere literary exercises; they indicate that a great masterpiece must fire off more than one gun. The first aesthetic shock is not enough. But to appreciate this demands time and a continuous state of alert receptivity, and in a philosophy of art based on the immediate sensation it is not easily achieved.

Then, as to rhetoric: the Laocoon is too rich for our frugal taste, and, in particular, we are apprehensive of this sauce by which our parents were persuaded, as we believe, to swallow many impure substances. No one will deny that rhetoric, the mechanism of art used to persuade us through our emotions, has been generously employed in the Laocoon. But rhetoric is not necessarily a garnishing added to an idea to make it persuasive; it may invest the idea so closely as to become a part of it, as in some famous speeches of Shakespeare; and such, it seems to me, is the case with the Laocoon. It contains no movement which cannot be justified by necessity as well as art, except some which are due to its restoration in the 16th century. We know that the father's right hand was originally behind his head, the symbolic gesture of pain, and Montorsoli's eloquent reconstruction not only deprived the group of its classical enclosure, what I have called the cameo quality of antique art, but has also introduced a new kind of oratorical language. Moreover, we must not confuse rhetoric with sentimental exaggeration. Winckelmann stressed particularly the restraint of the Laocoon. . . . Winckelmann was contrasting it, of course, with the works of the decadent baroque tradition, the current style of his youth, which his own writings were about to displace. For a hundred and fifty years artists had been trying to enhance the effectiveness of their works by gestures and expressions which went far outside the warrant of their subjects. The result was not precisely rhetoric, because in such a weak work as Guido Reni's Samson the nude figure is not trying to persuade us to feel any emotion, except satisfaction in the art itself:

it is as much a piece of art for art's sake as a sculpture by Brancusi, and in certain moods we welcome it because it is at such a comfortable remove from reality. In the Laocoon, on the other hand, although the situation is improbable, the conduct of the fable is remarkably real and afflicting.

<div align="right">Kenneth Clark, The Nude (1960).</div>

3. The Mona Lisa

(1) For Francesco del Giocondo Leonardo undertook to execute the portrait of his wife, Mona Lisa. He worked on this painting for four years, and then left it still unfinished; and today it is in the possession of King Francis of France, at Fontainebleau. If one wanted to see how faithfully art can imitate nature, one could readily perceive it from this head; for here Leonardo subtly reproduced every living detail. The eyes had their natural lustre and moistness, and around them were the lashes and all those rosy and pearly tints that demand the greatest delicacy of execution. The eyebrows were completely natural, growing thickly in one place and lightly in another and following the pores of the skin. The nose was finely painted, with rosy and delicate nostrils as in life. The mouth, joined to the flesh-tints of the face by the red of the lips, appeared to be living flesh rather than paint. On looking closely at the pit of her throat one could swear that the pulses were beating. Altogether this picture was painted in a manner to make the most confident artist—no matter who—despair and lose heart. Leonardo also made use of this device: while he was painting Mona Lisa, who was a very beautiful woman, he employed singers and musicians or jesters to keep her full of merriment and so chase away the melancholy that painters usually give to portraits. As a result, in this painting of Leonardo's there was a smile so pleasing that it seemed divine rather than human; and those who saw it were amazed to find that it was as alive as the original.

<div align="right">Vasari, Lives of the Artists (1550), trans. Bull (1965).</div>

(2) La Giaconda is, in the truest sense, Leonardo's masterpiece, the revealing instance of his mode of thought and work. In suggestiveness, only the Melencolia of Dürer is comparable to it; and no crude symbolism disturbs the effect of its subdued and graceful mystery. We all know the face and hands of the figure, set in its marble chair, in that cirque of fantastic rocks, as in some faint light under sea. Perhaps of all ancient pictures time has chilled it least. As often happens with works in which invention seems to reach its limits, there is an element in it given to, not invented by, the master. In that inestimable folio of drawings, once in the possession of Vasari, were certain designs by Verrocchio, faces of such impressive beauty that Leonardo in his boyhood copied them many times. It is hard not to connect with these designs of the elder, by-past master, as with its germinal principle, the unfathomable smile,

always with a touch of something sinister in it, which plays over all Leonardo's work. Besides, the picture is a portrait. From childhood we see this image defining itself on the fabric of his dreams; and but for express historical testimony, we might fancy that this was but his ideal lady, embodied and beheld at last. What was the relationship of a living Florentine to this creature of his thought? By means of what strange affinities had the person and the dream grown up thus apart, and yet so closely together? Present from the first incorporeally in Leonardo's thought, dimly traced in the designs of Verrocchio, she is found at last in *Il Giocondo's* house. That there is much of mere portraiture in the picture is attested by the legend that by artificial means, the presence of mimes and flute-players, that subtle expression was protracted on the face. Again, was it in four years and by renewed labour never really completed, or in four months and as by stroke of magic, that the image was projected?

The presence that thus rose so strangely beside the waters, is expressive of what in the ways of a thousand years men had come to desire. Hers is the head upon which all 'the ends of the world are come', and the eyelids are a little weary. It is a beauty wrought out from within upon the flesh, the deposit, little cell by cell, of strange thoughts and fantastic reveries and exquisite passions. Set it for a moment beside one of those white Greek goddesses or beautiful women of antiquity, and how would they be troubled by this beauty, into which the soul with all its maladies has passed! All the thoughts and experience of the world have etched and moulded there, in that which they have of power to refine and make expressive the outward form, the animalism of Greece, the lust of Rome, the reverie of the middle age with its spiritual ambition and imaginative loves, the return of the Pagan world, the sins of the Borgias. She is older than the rocks among which she sits; like the vampire, she has been dead many times, and learned the secrets of the grave; and has been a diver in deep seas, and keeps their fallen day about her; and trafficked for strange webs with Eastern merchants: and, as Leda, was the mother of Helen of Troy, and, as Saint Anne, the mother of Mary; and all this has been to her but as the sound of lyres and flutes, and lives only in the delicacy with which it has moulded the changing lineaments, and tinged the eyelids and the hands. The fancy of a perpetual life, sweeping together ten thousand experiences, is an old one; and modern thought has conceived the idea of humanity as wrought upon by, and summing up in itself, all modes of thought and life. Certainly Lady Lisa might stand as the embodiment of the old fancy, the symbol of the modern idea.

Walter Pater, 'Leonardo da Vinci' in *Studies in the History of the Renaissance* (1873).

(3) Standing on the slippery floor of the Salon Carré, breathing its lifeless

air, with the nasty smell of fresh paint in my nostrils, occasionally stealing a moment's rest on the high stool of an absent copyist, I would spend the hours of long summer days trying to match what I really was seeing and feeling with the famous passage of Walter Pater, that, like so many of my contemporaries, I had learned by heart.

I wonder even now how far I succeeded, for brought up almost exclusively on words, I easily yielded to incantations and talismanic phrases. They put me into states of body and mind not very different from those produced by hypnotic suggestion, and I should have stayed under the spell, if only I had been kept away from the object. But the presence of the object disturbed coma and prevented acquiescence. Its appeals grew and grew until finally it dared come into conflict with the powers of a shaman so potent even as Walter Pater. My eyes were unglamoured and I began to look. What an enchanted adept died in me when I ceased listening and reading and began to see and taste!

What I really saw in the figure of 'Mona Lisa' was the estranging image of a woman beyond the reach of my sympathies or the ken of my interests, distastefully unlike the women I had hitherto known or dreamt of, a foreigner with a look I could not fathom, watchful, sly, secure, with a smile of anticipated satisfaction and a pervading air of hostile superiority. And against this testimony of my instincts nothing could prevail. I argued with myself many scores of times that the landscape was mysterious and fascinating, that the conscious art of the painter was marvellous, for it was at once bold and large in conception and delicate, and subtle, in execution. Then the mass of the figure was imposing yet simple, the modelling persuasive, the existence convincing. I learned to revel in these qualities, to enjoy analysing them, and to dwell lovingly upon each point. I was soothed by the collectedness and fullness of her pose, delighted with the simple yet unobvious device by which her sloping shoulder is given a monumental breadth, and amused by the wary intricacies in the hair and folds. And besides, were not four centuries unanimous in repeating that 'Mona Lisa' was one of the very greatest, if not absolutely the greatest achievement of artistic genius?

So I hoped that my doubts would die of inanition, and that my resentment, convinced of rebellious plebeianism, would burn itself out of sheer shame. But neither happened, although in the meantime I too had become a prophet and joined my voice to the secular chorus of praise.

One evening of a summer day in the high Alps the first rumour reached me of 'Mona Lisa's' disappearance from the Louvre. It was so incredible that I thought it could only be a practical joke perpetrated by the satellites of a shrill wit who had expressed a whimsical animosity towards a new frame into which the picture had recently been put. To my own amazement I never-

theless found myself saying softly: 'If only it were true!' And when the news was confirmed, I heaved a sigh of relief. I could not help it. The disappearance of such a masterpiece gave me no feelings of regret, but on the contrary a sense of long-desired emancipation. Then I realized that the efforts of many years to suppress my instinctive feelings about 'Mona Lisa' had been in vain. She had simply become an incubus, and I was glad to be rid of her.

. . . whatever merits 'Mona Lisa' may have as pure decoration, although it is scarcely these that have perpetuated her fame, as illustration she is not really satisfactory. Looking at her leads to questioning, to perplexity, and even to doubt of one's intelligence, which does not interfere with our being fascinated by her, but does effectually prevent the mystic union between the work of art and ourselves, which is of the very essence of the aesthetic moment. That it is the fault of conflicting over-meanings I can scarcely doubt, for now we all know Chinese heads from Long-men, Hindoo heads from Borobodur, Khmer heads from Angkor, and heads from hundreds of other Buddhist sites, far more self-contained, far more inward, and far more subtle, which nevertheless, because of the untroubled clearness of the meaning, charm us into that ecstasy of union with the object contemplated which art should produce.
Bernhard Berenson, *The Study and Criticism of Italian Art* (third series), 1916.

(4) How exquisitely lovely the Mona Lisa must have been when Vasari saw her; for of course his description of her fresh rosy colouring must be perfectly accurate. She is beautiful enough even now, heaven knows, if we could see her properly. Anyone who has had the privilege of seeing the Mona Lisa taken down, out of the deep well in which she hangs, and carried to the light will remember the wonderful transformation that takes place. The presence that rises before one, so much larger and more majestical than one had imagined, is no longer a diver in deep seas. In the sunshine something of the warm life which Vasari admired comes back to her, and tinges her cheeks and lips, and we can understand how he saw her as being primarily a masterpiece of naturalism. He was thinking of that miraculous subtlety of modelling, that imperceptible melting of tone into tone, plane into plane, which hardly any other painter has achieved without littleness or loss of texture. The surface has the delicacy of a new-laid egg and yet it is alive: for this is Pater's 'beauty wrought out from within upon the flesh little cell by cell'—a phrase which more than any other in that famous cadenza expresses Leonardo's real intention.

Familiarity has blinded us to the beauty of the Mona Lisa's pose. It is so easy, so final, that we do not think of it as a great formal discovery until we rediscover it in Raphael's Maddalena Doni or Corot's Dame à la Perle. Where the romantic overtones are less insistent we are freer to contemplate formal relationships, and we see, in the Raphael for example, how carefully the axes

of head and bust and hands are calculated to lead us round the figure with an even, continuous movement. A proof that Leonardo's contemporaries felt the value of this invention is the number of pupils' copies in which the figure is shown undraped. It is possible that Leonardo did a large drawing of this subject in order to realize more fully the implications of the pose, and from this there derives the many pupils' versions, including an accomplished cartoon at Chantilly. At all events, a nude figure in the attitude of the Mona Lisa was well known in France in the early sixteenth century, and formed part of the stock in trade of the Fontainebleau painters on the frequent occasions when they had to portray royal favourites in their baths.

Once we leave these purely historical considerations, we are surrounded by mist and mirage. The English critic, above all, is embarrassed by Pater's immortal passage ringing in his ears, and reminding him that anything he may write will be poor and shallow by comparison. Yet the Mona Lisa is one of those works of art which each generation must re-interpret. To follow M. Valéry and dismiss her smile as *un pli de visage*, is to admit defeat. It is also to misunderstand Leonardo, for the Mona Lisa's smile is the supreme example of that complex inner life, caught and fixed in durable material, which Leonardo in all his notes on the subject claims as one of the chief aims of art. A quarry so shy must be approached with every artifice. We can well believe Vasari's story that Leonardo 'retained musicians who played and sang and continually jested in order to take away that melancholy that painters are used to give to their portraits'; and we must remember the passage in the *Trattato* (par. 135) which describes how the face yields its subtlest expression when seen by evening light in stormy weather. In this shunning of strong sunlight we feel once more the anti-classical, we might say the un-Mediterranean, nature of Leonardo. 'Set her for a moment,' says Pater, 'beside one of those white Greek goddesses, or beautiful women of antiquity, and how would they be troubled by this beauty into which the soul with all its maladies has passed.' In its essence Mona Lisa's smile is a Gothic smile, the smile of the Queens and Saints at Rheims or Naumburg, but since Leonardo's ideal of beauty was touched by pagan antiquity, she is smoother and more fleshly than the Gothic saints. They are transparent, she is opaque. Their smiles are the pure illumination of the spirit; in hers there is something worldly, watchful, and self-satisfied.

The picture is so full of Leonardo's demon that we forget to think of it as a portrait, and no doubt an excellent likeness of a young Florentine lady of twenty-four. She is often described as Leonardo's ideal of beauty, but this is false, since the angel in the Virgin of the Rocks and the two St. Annes show that his ideal was more tranquil and more regular. None the less she must have embodied something inherent in his vision. . . . At least we can be sure

that his feeling for her was not the ordinary man's feeling for a beautiful woman. He sees her physical beauty as something mysterious, even a shade repulsive, as a child might feel the physical attraction of his mother. And as often with Leonardo, this absence of normal sensuality makes us pause and shiver, like a sudden wave of cold air in a beautiful building.

Kenneth Clark, *Leonardo da Vinci* (1939).

4. *Guernica* by Pablo Picasso

Of the two descriptions of Picasso's *Guernica* which follow, the former betrays a preponderant interest in the iconography while the latter is more concerned with the expressive character of the forms.

(1) The deliberation with which Picasso worked out the symbolism of *Guernica* and the form exactly appropriate to its expression represents one aspect of his debt to the long tradition of classical art: Raphael and Poussin worked on exactly the same principles, even if their aims were different. But the painting is linked with tradition in other ways: the central symbol of the bull is one of the oldest in the art of the Mediterranean, going back at least as far as the Minoan Age, and in many other respects the iconography of the painting can be traced back to idioms current in European art for many centuries, in some cases as far as to classical Antiquity.

Even the basic conception of the picture is not without links with the past, for it would not be an exaggeration to describe *Guernica* as a *Massacre of the Innocents*—the *Massacre of the Innocents* of the Spanish Civil War. It was probably with a consciousness of the long series of paintings illustrating this theme that Picasso chose, as an essential vehicle for conveying the tragedy of the scene, the group of a mother carrying her dead baby, which appears first on the right and eventually on the left of the composition, and to the evolution of which he paid so much attention in the preliminary drawings. Further, the action and gestures of the mother in this group and of the two women on the right of the painting are closely related to those found in representations of the *Massacre* in the sixteenth and seventeenth centuries, where the mouth, wide open in a scream, and the head violently thrown back in anguish are frequently to be seen. Both these actions can be found in such vividly expressive paintings of the subject as Matteo di Giovanni's, so different in the gesticulating and howling agony of its mother from the sedate under-statement of a Giotto or a Giovanni Pisano. Even closer in some respects is Guido Reni's *Massacre*, the most celebrated seventeenth-century version of the subject, for, while the face of Matteo di Giovanni's mother expresses her distress in gnarled and wrinkled grimaces, Guido's heads are all based on the classical types which Picasso has used, not only for the woman holding the lamp, but also for the mourning women. Even closer to Picasso

in feeling, owing to its economy and concentration, is Poussin's *Massacre* at Chantilly, a painting which Picasso must certainly have known when he planned *Guernica*. The outstretched arm of the woman in the foreground, and the mother in the background carrying her dead child, with one arm hanging down, have the same expressive simplicity as the figures in Picasso's tragedy. The formalized features and the open mouth of the principal figure in Poussin's *Massacre* reveal unmistakably their origin in the masks which Greek and Roman actors wore when acting tragic parts, and it is not at all unlikely that Picasso also had such models in mind when he employed this device. . . .

Anthony Blunt, *Picasso's* Guernica (1969).

(2) The genesis of the *Guernica* panel (11 feet high and 25 feet wide) is worth a brief note. During the two years that preceded it Picasso's emotional preoccupations had been largely centred on the Spanish Civil War. Consequently his stylistic invention had developed in the direction of indignation at cruelty and injustice. During those years and especially in the latter months of that period he had been experimenting with shapes of unusual angularity and ferocity—or to be strictly precise, angularity which became in his hands the equivalent of ferocity.

But this stylistic development was often almost independent of the descriptive or narrative content. Portraits of Dora Maar and Madame Éluard painted in 1937 show the same set of angular conventions but contain no implications of anger. It is as though the formal vocabulary he had been evolving to fit a dominant mood had overflowed into paintings that had no connexion with the mood.

But parallel with these ferocious paintings and interspersed with them was another series of works left over, as it were, from the voluptuous 'gothic' series of 1932 but far more poetic in their imagery. They vary in mood between suave pathos and tenderness, and in content they are among his most memorable essays in a private mythology dominated by the minotaur. This extraordinary creature, sometimes a symbol of brute strength, sometimes of Caliban-like bewilderment, sometimes triumphant, sometimes subdued and even slain by beauty, is developed in a series of drawings and etchings that culminated in one of the most pregnant and memorable of all his works, the *Minotauromachie* of 1935.

This series of mythologies contains the germ of a great deal that was to reappear in a simpler, savager form in *Guernica*. The bull, the frightened horse, the vulnerable woman, the child holding a symbol of hope in an outstretched hand, are all echoes of previous innovations. A familiar melody has been reorchestrated. From a richly elaborated *andante* it has become a stark *allegro furioso*. *Guernica* combines the symbolic imagery with the fierce angularity of the years that preceded its appearance.

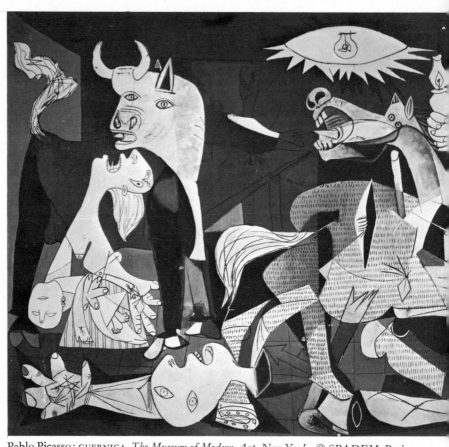

Pablo Picasso: GUERNICA. *The Museum of Modern Art*, *New York*. © SPADEM, Paris

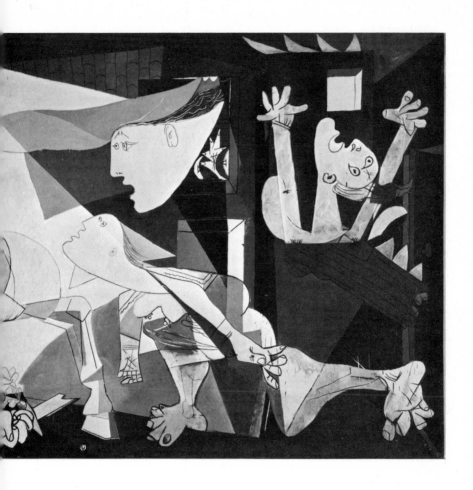

But also—as was inevitable in the case of so large a picture—its planning is purely classic. If proof were needed that romantic content need not be contradicted by a classically deliberate basic plan, *Guernica* supplies it. Mathematically speaking, the picture is based on a firm central pyramid strengthened on either side by groups whose dominant rhythms are vertical. And the verticals are carried across by further references to verticals within the pyramid itself. The basic architecture of the panel is that of a Greek pediment flanked by columns, and despite the almost hysterically expressive separate ingredients it contains, nothing could be structurally firmer than this overall plan.

The pyramid rises, in two shallow curves, like the silhouette of Mount Etna to a strongly marked centre line. Within its framework is packed most of the violence and suffering. On the left, the group of the bull and the woman mourning over her dead child makes a compact group, tapering *upwards*: on the right the woman with arms outstretched, falling downwards through a burning house, balances the bull, in a shape that tapers *downwards*. Nearer to the centre line are two more supporting shapes. On the left the horse-image and the sun-image, on the right the head and the arm that thrusts itself across the point of the pyramid and holds a lamp that adds another vertical.

This is the kind of basic architecture that a Raphael or a Poussin could easily have invented. That Picasso should have used it as a steadying framework is no sign of genius. Any good artist with a feeling for the laws of composition could have arrived at a similar solution to the problem of planning so large a surface. It is not until we begin to *read* the picture in terms of the invented glossary of form and the not very obscure language of accepted symbolism, that it begins to count as a masterpiece. And it seems clear that Picasso, in designing it, was determined that it should be read entirely in terms of its linear construction and the alternating masses of light and dark areas, since he ultimately decided to eliminate colour and make his final statement in grisaille, even though he was quite capable of fusing form-content with colour-content in order to double the emotional impact of the final product. He did, in fact, paint, in the same year, a head of a weeping woman, clearly connected with the mood and imagery of *Guernica*, in which the colour, acid and brilliant, is both appropriate and insistent.

The picture contains a good deal of symbolism, and here again is a painter's device that makes no demands on genius, for symbolism is fundamentally imagery that is valid for the spectator only by virtue of having an accepted meaning. It is, in fact, visually no more than a short cut—a device that overflows into the domain of literature but happens to use a formal instead of a verbal medium. To represent hope by an anchor and justice by a blindfolded woman requires neither talent nor ingenuity. Its presence in a work of visual art is no indication of an urge to increase the impact of emotional content.

Guernica could conceivably have dispensed with the bull, the horse, the lamp and the formalized sun with rays radiating outwards from an electric bulb. Even the broken sword in the hand of the fallen warrior is merely an easy way of indicating that he has been engaged in some form of combat with an anonymous adversary.

Once the literary content of the symbol has been accepted as adding something, however little, to the message, its function has been fulfilled. Beyond that it can only add a note of obscurity. And this Picasso has succeeded in doing for his symbols have a life of their own which lifts them out of the category of 'accepted' imagery and gives them a range of meaning that is normally beyond the range of the familiar stereotypes of literary symbols. The bull is another reincarnation of the mysterious minotaur, with all its patience, its pathos and its nobility: the horse is the most arresting item of imagery in the picture's surface, partly because of its central position, partly because it has become the crowning statement of anguish. Packed with 'meaning' though they are, the meaning conveyed by these two creatures is not simple or precise. Equally dubious is the almond-shaped form with the electric bulb in its centre that seems to mean the sun—but is it, in its turn, a symbol of hope? Or does it contain a hint of claustrophobia—the only source of light in a crowded, violated underground shelter?

But the secret of *Guernica*'s romantic impact is found neither in its classic, architectural symmetry, nor in its symbolism, but in the innate character of the forms themselves. And this is my central theme. If one regards them as wilful departures from descriptive realism, they are distorted with the kind of intelligent recklessness of which only Picasso knew the secret and which even he could use to its fullest effect only at certain moments when passionate emotion and formal inventiveness were working in perfect harmony with each other.

The eye is riveted immediately on certain details in which the formal invention is working at white heat. The outstretched empty hand of the warrior on the left—its fingers clumsily grasping the air, its palm crossed by a cat's cradle of brutal lines—is balanced by the foot and ankle of the woman who rushes in from the right. These two fragments—architecturally important because they mark the limits of the pyramid's base—are emotionally arresting because they establish the kind of linear tension that pervades the picture.

It would be possible, though it would be tedious, to analyse these formal tensions in detail. Some of them have a childlike obviousness, others sink in slowly and convey their meaning gradually to the mind behind the eye. Some are mere rudimentary simplifications of something that had to be included for clarity's sake but added nothing to the content: others, which occur at the

most vital points of intersection, are evidently the result of a long process of trial and error, where the lines gather themselves together into knotted complexities. In particular, the horse's head, more ruthlessly 'distorted' than any other piece of imagery, has been arrived at after a longish sequence of experimental drawings—attempts, as it were, to see the inside of the open mouth, to isolate the teeth, to turn the thrust-out tongue into a dagger, to reduce the eyes to tiny circles, as though they were sightless in death.

Eric Newton, 'Art as Communication' in the *British Journal of Aesthetics,* vol. 1, no. 2. Reprinted in H. Osborne (ed.), *Aesthetics in the Modern World.*

Note on Music

Discussion of the emotional character or possibilities of music has usually consisted of debate whether non-verbal music can express, communicate, evoke, 'non-musical' or 'life' emotions or whether it is restricted to 'musical' emotions.[1] This discussion is ill-considered and beside the point. No art in its abstract and formal aspects can express or communicate emotions. An emotion cannot be expressed by any correlate which does not present a situation inviting judgement and a possibility of action. In so far as music is formal—non-vocal, non-programmatic—it is in no different case from any other art. There may be a reaching down to basic moods and the undifferentiated mood of feeling may be articulated with quite extraordinary precision and delicacy in so far as musical structure exceeds the possibilities of any other art in complicated complexity. But the articulation of feeling is not that which takes place in the emotions of life any more than it is in painting or sculpture or architecture or drama. The formal articulation of feeling is something we have no language to describe, in music or any of the arts. This matter was expressed with insight, if somewhat rhetorically, by Busoni:

To music, indeed, it is given to set in vibration our human moods: Dread (*Leporello*), oppression of soul, invigoration, lassitude (Beethoven's last quartets), decision (*Wotan*), hesitation, despondency, encouragement, harshness, tenderness, excitement, tranquillization, the feeling of surprise or expectancy, and still others; likewise the inner echo of external occurrences which is bound up with these moods of the soul. But not the moving cause itself of these spiritual affections;—not the joy over an avoided danger, nor the danger itself, or the kind of danger which caused the dread; an emotional state, yes, but not the psychic species of this emotion, such as envy, or jealousy; and it is equally futile to attempt the expression, through music, of moral characteristics (vanity, cleverness), or abstract ideas like truth and justice. Is it possible to imagine how a poor, but contented man could be represented by

music? The contentment, the soul-state, can be interpreted by music; but where does the poverty appear, or the important problem stated in the words 'poor, but contented'? This is due to the fact that 'poor' connotes a phase of terrestrial and social conditions not to be found in the eternal harmony. And Music is a part of the vibrating universe.[2]

This does not prevent a *correspondence* between the mood of music and extra-musical situations and emotions of life. Music is used as a background to dance and poetry and drama. It is combined with vocalization in song and in opera. In all these uses the formal structure of the music may be appropriate or incongruous and the possibility for this correspondence depends on the fact that the basic moods which are articulated along one path by the musical structure may accord or conflict with the moods which are differentiated and made concrete along a different path in the emotional situations which are presented by the verse of drama which the music accompanies.

In one respect the formal structure of music differs, in degree if not in kind, from the configurations of the other arts. Its formal shapes and patterns have a quality which lends itself most readily to description in *orectic* language. We hear tension and movement, striving and stress, as if a vivid analogue of human will and desire. As R. W. Hepburn has said: 'Within the classical idiom we feel that in most contexts a dominant seventh, and more so a thirteenth, "want" to move to the tonic chord. The music wants, strives, to reach its resolution: the wanting is not mine who hear the chord, but the music's. This is one of *its* vicissitudes.'[3]

Yet appreciation at its best and most adequate should be a matter of percipience, apprehension of the structure of sound that is presented. It is an outgoing attitude of attention, concentrating upon the presented sound in all its complexity of configuration and not turning inwards upon the emotional stirrings of the hearer. Description in emotional language follows afterwards, when reflection looks back upon the experience. The experiencing of music means absorption in the music itself and attention given to subjective feeling while the music is being taken in can only deflect attention and jeopardize appreciation. To this extent at least one can accept the recommendations of that doyen of modern musical theory, Eduard Hanslick:

The majority of people listening to music float in a sort of singing void. They perceive only emotionally the happy, quick, or the slow majestic flow

of the music and if they listen to several pieces of the same general character they feel only what those pieces have in common, not the difference in construction, the particular and individual qualities of each piece. The music-ally trained listener will react in precisely the opposite way. He will perceive the artistic form, that which distinguishes one piece among a dozen similar ones, and this will weigh so heavily with him that he will attribute but little value and importance to a similarity in emotional content. But if the listener does not remain conscious of the craftsmanship, the form, the art in the music he hears, then as he is more securely bound by the enchantment of sound and as the intensity of his enchantment grows it comes to owe less and less to the composer. The number of those who hear or rather who feel music like this is very great. As they let themselves be overwhelmed by the elemental power of music, while they remain passive and limp, they seem affected by some supra-sensual excitement whose nature is but vaguely influenced by the general character of the music they hear. This attitude towards music is not so much aesthetic as pathologic.[4]

Notes

Chapter 1: APPRECIATION AS A SKILL

1 Clive Bell, *Enjoying Pictures* (1934), pp. 51–2.

2 Michael Polanyi, *Personal Knowledge* (1958), especially ch. 4; and *The Tacit Dimension* (1967).

3 In the nineteenth century the term 'connoisseurship', without entirely losing its more general connotation of sensibility and discrimination, became current in a narrower sense, linked with the specialized disciplines of the art historian and museum man—the apparatus of knowledge which in Germany was designated by the term *Kunstwissenschaft*. Influential in promoting this usage was Sir Charles Eastlake, who in an essay entitled 'How to Observe' (1835; reprinted in *Contributions to the Literature of the Fine Arts*, 2nd series, 1870) defined connoisseurship as follows:

The connoisseur, as the name implies, is he who more especially professes to *know*. The designation perhaps indicates an acquaintance with facts rather than truths, with appearance and results rather than their causes. In its general acceptance it comprehends a familiarity with the characteristics of epochs, schools, and individual masters, together with a nicer discrimination which detects imitations from original works. The chief distinction between the connoisseur and the amateur is that the knowledge of the first assists the exercise of judgement, while that of the latter tends to kindle the imagination. The studies of the connoisseur may, however, take a wider range, and be directed not only to recognize excellence in works of art, but to investigate the nature and principles of that excellence; in short, in addition to a practical and habitual acquaintance with specimens, and a discrimination of their relative claims, to penetrate the causes of the world's admiration. On the whole, therefore, he may be said to combine the views of the philosophical artist with an erudition to which the artist seldom aspires.

Nowadays 'connoisseur', with perhaps rather less emphasis upon 'erudition', indicates a person who is thought to be more thoroughly equipped with sound aesthetic standards of judgement than are amateur lovers of art. The greater emphasis upon aesthetic appreciation also differentiates the connoisseur from the expert, who, although a master of factual knowledge within his field, may be ill equipped for aesthetic discrimination.

The connoisseur contributes insights which deepen and promote aesthetic judgements outside the purview of the expert as such and of which the expert may be incapable.

The sense in which I have used 'connoisseurship' for the special purposes of this chapter carries no implications of external learning or knowledge about, but covers the whole class of cognitive mental skills—those which involve perceptiveness—distinguishing them from other mental skills as for example creativity, salesmanship, statesmanship, scholarship, etc.

4 Theophilus, *De Diversis Artibus*, ed. C. R. Dodwell (1961); Cennino Cennini, *Il Libro dell' Arte* (*c.* 1390).

5 Immanuel Kant, *Critique of Judgement* (1790), trans. Meredith, sec. 46.

Chapter 2: APPRECIATION AS PERCIPIENCE

1 Clive Bell, *Art* (1915), p. 27. Reprinted in *Aesthetics and the Philosophy of Criticism* (1963), ed. Marvin Levich.

2 John Dewey, *Art as Experience* (1934).

3 Thomas Munro, *Evolution in the Arts* (1964), p. 400.

4 For some decades past it has been argued by some philosophers that the concept of art cannot be defined in terms of any feature or set of features which all works of art have in common and without which no artifact can properly be called a work of art. It is maintained that 'art' is what has come to be known as a 'family resemblance term', that it refers not to one single kind but to a number of different classes of things, which may indeed display various and intricate strands of similarities but which there is no reason to believe will turn out to have properties common to all of them. Or, it has come to be believed by many such philosophers, any features which are common to all things which are traditionally and currently accepted as works of art will prove to be trivial and not worth pursuing. More recently a similar argument has been put forward in regard to aesthetic experience. A typical formulation of it will be found in a paper contributed by Marshall Cohen under the title 'Aesthetic Essence' to the collection *Philosophy in America* (1965) edited by Max Black. Cohen attacks the idea that 'if there is no property common to all works of art there may yet be some property or properties common to our proper experience of these works of art, or to the preconditions of that experience or to the criteria of our aesthetic judgements'. His method is to adduce not always quite convincing counter-instances to any description of aesthetic experience, and by this method he repudiates the hedonistic theory as recently revived by J. O. Urmson in his paper 'What Makes a

Situation Aesthetic?' (reprinted in Joseph Margolis (ed.), *Philosophy Looks at the Arts,* 1962). Edward Bullough's theory of 'aesthetic distance', and the widely accepted theory of aesthetic contemplation. He concludes: 'There is no way of determining the preconditions of all aesthetic experience, just as there is no way of knowing what qualities such experience must bear.'

In favour of this way of thinking we may admit that it would be silly to belittle the important differences that exist between the activities in which we engage when we enter into aesthetic commerce with such diverse works of art as, for example, the Taj Mahal, a miniature by Hilliard, a Tiepolo ceiling, a Mahler symphony, a play by Ionesco, and a Shakespeare sonnet. Even when we attend an exhibition of paintings by a single artist it may well be important to know that one picture is to be looked at in a different way from another because it is doing different things; that different modes of attention are called for and different sorts of things require notice. But it would be equally irresponsible to deny prematurely that there can be any common features of appreciation in virtue of which my words have meaning when I say that I am attending to something aesthetically and not in some other way. A person says that he is reading Homer as literature and not for purposes of textual criticism or in furtherance of archaeological research into the social customs of the ancient Hellenes; that he is drinking in the beauty of the landscape and not assessing its suitability as the site of an aerodrome; that he is enjoying the beauty of a Degas and not assessing its market value. We do in fact understand such statements even if we cannot articulate our understanding in theoretical terms. There is tacit knowledge of what sort of thing appreciation is and what it is not. When in such circumstances we say that a person is having appreciative contact with an object or attending to it aesthetically we are not talking idly and we expect our interlocutors to comprehend us. And they do indeed comprehend. For in order to understand one another it is not necessary to be able to render tacit knowledge articulate by laying down a set of precisely defined common features. In order to clarify and extend understanding the method is rather to hold out typical instances of appreciation in various modes, paradigm cases from which we can both construct a central core of meaning and gradually, by radiating examples, illuminate the penumbra of similar but not quite identical cases.

Cohen speaks of the practical as well as the theoretical importance of a correct understanding of aesthetic experience.

For [he says] in so far as conditions that are not necessary are taken to be so, inappropriate training is proposed, and false instructions are offered, to those who wish to quicken their aesthetic responses. Quickening one's

aesthetic responses is not a general problem, but a series of specific problems. In addition, in so far as insufficient conditions are taken to be sufficient, inadequate training and preparation are suggested.

> This reveals an intellectualist misapprehension. One must indeed have a correct notion of appreciation in order to be able to guide others and anyone whose notion is a false one will be a misleading guide. But having a correct notion of something does not necessarily involve being able to define it in terms of necessary and sufficient conditions. As has been said, art appreciation is a form of skill, an activity which is conducted according to rules not all of which are completely specifiable. It is itself an art. Some people are more proficient at it and some less so. Like other skills, it must be mastered by trial and error and perfected by guided practice; it is taught by demonstration and example, by general indications of method and by illustration through typical instances. If at some future time the tacit know-how which is latent in a skill to appreciate can be made articulate in clearly formulable rules, then it would be possible to evolve a technology of appreciation such as Dr. Munro desiderates. As will appear in the sequel, there may be reasons which make this impossible. But guidance and instruction in the art of appreciating are not for that reason impossible.

5 Herbert Read, *The Form of Things Unknown* (1960), p. 46.

6 M. Merleau–Ponty, *Phenomenology of Perception*, (Eng. trans., 1962), p. 30.

7 In his essay 'The Doors of Perception' (1954) Julian Huxley described how after taking mescalin his ordinary perceptions attained a heightened vividness and became fraught with metaphysical significance. 'Mescalin', he said, 'raises all colours to a higher power and makes the percipient aware of innumerable fine shades of difference, to which, at ordinary times, he is completely blind.' He developed a theory that: 'What the rest of us see only under the influence of mescalin, the artist is congenitally equipped to see all the time. His perception is not limited to what is biologically or socially useful. A little of the knowledge belonging to Mind at Large oozes past the reducing valve of brain and ego into his consciousness. It is a knowledge of the intrinsic significance of every existent.'

8 Archibald Alison, *Essays on the Nature and Principles of Taste* (1790).

9 Edward Bullough, ' "Psychical Distance" as a Factor in Art and an Aesthetic Principle.'

10 Pepita Haezrahi, *The Contemplative Activity* (1954), pp. 25 and 35–6.

11 Appreciation can hardly be characterized otherwise than in terms of

attention and readers may find it useful here to refer to Appendix, I, in which my use of the concept of 'attention' is particularized.

12 An exemplary instance of this sort of criticism may be seen in Anthony Blunt, *Picasso's* Guernica (1969). See the extract on pp. 262–3

13 Paul Weiss, *The World of Art* (1961).

14 Stanislaw Ossowski, *U Podstaw Estetyki* (3rd ed., 1958), pp. 271 ff.

15 Henri Michaux, *Light through Darkness* (1964).

16 Archibald Alison, op. cit.

17 Kant, *The Critique of Judgement*, Part 1, sec. 2. Kant himself conduces to the misunderstanding of which we take notice when he says (sec. 42): 'In this connection, however, it is of note that were we to play a trick on our lover of the beautiful, and plant in the ground artificial flowers (which can be made so as to look just like natural ones), and perch artfully carved birds on the branches of trees, and he were to find out how he had been taken in, the immediate interest which these things previously had for him would at once vanish . . . ' Again: 'But it is the indispensable requisite of the interest which we here take in beauty, that the beauty should be that of nature, and it vanishes completely as soon as we are conscious of having been deceived, and that it is only the work of art—so completely that even taste can then no longer find in it anything beautiful nor sight anything attractive.' There appears to be here an intrusion of metaphysical dogma into what purports to be a phenomenological analysis.

18 R. W. Hepburn, 'Aesthetic Appreciation of Nature', *British Journal of Aesthetics*, vol. 3, no. 3. Reprinted in *Aesthetics in the Modern World* (1968), ed. H. Osborne.

19 See my article 'Artistic Illusion' in the *British Journal of Aesthetics*, April 1969.

20 For example, by Richard Wollheim in *Art and Its Objects* (1968).

Chapter 3: APPRECIATION AS ENJOYMENT: AESTHETIC HEDONISM

1 Plato, *Hippias Major*, 298a.

2 David Hume, 'Of the Standard of Taste' (1741).

3 William James, *Principles of Psychology* (1890), vol. 2, p. 468.

4 Maurice Grosser, *The Painter's Eye* (1951).

5 Ananda K. Coomaraswamy, 'The Theory of Art in Asia' in *The Transformation of Nature in Art* (1934).

6 J.-M. Guyau, *Les Problèmes de l'esthétique contemporaine* (1884).

7 C. W. Valentine, *The Experimental Psychology of Beauty* (1962), pp. 3–4.

8 Thomas Munro, *The Arts and their Interrelations* (1967), p. 136.

9 Adrian Stokes, 'Strong Smells and Polite Society', *Encounter*, September 1961.

10 Carlos Chávez, *Musical Thought* (1961).

11 Wassily Kandinsky, *Über das Geistige in der Kunst* (Concerning the Spiritual in Art), 1912.

Chapter 4: AESTHETIC QUALITIES

1 Frank Sibley, 'Aesthetic Concepts', *Philosophical Review*, vol. LXVIII (October, 1959), reprinted in Joseph Margolis (ed.), *Philosophy Looks at the Arts* (1962) and in Cyril Barrett (ed.), *Collected Papers on Aesthetics* (1965).

2 *Proceedings of the Fourth International Congress of Aesthetics*, Athens, 1960. See also Presidential Address delivered to the Western Division of the American Philosophical Association.

3 Presidential Address delivered at the 24th Annual Meeting of the American Society for Aesthetics, October 1967. Published with modifications under the title 'Once Again, Aesthetic and Non-Aesthetic' in *The Journal of Aesthetics and Art Criticism*, vol. XXVI, no. 3 (Spring 1968). On the point of special sensibility she there says:

It is wrong to say, as I did, that the features in question require for their apprehension a special sort of sensitivity and training. The tranquility of a Rothko painting or the partly sympathetic, partly satiric nature of some forms of Pop Art commentary require special training or sensitivity to apprehend. But the A's (aesthetic features) belong to a large family. And it takes no special sort of training on the part of a child to get the angry or cheerful look of a face. What is required seems no more beyond the ordinary than what is required in the child's seeing that his ball is round and red. So, for the purposes of making a *prima facie* basis of distinction between A's and N's (non-

aesthetic features), I shall reject the requirement, proposed by Sibley, that a special sort of training or sensitivity is always required.

On the criterion of scientific measurement she says: 'No procedures of measurements or laboratory experiments are required. For both sorts of feature the only test is looking.'

4 Hungerland is not alone in having—perhaps for this reason—regarded certain of these qualities wrongly as 'aesthetic'. Of 'dumpy' she says: 'What *makes* her dumpy or dainty—what is *responsible* for her looking so— except her shape, size, and the relations of her curves and angles?' But 'dumpy' is a word descriptive of a category of shape, not a tertiary quality attributed to shape. Dumpy is short and thick: a thing is dumpy if the relation of length to thickness is less than the average for that kind of thing. That the word also carries emotional connotations at any rate in some contexts is another matter still.

5 See my book *Theory of Beauty* (1952), ch. VII.

6 Heinz Werner, *Comparative Psychology of Mental Development* (1948).

7 See Appendix II.

8 J.-P. Sartre, *Esquisse d'une théorie des émotions* (1939); Sylvia Honkavaara, 'The Psychology of Expression' in *British Journal of Psychology Monograph Supplements*, no. XXXII (1961).

9 See Aurel Kolnai, 'On the Concept of the Interesting' in *British Journal of Aesthetics*, vol. 4 no. 1. Reprinted in H. Osborne (ed.), *Aesthetics in the Modern World* (1968).

10 Huw Morris-Jones, 'The Language of Feelings' in *British Journal of Aesthetics*, vol. 2 no. 1. Reprinted in H. Osborne (ed.), *Aesthetics in the Modern World* (1968).

11 The best statements of the theory in English will be found in Vernon Lee, *The Beautiful* (1913); Wilhelm Worringer, *Abstraction and Empathy* (trans. Bullock, 1953); and Lord Listowel, *Modern Aesthetics* (1967).

12 Vernon Lee, *Beauty and Ugliness* (1911), p. 363.

13 Other objections which have been advanced against the theory of empathy are the following:

(i) It is not plausible to suppose that people experience in themselves and then project the many complicated and often conflicting emotions which may be presented simultaneously in a complex work of art.

(ii) In our talk about works of art there is a steady transition from

278

sensory qualities to emotional qualities, hence it seems arbitrary to intro-
duce the dichotomy between types of quality which empathy suggests. In
his article 'Emotions and Emotional Qualities' Professor R. W. Hepburn
says: 'At no point is there a shift from talk about the figure to talk about
the spectator.' *British Journal of Aesthetics*, vol. 4, no. 4. Reprinted in H.
Osborne (ed.), *Aesthetics in the Modern World* (1968).

(iii) An explanation which seems to carry with it an implication that
not the creative activity of the artist but the emotional response of the
reader is the source of aesthetic value has been thought to be inadequate
and wrongly conceieved. This feeling was summed up by C. C. Pratt as
follows: 'One of the reasons for the strong reaction against this view, and
others like it, is that it robs the artist of his due, for it implies that the
striking qualities of art have their origin in the viscera of the subject. It is
the latter who creates the masterpieces which the artist in his innocence or
vanity assumed he had contrived.' 'Aesthetics' in *Annual Review of Psy-
chology*, vol. 12 (1961).

14 Rudolf Arnheim, *Art and Visual Perception* (1956), pp. 367–8.

15 Paul Guillaume, *La Psychologie de la forme* (1932).

16 O. K. Bouwsma, 'The Expression Theory of Art' in William Elton (ed.),
Aesthetics and Language (1954).

17 See C. C. Pratt, 'Structural vs. Expressive Form in Music' in *Journal of
Psychology*, 5 (1938).

18 Susanne K. Langer, *Philosophy in a New Key* (1942) and *Mind: An Essay on
Human Feeling*, vol. 1 (1967).

19 See Chapter 5, sec. 8.

20 *Phénoménologie de l'expérience esthétique* (1953), vol. 2, p. 471.

21 See Vincent Tomas, 'Pictures and Maps' in Frederick C. Dommeyer (ed.),
Current Philosophical Issues (1966).

22 Walter Pater, *Studies in the History of the Renaissance*: 'All art constantly
aspires towards the condition of music.'

Chapter 5 : ART AS EXPRESSION

1 Kandinsky's theory in relation to that of Tolstoy is well presented in an
article 'Kandinsky's Theory of Painting' by Vincent Tomas in *British
Journal of Aesthetics*, vol. 9, no. 1.

2 Michael Polanyi, *Personal Knowledge*.

3 Anthony Blunt, *Picasso's* Guernica (1969), p. 57.

4 See Charles Lalo, *L'Expression de la vie dans l'art* (1933) and *L'Art loin de la vie* (1939).

5 The 'emotional qualities' inherent in landscape and in the abstract features of painting interested Poussin, who tried to systematize such formal expression in his theory of 'modes', taken up later by Seurat. Poussin combined the Classical style of representing the external signs of emotional expression as in naturalistic theatre with the use of 'emotional qualities' in the modern sense. René Huyghe writes: 'The tradition of Classicism was rooted in the Renaissance, which, in the seventeenth century, was revived in France (Poussin contributed to the brilliance of that revival), was interested merely in description—description of the external signs of the passions and emotions. They are portrayed in the figures, their facial features, and the movements of their bodies, and are intelligible to anyone. Such paintings are a little like the theatre, where the inner conflicts of human beings are expounded by "actors", in the most literal sense of the word . . .' Under the influence of the Venetians he developed his theory of modes. 'As Poussin remained faithful to a theatrical conception of painting, his notion of mode might be compared to background music accompanying the actors in a play or motion picture. He sees well that the landscape complements the human elements, that it possesses the power to amplify the latter in a confused way, as waves enlarge and extend the shock of the stone thrown into the water, that it provides the *ambiance* within which an action takes place. But he analyses it and discovers in it a play of suggestion born of combinations of lines, colours and lights. The painter must learn to use them and to influence the viewer by their means. In his own words, he adds to painting—which already has the power to "represent"—the power "to arouse and to give birth to" emotions.'

6 In the *Politics* Aristotle wrote: 'Mental disturbances, which are pathological in some cases, afflict us all in reduced or acute measure. Thus we find pity and fear in the former cases and pathological disorders in the latter. Persons who are a prey to such disorders are seen to be restored when they listen to the delirious strains of sacred song, just as though they had been medically treated and purged. In precisely the same way pity, fear and other such emotions, in so far as they affect each of us, will yield to the purificatory effect and pleasurable relief produced by music.' His only other allusion to the theory of *catharsis* is a causal statement, apparently an afterthought to his definition of tragedy in the *Poetics*: 'Tragedy is an imitation of an action that is serious, complete, and of

adequate magnitude, in language embellished in different ways in different parts, in the form of action not narration, through pity and terror effecting the purgation of these emotions.' There is doubt whether the metaphor of *catharsis* derived from medical purgation or from religious purification as for blood-guilt. Possibly both associations were present in Aristotle's use of the word. So difficult has it seemed to attribute so elementary and unsatisfactory a view of tragedy to Aristotle that some scholars have argued he did not intend to refer to the emotions of pity and fear as experienced by the audience to a tragedy but to the inherent 'emotional characteristics' of the drama itself. Thus Gerald E. Else writes in *Aristotle's Poetics. The Argument* (1957) that 'catharsis is not a change or end-product in the spectator's soul, or in the pity and fear (i.e. the dispositions to them) in his soul, but a process carried forward in the emotional material of the play by its structural elements, above all by recognition' (p. 439). This view is not easily reconciled with what is said in the *Politics*. And it must be remembered that Aristotle is not advancing a coherent theory of appreciation, but may rather be answering Plato's objection (e.g. *Republic*, 605) to poetry and drama that their effect is to enhance emotional lability. Our present interest, however, is less with what Aristotle intended to say (which is now beyond recovery) but rather in the theory of catharsis as it has been interpreted down the ages. See also my *Aesthetics and Art Theory* (1968), p. 168 ff.

7 Jean H. Hagstrum, *Samuel Johnson's Literary Criticism* 1967 (1952), p. 47.

8 C. K. Ogden, I. A. Richards, and James Wood, *The Foundations of Aesthetics* (1925), p. 75.

9 Nagendra, 'The Nature of Aesthetic Experience' in *Indian Aesthetics and Art Activity* (1968), p. 71, says: 'The majority of Indian art critics are agreed upon the inter-relationship of the artistic emotion and the human emotion, i.e. *rasa* is never without an emotional basis nor can an artistic emotion exist without *rasa*. Yet the artistic emotion is distinct from the human emotion and the two cannot be identical under any circumstances.'

10 K. Krishnamoorthy, 'Traditional Indian Aesthetics in Theory and Practice' in ibid., p. 44: 'Only when the experience of the connoisseur is that of an onlooker, there can be true awareness; if his experience is that of an involved participant, the charge of passionate excitement cannot be overcome.'

11 Nagendra, op. cit., p. 72. 'It is, therefore, clear beyond doubt that an aesthetic experience, though based primarily on human emotions, is not identical with our usual emotional experience; it is neither a personal

experience direct or indirect, nor is it a psycho-physical reaction to the emotional experience of the dramatic characters. . . . The aesthetic experience is not the experience of a personal emotion, it is the experience of a universalized or liberated emotion.' S. K. De, *Sanskrit Poetics as a Study of Aesthetic* (1963): '*Rasa* is not a mere highly pitched natural feeling or mood; it indicates pure intuition which is distinct from an empirical feeling.' See also the account by Philip Rawson in *Indian Sculpture* (1966).

12 D. W. Harding, 'Psychological Processes in the Reading of Fiction', first published in *British Journal of Aesthetics*; reprinted in H. Osborne (ed.), *Aesthetics in the Modern World* (1968), p. 301.

Chapter 6: SUBJECT AND REPRESENTATION

1 See my *Aesthetics and Art Theory* (1968), ch. 4.

2 It was in accordance with these principles that Reynolds advised young painters as follows:

All the objects which are exhibited to our view by nature, upon close examination will be found to have their blemishes and defects. The most beautiful forms have something about them like weakness, minuteness, or imperfection. But it is not every eye that perceives these blemishes. It must be an eye long used to the contemplation and comparison of these forms; and which, by a long habit of observing what any set of objects of the same kind have in common, has acquired the power of discerning what each wants in particular. This long laborious comparison should be the first study of the painter, who aims at the greatest style. By this means, he acquires a just idea of beautiful forms; he corrects nature by herself, her imperfect state by her more perfect . . . (*Discourse Three*)

By these principles he was able to justify his dislike for the realism of the Dutch and Flemish schools:

The terms beauty, or nature, which are general ideas, are but different modes of expressing the same thing, whether we apply these terms to statues, poetry, or pictures. Deformity is not nature, but an accidental deviation from her accustomed practice. This general idea therefore ought to be called Nature, and nothing else, correctly speaking, has a right to that name. But we are so far from speaking, in common conversation, with any such accuracy, that, on the contrary, when we criticise Rembrandt and other Dutch painters, who introduced into their historical pictures exact representations of individual objects with all their imperfections, we say—though it is not in good taste, yet it is nature. (*Discourse Seven*)

3 e.g. L. L. Whyte (ed.), *Aspects of Form* (1951).

4 Horace, *Ars Poetica*, 343 ff. Horace uses the words *ut pictura poesis* only in the restricted context of craftsmanship: 'Poetry is like painting in that some paintings please more when seen close at hand, others from further away; some are helped by obscurity, others welcome the light and have nothing to fear from critical acumen; some please only at first, others can satisfy us repeatedly.' Cicero in the *Ad Herennium* repeats the formula: 'Poema, loquens pictura; pictura tacita poema.' The saying was answered by Leonardo, who said: 'If you, oh poet, tell a story with your pen, the painter with his brush can tell it more easily, with simpler completeness, and so that it is less tedious to follow. And if you call painting dumb poetry, the painter can call poetry blind painting.' A similar sentiment was expressed by Francesco d'Hollanda with the words: 'That poets should call painting dumb poetry only implies that they were unskilled in painting, for had they realized how much more she speaks and sets forth than her sister they would not have said it, and I will rather maintain that poetry is the dumb art.'

5 John Ruskin, *Modern Painters*, vol. 1 (1843), pt. 1, sec. 1, ch. 2.

6 René Huyghe, *Art and the Spirit of Man* (1962), pp. 254–6. Of Nuno Gonçalvèz he writes: 'Here for the first time modern man defines himself primarily as an individual ... First to become aware of the infinite particularity of humanity and the enigmatic nature of the soul, Portugal passed on its discovery to the rest of European art.'

With this contrast Pascal: 'Quelle vanité que la peinture, qui attire l'admiration par la resemblance des choses dont en n'admire point les originaux.' To which André Malraux remarks: that 'ce n'est pas une erreur, c'est une esthétique'.

7 Eugène Fromentin, *The Masters of Past Time: Dutch and Flemish Painting from Van Eyck to Rembrandt* (1876), p. 101.

8 The still life has always seemed to have a special ontological significance. Étienne Gilson writes in *Painting and Reality* (1957), p. 28:

There is a sort of metaphysical equity in the fact that the humblest genre is also the most revealing of all concerning the essence of the art of painting. If, by the word 'subject' we mean the description of some scene or some action, then it can rightly be said that a still life has no subject. Whether its origin be Dutch or French, the things that a still life represents exercise only one single act, but it is the simplest and most primitive of all acts, namely, to be. Without this deep-seated, quiet, and immobile energy from which spontaneously follow all the operations and all the movements performed by each

and every being, nothing in the world would move, nothing would operate, nothing would exist. Always present to that which is, this act of being usually lies hidden, and unrevealed, behind what the thing signifies, says, does, or makes. Only two men reach awareness of its mysterious presence: the philosopher, if, raising his speculation up to the metaphysical notion of being, he finally arrives at this most secret and most fecund of all acts; and the creator of plastic forms if, purifying the work of his hands from all that is not the immediate self-revelation of the act of being, he provides us with a visible image of it that corresponds, in the order of sensible appearances, to what its intuition is in the mind of the metaphysician.

9 Maurice Grosser, *The Painter's Eye* (1951), p. 90. The practice of individual painters was never fully in keeping with the theories associated with the movement. Degas, of course, remained interested in the theatricality and grace of the ballet and Renoir had a sensuous joy in a young woman's beauty and charm.

10 Fernand Léger, *Fonctions de la Peinture* (1965), p. 13.

11 As, for example, Picasso is reported to have said: 'You see, one of the fundamental points about Cubism is this: not only did we try to displace reality; reality was no longer in the object. Reality was in the painting.' François Gilot and Carlton Lake, *Life with Picasso* (1966), p. 71.

12 Étienne Gilson, *Painting and Reality* (1957), p. 116.

13 I owe some of these examples to Mr. Peter Owen. In his book *Painting* in this series Peter Owen has said: 'For Turner also the nature of paint is part of the picture's subject, his *Snowstorm at Sea* being as much a maelstrom of pigment as a representation in paint of the movements, tones, colours and textures of sleet and foam.'

14 Joachim Gasquet, *Cézanne* (1926).

15 Letter to Émile Bernard, 21 September 1906. In John Rewald (ed.), *Correspondence*, p. 290.

16 In *Art* (1923).

17 This experience has been referred to by R. K. Elliott in his paper 'Aesthetic Theory and the Experience of Art' in *The Proceedings of the Aristotelian Society*, 13 February 1967, and elaborated on in letters to the author.

18 Roger Fry, *Last Lectures* (1939), pp. 95–6.

Chapter 7: PERCEIVING THE ART WORK

1 H. Osborne, *Theory of Beauty* (1953), pp. 202–3. There is a fairly extensive literature on the subject of the ontological status of works of art. The Idealist theories stemming from Croce are discussed in Beryl Lake, 'A Study of the Irrefutability of Two Aesthetic Theories' and Paul Ziff, 'Art and the "Object of Art"', both printed in William Elton (ed.), *Aesthetics and Language* (1954). There is a useful discussion by Joseph Margolis in 'The Definition of a Work of Art' printed in *The Language of Art and Art Criticism* (1965). A recent and incisive discussion will be found in Richard Wollheim, *Art and Its Objects* (1968). The literature on the subject was reviewed in R. Hoffmann, 'Conjectures and Refutations on the Ontological Status of the Work of Art', *Mind*, vol. LXXI (October 1962).

2 M. Merleau–Ponty, *Phenomenology of Perception* (Eng. trans., 1962), pp. 6 and 29–30.

3 Roman Ingarden has penetrated further than any other philosopher into the phenomenology of aesthetic perception and his works are a mine of interest. Unfortunately very little of what he has written is available in English. The following statement is taken from an article 'Artistic and Aesthetic Values' published in the *British Journal of Aesthetics*, July 1964:

Every work of art of whatever kind has the distinguishing feature that it is not the sort of thing which is completely determined in every respect by the primary-level varieties of its qualities, in other words it contains within itself characteristic lacunae in definition, areas of indeterminateness: it is a schematic creation. Furthermore not all its determinants, components or qualities are in a state of actuality, but some of them are potential only. In consequence of this a work of art requires an agent existing outside itself, that is an observer, in order—as I express it—to render it *concrete*. Through his co-creative activity in appreciation the observer sets himself as is commonly said to "interpret" the work or, as I prefer to say, to reconstruct it in its effective characteristics, and in doing this as it were under the influence of suggestions coming from the work itself he fills out its schematic structure, plenishing at least in part the areas of indeterminacy and actualizing various elements which are as yet only in a state of potentiality. In this way there comes about what I have called a 'concretion' of the work of art.

4 René Berger, *The Language of Art* (Eng. trans., 1963), pp. 177 ff.

5 Professor F. G. Asenjo mentions that Stravinsky's short *Variations in Memory of Aldous Huxley* 'was presented in ballet form several times in succession at one performance, each time danced with a different choreography, one stressing the energy of the music, another the structure, etc.' He notes that the music sounded completely different. ('The Aesthetics

of Igor Stravinsky' in the *Journal of Aesthetics and Art Criticism*, Spring 1968). If one listens, for example, to the piano music of Beethoven played by several great pianists, it will be apparent that each brings to prominence a completely coherent structure of relations which *could* not all be combined in one performance though all are valid.

6 The substance of the following remarks was first published in an article written by me jointly with Ruth L. Saw and published in the first number of the *British Journal of Aesthetics* under the title 'Aesthetics as a Branch of Philosophy'. The article is reprinted in H. Osborne (ed.), *Aesthetics in the Modern World*.

7 In the *Vorlesungen über die Ästhetik*, 111, ch. 1, Hegel wrote of Byzantine painting:

Nature and life are absent from its works. It remains traditional in the form of the features, stiff and conventional in its figures and modes of expression, in the more or less architectural disposition of the figures. We miss a natural environment or background of landscape, modelling with light and shade, chiaroscuro and neither perspective nor the art of forming living groups has attained more than an elementary stage of elaboration. In these conditions the art, reduced to the reproduction of fixed and immovable types, was without the power to raise itself to free creative production and degenerated into a mere craft divorced from life in general and the life of the spirit in particular...

One of the most extraordinary of all extraordinary judgements for modern appreciation.

8 Frank P. Chambers, *The History of Taste* (1932). Mr. Chambers was engaged in further work on this much neglected subject at the time of his premature death in 1963.

9 Leonard Rosoman on 'Bruegel's *Mad Meg*' in *Painters on Painting* (1969).

10 In his *Histoire de l'esthétique* (1961) Raymond Bayer says: 'Baumgarten a vu la région de l'esthétique entre la sensibilité et l'intelligence pure. Mais c'est Leibnitz qui l'avait découverte.'

11 'Aesthetica finis est perfectio cognitionis sensitivae, qua talis. Haec autem est pulcritudo' (*Aesthetica*).

12 Baumgarten's contrast between the two ideas of perception, scientific and aesthetic, was anticipated in England by Hutcheson, who wrote in his *Inquiry*, Treatise 1, ch. XII:

Let every one here consider how different we must suppose the Perception

to be with which a Poet is transported upon the prospect of any of those objects of natural beauty which ravish us even in his description, from that cold lifeless Conception which we imagine in a dull Critick or one of the Virtuosi without what we call a fine Taste. This latter class of men may have greater perfection in that knowledge which is derived from external sensation; they can tell all the specifick differences of trees, herbs, minerals, metals; they know the form of every leaf, stalk, root, flower and seed of all the species, about which the poet is often very ignorant. And yet the poet shall have a vastly more delightful perception of the whole; and not only the poet, but any man of a fine taste. Our external senses may by measuring teach us all the proportions of architecture to the tenth of an inch, and the situation of every muscle in the human body; and a good memory may retain them. And yet there is still something further necessary not only to make a man a complete master in architecture, painting or statuary, but even a tolerable judge in these works or capable of receiving the highest pleasure in contemplating them.

13 Anton Ehrenzweig, *The Hidden Order of Art* (1967).

14 For example, George Kubler in *The Shape of Time* (1962), p. 24. 'A fine painting also issues a self-signal. Its colours and their distribution on the plane of the framed canvas signal that by making certain optical concessions the viewer will enjoy the simultaneous experience of real surfaces blended with illusions of deep space occupied by solid shapes. The reciprocal relation of the real surface and deep illusion is apparently inexhaustible.'

15 See Roger Shattuck's account of the 'style of juxtaposition' in *The Banquet Years* (1959), ch. II.

16 I have discussed these matters in an article 'Artistic Unity and Gestalt' published in the *Philosophical Quarterly*.

17 There is a strangely persistent tradition, sometimes traced back to Plato, which connects geometrical regularity with beauty. In fact Plato evinced little or no interest in visual beauty apart from the beauty of the human body. When in the *Philebus* he mentions the pleasure derived from contemplating geometrical figures he was referring to *intellectual* pleasure— the pleasure taken in apprehending the formula of a circle or his mathematical analysis of the musical intervals and the movements of the planets into self-duplicating functions of the powers of 2 and 3—and he attributes beauty to the visible circle or sphere only because they symbolize for us the intellectual formulae. In the eighteenth century Hutcheson assumed the superior visual beauty of regular shapes and indulged in elaborate intellectual contortions in the attempt to bring them into line with his

formula for beauty—the 'compound ratio' of uniformity and variety. More recently attempts have been made to prove experimentally that regular symmetrical shapes have greater aesthetic value even for animals. Working with Capuchin and Guenon monkeys and with jackdaws and crows, Professor B. Rensch claimed to have obtained statistically significant results showing a preference for shapes which are characterized by regularity, radial or bilateral symmetry or rhythmical repetition of components (*Zeitschr. f. Tierpsychologie*, 1957 and 1958, 14 and 15). What is being tested, however, in these and some similar experiments with human subjects, is conspicuousness not aesthetic preference. It does not follow that what is easiest to see is most beautiful to see. There is no evidence that regularity in the sense of mathematical lucidity is a positive aesthetic quality except in the sense of beauty for intellectual apprehension.

Chapter 8: APPRECIATION AND VALUE

1 See Anand Krishna, 'Indian Aesthetics as Revealed in Sanskrit Literature' in *Indian Aesthetics and Art Activity* (1968): 'The psychological approach to art more or less ranked equal with *yoga*; in other words, a work of art was a result of deep concentration of mind.'

See also K. Krishnamoorthy, 'Traditional Indian Aesthetics in Theory and Practice' in ibid.

Though it is clear that art was valued primarily for its real aesthetic value, the very climate of India was such that everything was perforce to be invested with the holy spirit of religion. The genius of India is such that even the most mundane activity is naturally viewed as religious. This is a country where cooking, eating, bathing and sleeping can be regarded as religious. Cutting across the infinite variety of religious sects and forms of worship, there is the fundamental unity of approach common to all which is generally missed by the Westerner. In this widest sense, dance and drama, music and painting, are so many ways of divine worship. It does not mean, as is generally supposed, that art was a hand-maid to religion, that the aesthetic approach was subordinated to dogmas of religion. What it means is only this: artists in India were religious in their personal lives and took their vocation very seriously, so seriously that they deemed their art work to be on a par with the hardest disciplines like *yoga*.

See also K. C. Pandey, 'Indian Aesthetics' in S. Radhakrishnan and others, *History of Philosophy, Eastern and Western* (1963), pp. 480 f.

2 R. G. Collingwood, of course, based his theory of art in part on a distinction in principle between art and entertainment.

3 Kalyan Kumar Ganguli, 'Animals in Early Indian Art' in *Indian Aesthetics and Art Activity* (1968), p. 35.

4 S. S. Barlingay, 'Some Concepts in Bharata's Theory of Drama' in ibid., p. 11.

5 In *Indian Aesthetics and Art Activity* (1968), pp. 53–4.

6 *Sanskrit Poetics as a Study of Aesthetics* (1963), p. 56–57. See also V. Raghavan, *Sources of Indian Tradition*: 'Hindu aesthetics explained the philosophy of beauty in terms of the enjoyment or perception of a state of sublime composure or blissful serenity which was a reflection, intimation, image, or glimpse of the enduring bliss of the spirit . . .' Quoted in Thomas Munro, *Oriental Aesthetics* (1965), p. 39.

7 John Dewey, *Art as Experience* (1934), p. 28.

8 Niharranjan Ray, in *Indian Aesthetics and Art Activity* (1968), pp. 83 and 85.

9 I have discussed this from a different point of view in *Aesthetics and Art Theory* (1968), p. 199 ff.

10 See C. A. Mace, 'Psychology and Aesthetics' in H. Osborne (ed.), *Aesthetics in the Modern World*, p. 292:

What happens when a man, or for that matter an animal, has no need to work for a living? On the genetic approach the simplest case is that of the domesticated cat—a paradigm of affluent living more extreme than that of the horse or the cow. All the basic needs of the domesticated cat are provided for almost before they are expressed. It is protected against danger and inclement weather. Its food is there before it is hungry or thirsty. What then does it do? How does it pass its time?

We might expect that having taken its food in a perfunctory way it would curl up on its cushion and sleep until faint internal stimulation gave some information of the need for another perfunctory meal. But no, it does not just sleep. It prowls the garden and the woods killing young birds and mice. It *enjoys* life in its own way. The fact that life can be enjoyed, and is most enjoyed, by many living beings in the state of affluence (as defined) draws attention to the dramatic change that occurs in the working of the organic machinery at a certain stage of the evolutionary process. *This is the reversal of the means–end relation in behaviour.*

11 Kant proposed what is ultimately a social distinction between fine arts and the arts of entertainment. In the latter class he puts these arts which have 'mere entertainment' as their object and every kind of 'play' which 'is attended with no further interest than that of making the time pass unheeded'. Fine art, on the other hand, 'has the effect of advancing the culture of the mental powers in the interests of social communication'.

12 In his writings on philosophical Pragmatism Charles Peirce threw out hints that he was prepared to regard aesthetics as the supreme evaluative science with a function to co-ordinate values and ideals over the whole field of human endeavour and to underwrite norms of action and truth. Because he held that logical thought is thinking deliberately in conformity with some ultimate purpose or ideal, he argued that logic is subordinated to ethics. For right reasoning is reasoning which will be conducive to our ultimate aim and ethics is the science of ultimate aims. 'For if, as pragmatism teaches us, what we think is to be interpreted in terms of what we are prepared to do, then surely *logic*, or the doctrine of what we ought to think, must be an application of what we ought deliberately to do, which is Ethics.' He then carries the argument a stage further and maintains that ethics is subordinate to the doctrine of 'what it is that one ought deliberately to admire *per sè* in itself regardless of what it may lead to and regardless of its bearings upon human conduct'. This last doctrine he names 'aesthetics'. For him, therefore, aesthetics is 'the basic normative science on which as a foundation, the doctrine of ethics must be reared to be surmounted in its turn by the doctrine of logic'. He describes his three normative sciences and their relations to each other as follows: 'Aesthetics is the science of ideals, or of that which is objectively admirable without any ulterior reason . . . Ethics, or the science of right and wrong, must appeal to aesthetics for aid in determining the *summum bonum*. It is the theory of self-controlled, or deliberate, conduct. Logic is the theory of self-controlled, or deliberate, thought; and as such must appeal to ethics for its principles.' The notion that the apprehension of an ultimate ideal or absolute value is an aesthetic matter has had a long tradition of philosophy in its support. In England the school of Shaftesbury is noteworthy in this respect. Such discussion is, however, outside the scope of the present study.

13 Nikolai Shamota, 'On Tastes in Art'. Reprinted in Morris Philipson (ed.). *Aesthetics Today* (1961).

14 Morris Weitz, 'The Role of Theory in Aesthetics'. Reprinted in Joseph Margolis (ed.), *Philosophy Looks at the Arts* (1962).

APPENDIX V

1 See Leonard B. Meyer, *Emotion and Meaning in Music* (1956): 'The first main difference of opinion exists between those who insist that musical meaning lies exclusively within the context of the work itself, in the perception of the relationships set forth within the musical work of art, and those who contend that, in addition to these abstract, intellectual meanings

music also communicates meanings which in some way refer to the extra-musical world of concepts, actions, emotional states, and character.' An outstandingly sober and percipient treatment of this matter will be found in Donald N. Ferguson, *Music as Metaphor* (1960).

2 Ferruccio Busoni, 'Sketch of a New Esthetic of Music' in *Three Classics in the Aesthetic of Music* (1962).

3 R. W. Hepburn, 'Emotion and Emotional Qualities'.

4 E. Hanslick, *The Beautiful in Music* (Eng. trans., 1891).

Index